VOICING TODAY'S VISIONS

VOICING

WRITINGS BY

TODAY'S

CONTEMPORARY

VISIONS

WOMEN ARTISTS

EDITED BY MARA R. WITZLING

UNIVERSE

FRONT COVER
Audrey Flack, *Marilyn (Vanitas)*, 1977
Oil and acrylic on canvas, 96 x 96 in.
Courtesy Louis K. Meisel Gallery, New York

First published in the United States of America in 1994 by
UNIVERSE PUBLISHING
300 Park Avenue South
New York, NY 10010

© 1994 by Mara R. Witzling

Cover design: Douglas & Voss, NYC

94 95 96 97 98 / 10 9 8 7 6 5 4 3 2 1

Printed in the United States of America

Library of Congress Cataloging-in-Publication Data

Voicing today's visions : writings by contemporary women artists /
edited by Mara R. Witzling.
 p. cm.
 Includes bibliographical references and index.
 ISBN 0-87663-640-7
 1. Women artists--Psychology. 2. Artists as authors. 3. Art,
Modern—20th century. I. Witzling, Mara Rose, 1947– .
N8354.V59 1994
704'.042'09045--dc20 94-29392
 CIP

*Dedicated to all the artists included herein
who so generously shared
their voices and visions*

CONTENTS

ACKNOWLEDGMENTS

I HAVE BEEN particularly honored by being able to hear the actual voices, as well as the authorial ones, of most of the artists who have allowed their writings to appear in this collection. I cannot thank them sufficiently for so liberally sharing their time, resources, and expertise. To a woman, they responded to my calls for help promptly and magnanimously. It has been a benefit and a privilege to work with them on this project, and I am greatly indebted to them all for their helpful generosity, as well as for their incisive artistic visions.

I am especially grateful to Margot Clark, my colleague and friend, who encouraged this project at its inception and as it continued, by sharing her knowledge of contemporary art, and by making available to me a wealth of resources from her personal library. While she has not been directly involved with this endeavor, my work here has been informed by the conversation that has ensued from my collaboration with Melody Graulich on other projects. My circle of friends both in New Hampshire and elsewhere continues to provide me with the emotional and intellectual nourishment necessary to sustain creative work. Each semester, my students never fail to offer new insights and have contributed to my understanding of some of the artists included here; in this context, a special mention is due to Cynthia Katz who has grown from student into friend and colleague. Thank you, all.

At the University of New Hampshire, Dean Stuart Palmer supported

this work through a College of Liberal Arts Summer Faculty Fellowship. A special thanks is due the staff of the Interlibrary Loan Department at the UNH Dimond Library, particularly to Karen Fagerberg and Susanne Seymour, whose patience and diligence enabled me to have access to a range of materials that extended far beyond our geographical area. I also appreciate the help I received from members of the reference department at the UNH Library and from those at other collections, including museums and galleries, who generously made their holdings available to me.

At Universe, I am grateful to Dorothy Caeser for her careful editing of the manuscript, to James Stave for shepherding the project to completion, and most especially to Adele Ursone for her input and insight at every stage of the endeavor. Finally, I want to thank my three sons, Benjamin, Jacob, and Ethan Hamby, for their support of, interest in, and patience with "Mom's Book."

INTRODUCTION

THIS BOOK IS CONCEIVED as a sequel to *Voicing Our Visions: Writings By Women Artists* (Universe, 1991).[1] That earlier volume made visible a heritage that was heretofore hidden, by bringing together the previously inaccessible letters, diaries, poems, and essays of twenty nineteenth- and twentieth-century women artists in an attempt to facilitate the process of "hearing women's words."[2]

The introduction to *Voicing Our Visions* established the necessity of attending to the voices of women artists as expressed in their writing, in order to more effectively evaluate their artistic production.[3] Although all artists' writings are important primary sources for analyzing the art they have produced, those by women artists have had special significance. While artists of both genders ask similar questions in their writings (such as What is an artist? Am I an artist?), women artists have often had another level to negotiate. Isolated from other artists, other women artists, and from the concept of artist itself, women artists have used their writings to articulate their deepest, most heartfelt sentiments concerning their artistic activities. Personal writings have also provided women artists a forum in which they could work out issues related to gender, particularly concerning the male-oriented assumptions in the societal definition of an artist. Perhaps most significantly, women artists' writings have provided them a safe space in which to pursue the process of validating their vocational commitment and legitimacy. The question Can a woman be an

artist? further refined as How can a woman be an artist? and finally focused to Can *I* be an artist? is asked—and answered—by many artists in numerous ways: to confidants in their letters, to themselves in their diaries, to the public in autobiographies.

Despite numerous cultural changes that have taken place over the past few decades, writing still continues to be an important practice for women artists today. Like their forebears, many contemporary women artists feel disenfranchised. Writing still provides a much-needed medium through which their voices can be heard and they can attend to their own articulations. On reading *Voicing Our Visions*, Monica Sjöö (whose work is included here) wrote, "I was delighted to find that I was not the only woman artist who has written a lot, who has felt a need to express thoughts and visions also in words."[4] An important part of the current volume's agenda is to compare how women wrote then with how they are writing now. Does writing still fill the same needs that it did for earlier women artists? To what extent do contemporary women artists still find that "woman" and "artist" are mutually exclusive terms, and do they, as did their predecessors, need to negotiate an extra level, through their writings, to claim their artistic vocations?

The complexity of working with contemporary art has posed unique challenges to the editor in selecting and researching the artists included herein. One goal has been to prevent the book from appearing dated, but, denied the security of historical perspective, determining which artists will appear important ten, or even five, years from now has proved difficult. A collection of writings by contemporary artists cannot help but be constructed around critical assessments that are current at the time of publication. The artists selected for inclusion have already achieved some professional stature, while those who could best be described as "emerging" have been excluded. Most were born in the 1930s or 1940s; full critical appreciation of those who are older came later in their lives. An attempt has also been made to achieve a balance among artists who work in diverse artistic styles, media, and written genres.

Despite their established critical reputations, it has been extremely challenging to obtain information about many of these artists. Much of that written about them was not generally available; some has been culled from such ephemeral sources as catalogues, alternative periodicals, and broadsheets, in several instances generously supplied by the artists themselves. To some extent, the lack of available information is directly related to the gender, and in some cases the ethnicity, of the artists; it has been a goal here to refrain from perpetuating the silencing, or what Howardena Pindell refers to as the "enforced censorship," of artists of color.[5] Furthermore, many of the artists have not been considered in monographs or other extensive scholarly publications. Thus, the appropriate critical vocabulary with which to discuss their work is still in the process of evolving; the discussions here should be seen as a contribution to that process. The contemporaneity of the project has also had an impact on the genres of writings available for inclusion. The diaries, letters, and other private writings of living artists are usually not accessible for obvi-

ous reasons related to privacy. While these types of writings constituted a major portion of *Voicing Our Visions*, they are represented here in just a few instances.

Each of the fourteen contemporary women artists represented here is introduced by a brief biographical sketch in which her goals and achievements are assessed and her place in the history of art is examined. Major themes in both her artwork and her writings are identified and discussed. In selecting the writings, lengthier extracts have been favored over shorter ones, to allow the works to speak for themselves and to enable readers to make their own connections. As in its predecessor volume, each artist selected for inclusion in *Voicing Today's Visions* is a writer as well as a visual artist. The process of verbalizing has had more than a passing importance for each, and their writing—neither casual nor occasional—has been sustained over time.

WOMEN ARTISTS: SOCIAL CHANGE AND CANON RECONSTRUCTION

In our postmodern, supposedly post-feminist culture, it might seem as if gender no longer imposed the same obstacles to women's creativity as it did in earlier years. Indeed, many of the cultural and institutional barriers that faced women pursuing careers in art in the past are no longer operational.[6] It has been almost a century, for example, since women were denied access to the nude model. Rather than being an oddity, women art students are currently at least as common, if not more so, as their male counterparts.[7] In fact, the greater proportion of women art students could actually reflect the "feminization" of art study, in that our consumer- and product-oriented society grants young women permission to pursue such "extraneous" subjects as art more easily than it does young men.[8] General cultural restrictions on women's movement, dress, and ownership of property have long been obsolete, while knowledge of effective means to control childbearing has been widely disseminated. Thus a woman artist now has greater freedom of both mobility and choice than she would have had a century ago. Furthermore, the feminist movement has called into question some aspects of the tradition of patriarchal dominance and privilege, creating an environment that allegedly discourages discriminatory practices and establishing a political structure that is nominally committed to preserving women's equal status under the law. However far today's society has to go toward achieving true "equality," there can be no doubt that many barriers encountered in the past by women attempting to pursue artistic careers have been eliminated.

It remains to be seen, however, whether there are still other conditions in the current culture that will have a negative impact on women artists' abilities to claim their artistic vocations. Although there are many more women artists than in the past, far fewer women than men achieve positions of power in the artistic community, either as artists or as sponsors of the arts. Women artists

are under-represented by galleries, and their works command lower prices than those by male artists. For example, in 1985 the percentage of solo exhibitions by women artists at select galleries in four American cities was 19%, up from its low of 10% in 1973 and down from its peak of 26% in 1983.[9] Works by women artists constituted only 8% of the art sold at auction by Sotheby's and Christie's in 1985, and works by women artists represent only a fraction of the holdings of corporate art collections.[10] The situation is far worse for women artists of color as attested to by Howardena Pindell's statistical analysis in the mid-1980s.[11] The complacent illusion that many of the "equalizing" changes have been achieved reinforces the status quo and may actually serve to hinder further progress toward the goal of a world beyond gender (and racial) discrimination, and an art world based on artistic excellence alone.

Along with social changes in the status of women in general and of women artists in particular, in recent years the position of women artists in relation to the art historical tradition has been reassessed. The achievements of such artists as Artemisia Gentileschi, Angelica Kauffman, and Judith Leyster have been studied more closely and precisely.[12] Likewise, many modern movements have been scrutinized and the contributions of such women artists as Mary Cassatt and Berthe Morisot to Impressionism, of Gabriele Münter and Marianne Werefkin to Expressionism, and of Frida Kahlo, Leonora Carrington, and Remedios Varo to Surrealism have been acknowledged.[13] Recent scholarship that has uncovered information regarding various historical precedents could make it possible that contemporary women artists will be less likely than their forebears to suffer from what literary critics Susan Gubar and Sandra Gilbert defined as "anxiety of authorship," the feeling that by reason of gender, one cannot have an impact on a monolithic tradition.[14] Such a change presumes, however, that the knowledge gained by the research described above has been integrated into the art historical canon and become generally available. In fact, this has just begun to occur; many texts and courses still recount only the history of male artists.

The feminist critique of art history is situated within a more extensive project in which art and its production are being reevaluated. New critical approaches have begun to rebuild a history of art whose very construction worked against the inclusion of many women artists of the past.[15] In both their writings and artworks, many women artists have themselves contributed to the process of revision, in which the exclusionary canon has been destabilized and the traditional hierarchical boundaries between high art and popular culture have been challenged. Among those included here, Howardena Pindell has criticized the art world's de facto racism, Mary Kelly and Barbara Kruger have presented critiques of institutionalized scopophilia, Harmony Hammond has discussed the possibilities for lesbian self-representation, and Monica Sjöö has shown how her lived experience of the Goddess has been an antidote to patriarchal oppression.

Significant change occurring in the art historical canon is corroborated by the recent suggestion that contemporary women artists are no longer working

on the margins of art like their predecessors, but have finally moved into its mainstream. "Making Their Mark: Women Artists Move into the Mainstream," an exhibition of works by American women artists between 1970 and 1985, provided a good example of this point of view.[16] Artists represented in this book whose works were featured in that show include Audrey Flack, Eva Hesse, Barbara Kruger, and Howardena Pindell. In his review of the exhibition, the critic Arthur Danto asserted that not only would "at least half of the artists" turn up as a matter of course in any exhibition entitled "The American Mainstream, 1970-85," but that also, were he "asked to select the most innovative artists to represent this particular period . . . most of them would probably be women."[17] In other words, according to Danto, in the past two decades, women artists have been the leaders—rather than the followers—of the artistic avant-garde. The positioning of women artists as leaders of mainstream art movements offers a liberating and refreshing antidote to the traditional marginalization in the art historical canon of works by women practitioners.[18] But the very fact that feminist art practice is sometimes considered synonymous with other aspects of contemporary challenges to the canon raises doubts about the extent to which the polarity between marginal and mainstream continues to remain a valid critical construct.

The preceding comments should not suggest that our culture has reached a state of enlightenment with all of our problems solved. There are certainly major contrasts between current societal conditions and those of past centuries, even with those of the early twentieth century. On the other hand, while gender now has a different impact on women artists and their writing than it did in the past, one reason that contemporary women artists still write is that, in one way or another, they have felt disenfranchised by the patriarchal hegemony.

<div align="center">୰</div>

THE GENDERED SUBJECT

The assumption that men are the possessors of a controlling gaze, and its corollary, that women are its object, have been strongly challenged in recent years. In *Ways of Seeing*, John Berger first posited the idea of the "surveyor" and the "surveyed," the concept that "men act and women appear." According to Berger, within this economy (and not because of any essential "difference" between men and women) "the 'ideal' spectator is assumed to be male and the image of the woman is designed to flatter him."[19] Subsequent writers have further expanded on Berger's thesis. In her essay "Visual Pleasure and Narrative Cinema," Laura Mulvey explores the problematic position of the woman viewer in confronting images designed to fulfill male scopophilic pleasure, which assume that women are the object of the "determining male gaze." She concludes that, in its voyeuristic use, women's image has "continually been stolen."[20] Although Mulvey was referring specifically to cinematography, her

concept has proven relevant to critics of other aspects of visual culture. Lisa Tickner, for example, applied Mulvey's theory to the western art historical tradition, in which the female body is (in Tickner's words) "occupied territory," colonized by being the object of art produced by "a male artist for a masculine audience."[21] Whitney Chadwick has discussed the "serious challenges" posed by a woman's presumed position of object "to the woman artist who wishes to assume the role of speaking subject."[22] Yet, according to Tickner, the best antidote to this state is for women artists to reclaim that "stolen" territory from masculine fantasy by making art that effectively expresses the truths about their lives, through authentic images of actual female body experience.[23]

The dictum that women artists and writers can (and should) decolonize the image of woman, that is, transform "her" from "a mediating sign for the male" into "the expression of female experience"[24] has been echoed by other critics. Susan Suleiman conceptualizes the woman writer as a "speaking subject," a "laughing mother" who through her position rewrites the patriarchal script.[25] In her concept of the laughing mother, Suleiman expands upon Hélène Cixous's essay "The Laugh of the Medusa," which Suleiman calls "a trope for women's autonomous subjectivity and for the necessary irreverence of women's writing—and re-writing." She explains that Cixous's revision of Freud's reading of Medusa's decapitated head as a symbol for the Mother's castrated genitals "consists in imagining a female spectator who finds the very notion of women's castration laughable; and who, looking at her body through her own eyes rather than the man's, finds all of it beautiful."[26] Margaret Miles relates this idea specifically to the production of visual images when she says that although women artists are "visually trained in patriarchal societies to see ourselves and other women as objects . . . we can alter our visual practices by learning to see and read the female body as the intimate reflection and articulation of women's subjective experience."[27]

The works of many women artists of the past century show how "simply the act of 'looking as women' . . . means bringing a different kind of experience to the making and reading of images."[28] According to both Margaret Miles and Rosemary Betterton, this difference is exemplified in Suzanne Valadon's images of the female nude, described by Miles as "effectively challeng[ing] the patriarchal identification of 'woman' with female flesh" and, as such, "repossess[ing] the female body for a woman's subjectivity."[29] Valadon was not a political feminist and, as Betterton points out, she "cannot be assumed to have 'seen' differently from her male contemporaries." However, "the particular force of her experience produced work which was differently placed within the dominant forms of representations of her period," especially in light of the fact that she herself had been a model.[30] This concept of position dependence can be seen in operation in works by such other turn-of-the-century women artists as Mary Cassatt and Berthe Morisot. By force of their positions as bourgeois women, these two Impressionists focused on the intimacies of the domestic interior in their depiction of the actualities of contemporary life, while their

male counterparts, with access to the Parisian demimonde, produced few such images.[31]

More recently, *Jolie Madame* (1972) by Audrey Flack illustrates how the different societal placement of a woman artist can produce different work. In this work, Flack was not attempting deliberately to express a "feminine" point of view; rather, she wanted to "capture the elusive non-color of glass and reflective surfaces and textures."[32] But unlike her male photo-realist counterparts who depicted the shiny metallic surfaces of cars, trucks, and store windows, Flack focused on imagery that is traditionally identified as "feminine," such as perfume, jewelry, and knickknacks that she had gathered from her own house, objects that would typically adorn a woman's bureau. According to Flack's description, the work created an uproar, decried for its representation of "greed." Flack correctly identifies the cause of the hostility to her work. "As a woman," she writes, "I had instinctively chosen props that a woman would use. By merely being true to my nature . . . I had broken a silent code. These objects were not to be painted or taken seriously."[33] Despite their "inappropriateness" as artistic subjects, these objects had relevance to Flack because of her cultural position as a woman.

Women artists have also made works that have deliberately confronted and challenged the dominant artistic codes of iconographic and stylistic acceptability. As Rosemary Betterton has discussed, " 'looking as women' also demands a conscious attempt to transform the conditions under which such images are produced, seen and understood."[34] In this light, it is interesting that in a subsequent still life (*Chanel*, 1974), Flack deliberately focused on what was considered "inappropriate" content: trays, mirrors, rouge, lipsticks, and other items from department store makeup counters. Other contemporary women artists have followed this latter approach, making the exploration of gendered stereotypes and the deconstruction of their "codes and symbols" (Betterton's phrase) the overt subject and central focus of their art. In her autobiography, *Through the Flower*, Judy Chicago offers an excellent analysis of how she was able to resolve through her work the struggle she experienced between being a woman and being an artist.[35] For Chicago that meant the evolution of a new formal vocabulary, her much-discussed and little understood vaginal iconography. While not all women artists would claim to espouse Chicago's method of struggle or her solution, in fact, many have grappled with the dichotomy engendered when "woman equals object and artist equals man," but the woman is an artist. Harmony Hammond writes of a similar crisis: like Chicago she felt that she had to hide the content of her art in order to make art that was "acceptable," at that time, hard-edged abstractions. She wrote, "I knew that if I wanted to be taken seriously as an artist, I had to paint what the boys painted, and I had to do it bigger and better. I proceeded to do just that. Slowly, but consciously, I painted myself out of my work."[36] Like Chicago, Hammond was able to resolve through artistic practice the disjunction she perceived in her position as an active, creative woman in a cultural context in which women were considered as objects. It is especially significant that it was through her

work, once she had found a way of expressing her own vision, that Hammond became aware of her sexual orientation as a lesbian.

Many contemporary women artists who endeavor to disrupt convention-ally acceptable artistic constructions participate in the process of "redirecting the gaze." Thomas McEvilley has identified two seemingly opposite strategies that recent women artists have used to redefine the stereotypically gendered female image. He describes the first as "the redirection of attention to ages and cultures where women had not been subservient" and the second, as "the deconstruction of the communication codes by which unspoken assumptions of male supremacy have been held in place."[37] Chicago's use of vaginal iconog-raphy in which she attempts to reappropriate the meaning of "cunt," as in *The Dinner Party* in which female heroes from the past and present are celebrated, exemplifies the first approach. Several artists have specifically tried to "reclaim matristic iconography," to evoke in their work goddess-centered cultures in order to empower contemporary women.[38] Marybeth Edelson performed ritu-als at ancient goddess sites, Ana Mendieta etched her own silhouette into liv-ing rock, and Monica Sjöö draws upon ancient images of women's power in her paintings, complemented by her research into the history of goddess worship. For Sjöö, the Goddess is "THE cosmic creative energy" on which she bases her paintings, a living force "who speaks to us in visions and dreams," who can empower women to undo the destructiveness of patriarchal cultures.[39] Audrey Flack has also contributed to this reinterpretation in her most recent work, monumental sculptures of contemporary goddess figures, which she describes as representations of Jean Shinoda Bolen's concept of "goddesses in every-woman." Through these strong, positive female figures, Flack as well as Sjöö and Edelson have consciously sought a means of redefining the stereotyped and "colonized" image of woman as the passive object of the male gaze.

Other artists and critics, however, believe that because the female image is so overdetermined in western visual culture, all images of women cannot help but recreate the stereotypes that they attempt to replace. These artists have developed artistic strategies aimed at deconstructing the received visual system. For example, the photographer Barbara Kruger juxtaposes imagery appropriated from the popular media and gender-laden "slogans" with which she directly engages the viewer's position as either the possessor or the object of the controlling gaze. The relation between image and text is complex, forc-ing one to question the perpetuation of concepts related to both gender and power, "sometimes by reinforcement of the thrust of the image, sometimes by controversion of it, and sometimes by oblique wry comment."[40] Kruger achieves her effect through the use of "pronominal shifters"—"I," "you," "we"—which by their nature urge viewers to evaluate their position in relation to the hegemony. As Jane Weinstock asks, "What does she mean to you?"[41] In other words, by forcing viewers to confront their own connection to the group iden-tified in a particular work, Kruger compels them to actively question the status quo. In its considerations of the intersection of media, gender, and power, Kruger's work can be compared with that of other artists, such as Cindy

Sherman, Jenny Holzer, and Dara Birnbaum. Regardless of the differences in their specific works and intents, all these artists, along with Kruger, make the subject of their art the deconstruction of conventionalized, gendered ways of seeing.

Mary Kelly works from a similar position. In *Interim* (1984-89), her long-term project examining the aging female body, as in her earlier *Post-Partum Document* (1973-79), Kelly never presents a figural depiction of her subject. Her repudiation of the female figure was a deliberate strategy to represent women's subjectivity apart from what Emily Apter has called "the reifying regime of scopic masculinism."[42] By offering a diverse array of visual and written materials, she forces the viewer to construct, or "picture," the subject, without having recourse to timeworn visual stereotypes of femininity. Although *Post-Partum Document*, for example, deals with the relationship between mother and child, she never offers a visual image of either of them. Presumably the viewer is able to bypass conventional associations that Kelly believes would inevitably be evoked by any figurations of the theme, and to hear complexities and ambiguities in the maternal voice that otherwise would be overlooked.

Although the proponents of the two strategies of subverting the dominance of the "scopophilic gaze" display "a disturbing tension between them," as McEvilley points out, "both strategies are necessary and their difference is more complementary than contradictory."[43] Both approaches are represented by artists included in the current volume.

TELLING STORIES: GENDER AND GENRE IN WRITINGS BY CONTEMPORARY WOMEN ARTISTS

Writing about her life is still a significant act for a woman artist. Although artists' texts can be interpreted simply as additional frames of reference, resources that enhance our understanding of the artists' visual works (which is indeed how they are usually considered), they also can be seen as the link between she who visualizes and she who verbalizes, rebellious and courageous acts in a culture that has discouraged both activities for women. As demonstrated in *Voicing Our Visions*, during the past century women artists have used the written word as a means of self-validation. Women artists are writing now because they still need to struggle to gain legitimate voice; they still feel compelled to rupture the cultural proscriptions against speaking their own truths in real words.

Women artists have voiced their visions in a variety of literary genres. While diaries and letters predominated in the first volume, there is only one journal writer represented here—Eva Hesse—not coincidentally the only artist who is deceased. Because letters and journals are private forms not written for public presentation, they have been especially reliable sources of their writers'

authentic thoughts and feelings.[44] They are therefore usually not available for perusal during the lifetime of the writer or her close associates.

Frank and eloquent autobiographical essays comprise the predominant genre in the current volume. In the past, formal autobiographies have usually followed a predictable pattern, telling the story of travel toward and achievement of an identifiable goal.[45] This format, adopted by several artists of the recent past such as Cecilia Beaux, has been identified as conforming to a "masculine" shape.[46] The autobiographical pieces included here, on the other hand, are open-ended meditations that attempt to clarify enigmatic and pivotal life experiences, often in relation to their impact on the art-making process. Audrey Flack has written on her use of color, on the symbolism of her paintings, and on formative experiences in her artistic development, such as her encounter with Jackson Pollock when she was an impressionable, recent graduate from Yale. Magdalena Abakanowicz has evoked the texture of her childhood experience of landscape, nature, and war, in a way that helps to clarify the source of her imagery. May Stevens has considered how her racist and sexist upbringing contributed to her subsequent tolerance and compassion, and Monica Sjöö discusses how she painfully gained acceptance of the Dark Mother, whose face she had resisted despite her respect for the Goddess, after the deaths of two sons within two years. Adrian Piper writes that the introductory essay to her larger work *Autobiography of an Art Object* "grew out of the fact that I could not explain to myself why I had felt compelled to overcome the impasse [in her work] in the way that I did. . . . I began writing this in order to clarify to myself what I was doing and why."[47] The importance of these pieces to an artist's process of self-clarification is exemplified by Howardena Pindell, who turned to autobiographical writing as one means of regaining her sense of self after the temporary loss of memory suffered in a car accident. This, in turn, led to a large painting project, her ongoing *Autobiography* series, in which she attempts to integrate the fragments of her experiences through both words and images.

This volume also contains selections of poetry. When encountering these literary works, it is helpful to consider the relationship between the artist's visual and verbal images by asking such questions as, To what extent do they reinforce each other? How do they differ? and What does the artist express through each? Although Barbara Chase-Riboud has written several novels, her work is represented here only through poetry because of the particularly rich reciprocal relationship between her poems and sculpture: several poems and sculptures appear to be variations on the same theme, and her poetry, like her sculpture, is characterized by a melding of opposites, hard and soft, lyrical and violent. May Stevens's poems, particularly the moving suite about her mother in old age, reinforce the themes embodied in her *Ordinary. Extraordinary* project. Stevens's poem to her father, "Letters Home," softens and humanizes the image presented in her "Big Daddy" series of paintings. Poems often provide their writers with another outlet for pondering and working through troubling

issues, as Monica Sjöö laments her sons' deaths and Dorothy Dehner contemplates the passage of her life.

The importance of writing to the artists in this volume is related to writing's privileged status in postmodernist artistic practice. Griselda Pollock has pointed out that, whereas words and writing are "taboo" in modernist works, they are a "characteristic presence" in many postmodern endeavors.[48] In his essay "The Discourse of Others," Craig Owens articulates the relationship between feminist artists' use of text and postmodernist writing practice, saying that "feminist artists often regard critical or theoretical writing as an important arena of strategic intervention . . . a crucial part of [their] activity as artists."[49] He goes on to explain the distinction between modernist and postmodernist artists' use of text by pointing out that while "many modernist artists produced texts about their own production . . . writing was almost always considered supplementary to their primary work, whereas the kind of simultaneous activity on multiple fronts that characterizes many feminist practices is a postmodern phenomenon."[50] In other words, for many postmodernist artists—as well as for feminist ones—the written word forms an intrinsic part of their artistic activity, not simply an extrinsic theoretical commentary.

Several different approaches that characterize postmodern writing practice and its relation to visual art are represented here. In some instances, written work might be included within an artist's endeavor, but it is not an inherent part of the visual art itself. For example, in her numerous critical essays on film and television, Barbara Kruger speaks to many of the same issues regarding the intersection of scopic and cultural power that she explores through her visual art. Sometimes artists use text to supplement their art-making practice. In her *Autobiography of an Art Object*, Adrian Piper documents her work *Catalysis*, in which she used her body as the object of art, expanding upon her belief that art's purpose is catalysis and explaining her lack of interest in the discrete art object.

The most typically "postmodern" textual practice, also well-represented in this volume, is the incorporation of text into the artwork itself. Textual elements can be limited to single phrases that are either legible, as in Barbara Kruger's photographs, or barely legible, as in the phrases that surface in Howardena Pindell's, Harmony Hammond's, and May Stevens's recent paintings; they can provide a visual background for the image, as in the essays that are part of Adrian Piper's *Political Self-Portraits*; or they can hold equal importance with the visual elements, as in the narratives in May Stevens's artist's book *Ordinary. Extraordinary.*

Mary Kelly's use of text in combination with many other elements provides an excellent example of postmodern feminist practice. As discussed above, Kelly creates her works out of "multiple representational modes" (Owens's phrase) combining text, artifacts, and natural fragments, presented as if on exhibition at an anthropological museum, in order to allow viewers to construct their own images. On the most basic level, Kelly's use of text typifies a postmodernist approach, in that the text comprises an essential element of her

work. That work is quintessentially postmodernist because Kelly does not use text to present a unified narrative. Rather, the texts that Kelly uses in *Interim*, for example, come from many sources and simultaneously express multiple perspectives. Thus, instead of representing "one narrative that can possibly account for all aspects of human experience," Kelly's use of "multiple representational systems" testifies, as she herself indicates, that "there's no single theoretical discourse which is going to offer an explanation for all forms of social relations or for every mode of political practice."[51] Kelly's use of textual elements in her work, then, contributes to the process of destabilizing the center of cultural analysis and of artistic endeavor.

Even when not a part of a specifically postmodern agenda, many recent women artists have been drawn to storytelling "as a form of cultural criticism."[52] Brian Wallis connects this tendency to Walter Benjamin's understanding of "storytelling as a form melding personal experience and political desire."[53] Barbara Chase-Riboud, in several novels and an epic poem, speaks as a black woman re-envisioning the lives of "famous" women of African descent, such as Cleopatra and Sally Hemings, and of her own great-grandmother Anna, whose mother escaped slavery via the Underground Railroad to Canada. May Stevens, speaking as a working-class woman, tells her mother's story—that of an "ordinary" woman silenced and made crazy by patriarchy—intertwined with that of Rosa Luxemburg, an "extraordinary" woman who was also silenced, for being too powerful. Monica Sjöö, a working-class self-educated artist, searches for the Goddess's hidden history in essays and poetry; as she has said, she needed to find the stories to explain the source of her images to herself. These artists' writings gain their power through their simultaneous marginality and authority.[54]

The telling of stories provides "images of resistance and renewal"[55] that "challenge the pervasive 'master narratives' of the [bourgeois, western] culture, that would contain them."[56] bell hooks has shown that a marginal position can be one of empowerment rather than of exclusion, and that "the politics of location" is necessary to "those of us who would participate in the formation of counter-hegemonic cultural practice."[57] hooks defines the margin as a site of resistance, "a location of radical openness and possibility." It is a place that is "in the whole but outside the main body," wherein one is empowered by a double vision that engenders a "decentralizing energy," contrary to the hegemony of the center.[58] The world is defined as incomplete; it is polysemous, allowing differing perspectives without favoring a single one; it is polyphonic, multivoiced rather than authoritative.

Such a world view radically challenges the traditional grand narrative of art history by allowing women artists, and other "others," to represent their experience in their own terms, without implied devaluation. The power of the margin as simultaneously a site of difference and of authority is exemplified by Harmony Hammond's concept of "border art," whose "practices are based on multiplicity and understanding of both sides," and in which there are "frequent crossings back and forth."[59] Hammond is writing from her position as a lesbian

artist; however, as she says, "border art is any art that questions the hegemonic Western discourse."[60] Thus her comments are relevant to work by many women artists, particularly to many women artists who transgress the accepted "norm" in aspects other than their gender. Faith Ringgold's story quilts, all spoken by black female protagonists, and in which visual imagery and written text are pieced together in the same frame, epitomize this tendency on the part of women artists to tell stories that scatter the elements of the stereotypical "grand narrative."

The need for women artists to tell stories provides a further disruption to the relationship of image and text in the western art historical tradition, where the interdiction regarding text-image pairing occurs not only in modernism, but in the entire post-Renaissance, heroic, artistic tradition. According to the Renaissance view, the visual image was expected to communicate a parallel world through the unity of time and place, and to be unsullied by intrusions that disturbed its perfect illusion. A similar separation is not found during the Middle Ages when, particularly in illuminated manuscripts, words and images functioned reciprocally. The Korean-American film theorist and performance artist Theresa Hak Kyung Cha said, "Let the one who is *diseuse* . . . be found. Restore memory. The ink spills thickest before it runs dry before it stops writing at all."[61] And the Vietnamese-American writer and filmmaker Trinh T. Minh-ha wrote that "the story never stops beginning or ending. It appears headless and bottomless for it is built on differences. . . . The story circulates like a gift; an empty gift which anybody can lay claim to by filling it to taste, yet can never truly possess. A gift built on multiplicity."[62]

Carol Christ discusses the importance of telling women's stories to "the expression of women's spiritual quest." "Women's stories have not been told," she writes. "And without stories there is no articulation of experience. . . . If women's stories are not told, the depth of women's souls will not be known."[63] In the past, women's "utterances" were considered irrelevant, often reproduced in little-valued media, and created in genres of lesser significance by people who did not fit the accepted artistic profile. The destabilizing canon now challenges the supremacy of easel painting, the dominance of strong individuals, and the private ownership of precious works of art. The artists in this volume engage these issues in both their artistic work and their writings. By telling their stories, through words and images, they have contributed to our ability to construct a richer, fuller understanding of what it is to be human.[64]

NOTES

1. Mara R. Witzling, ed., *Voicing Our Visions: Writings by Women Artists* (New York: Universe, 1991).

2. Ibid., p. 1. The concept of voicing women's previously unarticulated experience is discussed in Carroll Smith-Rosenberg, "Hearing Women's Words: A Feminist Reconstruction of History," *Disorderly Conduct: Visions of Gender in Victorian America* (New York: Alfred A. Knopf, 1985), pp. 11-52.

3. Ibid., pp. 3-15. In particular, I considered such critical questions as the impact of gender on artistic self-definition, the problem of finding a voice, the myth of the artist-hero, and the intersections of gender and genre.

4. Monica Sjöö, "Thoughts Inspired by Reading *Gender and Genius: Towards a Feminist Aesthetic* by Christine Battersby and *Voicing Our Visions: Writings by Women Artists* edited by Mara R. Witzling," *From the Flames* 7 (Autumn 1992), p. 32.

5. See Howardena Pindell, "Breaking the Silence, Parts I and II," *New Art Examiner* (October 1990), pp. 18-23; (November 1990), pp. 23-29, 50-51.

6. Linda Nochlin, in "Why Have There Been No Great Women Artists?" *Art News* 69 (January 1971), pp. 22-39, 67-71 [reprinted in Linda Nochlin, *Women, Art and Power and Other Essays* (New York: Harper and Row, 1988), pp. 145-78], was the first to discuss the relationship between societal restrictions on women artists' education and the seeming lack of "great" women artists in history. In particular, she noted that women training to become artists did not have access to the nude model, a liability in an artistic culture in which making images that included humans in a variety of poses was considered (as in history or biblical painting) the most worthy form of artistic endeavor. This situation persisted well into the nineteenth century, when women students were documented as making life drawings from cows at the Pennsylvania Academy of the Fine Arts as late as 1885 (Nochlin, *Women, Art and Power*, p. 162). Restrictive styles of dressing and the assumption that nice women did not move around unaccompanied created other limitations. Rosa Bonheur, for example, went to great extremes, including obtaining a *certificat de travestissement* from the police, in order to gain the freedom of movement afforded males. In a passage in Marie Bashkirtseff's diary, the late-nineteenth-century artist bemoans the inhibiting effect of having to get dressed up and secure a companion in order to make a visit to the Louvre to study art. (See Witzling, *Voicing Our Visions*, pp. 23, 119.)

7. See Charlotte Yeldham, *Women Artists in Nineteenth-Century England and France* (New York: Garland, 1984) for information regarding education, as well as exhibition records, of women artists.

8. See June Wayne's essay on "The Male Artist as a Stereotypical Female" in Judy Loeb, ed., *Feminist Collage: Educating Women in the Visual Arts* (New York: Teacher's College Press, 1979) pp. 128-37, although Wayne's idea is certainly in conflict with macho myths about the artist that have persisted into the second half of the twentieth century, as well as with the economic facts of the art marketplace where far more men continue to show their work and make a profit.

9. Ferris Olin and Catherine C. Brawer, "Career Markers," in *Making Their Mark: Women Artists Move into the Mainstream 1970-85*, ed. Randy Rosen and Catherine C. Brawer (New York: Abbeville Press, 1989), p. 207. The cities surveyed were New York, San Francisco, Los Angeles, and Chicago. Women artists fared somewhat better at alternative spaces in those same cities (pp. 208-10).

10. Ibid., pp. 219-21. For example, the Mellon Bank in Pittsburgh has a collection of 1,900 artworks; 205 of these are by 73 women artists. Olin and Brawer list the solo exhibitions of twentieth-century women artists in 24 American museums between 1970 and 1985; 248 artists were given a total of 321 exhibitions (pp. 211-15).

11. Howardena Pindell, "Art World Racism: A Documentation," *New Art Examiner* (March 1989), pp. 32-36. The essay is excerpted from a larger document presented by Pindell at the Agencies of Survival conference at Hunter College, New York, in June 1987, reprinted in its entirety in *Third Text* 3/4 (Spring/Summer 1988), pp. 157-90. Excerpts from the essay are included in the current volume, including the gallery statistics. At the Brooklyn Museum, for example, in the years between 1980 and 1988, two exhibits (3.92% of their total one-person exhibits and 1.8% of their total exhibits) were one-person shows by artists of color, both of whom were male.

12. These women were cited in Nochlin, *"Why No Great Women Artists?"* and their works were included in the germinal exhibition at the Los Angeles County Museum of Art and accompanying catalogue by Ann Sutherland Harris and Linda Nochlin, *Women Artists 1550-1950* (New York: Alfred A. Knopf, 1976). Gentileschi was the subject of a monograph by Mary Garrard, *Artemisia Gentileschi: The Image of the Female Hero in Italian Baroque*

Art (Princeton, N.J.: Princeton University Press, 1989), and there have been recent exhibitions of Kaufman's and Leyster's work with accompanying catalogues containing scholarly reassessments. See Wendy Wassyng Roworth, ed., *Angelica Kaufman: A Continental Artist in Georgian England* (London: Reaktion Books, 1992) and *Judith Leyster: A Dutch Master and Her World* (Zwolle, Netherlands: Waanders Printers, 1993), published in connection with an exhibition held at Frans Hals Museum, Haarlem, Netherlands, and Worcester Art Museum, Worcester, Mass.

13. The position of women artists in such mainstream modern movements as Surrealism, Impressionism, and Abstract Expressionism has been clarified and revised in recent years. See Whitney Chadwick, *Women Artists and the Surrealist Movement* (Boston: Little, Brown and Co., 1985); Shulamith Behr, *Women Expressionists* (New York, Rizzoli, 1988); Griselda Pollock, "Modernity and the Spaces of Femininity," *Vision and Difference* (London: Routledge, 1988); Norma Broude, *Impressionism: A Feminist Reading* (New York, Rizzoli, 1991); and Ann Wagner, "Lee Krasner as L.K.," in *The Expanding Discourse: Feminism and Art History*, ed. Norma Broude and Mary D. Garrard (New York: HarperCollins, 1992), pp. 425-36.

14. Sandra Gilbert and Susan Gubar, *The Madwoman in the Attic: The Woman Writer and the Nineteenth-Century Literary Imagination* (New Haven, Conn.: Yale University Press, 1979), p. 13. Gilbert and Gubar are using Harold Bloom's concept of "anxiety of influence" as their source for "anxiety of authorship."

15. In particular, see F. Frascina et al., *Modernity and Modernism: French Painting in the Nineteenth Century* (New Haven, Conn.: Yale University Press, 1993), one of a series of books published in conjunction with the Open University in London in which issues related to gender are treated within other considerations of the cultural construction of art and its making.

16. Rosen and Brawer, eds., *Making Their Mark*.

17. Arthur C. Danto, "Women Artists, 1970-85," *The Nation* (December 25, 1989), pp. 794-98.

18. As has been well substantiated, although many women artists established solid reputations during earlier art historical periods, few held acknowledged positions of leadership during their lifetimes, and most had been written out of the historical record only to be "rediscovered" in recent years. Likewise, although women participated in most mainstream modernist movements, it is only through the process of retrieval and redefinition that we are now recognizing their contributions to those movements.

19. John Berger, *Ways of Seeing* (New York: Penguin Books, 1972), pp. 46-47, 64.

20. Laura Mulvey, "Visual Pleasure and Narrative Cinema," *Visual and Other Pleasures* (Bloomington: Indiana University Press, 1989), particularly pp. 19, 25-26.

21. Lisa Tickner, "The Body Politic: Female Sexuality and Women Artists Since 1970," in *Looking On*, ed. Rosemary Betterton (London: Pandora Press, 1987), p. 239.

22. Whitney Chadwick, *Women, Art and Society* (London: Thames and Hudson, 1990), p. 12.

23. Tickner, "The Body Politic," p. 239.

24. Ibid., p. 237.

25. Susan Suleiman, *Subversive Intent* (Cambridge: Harvard University Press, 1990), p. 10: "To see things anew/Teach the daughter to play/Imagine the mother playing," and pp. 179-80: "If the mother were really recognized in our culture as an independent subject with desires of her own . . . it would change the way we in the West think about the constitution of human subjectivity."

26. Ibid., p. 168. See Hélène Cixous, "The Laugh of the Medusa," *Signs* 1:4 (1976), pp. 875-93. See p. 885 where Cixous writes, "you only have to look at the Medusa straight on to see her. And she's not deadly. She's beautiful and she's laughing."

27. Margaret Miles, *Carnal Knowing* (Boston: Beacon Press, 1989), p. 184.

28. Rosemary Betterton, "How Do Women Look? The Female Nude in the Work of Suzanne Valadon, " in *Looking On*, ed. Betterton, p. 222.

29. Miles, *Carnal Knowing*, p. 184.

30. Betterton, "How Do Women Look?" pp. 222-23.

31. This is Griselda Pollock's thesis in "Modernity and the Spaces of Femininity," in *Vision and Difference*.

32. Audrey Flack, *Art and Soul: Notes on Creating* (New York: E. P. Dutton, 1986), pp. 48-49. Extract reprinted in this volume.

33. Ibid., p 49.

34. Betterton, "How Do Women Look?" p. 233.

35. Judy Chicago, *Through the Flower: My Struggle as a Woman and an Artist* (Garden City, N.Y.: Doubleday and Co., 1974). Also see Witzling, *Voicing Our Visions*, pp. 368-82.

36. Harmony Hammond, "Creating Feminist Works," originally written in 1978, published in Harmony Hammond, *Wrappings: Essays On Feminism, Art and the Martial Arts* (New York: TSL Press, 1984), p. 12. Extract reprinted in this volume.

37. Thomas McEvilley, "Redirecting the Gaze," in *Making Their Mark*, ed. Rosen and Brawer, pp. 191, 194.

38. In Gloria Feman Orenstein, *The Reflowering of the Goddess* (New York: Pergamon Press, 1990), see Chap. 7, "Reclaiming and Remembering Matristic Iconography," particularly pp. 78-79.

39. Ibid., p. 80. Also, unpublished broadsheet statement regarding Monica Sjöö's artistic intent.

40. McEvilley, "Redirecting the Gaze," p. 195.

41. Jane Weinstock, "What she means, to you," *Barbara Kruger: We Won't Play Nature to Your Culture* (London: Institute of Contemporary Arts, 1983), pp. 12-16.

42. Emily Apter, "Fetishism and Visual Seduction in Mary Kelly's *Interim*," *October* 58 (Fall 1991), pp. 97-108.

43. McEvilley, "Redirecting the Gaze," p. 195.

44. See Witzling, *Voicing Our Visions*, pp.13-15, for a discussion of the importance of women artists' diaries and letters.

45. See Witzling, *Voicing Our Visions*, p. 12, for a discussion of the development of autobiography as a genre and its use by women artists. This approach to autobiography informs Mary Grimley Mason and Carol Hurd Green, *Journeys: Autobiographical Writings by Women* (Boston: G. K. Hall, 1979). For women's autobiographical practice, also see Estelle Jelinek, *Women's Autobiography* (Bloomington: Indiana University Press, 1980); Shari Benstock, ed., *The Private Self: Theory and Practice of Women's Autobiographical Writings* (Chapel Hill: University of North Carolina Press, 1988); and Sidonie Smith, *A Poetics of Women's Autobiography* (Bloomington: Indiana University Press, 1987).

46. Witzling, *Voicing Our Visions*, p. 13. See pp. 94-107 for discussion of Cecilia Beaux and excerpts from her autobiography, *Background With Figures* (Boston: Houghton Mifflin, 1930). According to Smith in *Poetics of Women's Autobiography,* p. 40, "autobiography is ultimately an assertion of arrival and embeddedness in the phallic order."

47. Adrian Piper, *Talking to Myself: The Autobiography of an Art Object* (Brussels: Hossmann Hamburg, 1974), p. 6. Excerpt reprinted in this volume.

48. Griselda Pollock, in *Mary Kelly: Interim*, exhibition catalogue (New York: New Museum of Contemporary Art, 1990), p. 49.

49. Craig Owens, "The Discourse of Others: Feminists and Postmodernism," in *The Expanding Discourse*, ed. Broude and Garrard, p. 491.

50. Ibid.

51. Mary Kelly, "No Essential Femininity: A Conversation between Mary Kelly and Paul Smith," *Parachute* 26 (Spring 1982), p. 33, as quoted in Owens, "Discourse of Others," p. 492.

52. The phrase is from Brian Wallis, "Telling Stories: A Fictional Approach to Artists' Writings," in *Blasted Allegories: An Anthology of Writings by Contemporary Artists*, ed. B. Wallis (Cambridge: MIT Press, 1987), p. xiii.

53. Ibid.

54. Ibid.

55. Ibid., p. xvii.

56. Lucy Lippard, *Mixed Blessings: New Art in Multicultural America* (New York: Pantheon Books, 1990), p. 57. Significantly, Lippard's chapter is titled "Telling."

57. bell hooks, "Choosing the Margin as a Space of Radical Openness," *Yearning: Race Gender and Cultural Politics* (Boston: South End Press, 1990), p. 145.

58. Ibid., p. 149. Smith makes a similar point, saying that "woman speaks to her culture from the margins" in "heretical" texts that negotiate "the stories of man and woman." She explains: "While margins have their limitations, they also have their advantages of vision. They are polyvocal, more distant from the centers of power and conventions of selfhood,"(*Poetics of Women's Autobiography*, p. 176).

59. Harmony Hammond, "Mechanisms of Exclusion," *THE magazine* (April 1993), p. 43. Excerpt reprinted in this volume.

60. Ibid.

61. Theresa Hak Kyung Cha, *Dictée* (New York: Tanam Press, 1982), p. 133.

62. Trinh T. Minh-ha, *Woman, Native, Other* (Bloomington: Indiana University Press, 1992), p. 2.

63. Carol Christ, *Diving Deep and Surfacing: Women Writers on a Spiritual Quest* (Boston: Beacon Press, 1980), p. 1.

64. Several critics have commented on the power women gain by writing their own stories. Smith, in *Poetics of Women's Autobiography*, p. 42, writes that "despite the textual repression of woman that supports the phallic order, woman has chosen to write the story of her life, thereby wresting significance and . . . authority out of cultural silence." Lynda Nead, *The Female Nude* (London: Routledge, 1992), p. 82, writes: "To write, or more generally to represent, is to take power; it is to tell your own stories and draw your own lines, rather than succumb to the tales and images of others."

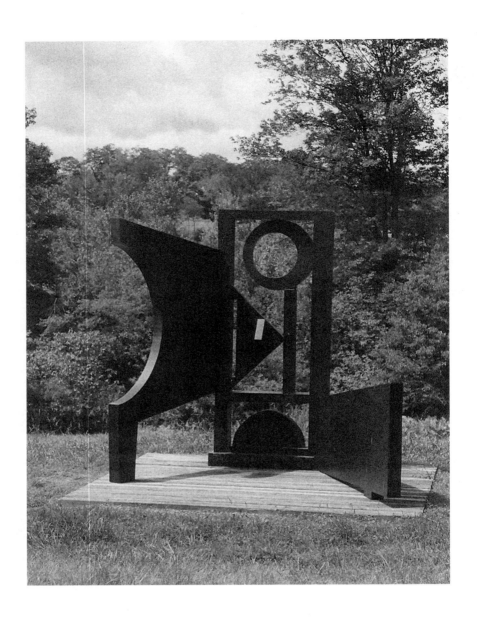

Sanctum with Window II, 1969/91. Painted aluminum, 147 x 157 x 149 in. The Hyde Collection, Glens Falls, N.Y. Photo courtesy André Emmerich Gallery, New York

DOROTHY DEHNER

B. 1901

ALTHOUGH SHE CAME OF AGE with the first generation of Abstract Expressionists, Dorothy Dehner did not begin to achieve recognition for her artistic achievements until well into the 1960s. Her almost twenty-five-year marriage to the sculptor David Smith diverted her from developing her own vision, and it was only after separating from him in her early fifties that she began to make the abstract, totemic sculptures that form her mature oeuvre. In her deflected artistic development and late acknowledgment, Dehner's biography exhibits a familiar pattern in the lives of some earlier women artists. Dehner showed awareness of the irony in her situation when she responded to a critic's comment concerning a retrospective when she was eighty, that it was a "nice occasion." She quipped that it was like an offer of marriage at the same age, "nice, but a little bit late." Now in her nineties, critics hail her as "a major figure in American sculpture." Dehner has finally fulfilled the promise she evinced in her youth when she was a passionate young woman, committed to a career as a professional artist.

The third of three children born in Cleveland, Ohio, to a pharmacist father and suffragist mother, Dorothy Dehner experienced a childhood marred by a series of profound losses. Her parents had lost a young son a year before her birth, and her father died when she was eleven. In 1915 she moved with her mother and sister to Pasadena, California, to live with her two maternal aunts.

Their happiness was short-lived, however, as her sister died of tuberculosis that year, and her mother who had been an invalid, died a year later. From then on, she was raised by her aunts, particularly Aunt Flo Uphof.

Art became an important part of Dehner's life at a very young age. She has described how her mother had set up a blackboard and a bucket of chalk in the kitchen for her daughters "as a baby-sitter when she was cooking." When Dehner was older, she took lessons in painting and drawing. As a teenager she became interested in dance and drama while maintaining her interest in the visual arts. After her graduation from Pasadena High School, she began to pursue an acting career, first studying with Gilmor Brown at the Pasadena Playhouse, and then enrolling as a drama major at UCLA in 1921. In 1922 she moved to New York City to study acting at the American Academy of Dramatic Arts, where she remained for two years, also performing in several off-Broadway productions. Dehner has acknowledged that her involvement in the theater provided her with a means of escaping from the painful reality of her life, as well as enabling her to gain "instant love;" as she said, "pleasing an audience is like having a whole family."

Despite her early progress toward a theatrical career, in 1925 Dehner decided to take a year to travel in Europe by herself, to "have adventures" and to contemplate the future direction of her life. It was during this trip that she decided to abandon acting in order to become a visual artist because in that way "you could work all the time without having to wait for an audience." Her decision was influenced by the impact of Parisian modernism and her encounter with Cubism and Constructivism. Upon her return to New York she immediately enrolled in the Art Students League intending to study sculpture but, disappointed in the "old-fashioned" approach of her teachers (who included William Zorach and Robert Laurent), she decided to concentrate instead on drawing.

By 1926, at the time of her meeting with David Smith, Dehner was an intense, committed art student, perhaps more sophisticated than her peers at the Art Students League because she had actually experienced European modernism firsthand. Dehner met Smith at the rooming house where each lived on Manhattan's Upper West Side, and they became fast friends via a "twelve-hour" conversation. Smith enrolled at the Art Students League at Dehner's suggestion. They were married in December 1927, and pursued a mutual life dedicated to art, a romantic vision, two young struggling art students who pooled their resources and destinies.

The most important artistic influence on both Dehner and Smith during this period was the painter Jan Matulka, a Czechoslovakian immigrant who became their teacher at the League. Matulka had studied in Paris and exhibited with the Société Anonyme in New York; he was the first teacher Dehner encountered who painted in the Cubist style that had initially impressed her and had stimulated her pursuit of an artistic career. While at the League, and then for a short period later, Matulka taught a remarkable group of students including Burgoyne Diller and Irene Rice Pereira, as well as Dehner and Smith,

all of whom went on to pursue artistic careers. Dehner felt that with Matulka, "a very avant-garde figure," she had finally arrived at the "wild fringes" of art, and she remained grateful for his instruction throughout her life (expressing her appreciation in a memoir for a 1980 retrospective of Matulka's work). In 1929 Dehner and Smith encountered other important avant-garde figures, particularly John Graham, who subsequently introduced them to Milton Avery, Stuart Davis, and Arshile Gorky. Graham also influenced the development of both artists by acquainting them with African sculpture and its expressive power. Smith and Dehner made their first trip to Bolton Landing in the Adirondack region of New York that same year and, with Dehner's inheritance, purchased the farm on which they settled permanently a decade later. Until their move to Bolton Landing, the couple divided their time between travel and residence in New York, spending 1931-32 painting in the Virgin Islands, and 1935 and 1936 touring various parts of Europe, most notably Paris and Greece, Dehner's small inheritance providing their support.

For the first two decades after her study at the Art Students League, Dorothy Dehner pursued a career as a painter, not turning to sculpture until after her break from Smith in 1950. Although to some extent those years were a twenty-year detour, they were not totally unproductive in leading her to her goal. Many of her early paintings were destroyed, kept in a barn and exposed to the elements when she left Bolton Landing; the remaining work, however, reveals a curious pattern of development. Her works from the first half of the thirties show a tendency toward abstraction, the mutual influence of study with Jan Matulka and exposure to Parisian Purism. This approach is seen in a still life from 1932, in which she has built the picture surface from large, faceted forms, and mixed paint with sand for textural contrast, as in her paintings executed while in the Virgin Islands. A still life from 1937, however, reveals that by this time Dehner was backing away from abstraction, a move that Joan Marter believes was occasioned by her negative reaction to the influence of Smith, who continually urged Dehner to make her work more abstract. In 1940 when the couple moved to Bolton Landing, Smith was concentrating entirely on sculpture (which he first attempted in the Virgin Islands) and Dehner's studio space was reduced to "a small table in a corner of the living room." Dehner's works from the early years of the forties are even more dramatic in their retreat from abstraction. Most notable is the *Life on the Farm* series (1941-44), eighteen paintings influenced by the calendar illustrations in the fifteenth-century illuminated manuscript *Les Très Riches Heures*. Dehner's paintings feature small, anecdotal, idealized representations of her daily life with Smith, and are now housed in the Storm King Art Center in Mountainville, New York, along with Dehner's captivating descriptions, detailing the couple's bohemian life-style.

A change in the direction of her art began to evolve in 1945 when Dehner temporarily left Bolton Landing after one of Smith's violent outbursts. When she returned, both the style and the content of her drawings had changed. As opposed to the earlier idyllic view of their life together (one painting was titled

Garden of Eden), Dehner depicted a *Landscape for Cynics* (1945) in which a giant cockroach crawls in an arid terrain. She also abandoned the descriptive and illustrative approach of her earlier drawings, delineating the inhospitable panoramas of such works as *Country Living (Bird of Peace)* (1946) and *Desert* (1948) with jagged lines and shapes. She explored similarly morbid and uncomfortable forms in her sketchbooks. The imagery from this period has been interpreted as stemming simultaneously from her response to tensions in the aftermath of World War II and to her personal anguish in the face of the breakdown of her marriage to Smith. In the late 1940s and early 1950s Dehner pushed her new style further into the abstraction that she had previously resisted, in a series of gouache-and-ink drawings, perhaps inspired by her reading of Ernst Haeckel's study of natural forms, *Kunstformen der Natur* (1904). At first she worked with biomorphic forms, going back to the bits of coral and shell that she had seen on her trip to the Virgin Islands more than a decade earlier. Over the next few years her shapes gained a greater sense of geometric structure. Dehner joined Smith in his experiments with wax-casting and, as she said, "itched to get her hands into the material." The reemergence of her urge to work with sculptural form is corroborated by the fact that many of her works from this period make either visual and/or verbal reference to figural elements. Critics have noted the oppositional intersection of her career and marriage: in 1946 she was awarded a prize for a drawing at the annual exhibition of Audubon artists; in 1948 she had her first one-artist exhibition, at Skidmore College; and in 1950 she exhibited for the first time at the Whitney Museum of American Art. She left Bolton Landing permanently in late 1950 and her divorce was finalized two years later.

It was not until 1955, however, that Dehner began her almost forty-year career as a sculptor. After her departure from the farm, she earned a bachelor's degree from Skidmore College in order to gain the means to support herself, and later studied printmaking at Stanley Hayter's (whom she had first met years earlier in Paris) Atelier 17, while at the same time teaching and exhibiting her artwork. She has explained how the experience of dragging a burin into a plate catalyzed her desire to return to working with three-dimensional media, a desire she pursued by continuing her earlier experimentation with wax. Dehner recounts that "the minute I started doing sculpture I felt that it was something I had done all my life." Her self-assessment as "not a green student" is correct and, as she points out, as an already accomplished artist at the time she became a sculptor, she was able to draw upon a mature repertoire of personal images.

Dehner's mature vision in her sculpture developed rapidly in the mid-fifties and underwent only a few changes over the subsequent years. In 1955 she began to work with the lost-wax method at the Sculpture Center in New York, and continued to use this method of bronze-casting until 1974, the year her second husband Ferdinand Mann (whom she married in 1955) passed away. *Man in Cage* (1956), a small work with a male torso centered in a web of bronze lines, simultaneously shows the influence of Giacometti's *The Palace*

at 4 A.M. and some early sculptures by David Smith. *All-American Girl* (1955) is an early work in which Dehner used the structure of stacked oneiric imagery that figured so prominently in her subsequent sculptures, albeit in a far more literal format than later, as in the top image of a woman's head enclosed within a cage. By 1957, Dehner had begun to build her sculptures with abstract, biomorphic forms, an approach that she expanded upon in later works such as *Rites at Sal Sfaeni #1* (1958), a small figural form built with fetishistic symbols, evoking her "sense of mystery" in the prehistoric ritual chambers of Malta, or in a figural group such as *Encounter* (1969), a cluster of six vertical pieces that all evoke figures. While her many works with a vertical format represent figures, in the early sixties Dehner also began a series of cast bronze "landscapes" that extend horizontally, as in *Low Landscape* (1962) and *Looking North F* (1964), suggesting her experience of looking out her studio window. In her identification of the horizontal with landscapes and the vertical with figures, Dehner recalls the earlier twentieth-century sculptor Barbara Hepworth who made a similar analogy in her works.

In 1974 Dehner began to build her figures out of wood, playing the textural contrasts of differing surfaces against each other. She continued the figural analogy in these works, as well as the effect of totemic mystery. Particularly in these wood pieces, one sees the influence of Louise Nevelson whom Dehner had met in Hayter's Atelier 17, and with whom she had become friends. Because the lost-wax works were solid bronze, their size was restricted by financial considerations. Dehner's works in wood, executed over about a five-year period, kept comparable dimensions to those of her bronze castings. In the 1980s, however, Dehner began using Cor-Ten and fabricated steel, which enabled her to build works on a more monumental and "heroic" scale—although, as Marter points out, her works were always monumental in conception. A work such as *Sanctum with Window II* (1990-91) shows Dehner's vision realized in a more than twelve-foot by twelve-foot vehicle.

There is a vital interconnection among Dehner's works from the differing phases of her artistic career. The influence of her travels, particularly to Paris, the Virgin Islands, and Greece, persisted throughout her life: *Demeter's Harrow* (1990), for example, was inspired by a trip taken fifty years earlier. The fabricated steel works of recent years clearly make reference to earlier sculptures and drawings. Several recent sculptures, such as *Chopiniana* and *Dark Harmony* (both 1992) relate to drawings that preceded them by ten or fifteen years. Additionally, Dehner based several recent steel constructions on earlier bronze sculptures. One difference between her earlier works and their "translation" into fabricated steel is that, despite their surface variegations, the "handwriting" of the lost-wax bronzes disappears in work such as the second version of *Encounter* (based on the smallest of six figures from 1969). Also, the recent works are characterized by a more tidy geometry. While there is no doubt that her smaller works cry out for a larger presentation, one should not assume there to be an inherent value to "heroic" scale. In fact, the intimate form of her bronzes uniquely expresses her personal touch, an aspect of her

work that Dehner herself found significant.

One perennially nagging question regarding Dehner is the intersection between her career and her relationship with David Smith, particularly in its negative impact on her ability to follow her own vision. Although it would be preferable to consider her contribution on its own terms, so far all biographers have felt compelled to deconstruct the tangled connections between Dehner and Smith. Unlike the mutual influences of artist-couple Marguerite and William Zorach, for example, something in the Smith-Dehner relationship exerted an overtly negative impact on Dehner. In one clearly documented instance, David Smith said he wanted to use Dehner's drawing *Star Cage* as the basis for a sculpture, and dismissed her suggestion that perhaps they could collaborate by saying that he was "too jealous." However, she maintained a friendship with him until his death in 1956 and with his second wife Jean Smith Pond thereafter.

Although she gave up dancing and acting, Dehner continued to write throughout her life. Besides poetry she wrote memoirs of her family, of John Graham and Jan Matulka, and of her years with David Smith. She also wrote an essay discussing the symbolism in Smith's series of bronze *Medals of Dishonor* protesting World War II. Much of the material in her "Reminiscences" of David Smith is duplicated by her descriptions in *Life on the Farm*, which has been selected for inclusion here because of its less formal tone, one in which her personal voice is heard with special clarity.

Dehner, like many twentieth-century sculptors, sought a means of image-making that bypassed the classical tradition, one that tied into an older, more primal consciousness. Thus her experiences of Malta, Egypt, and tribal art forms exerted an enduring influence on her work, particularly in her desire to make endless "reliquary kingdoms." Her motifs are not literal but tantalizing references to masks, moons, tools and body parts. Perhaps a positive by-product of the fact that she took so long to find the medium that expressed her vision is that she continued to grow artistically, well into her nineties.

SOURCES

Dehner, Dorothy. "Memories of Jan Matulka." In *Jan Matulka, 1890-1972*. Exhibition catalogue (National Collection of Fine Arts). Washington, D.C.: Smithsonian Institution Press, 1980.

_____. Selected writings. Archives of American Art, Washington, D.C. Microfilm, rolls D 298, 1269, 1372, 3482.

Dorothy Dehner and David Smith: Their Decades of Search and Fulfillment. Exhibition catalogue (organized by Joan Marter; Jane Voorhees Zimmerli Art Museum). New Brunswick, N.J.: Rutgers University, 1984.

Dorothy Dehner: Sixty Years of Art. Exhibition catalogue (Joan Marter, guest curator; Katonah Museum of Art). Seattle: University of Washington Press, 1993.

Dorothy Dehner: A Retrospective of Sculpture, Drawings and Paintings. Exhibition

catalogue (essays by Joan Marter and Sandra Kraskin). New York: Baruch College, City University of New York, 1991.

Rubinstein, Charlotte Streifer. *American Women Sculptors*. Boston: G.K. Hall, 1990.

DOROTHY DEHNER—SELECTED WRITINGS

"OF DEATH AND LIFE"

I put the long black tube to my eye, slowly turn the end, and the enchantment of changing shapes and colors meets my eye.

My father, seeing the snow wet and large-flaked drew his handkerchief from his pocket and tucked it into the space between my neck and my black velvet collar. I knew then that he loved me. To me it meant he loved me. When I got home the handkerchief was wet with snow. In its corner was a finely embroidered red seal, round and red, with initials carefully wrought in the center in white. The seal was coming away from the surrounding linen, so heavily and closely had it been worked it needed only slight pressure to have it loose altogether. And then it lay in my hand, a Valentine, a red wound, and mine. If the seal were lifted from my hand surely my palm would bear the stigmata of my father's love. It must be kept in a safe place. Tucked into my black ribbed stocking in the little hollow just below and to the left of the knee cap. The handkerchief was forgotten, but the red seal, my Valentine, was carried around with me all day under my stocking. I, now, was also a favorite. My sister was there, but I was too. And I was warmed by his love and by life.

Why doesn't anybody write about dying. About death before and after, much has been said, but not about dying itself. All sorts of things can be imagined by writers or by anybody, but the process of dying itself, is left for each one to live through, to die through, no imagination needed. My friend and I are not old, but we are not young, either. We now taste life with great savoring, as a child does the last of his vanishing portion of ice cream. She looks at me as I hold her hand, and I know she is dying. Her eyes burrow deep into mine. The look comes from deep inside her, and burrows deep inside of me. I wish momentarily that the look would move out the back of my head and be gone. But it does not. It stops only when it reaches into my heart. It says, what do you know, what do you know about me. Don't tell me, don't tell me. That is part of what I know about her dying. Her own agony, her own bottomless terror, the soundless flapping wings of her black fear, her body's wretchedness and pain, how can I imagine that? I can paste words upon the word of dying and make an image from that collage. A small pain can give me a clue, but that big pain, that fading light that finality. . . .

And I sat miserable and small that February night, huddled in a quilt. In the bedroom the priest, the doctor, and my dying father, and my mother praying, my father's maiden sisters, and my sister old enough to pray and to watch, and I, banished to the sofa in the adjoining room, old enough to pray, old enough to be told to pray, but not old enough to watch the dying of my father, dying in his thick pneumonia jacket, dying in the room with snow coming in the window, open for fresh air, thought to be helpful to the still living. The nurse had told me, that in his delirium, he had wanted me to have a party and to invite all the children. I chose to believe it was not delirium. My hat was fur, warm and soft and brown. From heaven knows what forgotten Maypole dance, I had salvaged a wreath of silken rosebuds. It fit exactly around the crown of my hat, my crepe, my funeral hat. My father lowered into his cold February grave, the horses hitched to little black carriages, creaking, protesting the cold, hedged into the frozen ruts, the priest intoning at the grave, the family feuds perversely blooming in the winter air, harsh, tight-lipped and cruel, even at the grave-side. So I am talking about death, but not about dying. It is just too hard. I could not live it if I could bear to imagine it.

My dress is pink, satin with net over it, wide and crisp like a ballerina's. My body moist and supple, with a strange new liveliness and heat that was new to me. I was drugged with joy and dancing and boys. One of them took my hand and led me into the California garden, so like a scene on an old fashioned candy box. A boy, a girl, the moon lighting up the heavy scented heavy headed pink roses on the trellis. We stood for a moment under the soft sky, looking up, hearing the music of the dance, and then he put his hands about my waist moving them ever so gently. Then he touched my hair and bent my head backwards, and my Aunt came screaming out of the night after me, the party chaperone, my guardian angel. She grabbed my hand and suddenly, painfully, her maledictions ringing in my ears, she drew me to the house. What a thief she was to steal that gift from me. A kind of death, a part of my life.

Abandoned by the porter, who served also as ticket seller, train flagger, tender of wayside garden, vendor of sweets and waters, father of three who straggled after him up and down the tracks, I struggled with suitcases, trying to find a vacant seat in a second class carriage. A head, with an eye like that of a curious bird poked out of a window. The owner of the eye jumped out of the train, flew down the platform to me, flapping his wings. As I cursed my suitcases he smiled and tossed them into a compartment. We both followed them, and sweeping the floor with an imaginary plumed hat, he batted his eyes outrageously, and addressed me. Bella Signoria, Viva Cristoforo Columbo. They sat there, the others, he like blocky granite, she fat, like a loaf

of bread that runs over the pan. They batted not an eye. They viewed with alarm my suitcases which if not disposed of could hamper the movements of their feet and spoke harshly to one another in a bitter and unknown tongue. . . . I am in ITALY. I am in ITALY. Viva Cristoforo Columbo! And that was life!

How long is life. The world is such a big place. I want to see all of it. I want to live in all of it. I want to know everything. I want to speak the language of the French and of the Italians, and of the Chinese. Of the birds and the beasts, of the herbs and the trees. Is there time for all that. I want to paint, I want to write, to act, to dance, oh please explain the Einstein theory to me. Is there time for all that. How can there be time if I am running all over the world trying to see it, trying to live in it, grasping hands of many colors, looking into eyes of many shapes, studying all those languages. I must learn about love too. I must learn it well, and from many, and I must find my true love also. I want to hold my child and put my lips to his soft neck and feel and smell his sweetness, and close my hands upon his thighs. Is there time for all that. I imagine that everything I learn will be beautiful. Everything. It will all lead someplace to a Nirvana of my own making. I will make my life and it will be beautiful, and when I find my true love it will be perfect. I am not yet twenty, but what wisdom I have! All my troubles have come from the life that others have made for me, the restraints, the patterns, the modest pinnacles presented for my aspiration. I know that if I make my own life it will be exactly the way I want it. As high as the sky, as deep as the sea, and as wide as the ends of all spaces. Have I already started? I have been emboldened to try many things. I now speak the language of the French and the Italians, if not the Chinese. I am painting, I am dancing and I am writing poems while listening to the nightingales in the rose garden in Assisi. Yes, there is even a rose garden. My head is a jumbled file cabinet labeled Renaissance. I have a box of herbs on my window sill, and when my face is buried in the rough perfume of their leaves, I learn their language. I am learning the secrets of my body, too. Not without a struggle, not without a backward glance at my guardian angel, but I am learning from my dear Fredrigo, who buys me a Strega each evening at the local cafe and he doesn't know about the history of painting but he does know other and perhaps more important things. My troublesome metabolism? Is it so perfect I cannot think of having it tested. My indigestion of loneliness? Ah that is for old people only, who eat bad food.

But all is not simple, I have learned this now. Time is not simple, it has proven to be full of tricks. My friend is dead for a very long time. Her loss, her going, is a soft red wound that lies incurable within my body, because it is also my death, and that of my friends. Who shall comfort whom, first, and when. It takes a long time, a life time to learn about this one.

That old man on the corner. His long white hair is whipped in the wind and he is reeking with filth, and foulness, and vomit. But he wants only more alcohol, he will again lie in filth, and he will again vomit and befoul himself. Our local newspaper is leading a campaign. It is supported by those whose

pockets are comfortably heavy. The campaign says, vanish! You are a blight upon this lovely neighborhood! But the poor do not vanish. They stay, because some whose pockets jingle, give a little, and where a little is given, it is enough for these old waifs, and so they stay. This makes the campaigners wild. They would have us wear buttons. The buttons would say, WE DO NOT GIVE. What a proud slogan. WE DO NOT GIVE! My window frames this old man. If only he were a Rembrandt instead of a living old man, the cultured could not get enough of him. He is lost now, but Death will find him.

Where is the beauty of my life, the perfect life I was to make for myself. My life would not stay beautiful. The sickness of the world creeps in. Creeps in? It charges in, it bounds, it leaps, it comes in battle dress. I am surrounded by it, pervaded by it. But where oh where is that beautiful life. I have ceased to think of it. Long since. It is only when I remember what I was that I remember about that. And I have learned that what I thought I wanted was not only beauty, but Living. All of it.

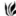

SELECTED DESCRIPTIONS FROM *LIFE ON THE FARM* (1941-1944)

LIFE ON THE FARM

I painted these small works in the early forties to record my life on the farm in Bolton Landing, on Lake George, N.Y.

David Smith and I had bought the farm in 1929, the second year of our marriage, and lived there intermittently until 1940 when we made it our permanent home.

The idea to paint the days and seasons of our lives came to me from the French 15th Century Book of Hours, *Les Très Riches Heures du Duc de Berry*, which David had given me at that time.

The daily life included the usual cooking, cleaning, planting, harvesting, and preserving, for we raised most of our food and kept it for future use by canning, drying, smoking (both pork and fish) and salting down gallons of corn. It was a busy life, new and exciting to us, as city people, and we rather quickly became country people. Survival depended partly on information supplied by Department of Agriculture pamphlets, of which we had a great store. One, most useful, gave instructions for making a man's overcoat. Sewing and knitting went on constantly, wool provided by neighboring sheep was sent away to be washed, carded and spun.

The seasons of the year and their special activities were recorded as a kind of visual diary, depicting visiting friends such as Marian Willard and David planting trees, our nearby neighbors who helped with the slaughtering of the pigs, lumbering, sawing wood (for that was our heat source), and other chores.

Scenes in which we do not appear show our small friend, Jamie Dodge, who stayed with me when his father and David went to New York for a few days. *Two Memories of St. Thomas* recalled our year on that tropical island—shells, coral, shrimps, and blue sea. The old Saratoga Springs burying ground where many Revolutionary War soldiers rested, marked one of our visits a bit farther South, and the cluster of red brick buildings in Schenectady marked our eighteen month stay when David worked there on tanks for World War II, at American Locomotive.

That ended that particular saga. We went back to Bolton and resumed our country life again in much the same way. I then devoted my painting time entirely to my abstract work, but the temptation to have recorded the beauty of that life on the farm was not to be put aside, only to be celebrated by rendering that life and those times in these small paintings.

My Life on the Farm (1942)

This composite picture presents a day in my life on the farm, from sun-up to night. Although the central panel depicts me painting a still life, there were hours and hours that had to be spent on regular household chores. Without running water our bathing and washing was accomplished at the kitchen sink, the water being bucketed out of the well . . . the pump was a prop that never worked. Breakfast was prepared as David brought in wood for the fire. The second leisurely cup of coffee was accompanied by the news of the day from the New York paper, *P.M.*, which came by mail. The maps on the paper indicate the date, they were war maps of the progress of the battle of Stalingrad.

Housecleaning, going for the mail, gardening, caring for animals, in this case squab, and then finally after a late dinner the relaxation of a cosy evening. There was always knitting and sewing to do, reading, listening to music and finally bed. . . .

The living standard in terms of cash outlay was minimal, but most families back in the hills near us, had a horse, a cow and raised animals for meat as well as chickens. Odd jobs were a major source of income. This was during the Great Depression, it was only long after the war that there was drastic change. Motels took over the fine mansions, and more and more folk from the outlying areas were servicing those accommodations. Tourism had become middle class, the old ways had gone, along with the people I knew best.

David Reading about Himself (1941)

This picture shows a typical winter evening at the farmhouse. Very cold outside, it could be twenty below for a month at a time, and sometimes went to forty below.

We, however, were cosy and warm with our wood stoves and oil lamps. David reads a review of his exhibition at the Willard Gallery, written by Thomas Hess in *Art*

News, with great satisfaction. He valued Tom's opinions highly for Tom was one of the first critics to recognize the new wind that was blowing through the art world. A wind that would eventually move the center of the art world from Paris to New York City.

David's feet rest on a table top that was once the clock face of the old Brooklyn Borough Hall. With the usual Smith curiosity and interest he investigated this ancient abandoned building in Brooklyn Heights, found the clock face and a vandalized broken up clock on the top floor, and brought it home and made a table out of it for me as a birthday present.

I am knitting as usual during those long winter evenings making all of our sweaters, socks, long and short, mufflers, caps and mittens. We usually read and listened to music. Bohack, the cat snuggles on the horse blanket belonging to my grandfather's horse that won the Derby decades ago.

One of David's small steel sculptures rests on the chest in the kitchen. Our days, so active and sometimes strenuous allowed us to enjoy the quiet and solitude of the evenings. When in need of company we visited neighbors, drove to a movie in Glens Falls (twenty-five miles each way was no obstacle), saw friends there or at times we would take off for the big city staying in Marian Willard's town residence and seeing our artist friends.

We felt we had a very good life and neither of us ever felt deprived or unhappy because of our primitive way. On the contrary we knew it enriched us. When my Aunt [Flo Uphof] visited us she said, "Oh Dorothy, you have all of the luxuries and none of the necessities." We made our own excellent wine, our food was marvelous, we had books and music and freedom to WORK. True, we had no running water, no electricity or central heating. We didn't care!

October Scene (1942)

This is one of the first pictures painted in this series. I used gouache on paper for this, as I did for "David Reading about Himself." The others are all in egg tempera on gesso panel.

This scene is typical of our activity at that season . . . getting ready for the Big Winter. Marian Willard and David are planting trees, I am planting tulip bulbs, Leo Campbell is pumping oil for our new Sears Roebuck space heater and Peanut Monroe is trucking a supply of logs for the kitchen stove.

The green has been subdued except for the pine, hemlock and spruce in our woods which would soon be covered with snow. Leaving the truck at the gate which meant a quarter mile walk to the house, saved us from being snowbound. The house, small but cosy was our refuge and we took great care to have ample supplies of wood, oil and food for the long winter. The State Library in Albany sent any desired books, postage free to rural folk, an excellent program which may no longer exist.

We always enjoyed Marian Willard's visits. She had a very real and very great love for the country and for all nature. She took part in all of our activities, cooking, gardening, or roaming in the woods. She was perfectly at home with our way of life.

Our neighbors were always good friends, not the wealthy ones who had mansions along the lake, but the real country people, who like ourselves lived a relatively primitive life. We exchanged recipes, shared mountain lore, had concern for our mutual welfare, and partook in ceremonies involving marriages, births and neighborly visits.

POOR ROSEBUD (1942)

The time had come for slaughtering the pigs, Rosebud, Big Booby and Baby. Summer had long gone, snow was to be the scene for many months with no possible danger of thaw to spoil the meat. All of our neighbors were involved with this same occupation, and two of them helped us with the heavy animals.

David is shown taking the fur off with rosin and a stiff brush. Johnny Neuman carries wood for the fire to boil the huge tank of water. It is necessary to dip the animals, after they have been slaughtered, into hot water to loosen the hair. Wilfred Monroe helps with the cutting. I stand and mourn as does Dinah the cat. They had become friends, and I despaired to realize that they would become our meat for a long time. It was all a very big job, involving cutting, smoking, making lard and head cheese, keeping some of the meat fresh or frozen, and some made into sausage. That part was my particular responsibility. After smoking in the pungent hickory bark gathered from our woods, we wrapped the hams and bacon in heavy brown paper and painted it with a special recipe supplied by the Department of Agriculture. Actually it was fun learning all of those skills and our inventiveness kept pace with our problems.

The freshness and clarity of the country was always present whatever the season; the air so clear and pure that even in the forties we choked on the fumes of city pollution when we drove into New York.

As city people scenes like this stand out in my memory. A whole new discipline had come into our lives. How to work and live and become part of country living was a challenge. It was a delightful course and we became A+ students. The highest compliment David could give me was, "Dorothy Dehner, you are a real Pioneer Woman!" . . delivered with relish and admiration!

WINTERSET (1943)

The winters were long cold and beautiful, the snow was endless and drifted as high as ten feet against windows and doors. But what a sight, the fine contours of the mountains, the forests of evergreen, the bluest of skies and the warmth of an occa-

sional friend who would brave our North Country.

To get additional money to pay for our projected new house,—the old one was always falling about our head,—we sold timber during the war years. Our neighbors who had horses would chop down the selected trees and snake out the logs on skids over the snow. The County Agricultural Agent would mark the trees to be harvested, and our woods were never denuded. We sent for seedlings to the state nursery to replenish the loss. They cost but a few dollars a hundred.

David walks to his studio, the smallest figure in the picture, and to his new electric welder. Thanks to F.D.R.'s efforts, rural electrification was being enjoyed in many isolated areas. Not however without our own efforts in getting petitions signed by all of the people on the road, and writing many letters to Washington.

The scene looks out on our West view. We were perched high on a hill, our neighbors directly across the road but a good distance away. They were good neighbors and supplied us with milk and we on occasion would buy a quarter of beef from them and hung it in the woodshed. We had our own frozen food department before such luxuries were on the market.

MEMORY OF ST. THOMAS, #1 AND #2 (1942, 1944)

We went to St. Thomas, V.I. in 1931 for almost a year, long before it had become a tourist trap. This was a typically romantic concept of ours, to live in a tropical Paradise. We would have preferred the South Seas, like Gauguin, but they were too far away and we had heard that St. Thomas was perfect from a friend who had had a shark factory there. A questionable enterprise that had ended in disaster . . . not from JAWS but because the barracuda ate the sharks before they could be pulled aboard.

We wanted to live a simple far-away life, paint, swim, fish, take pictures and spend days with sun and sea. This series of pictures was painted about ten years after our V.I. adventure, and when we lived there we both were painting abstractions. We finally felt we wanted to paint on our own, no more classes, and our last year at the League with Jan Matulka had given us new ideas to follow.

Back at Bolton we yearned sometimes amid the snow, for our days spent on the island. It was there that David made his very first sculpture. He carved the head of a Negro from a chunk of white coral, and painted it a dark purplish brown. Then he carved a female torso, partly *objet trouvé* and partly his handiwork. When we returned we brought boxes of shells, coral and other beach combings to Bolton, and David continued to use these materials along with brass rods, some painted, sheets of lead, which he soldered, and used with great invention. The winter scene shows a fantasy of shells and coral set against our snow bound barns. The other was done during our stay in

Schenectady. My hand holds a St. Thomas shrimp (we often went shrimping). The blue Caribbean is the backdrop. It was good to recall those happy days in St. Thomas when we were housed in grim and war-time Schenectady.

PASTORAL (1944)

I had just returned from California and a visit to my Aunt with whom I had lived much of my life. It was mid-summer and out there all was sere and brown except for the miracle of imported water for lawns and gardens. The mountains were covered with dry brush, the desert quality of that region at that season at its most insistent.

Bolton Landing was almost a shocking surprise, green, green, all shades of green, all textures. My beloved country . . . it was like living in a great salad bowl. There were the newly planted trees of our orchard, there was Lake George, there was Edgecomb Pond, there were the animals, and there was our own tiny house and dear companionship. All of it a deep full breath of new life as well as regret in leaving my aging Aunt alone. But Bolton was my home, my closest tie was there. The row upon row of green hills, and finally the misty blue ranges of the Adirondacks, a backdrop of our meadows and pastures and woods.

Pastoral was my expression of that tie and the final picture of the *Life on the Farm* series.

FROM "MEMORIES OF JAN MATULKA" (1980)

David Smith and I came to know Jan Matulka as a teacher at the Art Students League before we knew him as a painter. Among the large number of students who passed through his class, we considered ourselves part of a core group consisting of Richard Abernathy, Lucille Corcos (Levy), Francis Criss, Burgoyne Diller, Alfred Kraemer, Bella (Anne) Kroll, Edgar Levy, Mary Lorenc, George McNeil, Irene Rice Pereira, Jim Robertson, and Peter Sekaer. As a group, we were uncommonly dedicated. Matulka gave us that extra feeling of confidence in ourselves which acknowledged our serious intent to become professional artists. And all of us—that is, the core of the class—in one way or another realized this ambition. With the possible exception of Sekaer, who became a documentary photographer, we all worked and defined ourselves as painters though certain of our group supported themselves in advertising and illustration. Matulka's dedication to his own painting was passed on to us. An awareness of what it meant to live the life of an artist and accept the responsibilities to one's work.

There were no dilettantes in Matulka's class, which was officially a

drawing class held two nights a week. We paid between eleven and thirteen dollars a month for the class. Most of us supported ourselves by working at full-time jobs during the day. In class we drew from a model, who took various poses during each session. Job Goodman was the class monitor. Although Matulka instructed only two nights a week, we were free, like all students at the League, to work on our own in the classrooms at certain times. We also painted furiously at home on Saturdays, Sundays, or whenever we could grab a minute. We brought our canvases to Matulka for criticism, which he would give during the model's rest periods, and he also stayed after the class for an hour or so to give critiques and hold general discussions. Often our girl friends or boy friends would join these sessions and later we would all go out for coffee. Matulka's thoughtful and serious attitude, coupled with an awareness of our growth, made for a fine and unusual comradeship between students and teacher.

Ordinarily a rather shy and introverted man, Matulka blossomed in the atmosphere of the classroom. In return for the respect and admiration that we gave him, he showed a deep and concerned interest in us. He never failed to impart his passionate feelings about art. The very fact that an artist like Matulka taught at the League was a tribute to the openness of mind and spirit that characterized the institution. At the League there were no marks, no one was looking for credits; indeed, we scorned the academic life. Those days were long before "artists-in-residence" took over classes in colleges. At the League no one took the roll and students could change classes at the end of their month if they preferred to study with another artist. There was no "boss" to consult or to keep us in line, only a monitor to time the model and perform a few studio duties. Discipline had to come from within, and only the sufficiently motivated stayed on.

Despite the freedom that we enjoyed at the League and the fact that its artist-teachers originally had been dissenters from the National Academy of Design, abstract painting had not been represented there except for a brief period when Max Weber taught in 1920-21. New ideas and a break from past tradition were entering the academic art world, and those new ways were to be taught by the rebellious escapees from the painting taught in the academies. . . .

The teaching by the League artists was a very far cry from the conservative National Academy tradition. Thomas Hart Benton, Walt Kuhn, Kenneth Hayes Miller, Kimon Nicolaides, John Sloan, and many others were all teaching there at the time I attended. Yet except for the aforementioned period when Max Weber taught, no abstraction, no cubistic approach, and certainly no nonobjective painting had been introduced. Matulka, both as a painter and a teacher, was for that period a very avant-garde figure. He was bold in his concepts, unique in his palette, and unshakable in his convictions. . . .

Matulka taught us in many ways. Constantly recommending the work of other interesting artists to us, he aimed to give us as broad a view as possible of the entire spectrum of art, past and present. We had first encountered his

work at the Whitney Studio Club and Edith Halpert's Downtown Gallery on West Thirteenth Street, where Matulka's lithographs were displayed along with paintings by Stuart Davis. Each Saturday we visited the galleries, of which there were relatively few in those days, to see the works that Matulka had mentioned to us. . . . Now, when New York has everything, it is hard to imagine a city with so little avant-garde work to be seen. In those days avant-garde meant Picasso, Braque, Matisse, Juan Gris, other cubists, and the German expressionists. Even post-impressionist works were rarely to be seen. A few years later this was no longer true. Suddenly, it seemed, America had become art conscious, willing to look at the new as well as the old. The new work was shown in the late 1930s by such hardy pioneers as Rose Fried, who exhibited Kasimir Malevich's white-on-white work. Marian Willard, at her East River Gallery and later at Neumann-Willard, introduced Mark Tobey, Morris Graves, Loren MacIver, and David Smith.

As I remember I was the only one in the class who had been to Europe, and it was nourishing and engrossing to hear Matulka speak of his firsthand knowledge of cubism, dadaism, and surrealism. He spoke of all the arts, as he was interested in music and literature also. He spoke to us of the Bauhaus, German expressionism, and the new architecture of Mies van der Rohe, Le Corbusier, Eric Mendelsohn, Walter Gropius, and others. Because Matulka had lived in Europe and had had a studio in Paris and made friends among the artists there, his words carried a special authority.

We were devastated when we learned in 1931 that Matulka would not be able to continue at the League. The reason given was that his enrollment was not sufficient to keep him on. With only thirteen or fourteen registered students, his class did not meet the minimum requirement of an enrollment of seventeen. Our despair was short-lived. It turned into action when Matulka got together with us to create a special private class. This project was discussed at many meetings, mostly with Matulka present. We found studio space on West Fourteenth Street between Seventh and Eighth Avenues. A large proportion of the students were part of this effort: Lucille Corcos (Levy), Burgoyne Diller, Al Kraemer, Edgar Levy, Mary Lorenc, Irene Rice Pereira, and Jim Robertson were especially active. Romana Javits, head of the Picture Department at the New York Public Library where Lorenc worked, helped with her advice. We found secondhand easels, stools, and studio equipment. David and I provided a table and collected items for still-life paintings. Anticipating pop art, we bought boxes of soap flakes, labeled canned goods, and a fruit dish for subject matter. Two tables were brought for the still lifes, and a white plaster head of Voltaire completed our assortment of still-life elements. As a group we cleaned and organized the place. Though it was summertime and the League's spring sessions were finished, many of Matulka's students kept on with the private class; Matulka's teaching was what we wanted. . . .

Thinking back on particular members of our group, I remember that Burgoyne Diller was the first one to want to have a one-man show. Although

we all believed without question that someday we would all have solo shows, it amazed us that he would have had that much confidence at the time. Lucille Corcos (Levy) was our group's first success; in 1938 she had a work included in a show at the Whitney Museum, and it was purchased by the museum. . . . Irene Rice Pereira was the first one in the group to make really big paintings. As she was quite short, we would watch her huge pictures with two small feet beneath them proceed up the stairs to the top floor where Matulka's class was held. . . . I was the last one to have a solo show in New York City. It was held at Rose Fried Gallery in 1952, although I had had solo shows elsewhere and had exhibited at the Whitney and many museums throughout the country previously. . . .

The last time I saw Matulka was in the mid-1960s when he was quite ill. Lucille Corcos, Edgar Levy, and I drove out to Jackson Heights to visit him. He embraced us with great affection, delighted to see us and to know that we had not forgotten him. Despite his deafness, we had no difficulty in communicating. We were all almost unbearably touched. The old respect and affection had endured, even though it had been more than thirty years since our classes with him. To this day, when I am in contact with the few classmates who are still around, there are memories of the great spirit of art and comradeship that Matulka's class gave us. We continue to say, "Thank you, Mr. Matulka."

SELECTED POEMS

"WINTERSET"

The snow falls softly, but
Hush! tiny icy sounds fill the air
Gather the flocks
Prepare the altars
Kneel to the Winter Gods.

"THE PLACE BETWEEN . . . THE TIME BETWEEN" (1953-54)

Great empty shell, hollow, roaring,
Sealed with rusted, bent protuberance,
Jagged, glass sharp slashing edges.

Space pierced with pointed wounding sounds,
Ear split fragments, high and terrible to hear,
Centered in tumultuous roar.

Eye, ear, sense and spirit torn,
While curling cuticle shrinks dying,
Unto itself, escapewards.

Emerge but with pain into a
Heavy drumming world, unembracing,
Except with dead and heavy tentacle,
Slime encased and suffocating.

"DAPHNE"

A man asks of a woman: Daphne, Daphne what am I like?
She sings the answer: You're like wind when it roars,
 Daphne, Daphne, what am I like?
 You're like the rain when it pours.

 Daphne, Daphne, what am I like?
 Like a tender new-picked flower.
 Daphne, Daphne, what am I like?
 Like the sun, through a diamond shower.

 Daphne, Daphne, what am I like?
 Like the dark and murky tide.
 Daphne, Daphne, what am I like?
 Like the stallion that you ride.

 Daphne, Daphne, how do I work?
 Like Vulcan, with his fire.
 Daphne, Daphne, what will I do?
 Stretch me out on your pyre.

 Daphne, Daphne, whom do I love?
 Julie and me and May.
 Daphne, Daphne, whom do I love?
 Mary and Kate and Gay,
 And Helen, and Meg, and Liz, and Bet,
 And a mound of new mown hay.

 Daphne, Daphne, what will I do?
 Climb till your heart is sore.
 Daphne, Daphne, where shall I go?

Always looking for more.

Daphne, Daphne, shall I have rest?
Not till you're brittle and grey,
Daphne, Daphne, shall I have rest?
Only you can say.

Daphne, Daphne, I don't want to rest,
I want to straddle the East and West,
I want to wrestle and romp 'til doom,
And hug to myself tremendous gloom.

I want to roll in a cloud and glide,
I want to shout down the mountain side,
I want to love and have a new bride,
And stop my ears to those who've cried.

I want to summon the evening star,
And have no one to say me "nay,"
I want to wear Orion's Belt
And a garment made of the Milky Way.

I want to be God, and walk along side
the Sun and the Moon and the roaring Tide
I want to posess the earth and sea
And climb to the wide blue canopy,

And shout for the world to hear and see,
THIS IS ME, *THIS IS ME, THIS IS ME*!

"To A Bug" (1952)

Dainty arthropod, whose chitin fits like some sleek armor
Tailored to your being,
Precision tooled and elegant,
Find your secret grasses or your small soft bodied prey.

Bask in summer warmth, your satin garment glistening ochre,
Polished ebony.

Man's outwardness, forever linked a life span to
Inner being metamorphosized.
While you, small mindless creature shed the outer coats

Until your final stature reached,
Your garment, perfect in size and kind, befits maturity.

"An Autumn Poem"

Black skeletons climb the rocky hill
And skinny hands off leafless birch and maple
Wave and bid goodbye to green and summer gaiety.
So Autumn burned and flamed with promise false
Heralding but winter's sleep and slow long rest
Come silently to silent wood,
Except for falling leaf or some small animal
Scuttling to winter hideaway.

The lonely brook keeps to its song
Plaintive now, and solitary,
Sheltering ferns and grasses now withered, dry.
The sounds of summer fled, the insect hum
The bird trills stilled.
And earth so soon to sleep, awaits its urge
To change once more to Spring's delights
New buds, new scents, new life.

"Past Tense"

My feet kick up the dust of years
I am an archaeologist of sorts
I tamper with the past.
Kicking, kicking that dust, oblivious almost
Until a twisted bit of steel, sharp-edged,
A shard of broken glass, still keen
Wounds my foot.
Just a memento of the past
The bloody battles when I died in action.

I asked for no cross at my grave
I made my own, and buried it deep
Six feet down, six feet under.
Not to emerge except as wraiths do,
Fluttering, hovering, but unsubstantial.

But then, there is that dust—
And my degree in archaeology
My sheepskin hides the wolf.

"Two Lives"

I was the Lady of the Lake,
There did I lie on soft green hills,
The deep blue folds of clean-lined Adirondacks
Sharp against the sky.

I was the one who felt the chill
Of cold lake water on my thighs.
And trembled at the icy touch,
But felt however much it conquered me
I loved it still.

Now I am a River Queen
Watching the Hudson as it flows,
Deep and wide with spill of
Many lakes and streams,
Abundant, rich and wise
As like a King with grace it glides,
Knowing the lives it passes.
(Tears and follies are its wisdoms)
Sheltered by gently moving skies.

I occupy my bower and look down,
And throw my sceptre in the wake
Of ships that pass, and think
How once I was the Lady of the Lake.

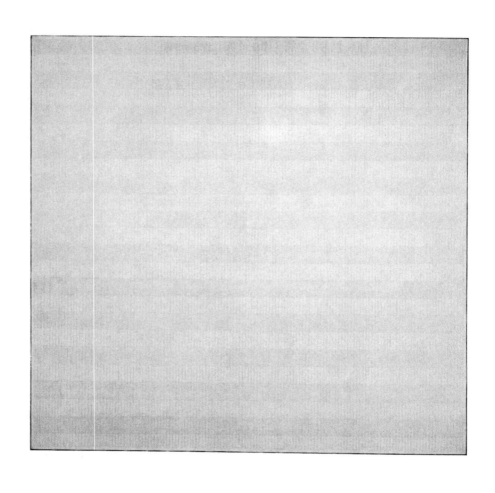

The Tree, 1964. Oil and pencil on canvas, 6 x 6 ft. Collection: The Museum of Modern Art, New York. Larry Aldrich Foundation Fund

AGNES MARTIN

B. 1912

EXPANSIVE AND MEDITATIVE, Agnes Martin's sparse canvases induce a contemplative state similar to that experienced while watching the flames in a fire or, as the artist has said, water rushing over rocks. Often considered a Minimalist because of her work's visual economy, Martin's artistic purpose differs significantly from the artists usually associated with that movement in that her aim in reducing visual elements is expressive rather than purely formal. Martin followed an arduous and solitary path and, although her work was never poorly received, she was accorded the acclaim for her achievement rather late in her life, culminating in a major retrospective of her work in 1992. In the early seventies Martin began to make a written record of her thoughts about art and the artist's way of life. These essays, with sources in both eastern and western mysticism, constitute a major piece of writing that complements and clarifies Martin's expression in her visual works.

Agnes Martin was born in Maklin, Saskatchewan, the third of four children in a family of pioneer stock. Her forebears had emigrated from Scotland and made the trek across the Canadian plains in the latter part of the nineteenth century. Her father, a wheat farmer who also managed a grain elevator, died when she was two, and the family went to live on the farm of her maternal grandfather, Robert Kinnon, a major influence in Martin's life whom she

describes as the only person for whom she was ever "first." Although her mother soon moved with her children, first to Calgary in 1916 and then to Vancouver in 1919, where she supported herself by renovating old houses, the early years on the prairie had a profound influence on Martin's later development. She had a lasting response to the plains' expansiveness and, like Georgia O'Keeffe, can be considered to be "of the plains." In 1931 Martin moved to Bellingham, Washington, to help care for her pregnant sister. She graduated from high school in that city two years later and, in 1934, enrolled in Western Washington College of Education (later to become Western Washington University) in Bellingham, from which she received a teaching certificate in 1937. For the next four years, she taught public school at various locations in Washington State.

Martin's evolution into a practicing artist was a slow process that was achieved over a two-decade period. Although she first evinced a special interest in art when she began studying for her teaching certificate in 1933, she did not act upon that interest until 1941 when she entered Teachers College at Columbia University, where she majored in fine arts and arts education in order to complete her bachelor's degree. Martin's commitment to art solidified during her time in New York; however, she spent the next four years working at teaching and other jobs in order to save money to devote herself to the exclusive practice of art. In 1946, drawn to the openness of the southwestern desert, she enrolled in the art department of the University of New Mexico; by the next year, she was teaching in the department herself. After four more years of college and public school teaching, Martin returned to Columbia University for her Master of Arts, received in 1952. After a year in Oregon, she did one final year of study at Columbia and, although urged to stay in New York by gallery director Betty Parsons, she returned to New Mexico in 1954 to live in Taos. She remained there until 1957 when Betty Parsons's offer of financial support persuaded her to go back once again to New York, where she established a studio in Coenties Slip, near other Parsons protégés Ellsworth Kelly, Jack Youngerman, and Robert Indiana. She remained in New York for over a decade until, in an enigmatic gesture, she abandoned painting to travel around the country alone for a year-and-a-half before settling in New Mexico in 1968.

It is difficult to assess Martin's stylistic development prior to her first years with Parsons because she subsequently destroyed most of her early work. The remaining pieces, however, reveal how the artist steadily moved from descriptive works into the realm of abstraction. In her work from the first New Mexican period (the late forties), Martin expressed her closeness to nature in a series of paintings in which she depicted the surrounding environs in a somewhat Expressionist idiom. As Barbara Haskell points out, Martin "eventually grew dissatisfied with these because they contained little of the revelatory, transcendental expression she desired for her art." Martin herself later disparaged the mountains she painted in New Mexico as "looking like anthills." By the time she returned to New Mexico in 1954, Martin's style had shifted to a form of biomorphic abstraction, similar to that employed but already aban-

doned by Abstract Expressionists Mark Rothko and Barnett Newman, although still effected by William Baziotes. Although the work in her first New York exhibit in 1958 still shows Martin using this idiom, by that year, perhaps influenced by her New York neighbors, geometric shapes had begun to predominate in her painting.

Martin's first mature style developed during the 1960s, as she explored the potential of geometric abstraction for communicating a sublime meditative state, untainted by reference to material things. She experimented with contrasting pale, atmospheric color fields in her paintings of the late fifties, in such works as *The Book* and *Study for Rain*, but ultimately abandoned this approach, frustrated with her sense that her work remained bound to concrete reality. Of the latter piece, she said that she wanted to paint "the spaces between the rain," a telling comment regarding her Zen consciousness even at that point. She also worked with found materials, such as bolts and bottle caps, that she arranged in a grid, but she abandoned her constructions in 1963, also as too grounded in the material world. In the early sixties she began to use a grid format in many untitled sketches, and in such large-scale paintings as *White Flower* (1962) and *Night Sea* (1963). With these canvases, Martin arrived at the motif that characterized her art for the next five years: all of her subsequent work during this period was built upon a grid inscribed within a six-by-six-foot canvas. The power of these works came, according to Martin herself, in part through the tension between the field, which was square, and the imposed grid, which was rectangular. Her method of working provided another means of creating dynamic tension. Because she applied each line by hand rather than through mechanical implements, the regularity of the grid was subverted. Through these variations, her works showed shimmering, evanescent color veils, devoid of references to specific visual imagery. Although all her major canvases of this period were given titles suggestive of natural phenomena, such as *The Tree* (1964), Martin's goal was not to depict nature itself, but rather to find what Barbara Haskell has described as the "visual correlatives for the detached emotions that attend the experience of these rhythms and visual expanses." This is in accord with Martin's reference in a lecture to William Wordsworth's "host of golden daffodils" recalled in tranquility in the mind's eye.

This period in Martin's professional life ended during the summer of 1967 when she announced her retirement from painting and left New York somewhat abruptly, heading for unknown points out west. After a year-and-a-half of travel, she settled on a leased mesa near Cuba, New Mexico, where she remained for ten years until she purchased property in Galisteo in 1978. She absented herself from the art-making process until late 1971 when she responded to an invitation from Robert Feldman of Parasol Press to make a series of thirty prints, which were published in 1973. At the same time, Suzanne Delehanty of the Philadelphia Institute of Contemporary Art received Martin's approval to mount a retrospective, which also occurred in 1973. In early 1974 Martin began to build a studio on the mesa, and she soon resumed

painting, after a hiatus of approximately six years.

The work Martin has produced since 1974 constitutes her second mature style, with many similarities to the first, but characterized by several notable differences. Like her work from the sixties, each painting is executed on a six-by-six square, and is purely geometric, devoid of any external references. In fact, Martin has gone even further in eliminating referential elements in these later paintings, which are no longer symmetrically constructed on a grid structure and consist of horizontal (or, less often, vertical) fields of limited color and tonality. In all but a few isolated instances, she has provided no referential titles; instead, they are identified by number according to year, as in *Untitled #2, 1975*. Clearly, Martin has taken steps to unbind her works from the material plane in order for them to express more effectively a meditative, sublime state. She has succeeded in achieving in her works an even greater sense of expansiveness through the elimination of both symmetry and the grid structure. Their transcendent effect is further enhanced by the elimination of the struggle between horizontal and vertical forces. Furthermore, the extremely close tonal relationship among Martin's colors, in combination with their low saturation, contributes to the interior glow that seems to emanate from her canvases. Thus, while the works defy descriptiveness, they are even closer to fulfilling her goal of inducing in the viewer the transcendent state achieved when immersed in nature. As Thomas McEvilley recounts, when Martin was told by a viewer that he could see no geese in *Grey Geese Descending* (1985; one of the few titled works from this period), she replied, "I painted the emotions we have when we feel gray geese descending." As she said at another time, "My interest is in experience that is wordless and silent, and in the fact that this experience can be expressed for me in artwork which is also wordless and silent."

Despite her affinity for the "wordless and silent" in the work of art, Martin began to write during the gap in her artistic production. As McEvilley points out, the reflective notebooks and lecture notes that constitute her writing exactly parallel her "transition back into making art" and, as such, they reflect a phenomenon in the careers of many other artists who turned to the written word to express something that they had difficulty grasping in their art. Now considered an important part of her artistic endeavor, as witnessed by their publication in several recent exhibition catalogues, Martin's writings have been viewed as a distillation of eastern and western mystical traditions, with sources in the Bible, Plato, and Lao-tzu. Their titles suggest their spiritual focus: "The Untroubled Mind," "The Perfection Underlying Life," "Beauty Is the Mystery of Life." Martin has been grouped with many other writers and artists of the fifties and sixties, such as John Cage and Ad Reinhardt, who turned to Zen philosophy. Although some have criticized Martin's writings as reinforcing her image as a self-made guru, in fact, they provide an excellent and informative statement of the precepts of artistic abstraction that rival Piet Mondrian's explanations of pure plastic art in their coherent presentation of the difference between concrete emotions and purely aesthetic ones. Her view

regarding the selflessness required of the artist in order to listen to an interior voice, and the artist's need for persistence and focus, is also universally useful, and one of the best statements on the subject. She writes, for example, that "when an artist becomes aware of his [sic] exact function, that is, when he knows, suddenly, exactly what he will do and how he will do it, we say that he has attained his vision."

Martin's work is often discussed in the context of Minimalism, a connection that is accentuated by the fact that both Martin and the Minimalists were centered in New York during the 1960s. Her work bears a strong formal resemblance to works by artists of that school, in that the pictorial elements have been severely distilled and extraneous referential components have been eliminated. Additionally, the serial aspect of Martin's work is similar to that of some Minimalists such as Sol Lewitt, as is her use of the grid structure with its mathematical implications. Martin, however, has described herself as an Abstract Expressionist and, for the most part, the description holds, despite the obvious contrast between her self-effacing approach to the art-making process and the heroic, histrionic attitude espoused by many first-generation Abstract Expressionists. As McEvilley points out, Martin is generationally closer to the Abstract Expressionists than to the Minimalists, and her work bears numerous resemblances to those formal elements of Rothko, Newman, and Reinhardt's work that passed into Minimalism, such as overall composition and hard edges. Martin's use of these visual strategies seems diametrically opposed to their reinterpretation in Minimalism, in which there is no meaning beyond the form. Rather, her goal has been to find a formal structure for inducing contact with the sublime, an artistic approach consistent with the philosophical stance espoused by earlier Abstract Expressionists in such publications as *The Tiger's Eye*.

Martin is a particularly problematic subject for a feminist critique; she herself has voiced strong opposition to considerations of gender and art. In her relatively late public acknowledgment, as well as the fact that she did not receive her master's degree until she was forty, her career path reflects a pattern of late success found more frequently in women artists, e.g., Alice Neel and Louise Nevelson, than in their male counterparts. As Anna Chave suggests, however, Martin's work was always positively received; she simply never pushed it as aggressively as someone with a less self-effacing attitude. That quietness can also be interpreted as an aspect of "the feminine," described by Martin as "humility the beautiful daughter" who "does not do anything." On the other hand, Martin's work seems to challenge many of our assumptions regarding gender's impact on visual art; abstract, geometric, and devoid of any external references, it would seem to exhibit more "masculine" characteristics than "feminine" ones. Yet Chave posits a comparison between Martin's empty canvases and Susan Gubar's theory of the blank page as a metaphor for women's creativity, "not as a sign of innocence or purity or passivity," but as a "potent act of resistance." Martin can also be associated with a long line of female mystics who, while they might not have viewed their gender as impor-

tant in their search, had a distinctly feminine, or at least emotional, approach. Leonore Tawney reports that she and Martin read St. Teresa of Avila, who described herself as being pierced by divine light. Two twentieth-century women artists, Gwen John and Irene Rice Pereira, expressed a mystical fervor through their art. John came to see herself as "god's little artist," assuming like Martin a self-effacing and humble position as a creator, and writing that painting was "like doing housework or like breathing." Irene Rice Pereira, a contemporary of Martin's, expressed the influence of both eastern and western mystical traditions by painting geometric abstractions, suffused with warmly radiating light, and by writing philosophical texts.

"We are in the midst of reality responding with joy," began a lecture given by Martin at Yale in 1976; Martin's achievement has been in creating works that communicate an intense, joyful, sublime response.

SOURCES

Agnes Martin. Exhibition catalogue. Philadelphia: Institute of Contemporary Art, University of Pennsylvania, 1973.

Agnes Martin, Paintings and Drawings 1957-1975. Exhibition catalogue. London: Arts Council of Great Britain, 1977.

Eisler, Benita. "Life Lines," *The New Yorker* (January 25, 1993), pp. 70-83.

Haskell, Barbara. *Agnes Martin*. Exhibition catalogue (essays by Barbara Haskell, Anna Chave, and Rosalind Krauss, and selected writings by Agnes Martin; Whitney Museum of American Art). New York: Harry N. Abrams, 1992.

Martin, Agnes. *The Perfection Underlying Life*. Philadelphia: Institute of Contemporary Art, University of Pennsylvania, 1973.

McEvilley, Thomas. " 'Grey Geese Descending': The Art of Agnes Martin," *Artforum* 25 (Summer 1987), pp. 94-99.

AGNES MARTIN—SELECTED WRITINGS

FROM *THE PERFECTION UNDERLYING LIFE*
(1973; a lecture first given at the Institute of Contemporary Art, University of Pennsylvania)

The process of life is hidden from us. The meaning of suffering is held from us. And we are blind to life.

We are blinded by pride. . . .

It is not possible to overthrow pride. It is not possible because we ourselves are pride, Pride the Dragon and Pride the Deceiver as it is called in

mythology. But we can witness the defeat of pride because pride cannot hold out. . . .

Work is self-expression. We must not think of self-expression as something we may do or something we may not do. Self-expression is inevitable. In your work, in the way that you do your work and in the results of your work your self is expressed. Behind and before self-expression is a developing awareness in the mind that affects the work. This developing awareness I will also call "the work." It is the most important part of the work. There is the work in our minds, the work in our hands and the work as a result.

In your work in everyone's work in the work of the world, the work that reminds us of pride is gradually abandoned. Having in moments of perfection enjoyed freedom from pride we know that that is what we want. With this knowing we recognize and eliminate expressions of pride. . . .

My interest and yours is art work, works of art, every smallest work of art and every kind of art work. We are very interested, dedicated in fact. There is no halfway with art. We wake up thinking about it and we go to sleep thinking about it.

We go everywhere looking for it both artists and non-artists. . . .

When we wake up in the morning we are inspired to do some certain thing and we do do it. The difficulty lies in the fact that it may turn out well or it may not turn out well. If it turns out well we have successfully followed our inspiration and if it does not turn out well we have a tendency to think that we have lost our inspiration. But that is not true. There is successful work and work that fails but all of it is inspired. I will speak later about successful works of art but here I want to speak of failures. Failures that should be discarded and completely cut off.

I have come especially to talk to those among you who recognize these failures. I want particularly to talk to those who recognize all of their failures and feel inadequate and defeated, to those who feel insufficient—short of what is expected or needed. I would like somehow to explain that these feelings are the natural state of mind of the artist, that a sense of disappointment and defeat is the essential state of mind for creative work. . . .

Moments of perfection are indescribable but a few things can be said about them. At such times we are suddenly very happy and we wonder why life ever seemed troublesome. In an instant we can see the road ahead free from all difficulties and we think that we will never lose it again. All this and a great deal more in barely a moment, and then it is gone. . . .

Perfection, of course, cannot be represented. The slightest indication of it is eagerly grasped by observers. The work is so far from perfection because we ourselves are so far from perfection. The oftener we glimpse perfection or the more conscious we are in our awareness of it the farther away it seems to be. Or perhaps I should say the more we are aware of perfection the more we realize how very far away from us it is. *That is why art work is so very hard.* It is a working through disappointments to greater disappointment and a growing recognition of failure to the point of defeat.

But still one works in the morning and there is inspiration and one goes on.

I want to emphasize the fact that increase in disappointment does not mean going backward in the the work. There is no such thing as going backward in anything. There is increased and decreased awareness that is all and increased awareness means increased disappointments. If any perfection is indicated in the work it is recognized by the artist as truly miraculous so he feels that he can take no credit for its sudden appearance.

What does it mean to be defeated? It means that we cannot go on. We cannot make another move. Everything that we thought we could do we have done without result. We even give up all hope of getting the work and perhaps even the desire to have it.

But we still go on without hope or desire or dreams or anything. Just going on with almost no memory of having done anything.

Then it is not us.

Then it is not I.

Then it is not conditioned response.

Then there is some hope of a hint of perfection. . . .

Helplessness, even a mild state of helplessness is extremely hard to bear. Moments of helplessness are moments of blindness. One feels as though something terrible has happened without knowing what it is. One feels as though one is in the outer darkness or as though one has made some terrible error—a fatal error. Our great help that we leaned on in the dark has deserted us and we are in a complete panic and we feel that we have got to have help. . . .

It is so hard to realize at the time of helplessness that that is the time to be awake and aware. The feeling of calamity and loss covers everything. We imagine that we are completely cut off and tremble with fear and dread. The more we are aware of perfection the more we will suffer when we are blind to it in helplessness. . . .

Our lack of independence in helplessness is our most detrimental weakness from the stand point of art work. Stated positively, independence is the most essential character trait in an artist.

Although helplessness is the most important state of mind, the holiday state of mind is the most efficacious for artists: "Free and easy wandering" it is called by the Chinese sage Chuang Tzu. In free and easy wandering there is only freshness and adventure. It is really awareness of perfection within the mind. . . .

Being an artist is a very solitary business. It is not artists that get together to do this or that. Artists just go into their studios everyday and shut the door and remain there. Usually when they come out they go to a park or somewhere where they will not meet anyone. A surprising circumstance that I will try to explain.

The solitary life is full of terrors. If you went walking with someone that would be one thing but if you went walking alone in a lonely place that

would be an entirely different thing. If you were not completely distracted you would surely feel "the fear" part of the time. I am not now speaking of the fear and dread of helplessness which is a very unusual state of mind. I am speaking of pervasive fear that is always with us. It is a constant state of mind of which we are not aware when we are with others. We are used to this fear and we know that when we are with anyone else even a stranger we do not have it. That is all that we do know about it. In solitude this fear is lived and finally understood.

Worse than the terror of fear is the Dragon. The Dragon really pounds through the inner streets shaking everything and breathing fire. The fire of his breath destroys and disintegrates everything. The Dragon is indiscriminating and leaves absolutely nothing in his wake.

The solitary person is in great danger from the dragon because without an outside enemy the dragon turns on the self. In fact, self-destructiveness is the first of human weaknesses. When we know all the ways in which we can be self-destructive that will be very valuable knowledge indeed. . . .

Sometimes through hard work the dragon is weakened. The resulting quiet is shocking. The work proceeds quickly and without effort. But at anytime the dragon may rouse himself and then one is driven from the studio. If he can then have a good contest with someone else he is thoroughly aroused and the next day will go on and on about his victories round and round in the mind. I am sure you have noticed it. But if he only goes to the park he does not get completely roused and the next day he will perhaps be quiet.

We cannot and do not slay the dragon, that is a medieval idea I guess. We have to become completely familiar with him and hope that he sleeps. The way things are most of the time is that he is awake and we are asleep. What we hope is the opposite. . . .

We will get there someday however and do the work that we are supposed to do. Of all the pitfalls in our paths and the tremendous delays and wanderings off the track I want to say that they are not what they seem to be. I want to say that all that seems like fantastic mistakes are not mistakes and all that seems like error is not error and it all has to be done. That which seems like a false step is just the next step. . . .

Say to yourselves. I am going to work in order to see myself and face myself. While working and in the work I must be on the alert to see myself. When I see myself in the work I will know that that is the work I am supposed to do. I will not have much time for other peoples' problems. I will have to be by myself almost all the time and it will be a quiet life. . . .

Perfection is not necessary. Perfection you cannot have. If you do what you want to do and what you can do and if you can then recognize it you will be contented. You cannot possibly know what it will be but looking back you will not be surprised at what you have done.

For those who are visual minded I will say. There seems to be a fine ship at anchor. Fear is the anchor, convention is the chain, ghosts stalk the decks, the sails are filled with Pride and the ship does not move.

But there are moments for all of us in which the anchor is weighed. Moments in which we learn what it feels like to move freely not held back by pride and fear. Moments that can be recalled with all their fine flavor.

The recall of these moments can be stimulated by freeing experiences including the viewing of works of art.

Artists try to maintain an atmosphere of freedom in order to represent the perfection of those moments. And others searching for the meaning of art respond by recalling their own free moments.

❦

FROM *THE UNTROUBLED MIND* (1973)

People think that painting is about color
It's mostly composition
It's composition that's the whole thing
The classic image—
Two late Tang dishes, one with a flower image,
one empty—the empty form goes all the way to heaven
It is the classic form—lighter weight
My work is anti-nature
The four-story mountain
You will not think form, space, line, contour
Just a suggestion of nature gives weight
light and heavy light like a feather
you get light enough and you levitate . . .
Inspiration and life are equivalents and they come from
outside
Beauty is pervasive
inspiration is pervasive . . .
The development of sensibility, the response to beauty
In early childhood, when the mind is untroubled, is when
inspiration is most possible
The little child just sitting in the snow . . .
Nature is conquest, possession, eating, sleeping, procreation
It is not aesthetic, not the kind of inspiration I'm interested in
Nature is the wheel
When you get off the wheel you're looking out
You stand with your back to the turmoil
You never rest with nature, it's a hungry thing
Every animal that you meet is hungry
Not that I don't believe in eating
but I just want to make the distinction between
art and eating . . .
The satisfaction of appetite happens to be impossible

The satisfaction of appetite is frustrating
So it's always better to be a little bit hungry
That way you contradict the necessity
Not that I'm for asceticism
but the absolute trick in life is to find rest
If there's life in the composition it stimulates your life moments,
your happy moments, your brain is stimulated
Saint Augustine says that milk doesn't come from the mother
I painted a painting called *Milk River*
Cows don't give milk if they don't have grass and water
Tremendous meaning of that is that painters can't give
anything to the observer
People get what they need from a painting
The painter need not die because of responsibility
When you have inspiration and represent inspiration
The observer makes the painting
The painter has no responsibility to stimulate his needs . . .
I used to paint mountains here in New Mexico and I thought
my mountains looked like ant hills
I saw the plains driving out of New Mexico and I thought
the plain had it
just the plane
If you draw a diagonal, that's loose at both ends
I don't like circles—too expanding
When I draw horizontals
you see this big plane and you have certain feelings like
you're expanding over the plane
Anything can be painted without representation . . .
Classicism is not about people
and this work is not about the world
We called Greek classicism idealism
Idealism sounds like something you can strive for
They didn't strive for idealism at all
Just follow what Plato has to say
Classicists are people that look out with their back to the world
It represents something that isn't possible in the world
More perfection than is possible in the world
It's as unsubjective as possible
The ideal in America is the natural man
The conqueror, the one that can accumulate
The one who overcomes disadvantages, strength, courage
Whereas inspiration, classical art depends on inspiration
The Sylphides—I depend on the muses
Muses come and help me now
It exists in the mind

Before it's represented on paper it exists in the mind
The point—it doesn't exist in the world
The classic is cool
a classical period
it is cool because it is impersonal
the detached and impersonal . . .
Being detached and impersonal is related to freedom
That's the answer for inspiration
The untroubled mind
Plato says that all that exists are shadows
To a detached person the complication of the involved life is like chaos
If you don't like the chaos you're a classicist
If you like it you're a romanticist
Someone said all human emotion is an idea
Painting is not about ideas or personal emotion
When I was painting in New York I was not so clear about that
Now I'm very clear that the object is freedom
not political freedom, which is the echo
not freedom from social mores
freedom from mastery and slavery
freedom from what's dragging you down
freedom from right and wrong . . .
The future's a blank page
I pretended I was looking at the blank page
I used to look in my mind for the unwritten page
if my mind was empty enough I could see it
I didn't paint the plane
I just drew this horizontal line
Then I found out about all the other lines
But I realized what I liked was the horizontal line
Then I painted two rectangles
correct composition
if they're just right . . .
They arrive at an interior balance
like there shouldn't need to be anything added
People see a color that's not there
our responses are stimulated
I'm painting them for direct light
With these rectangles I didn't know at the time exactly why
I painted those rectangles
From Isaiah, about inspiration
"Surely the people is grass"
You go down to the river
you're just like me
an orange leaf is floating

you're just like me
Then I drew all those rectangles
All the people were like those rectangles
they are just like grass
That's the way to freedom
If you can imagine you're a grain of sand
you know the rock ages . . .
If you can imagine that you're a rock
all your troubles fall away
It's consolation
Sand is better
You're so much smaller as a grain of sand
We are so much less
These paintings are about freedom from the cares of this world
from worldliness
Not religion
You don't have to be religious to have inspirations . . .
A boy whenever he had a problem
he called this rock up out of the mud
he turned into a rock
he summoned a vision of quiet
The idea is independence and solitude
nothing religious in my retirement
religion from my point of view
it's about this grass
The grass enjoyed it when the wind blew
It really enjoyed the wind leaning this way and that
So the grass thought the wind is a great comfort
besides that it blows the clouds here which make rain
In fact we owe all our self being to the wind
We should tell the wind our gratitude . . .
My painting is about impotence
We are ineffectual
In a big picture a blade of grass amounts to not very much
Worries fall off you when you can believe that
pride is in abeyance when you think that . . .
Don't look at the stars
Then your mind goes freely—way, way beyond
Look between the rain the drops are insular
Try to remember before you were bom
The conqueror will fight with you
if there's no one else around . . .
We eat
We procreate
We die

We can see the process and recognize suffering as the defeat of
ego by the process of destiny
We can relinquish pride, conquest, remorse and resolution
inevitably as destiny unfolds
Cradled on the mountain I can rest
Solitude and freedom are the same under every fallen leaf
Others do not really exist in solitude, I do not exist
no thinking of others even when they are there, no interruption
a mystic and a solitary person are the same
Night shelterless, wandering
I, like the deer, looked
finding less and less
living is grazing
memory is chewing cud
wandering away from everything
giving up everything
not me anymore, any of it
retired ego, wandering
on the mountain
no more conquests, no longer an enemy to anyone
ego retired, wandering
no longer a friend, master, slave all the opposites dead to the world and
himself unresponsible
perhaps I can now really enjoy sailing
adventure in the dark
very exciting
Beast seems to be stretched out dead
He is very mild
I will not be seeking adventure but it might happen I suppose . . .
Westward down the mountain
I am nothing absolutely
There is this other thing going on
the purification of reality
that is all that is happening
all that happens is that process
not nature, the dissolution of nature
The error is in thinking we have
a part to play in the process
As long as we think that, we are in resistance
I can see that I have nothing to do with the process
It is very pleasant
The all of all, reality, mind
the process of destiny
like the ocean full to the brim
like a dignified journey with no trouble and no goal on and on . . .

Everyone is chosen and everyone knows it
including animals and plants
There is only the all of the all
everything is that
every infinitesimal thought and action is part and parcel of
a wonderful victory
"freedom on the mountain, a glimpse of victory"
We seem to be winning and losing,
but in reality there is no losing
The wiggle of a worm as important as the assassination of a
president.

<p style="text-align:center">❦</p>

FROM *WHAT IS REAL?*
(1976; a lecture first given at Yale University)

We are in the midst of reality responding with joy. It is an absolutely satisfying experience but extremely elusive. It is elusive because we must recognize so many other things at the same time.

The memory of past moments of joy leads us on. The responses of happiness and joy are our first concern.

Works of art have successfully represented our response to reality from the beginning. The artist tries to live in a way that will make greater awareness of the sublimity of reality possible. Reality, the truth about life and the mystery of beauty are all the same and they are the first concern of everyone.

I want to emphasize the fact that we all have the same concern, but the artist must know exactly what the experience is. He must pursue the truth relentlessly. Once he sees this fact his feet are on the path. If you want to know the truth you will know it. The manipulation of materials in art work is a result of this state of mind. The artist works by awareness of his own state of mind.

In order to do so he must have a studio, as a retreat and as a place to work. In the studio an artist must have no interruptions from himself or anyone else. Interruptions are disasters. To hold onto the "silver cord," that is the artistic discipline. The artist's own mind will be all the help he needs.

There will be moving ahead and discoveries made every day. There will be great disappointments and failures in trying to express them. An artist is one who can fail and fail and still go on. . . .

Responding with joy is the path and we should work and eat with joy. The joy counts and nothing else does.

There is in reality no need for self-sacrifice and no call for it. Do not settle for the experience of others. If you follow others you are in reality at a standstill, because their experience is in the past. That is circling. Even fol-

lowing your own past experience, is circling. Know your own response to your own work and to the work of others.

To *recall* in one's own mind past concrete experience is not circling. It is so much easier to respond accurately when alone. Experiences recalled are generally more satisfying and enlightening than the original experience. It is in fact the only way to know one's whole response. . . .

The straightforward path, as we so often have been warned, is extremely hard to maintain. Only joyful discoveries count. If you are not making them you are not moving.

Now let us turn to abstract response, the response that we make in our minds free from concrete environment. We know that it prevails. We know that it is infinite, dimensionless, without form and void. But it is not nothing because when we give our minds to it we are blissfully aware.

Being without imperfection it is perfection. And being without parts it is whole.

It is from our awareness of transcendent reality and our response to concrete reality that our minds command us on our way—not really on a path or to a gate—but to full response.

Complete consciousness is present to us at all times, every moment, but we reject it in order to maintain our prejudices, our ideas. But sooner or later we will relinquish our ideas in favor of response because the truth prevails.

In the meantime we can see ourselves in our work. We can see ourselves moving along. We can see the steps we take. We can see that there is no such thing as going backward. We can be contented.

We can know every day what we must do and we will have plenty of energy with which to do it. We will know when it is something we want and we will know when it is something that we do not want.

There is a great hunger and thirst in all of us for the truth whether we are aware of it or not. There is no one unfeeling or unseeing. To think ourselves unique is the height of ignorance.

Appetite is of course positive but sometimes in moments of weakness we have an immense yearning to escape. This is a very strong feeling and very unattractive. If you feel yearning you should go off by yourself and give it full reign and then you will see that with great earnestness and determination it says, "me, me, me, me, me." You will see that yearning is defiant and rebellious and, also, it exhausts itself which proves that it is unreal. We must give up the idea of salvation. You cannot be saved and the rest left.

You must want joy for all not just for yourself. The exact same joy, want it wholeheartedly for all. To want joy for yourself is unreal, off the track and untrue. It is just as unreal to think you give joy to others. Each has its own joy. Joy is life. You cannot give life. You can want them to have it, that is as much as you can do.

Joy is Perception. Perception, reception and response are all the same. Sometimes we perceive, sometimes we receive and sometimes we respond but it is all the same.

It is all awareness of reality.

In a Chinese vase we can see all that the artist rejected in order to have as close an approximation as possible to his response to reality. We can feel as he felt looking at his work. The same response is made continually over a thousand years. Proving it is reality. That is what art is about.

There is no such thing as "contemporary" art. Any material may be used but the theme is the same and the response is the same for all art work.

There is one great difference from man to man that I must mention. It is a difference in willingness to perform his function. We, each of us, are born to a certain function. Sometimes our function is hidden from us by prejudice and fear. When an artist becomes aware of his exact function, that is when he knows, suddenly, exactly what he will do and how he will do it. We say that he has attained his vision. If this happens when he is very young we say that he is a genius. It is sometimes baffling to the rest of us that we have to do so much work that is unrelated to art work. But looking back we can see the positive aspect of all of our actions. Without vision that is without exact awareness of our function we are discontented. When we are completely aware of our function we are contented. You can see that discontent is a positive state of mind urging us on to discover our function.

Do not waste your feelings of discontent on society. When you feel discontented ask yourself "what do I want?", "what do I really want?" As soon as you ask yourself this question you will realize that discontent arises out of it.

Your unwillingness to function may be so strong that you cannot even ask yourself this question, in which case you will seek help from others. But there will be no help for you anywhere. You will find your vision for yourself at some time when you are alone. . . .

Now we must consider the idea of *Power* because without freedom we cannot make our full response. With the idea of power in our minds we are subject to that power. If you believe in it, then it exists for you and you are naturally subject to it. But in reality there is no power anywhere. . . .

In the psychological field: still considering power we encounter one of our most troublesome concepts, the idea of authority and obedience. Using the parent-child situation as a base it is generally believed that those in authority are on top and those in obedience below.

I want to take time with this concept and prove to you beyond doubt that authority and obedience exist at the same time in each of us, that we are all in a state of obedient authority at all times, that it is a sublime state and that it is in fact a state of positive freedom. In order to do this I will speak only of obedience.

Our lowest form of obedience is perhaps our obedience to animals. We strive to accurately obey animals providing them with water, food, clean housing, medicare and social security. In return, and all the time the animal obeys us. If it does not, it is considered to be a no-good animal.

Our most heartfelt and anxious obedience is a mother's obedience to the infant, and her slavish obedience to her children as long as they are in her

care. Also from the very first moment the infant and child must obey the mother. It plain, is it not, that they are both in authority and both in obedience at the same time. The authority-obedience state of being is not a "sometimes" state but a contin uous state of being. We are always in authority and always in obedience.

The obedience of children is generally worthless because they are inattentive and desultory. But there is obedience on the part of some adults that is marvelous in its expression.

The obedience of performing musicians is extremely sensitive and accurate. There is no way to describe the reward of absolute obedience. Any response to art i obedience. I wish I could point out how authoritative art work is dependent on the obedient state of mind. . . .

The most troublesome anti-freedom concept is our belief in a transcendent supreme authority. It is recognition of our state of obedience that makes us postulat this authority. But when we see that all the authority there is, is within ourselves as result of our obedience then we are free. This is the only road to freedom.

The idea of leadership is another stumbling block to freedom. You must see through leadership to its non-existence. A leader exists only in the mind of his fol- lowers. Some leaders keep their followers from changing their minds by the use of fear. In reality there are no leaders or followers. Everyone is on his own private lin

The first step in giving up the ideas of power and leadership is to give up wanting them for yourself. It sounds easy but your conditioning has been *that powe and leadership lead to freedom* regardless of the inherent contradiction in that state ment.

What is our happy conclusion? It is that we have plenty of energy and we enjoy action. There is a purpose in our lives and it is in operation every minute. When we are right *on the track* we are rewarded with joy. We can know *the whole truth* with quest to our minds. If we are completely without direction we can withdraw and ou minds will tell us the next step to take.

BEAUTY IS THE MYSTERY OF LIFE
(1989; lecture given at the Carnegie Museum of Art, Pittsburgh, and the Museum of Fine Arts)

When I think of art I think of beauty. Beauty is the mystery of life. It is not in th eye it is in the mind. In our minds there is awareness of perfection.

We respond to beauty with emotion. Beauty speaks a message to us. We are con fused about this message because of distractions. Sometimes we even think that it i in the mail. The message is about different kinds of happiness and joy. Joy is most successfully represented in Beethoven's Ninth Symphony and by the Parthenon.

All art work is about beauty: all positive work represents it and celebrates it. Al negative art protests the lack of beauty in our lives.

When a beautiful rose dies beauty does not die because it is not really in the rose. Beauty is an awareness in the mind. It is a mental and emotional response tha we make. We respond to life as though it were perfect. When we go into a forest we

o not see the fallen rotting trees. We are inspired by a multitude of uprising trees. We even hear a silence when it is not really silent. When we see a newborn baby we say it is beautiful—perfect.

The goal of life is happiness and to respond to life as though it were perfect is the way to happiness. It is also the way to positive art work.

It is not in the role of an artist to worry about life—to feel responsible for creating a better world. This is a very serious distraction. All of your conditioning has been directed toward intellectual living. This is useless in art work. All human knowledge is useless in art work. Concepts, relationships, categories, classifications, deductions are distractions of mind that we wish to hold free for inspiration.

There are two parts of the mind. The outer mind that records facts and the inner mind that says "yes" and "no." When you think of something that you should do, the inner mind says "yes" and you feel elated. We call this inspiration.

For an artist this is the only way. There is no help anywhere. He must listen to his own mind.

The way of an artist is an entirely different way. It is a way of surrender. He must surrender to his own mind.

When you look in your mind you find it covered with a lot of rubbishy thoughts. You have to penetrate these and hear what your mind is telling you to do. Such work is original work. All other work made from ideas is not inspired and it is not art work

Art work is responded to with happy emotions. Work about ideas is responded to with other ideas. There is so much written about art that it is mistaken for an intellectual pursuit.

It is quite commonly thought that the intellect is responsible for everything that is made and done. It is commonly thought that everything that is can be put into words. But there is a wide range of emotional response that we make that cannot be put into words. We are so used to making these emotional responses that we are not consciously aware of them till they are represented in art work.

Our emotional life is really dominant over our intellectual life but we do not realize it.

You must discover the art work that you like and realize the response that you make to it. You must especially know the response that you make to your own work. It is in this way that you discover your direction and the truth about yourself. If you do not discover your response to your own work you miss the reward. You must look at the work and know how it makes you feel.

If you are not an artist you can make discoveries about yourself by knowing your response to work that you like.

Ask yourself: "What kind of happiness do I feel with this music or this picture?"

There is happiness that we feel without any material stimulation. We may wake up in the morning feeling happy for no reason. Abstract or non objective feelings are a very important part of our lives. Personal emotions and sentimentality are anti-art.

We make art work as something that we have to do not knowing how it will work out. When it is finished we have to see if it is effective. Even if we obey inspiration we cannot expect all the work to be successful. An artist is a person who can recognize failure.

If you were a composer you would not expect everything you played to be a composition. It is the same in the graphic arts. There are many failures.

Art work is the only work in the world that is unmaterialistic. All other work contributes to human welfare and comfort. You can see from this that human welfare and comfort are not the interests of the artist. He is irresponsible because his life goes in a different direction. His mind will be involved with beauty and happiness. It is possible to work at something other than art and maintain this state of mind and be moving ahead as an artist. The unmaterial interest is essential.

The newest trend and the art scene are unnecessary distractions for a serious artist. He will be much more rewarded responding to art of all times and places. Not as art history but considering each piece and its value to him.

You can't think "My life is more important than the work" and get the work. You have to think the work is paramount in your life. An artist's life is adventurous. One new thing after another.

I have been talking directly to artists but it applies to all. Take advantage of the awareness of perfection in your mind. See perfection in everything around you. See if you can discover your true feelings when listening to music. Make happiness your goal. The way to discover the truth about this life is to discover yourself. Say to yourself: "What do I like and what do I want?" Find out exactly what you want in life. Ask your mind for inspiration about everything. Beauty illustrates happiness; the wind in the grass, the glistening waves following each other, the flight of birds, all speak of happiness.

The clear blue sky illustrates a different kind of happiness and the soft dark night a different kind. There are an infinite number of different kinds of happiness.

The response is the same for the observer as it is for the artist. The response to art is the real art field.

Composition is an absolute mystery. It is dictated by the mind. The artist searches for certain sounds or lines that are acceptable to mind and finally an arrangement of them that is acceptable. The acceptable compositions arouse certain feelings of appreciation in the observer. Some compositions appeal to some and some to others.

But if they are not accepted by the artist's mind they will not appeal to anyone. Composition and acceptance by mind are essential to art work. Commercial art is consciously made to appeal to the senses which is quite different. Art work is very valuable and it is also very scarce. It takes a great deal of application to make a composition that is totally acceptable. Beethoven's symphonies with every note composed represent a titanic human effort.

To progress in life you must give up the things that you do not like. Give up doing the things that you do not like to do. You must find the things that you do like. The things that are acceptable to your mind.

You can see that you will have to have time to yourself to find out what

appeals to your mind. While you go along with others you are not really living your life. To rebel against others is just as futile. You must find your way.

Happiness is being on the beam with life—to feel the pull of life.

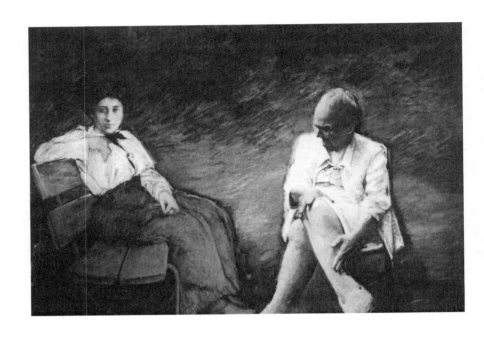

Forming the Fifth International, 1985. Acrylic on canvas, 78 x 115½ in.
Photo: David Heinlein

MAY STEVENS

B. 1924

FOR MORE THAN twenty years, painter May Stevens has used the members of her own family as the basis for her work, moving them from the personal realm into a broader context. First her father, then her mother, and finally her son via his own art production became repeating images in Stevens's work. As Stevens herself has said, these were not simply "touching representations" or "cozy anecdotes," but emotionally charged images that "speak to the uneasy, frightening, unsolid, awful, extreme places we can go," places "both personal and communal, both private and historical." Through her intense commitment, both to art and its process, Stevens has succeeded in making her art an instrument of change in this world. For Stevens, writing has always been important as another means of creative expression. A skilled and prolific writer, she has articulated the connection between the personal and social spheres and between art and action, in numerous poems and essays, as well as in her visual work.

Born in Quincy, Massachusetts, to a working-class family, May Stevens was the oldest of three children and the only girl. Her father worked as a pipefitter in the nearby shipyard, and her mother, Alice Dick Stevens, was a housewife who had dropped out of school in the eighth grade to work as a mother's helper when her own mother died. Stevens was the first member of her family to go to college. Her father approved, hoping that it would allow her to break with

her working-class origins; he little suspected that it would make her "grow her hair long, dress all in black" and ultimately end up "identifying more with his class than he did." Afraid that she would end up as a schoolteacher, Stevens chose the Massachusetts College of Art in Boston instead of a conventional liberal arts college. Her conviction that regardless of what else she did, she would always be an artist dates from her art school years. After graduation, at her parents' request (in order to help care for her sick mother), she remained in the Boston area for two years, doing advertising for a local department store.

In 1948 Stevens's life underwent a series of rapid circumstantial changes. Upon hearing from an art-school friend about an opening in her New York City apartment building, Stevens moved to New York, obtained a menial sales position to support herself, and signed up for night classes at the Art Students League. She met her future husband, the painter Rudolf Baranik, her very first night there. Stevens has described how her meeting with Baranik, a Jew who had lost his family in the Holocaust, had been presaged by dreams in which she heard people crying. Stevens and Baranik were married in June 1948, and in September they moved to Paris where they remained for three years. After their son Steven was born in December, Stevens quit the classes she had begun at the Académie Julian, although she continued to paint and to exhibit at a cooperative gallery run by American students. Her work received favorable press notices, although one piece was criticized in the international edition of the *Herald Tribune* for its title, *Martinsville Seven* (referring to the politically motivated rape trial of seven black men in Virginia), which the critic found "distracting." Significantly, political meaning became an important aspect of Stevens's artistic oeuvre.

A period of consolidation followed the family's return to New York in 1951. Despite her earlier resistance to teaching, Stevens took education courses to become a certified art teacher, and taught (ultimately at the prestigious New York City High School of Music and Art) until the late fifties, when she resigned because her request for a one-year leave of absence to concentrate on her painting was denied. The attitude that led to her quitting neatly communicates Stevens's anti-bourgeois perspective: she was "more frightened" that her life might be governed by such "petty securities" as a pension than by not having a job. Subsequently she found a series of part-time college teaching stints, and developed a life-style that was dedicated to work. Her son Steven and themes from his daily life provided her major subject during these years.

By the 1960s Stevens had begun to redefine the direction of her work to include greater political content. Personally moved by and committed to the civil rights movement of the early sixties, Stevens did a series of paintings called *Freedom Riders*. Although she was "locked into a suburban apartment and a teaching job," she "lived mentally in the South." Her political awareness made her angry at the conservatism of "ordinary" Americans and "what they were letting happen in the South and in Vietnam." The linking of her personal circumstances to the larger political arena was made through two photographs of her parents taken by her son Steven, in 1968. That of her mother was "too

terrible" to deal with and she laid it aside for future use (it later became the basis for her long-term project *Ordinary. Extraordinary*, discussed below). The image of her father was transmuted in the *Big Daddy* series into "a symbol of American complicity in the war in Southeast Asia," in which she expressed her outrage at the effects of American racism and imperialism. As a symbol, "Big Daddy" was no longer the complex, actual father whom Stevens loved despite his deplorable politics, but a hard-edged, phallic caricature, presented in front of a TV screen or the American flag, or as a paper-doll cutout, a smug expression on his face and with his equally phallic bulldog seated in his lap.

Stevens worked with the *Big Daddy* series for seven years, during which time she had become involved in feminist circles and, like so many other women during the early 1970s, made the important link between the civil rights and anti-war movements and the struggle against patriarchal oppression. Although Stevens had painted the *Big Daddy* series to protest the war in Vietnam, the works simultaneously communicated a clearly anti-patriarchal message. She continued to explore feminist themes in several works in the seventies. In *Artist's Studio (After Courbet)* (1974), Stevens recast an icon from the art-historical tradition in feminist terms, a strategy used by other contemporary women artists. Basing her work on Courbet's painting of the same title, Stevens placed herself in Courbet's pivotal position, in front of one of the later *Big Daddy* paintings, surrounded by intimates from her art community. Four years later, in *Soho Women Artists* and *Mysteries and Politics*, Stevens created two more imaginary gatherings, this time exclusively female. In *Mysteries and Politics*, Stevens placed thirteen women important to her in a "sacred conversation," the picture surface divided between those who represented a visceral approach to the world, placed on the left, and those who represented the intellectual, on the right. This was the first painting in which the image of her mother and that of the early twentieth-century revolutionary Rosa Luxemburg appeared simultaneously.

Comparison of Rosa Luxemburg and Alice Stevens's lives was the theme around which Stevens's work for the next decade was organized. This complex, multifaceted series, titled *Ordinary. Extraordinary*, explored the contrasts between the life of an ordinary woman, Stevens's mother, and an extraordinary one, Rosa Luxemburg. Stevens's first work on this theme actually predates *Mysteries and Politics*. In 1976, while working with the feminist artists' collective Heresies, Stevens made a collage, *Two Women*, for inclusion in its first publication. In this work, in which she paired three photographs of Luxemburg with three of her mother at various stages of their lives, she was finally able to use the photograph of her mother to which she had previously responded as "too terrible." She further explored this theme not only in collages but through the joining of the two women's words, in an artist's book, *Ordinary. Extraordinary*, published in 1980 (the first time she used that title). In her introduction she said that her goal was to examine and document "the mark of a political woman and mark the life of a woman whose life would otherwise be unmarked." Or, as Josephine Withers has suggested, she wanted "to

erode, break apart, and confound the divisive and polarized notion that the o
woman's life was special, exemplary, *extraordinary*, and the other was banal, forg
table and *ordinary*." By pairing her mother, Alice Dick Stevens, with Rosa Luxembu
Stevens was connecting her biological mother with a spiritual foremother, an impo
tant step in feminist revisioning and reclaiming taken by numerous women artists a
writers of the past century. Stevens explored some aspects of this theme in all t
large-scale paintings she executed between 1981 and 1987, in images that relat
either to Rosa's life or to her mother's. The two women were portrayed in a sing
space in *Forming the Fifth International* (1985), where they are placed in a parkli
setting in conversation as friends, although Rosa is executed in the wraithlike grisai
that characterized some of the earlier paintings.

By the late 1980s Stevens had exhausted the course of the *Ordinary. Extraordinc*
series and had begun formulating a new body of work. She began to incorporate i
a series of smaller works titled *Burning Horses: Fire Series*, images made by her pi
tographer son, Steven, who died in 1981. Images of women against backgrounds
densely woven words characterize several large paintings, such as *Sea of Words a
Live Girls*, works about which Stevens has said that she "is particularly interested
representing women still barely heard (or believed) among the power brokers."

Despite the taboo attached to "political art" in the western art-historical traditi
most of Stevens's mature work has had political implications. For Stevens, art and p
itics both stem from the individual's responsibility as an agent of change. She has wr
ten numerous perceptive analyses regarding the circumstances in her backgrou
that led her to assume her activist position, particularly regarding her experienc
growing up in a working-class family with a racist father. She has described how I
father's hierarchy, which placed blacks and Jews at the bottom of humanity, disgust
her and ultimately caused her to identify strongly with the struggle for equality
groups who were subjected to discrimination. This feeling influenced her choice o
Jewish mate, and it informed her art; the *Big Daddy* series was precipitated by I
anger against American society's complacent racism and imperialism. At the sai
time, Stevens strongly identified with the working class into which she was born, a
has written perceptively about her early class consciousness. Her choice of Re
Luxemburg as artistic subject and spiritual foremother directly relates to Luxembur
role as a radical socialist theorist, whose visions for the liberation of humanity have
to be realized. Additionally, Stevens has directly confronted the western art-histori
tradition's prejudice against mixing art and politics. Her understanding that ordina
lives are driven by a need for aesthetic experience aligns Stevens with other wom
artists of the twentieth century, most notably Käthe Kollwitz and Elizabeth Catlett.
her essay "Taking Art to the Revolution," she criticizes the elitist assumption that or
nary people do not need art in their lives and the "formalist rule" that discrimina
against protest art. As she points out, what makes art art is precisely what makes it i
a commodity; because it is "amorphous and infinitely variable," art does not suf
from being overtly political, nor does it need to be in order to "engender social acti
(in delayed time and unforeseen ways)."

Stevens has challenged also the class-related boundaries between high and pop
lar art. Particularly in her early collages on the ordinary/extraordinary theme, Steve

used nontraditional media such as found and Xeroxed photographs incorporated with textual fragments. These materials formed the basis of her privately printed artist's book, which created what Lisa Tickner has called a "filmic" series of dissonant juxtapositions in which "a range of traditionally silent positions and speakers" were "incorporate[d] into the area of legitimate cultural expression." Stevens has discussed how these collages are able to communicate contradictory levels of consciousness, e.g., the processes of surfacing and disappearing. While she has taken issue with critics such as Donald Kuspit who suggest that painting is the highest art, the privileged locus of moral struggle, she has also vehemently opposed John Berger's assertion that painting is "incurably bourgeois." In her own work, she developed as large-scale paintings many of the images in *Ordinary. Extraordinary* that she had initially explored through photos and Xeroxes. These works are distinguished by a lush and complex painterly surface.

Writing plays a central role in May Stevens's artistic endeavor. She has incorporated the written word into various compositions, creating tensions between the legible and illegible. In the early collages dealing with Rosa and Alice, fragments of legible text appear to surface from a scrawled background, while in her artist's book the words of both women are clearly written out in a separate section. In *Voices*, the painting commemorating Rosa Luxemburg's funeral, a jumble of textual fragments represents a chorus of bits and pieces of conversation, while Luxemburg's statement regarding the endurance of the revolution (and of her memory) "I was, I am, I will be," ring out loud and clear. In her most recent works, images stabilize amidst a sea of words.

Stevens is a prolific writer in several genres, often working her ideas through in letters and essays. Several of her poems and essays were reprinted in *in words*, published simultaneously with a 1994 exhibition. She is an especially eloquent and moving poet. "I have gone back to writing poems, perhaps to say some of the things the paintings could not say," she said in an interview in the mid-1980s. In her poetry Stevens adds a layer of further complexity to issues she explores in her paintings, as in the poem "Letters From Home" where she presents a less caricatured view of her father than in the *Big Daddy* series. The poignant series of poems to her mother bespeaks the complexity of their relationship: love of her mother, pain at what life did to her, fear of their similarity, and ultimate acceptance of their commonality.

The complex issue of mothers and mothering is a frequent concern in Stevens's art and writing. Virginia Woolf said that "a woman writing thinks back through her mothers." [In *A Room of One's Own*, Harmondsworth, England: Penguin Books, 1963, p. 96.] For Stevens, the process of defining and identifying with a matrilineal progression has taken several forms. In the Rosa/Alice series she has paired two mothers, her biological mother whose life was private and whose ability to speak was repressed, and a spiritual foremother, who was active and articulate in the public sphere, yet who was also silenced prematurely for daring to maintain her radical views. Stevens has repeatedly asserted that their lives should not be seen as unconnected and that,

in fact, they are related to each other. Through their mythical juxtaposition, Stevens the daughter is able to wrest speech from them both. While her mother's "aborted life" was for her "the clearest argument for the liberation of women," in her many poems to her mother, Stevens has underscored the connection between mother and daughter. "The milk that is spilled / In the well of your neck / I will write words with it" ("You Can Go") is only one example of Stevens's promise to write her mother's "name," in this case in language that is reminiscent of Hélène Cixous's dictum to "write in white ink of that good mother's milk." [In "The Laugh of the Medusa," *Signs* 1:4 (1976), p. 881.] Stevens eloquently "writes the female body" in many poems, describing the "hawkcords" of age, her "rusty and protein-rich monthly blood," or her womb as "a limb, a handle, a tool that speaks."

Stevens's participation in a community of women has enabled her to speak: her involvement with the Heresies collective and with the group of Soho women artists (whom she memorialized in paint) allowed her to confront the photograph of her mother that she had previously found "too terrible" to contemplate. Stevens continues to be actively involved in the community of women artists, in which she maintains nurturing and generous relationships with women artists of the next generation, women who could be her spiritual "daughters."

Sources

Baranik, Rudolf and May Stevens. *in words*. (Published in conjunction with the exhibition "Existential/Political: Works from the Fourth Decade by Rudolf Baranik and May Stevens.") New York: Exit Art, 1994.

Lippard, Lucy. "May Stevens' Big Daddies." In *From the Center: Feminist Essays on Women's Art*. New York: E. P. Dutton, 1976.

Stevens, May. "Looking Backward in Order to Look Forward: Memories of a Racist Girlhood." Heresies 15 (1982-83), pp. 22-23.

_____. "My Work and My Working-Class Father." In *Working It Out: Conversations with Women Writers and Artists*, ed. Sara Ruddick and Pamela Daniels. New York: Pantheon, 1977.

_____. *Ordinary. Extraordinary*. Artist's book. New York: 1980.

_____. *Ordinary. Extraordinary: A Summation 1977-1984*. Exhibition catalogue (essays by Donald Kuspit, Lucy Lippard, Moira Roth, Lisa Tickner; foreword by Patricia Hills). Boston: Boston University Art Gallery, 1984.

_____. *Ordinary. Extraordinary*. Exhibition catalogue (Melissa Dabakis and Janis Bell, editors; Olin Gallery, Kenyon College, Gambier, Ohio). New York: Universe, 1988.

_____. "Taking Art to the Revolution." In *Visibly Female*, ed. Hilary Robinson. New York: Universe, 1988.

Tarlow, Lois. "Profile: May Stevens." *Art New England* 12 (February 1991), pp. 7-9.

Withers, Josephine. "Revisioning Our Foremothers: Reflections on the Ordinary. Extraordinary Art of May Stevens." *Feminist Studies* 13 (Fall 1987), pp. 485-512.

MAY STEVENS—SELECTED WRITINGS

FROM "TAKING ART TO THE REVOLUTION" (1980)

Art as propaganda: All art can be placed somewhere along a political spectrum, supporting one set of class interests or another, actively or passively, at the very least supporting existing conditions by ignoring other possibilities, silence giving consent.

Art as not propaganda: The meaning of art cannot be reduced to propaganda; it deals with many other things in addition to those revealed by class and sociological analysis.

Both definitions are true; they are not opposites, but ways of measuring different properties.

Philistinism: Fear of art. Unclarity of meaning, inability to demonstrate immediate social usefulness, difficulties of definition and standards make art seem untrustworthy to the philistine mind (which may be highly trained in other areas of culture). An activity that encourages emotion and individuality, that permits eccentricity and obsession, is necessarily suspect. But art is not subject to social engineering—in this sense: there is no formula for artmaking; art schools do not produce artists (in any positive numerical ratio); high morals do not produce art; effective propaganda does not constitute a definition of art.

That art is amorphous and infinitely variable is one of the properties that defines it and gives it value; here is one area of life where dreams and passions can work out their meanings. That which we feel is worth devoting one's life to and whose value cannot be proven, that is art. Artists create spirit traps, forms to catch our minds and spirits in. These forms may be two- and three-dimensional, of long or short duration, planned or spontaneous. They may engender social action (in delayed time or unforeseen ways) or not. Only a philistine mind could imagine an art accessible to all, accountable to social and political needs, and unconcerned with the hunger for beauty (for color, for tactility, for sensation) and transcendence. . . .

To the philistine, the aesthetic experience is either trivial or nonexistent.

Philistine criticism of art is often a species of puritanism; it is equivalent to criticism of sexuality by the impotent or the non-orgasmic.

But the aesthetic experience is important—regardless of class, age or sex. People unintimidated by class or fashion have a sure sense of style—in their lives, their clothes, their language and what they put on their walls. Social thinkers who see non-intellectuals as a mass have little awareness of everyone's sense of and need for art. But people grow and arrange flowers; choose objects, this one over that one; put "useless" things on walls, shelves, mantelpieces, automobile dashboards and locker doors. These are aesthetic objects, reminders of what one cares about, dreams of, needs to stir one's feelings through visual codes. Whether it is movie star or sports hero, pin-up or sad-eyed cocker spaniel, the sacred heart of Jesus, sunset or sunflower, the Pietà in the Italian barbershop or the ruffled doily in the back of the Hispanic automobile—people need and love "useless objects," art of their own choosing, culturally defined, educationally conditioned. The problem is not with people's taste (often called "kitsch" by superior minds) but with defining art as one thing only. Art is that which functions as aesthetic experience, for you. If a certain art works that way for enough people, there is consensus; that becomes art. For a while.

The clipping on my wall (a news event that has aesthetic meaning for me; a face, a body that moves me) is as much art as the O'Keeffe iris and the Cunningham magnolia or the Ellsworth Kelly black-and-white shaped canvas that I see in the museums/galleries and whose replicas in media reproductions I also pin to my wall. I must assume I share with "ordinary," "unsophisticated," "less educated" people the same need for a quality of life that includes beauty as I, for myself, define it, as they, for themselves, define it. To make any other assumption, for example, that "art" as it has existed is of no interest to them and that art for them should be my definition of what will "raise" them or "free" them, is contemptuous. Honesty requires that I admit my tastes and that I respect theirs. To see people as totally media-brainwashed and culturally deprived is to ignore ethnic, racial and gender-based traditions; and the way we all become immune to propaganda after a while. The TV runs all day perhaps, but we make phone calls, fry an egg, make grocery lists, do homework or tax returns, play cards or chat with a neighbor over the clamor. . . .

New ideas, new art, new situations do not displace history; they modify it. They create a new dialectic. It is our job as people who care to sort out the contradictions, to integrate new with old. We have to, as Adrienne Rich said, dive into the wreck to find what is salvageable. We have spent too much time killing our mothers and our fathers. Let's pick their brains instead, subject their knowledge (our heritage) to analysis based on what we need and want.
. . .

Art as propaganda must help to bring about the conditions under which it can achieve its fullest propaganda function. This means propagation of respect for art, respect which can help bridge the gap between art of the

highest order and working-class experience. When Mary Kelly makes art out of baby nappies and documents her child's development with Lacanian theory, she attempts to integrate the artifacts of woman's daily reality, charged with complex emotional affect (Marxist/feminist/ artist/mother raising a male child on the edge of the working-class), with the keenest contemporary intellectual analysis she can bring to bear. This art swings between the nursery and the tower and shows in the starkness of its oppositions the way we are split—worker from knowledge, woman from science. . . .

I do not think the meaning of the effort for social change implicit or explicit in the works of social realism, surrealism, futurism, neo-plasticism, conceptual art, black art and feminist art is negated by hanging these works in galleries and museums. Until the intent is realized, they hang like unopened letters, unanswered invitations. They will look different when those battles are won—more formalist, I suppose. They testify to capitalism's appetite for sensation. They testify that art is not a gun; a manifesto is not a military command. They also testify that possibility lives in art, like weeds in an untended lot. . . .

Utilitarianism—defining things by use, or excluding things by measuring their purposefulness and effectiveness for certain specific aims—may be a great way to bake a cake. It is hardly adequate as an attitude for making or judging art, art being one of the more complicated, layered and resonant areas of human work. It is true that one makes art by asking is that form (color, shape, word) useful in this context? This is not the same as saying (by implication or omission) that art must move the revolution forward directly, as forcefully as possible, now (because people are indeed suffering and dying now under oppression), or be classed as part of the oppression. We must take art with us to the revolution—all kinds of art, including that which is funny, beautiful, puzzling, provocative, problematic. Think of it like music, or writing. Will we leave out that which doesn't give us instruction on how to get to our destination, or provide us with marching beat?

Art often deals with unclarities, looking for new understanding true to feeling—the basic measure—and to theory, which is to say fitted correctly to the artist's concept (a part of her/his larger world-view). Murkiness allows germination. Since it is not all knowable, plannable, and the nature of being is explored in the nature of art. The nature and praxis of art must be seen as reflexive, as well as reflective. . . .

Art is political. But one also has to understand that the uses to which it is put are not its meaning. Its status as object and commodity is not its meaning: there are many objects and commodities. They are not all art. What makes art different? Exactly the ways in which it is not an object, can never in its nature be a commodity. (Humans can be sold as slaves: to be human is essentially not to be a slave, in one's nature.)

A socialist and feminist analysis of culture must be as careful as it is angry—fierce and responsible.

FROM "LOOKING BACKWARD IN ORDER TO LOOK FORWARD: MEMORIES OF A RACIST GIRLHOOD" (1982)

Quincy, Mass., 10 miles south of Boston. 1930. In elementary school: Scots, mostly, or Anglo-Saxons and Nordics. Lovejoy, Mackenzie, Scrimshaw. Rogers, Robertson, Gordon. My friend Frances Fitzgerald was Catholic as my mother had been before she married. I was safely Congregational and Scots-English with the slight stain of my mother's Irishness. My father despised the culture of poverty, Catholicism, sacrifice and forbearance she brought with her from Canadian mill towns.

Selma Brick and Faheem Hanna. Both dark as Italians, but less open, available, confident. The Italian community in my town was larger than any other minority. And though they were Catholic, they weren't Jewish or Moslem. Catholic was a known aberration. Selma was the only Jew in school. Thick black hair, huge grave eyes, face shaped like a mandala, she was invariably serious. We often ended up together receiving honors, A's, teacher's praise and students' envy. I longed to extract from her the admission that the story of the Nativity was beautiful even if it wasn't true. I didn't know if it was true but I knew it was beautiful and I loved it. I was afraid to ask her, afraid of insulting her. I did not know that while my culture disliked religious argument hers encouraged it.

Selma was a cherished only child but Faheem had brothers, sisters, cousins. They were part of a small Syrian colony, some of whom ran a bakery, sold good Syrian bread. I remember Faheem and his sister as not good in school; big, clumsy, slow. I think my mother too, feeling far from the place where she belonged, must have seemed, even become, clumsy and slow, out of her element.

On my street, on my block on all its sides, and on all the surrounding blocks; on the nearby beach where I spent nearly every summer day; in all my six years in elementary school, there were never any black people. Racism was something that went on in the South. . . .

At home my father talked against Jews, blacks, Italians and Catholics in general. He had his own internal chart: English Scots Scandinavians Germans Irish French Italians Jews/Syrians Blacks.

He never said these things publicly, nor did he act on them. He had the Yankee character of reticence, common sense, responsibility, moderation. He hated too much: too much religion, passion, expression. He often told me I gushed.

He never said these things publicly, nor did he act on them—to my knowledge. But he said them over and over. To my child's ear it seemed to have something to do with drinking and laughing loudly. Doing something immoderately.

My father was raised by his older sister Addie, who kept house for her widowed father and five siblings. They both expressed pride in their Yankee heritage, Addie by reading American history and claiming she and I had the right to join the DAR twice over since we had two ancestors who had fought in the American Revolution, and by keeping the family archives and drawing in branches on the family tree. All this was done in a matter-of-fact and orderly way; it was an ordinary housekeeping task, keeping the records straight.

What in Addie appeared almost a virtue, was in my father a condoning of evil. He approved of Hitler's policies towards Jews; he said Jews were niggers with their skin turned inside out. Was it some sort of game he was playing? A playing at toughness . . . ? Was he far unhappier than I ever knew, he who had been motherless and was now in every way that counted wifeless? What does it do to a big, lumbering, laboring man to lose a son to illness at fifteen and carry along a wife whose mind is misshapen with anger, whose will is incapable of any action but refusal?

On through the public school system I went, Selma and I competing for and alternating first-in-class and head-of-honor-roll. In high school we were dispersed a little, met others who did equally well. Ruth Eng was almost as smart as we were. Her family ran the one Chinese restaurant in town. Ruth waited tables after school. She made fun of everybody and criticized non-Chinese people freely. I could not understand why she was not embarrassed, where she got her high spirits, her sense of self. I wonder now if she laughed more than she wanted to.

There were still no black people. Until art school where I met Skeeter. 4F, rejected by the military, slim, brown-skinned, he was always dismissing himself with soft apologetic laughter. Nobody could possibly take offense at him. Nobody knew what he really thought. But Marilyn who was Jewish and intense told everyone how she felt. She was passionate about Leonard Bernstein, claimed to be highly sexed, got herself sent home from a school dance for wearing a skin-tight knit top. There didn't seem to be any softness in her. The rest of us were tentative in our sexuality, in what we said and what we did. But under our huge sloppy sweaters and pleated skirts we seethed and moistened.

Marilyn and Selma. We caricatured them. They didn't seem to us fully human, like us. They were outside because they were different and different because they were outside. Outside. Us. The rest of us. Were we really so close? Did we know each other, care about each other? Was I more "in," closer to some center, more secure, to the degree that I dissociated myself from Marilyn and Selma, emotionally, socially? Did I really want to know what Skeeter thought? . . .

Art school changed as returning GIs brought a new sense of reality into what had been essentially an all-female, protected environment. About to graduate as the war ended, we became aware of the dangers that lay outside. I dreamed I heard people crying in a foreign language; I wrote a poem about

Hitler and the camps, about madness and individual evil. I had no tools for analysis, but a need to know, a desperate need to understand. The dream prefigured my meeting R. in New York; the murder of his family by Fascists in the Lithuanian countryside—those, I felt, were the cries I heard. Here was someone—a Jew who had fought with the American army in Europe, anti-racist, socialist—who could teach me what I needed to know. I fell in love. Missing pieces were falling into place.

R. and I married and went to Paris to study painting. Paris in 1948 was in post-war turmoil. Art was dominated by Picasso, Léger, and Fougeron, around whom political and cultural controversies swirled. Picasso did a peace dove, Léger, construction workers full of optimism, and Fougeron, miners with broken bodies and missing limbs. Anti-Americanism ran high. A painter I met told me I was too sympathetic and humane to be an American.

It was the era of SHAEF and the Marshall Plan abroad and McCarthyism at home. Graffiti on pavements under our feet said AMERICANS GO HOME. We were actually afraid to return to our country. Abroad I felt patriotism for the first time. A sense of place. The desire to be with people I had grown up among, to hear my own language in the street, to have a fullness in my speech that comes only from stored-up images and remembered relationships. Paris was not beautiful to me until I had met someone on that street corner, had lunch in that café, and it developed a human history I could touch.

After three years we returned to newspaper photographs and television films of buses burning in Alabama and Civil Rights workers being hosed and beaten in southern towns and cities. The nonviolent nature of the struggle spoke to my New England upbringing. I lived out that drama daily and turned the media documentation into a series of paintings and collages I called *Freedom Riders*. . . . Nothing sold until later when . . . someone bought a little painting on which I had written edge-to-edge: WESHALLOVERCOMEWE-SHALLOVE / RCOMEWESHALLOVERCOME WESHAL / LOVERCOMEWE-SHALLOVERCOMEW. People who saw these works over my Anglo-Saxon name thought I must be black. John Canaday of the *New York Times* thought they were not violent enough. Others thought paintings and politics shouldn't be mixed. I almost despaired of being understood.

If I had been able to leave my five-day-a-week teaching job and my small son and go south, I would have painted different paintings. (Or perhaps not painted at all. How many paintings came out of that struggle, painted by people who were there?) Northern white that I was I romanticized distant battles. But I painted with a feeling of great excitement, risking my art in an attempt to move others as I had been moved. I would move out of the guilty past into a fighting present.

These collages, drawings, and paintings approached the social issue I cared most deeply about. The personal aspect was my father's racism and the racism I had breathed in growing up where and when I did. Since my father's ethnocentrism had many faces, I saw them as part of the same pattern in

spite of their differences and the extremity and singularity of black history in America.

In my private emotional journal through this swamp, I
> turned to a Jew and a radical and married him
> turned against my Yankee racist father
> publicly painted him as a bigot
> turned toward my Catholic mother
> celebrated her in poems and painted her as companion
>> to Rosa Luxemburg
> turned to Rosa Luxemburg, Jew, radical, as spiritual mother
> bore a half-Jewish son in Europe when the smoke from the
>> ovens was still in the air
> painted the Freedom Riders of the Civil Rights Movement
> painted myself in the place of Courbet/male
>> artist/leader/master surrounded by art world friends
>> and supporters
> painted contemporary women artists as they enter a new role
>> in the history of art

I think I've come to a place where it's necessary to say: No single oppression justifies the practice of or indifference to, or ignorance of, any other. No doubt there is need for different emphases at different moments and we each fight best our own particular victimization. But surely nobody believes any more we can take them in some sort of sequence, assigning values—whose pain hurts more, whose sense of rejection is more profound.

Strangely, my racist father taught me to hate racism just as his oppression of my silent, sick, lapsed Catholic mother taught that oppressions come in clusters. Somehow I must look at what he did and what he became in doing it, without throwing up on the wall of the cave another phantom that caricatures the world.

FROM "THE WHITE PAPER"
(1992, delivered as a talk at the Butler Institute of Art, Youngstown, Ohio)

. . . Underneath all that we see is white . . . nothing but white . . . blank . . . extending endlessly. Blankness. Without depth . . . or form. If we could rip the image of what we see, a white crack appears . . . that which is in back of, behind. White. White paper. As under a photograph . . . or the screen behind the movie of the world. Nothing is out there, but the image we see. All that we see is a layer, a coating . . . behind that, nothing . . . whiteness. When I described this perception to a group recently, one person said: death. But it's not death. Death presupposes life. Both death and life are part of the familiar drama of our days. Whiteness, blankness, is different. It is without drama, without inflection. It says all we have is what we see. There is no more.

Seeing is having. To see is to have, to own, to possess. The joy, the visual pleasure—a kind of scopophilia—a love of seeing (since that is the way we possess the world)—is all we have. I see you, means: I know you, I have you; you are part of my universe. If I close my eyes you are no longer there. You are vanished. You don't count anymore.

In Lorna Simpson's work the face and the body of the young black woman are denied to the viewer. She wears a shift. She has her back turned. Her eyes, most of her face, are blocked. The black woman—who was in U.S. history the most available sexual object of all—is here presented as unavailable and witness to, evidence of, her own misuse. Your desire to see her, to know her, are aroused and rejected.

Being in love with vision can lead to a kind of democracy (noneditorializing) toward what is seen, a passive receptivity toward the-thing-in-itself—and a satisfaction in reproducing it. On the other hand, a powerful preconception can lead to seeing only what you need to see. But an active, responsive, thinking sensibility asks questions of what is seen, makes some headway with it.

The tension between the seductiveness of vision and the seductiveness of art (in my case, painting) with the need to question sharpens perception, shifts sight lines, creates a multiple image. On one hand, I read meaning into the work I do as I make it or, more precisely, as it speaks to my evolving, coming-into consciousness focus on the situation before me. This is the mystery: when the painting works it is because the forms give off a meaning that feels right. When the forms *don't* work, I must find/invent a form that tells me it's the right one and then study it to read the meaning that emanates from it. And that is its meaning—even if it's not politically correct, or the one I would have articulated if asked for an opinion. . . .

The narrative of color/light in the air makes a shape that has its own rules to play. Through homology and analogy forms call up other forms, look-alikes fitting together in the same way, replicating similar force relationships (one shape squeezing into another or floating on top of another, etc). These bring memories, echoes, references, allusions to what is not there by name. This is true whether the forms are abstract, representational, or in between. . . .

When I work I go to the themes that move me most, where meaning lies for me: women, words, water, speech, silence, loss, time; the white paper is underneath. Invisible but fixing me in the place where I am, I see the vertical intersection of all the lives that went before, especially women's and all the other voiceless ones, as they cross the lives of those who live with me horizontally, in my time. I am connected in both directions: with Alice Stevens and Rosa Luxemburg, with the freedom riders of the civil rights movements, with American labor leader Lucy Parsons, with the vanished Selk'nam women, and with the 14-year-old Irish girl forbidden an abortion after being raped by a playmate's father, the 8 unnamed women molested by a U.S. Senator, the lawyer sexually harassed by a U.S. judge, the girls turning tricks on the streets of Detroit in the middle of a city devastated by unemployment, crime and corruption. I use their words and images because I am connected, I am a piece of

them, made of the same stuff.

So, in the ongoing multicultural debate my particular interest is in repre-
senting women, still scarcely heard (or believed) among the power brokers;
the artist, marginalized by greed, by the need for instant success in a con-
sumerist economy; and issues of class which is the name for so many basic
ills of our society: racism, homelessness, lack of health care, unemployment,
a failed educational system. Socialism may have failed but our capitalist
economy is beginning to look like a kind of feudalism: an upper class privi-
leged as no other group has been in the history of the world,—and a mass of
throwaway people: women, children, black men, people of color. And my own
students—who are mostly white and lower middle class—know no history, no
geography, no science, no literature, no politics, no poetry. They have lost or
are losing the ethnic traditions of their parents and grandparents. But they
have a great hunger for knowledge, a desire not to be shut out from the
world of ideas and understanding. But for them, learning is a luxury hard to
come by, and time to think an unthinkable demand.

Sometimes I wonder how much of my commitment to the working class I
come from, and to women, and to all the voiceless, I can afford to carry with
me. Does this commitment, this anger, warp my work, make it parochial? . . .

Many artists and writers are speaking out against the linear narrative,
against binary oppositions; speaking for a multi-layered experience, the
space between, the margins, the unresolved. In *Mysteries and Politics*, a 1978
painting in the San Francisco Museum of Modern Art, I was told I was work-
ing with irreconcilable opposites. In *Ordinary. Extraordinary* (1976-85), I jux-
taposed Rosa Luxemburg and Alice Stevens to find out what the working
class mother and the intellectual leader might mean to each other. The
works I do continue to speak to issues of art and society and give up nothing
to either but exist in the heat of those contradictions. I don't want to shred
the white paper. I want to make it burn.

❦

FROM *ORDINARY. EXTRAORDINARY* (ARTIST'S BOOK, 1980)

Ordinary. Extraordinary. A collage of words and images of Rosa
Luxemburg, Polish/German revolutionary leader and theoretician, murder
victim (1871-1919), juxtaposed with images and words of Alice Stevens (born
1895) housewife, mother, washer and ironer, inmate of hospitals and nursing
homes. A filmic sequence of darks and lights moving through close-up to
long-view and back. Oblique. Direct. Fragments of Rosa's thought from inti-
mate notes sent from prison to her comrade and lover, Leo Jogiches, and to
her friends; from agit-prop published in *Die Rote Fähne*; and from her serious
scientific writings. Images from her girlhood, her middle life, and the final
photograph of her murdered head. Alice's words from the memory of and let-
ters to her daughter. An artist's book examining and documenting the mark
of a political woman and marking the life of a woman whose life would oth-

erwise be unmarked. Ordinary. Extraordinary.

THE WORDS OF ALICE STEVENS

She lived in a 4-room house on a working class street for 20 years. Over the years she spoke less and less. She drew in; lost year by year the habit of speaking. She smiled. She nodded. I could make her laugh, or blush. Sometimes she held me, rocked me. But she had no words to give. What she wanted to say became too big to be sayable, and the habit of not speaking too fixed. Or, as she said, much later: too big to put your tongue around.

Some days the restraints broke, and words came. Words about cars that drove by in the night, but she knew who they were. Words about voices that came over the radio, but she was not fooled, she knew who they were. Words about turning pictures to the wall: it wasn't safe to look at them.

She never asked why do I ride in the back of the car with the children while another woman rides up front with my husband? She never asked why is a mother never a wife never a lover? She never asked why does my husband call me Bertha when my name is Alice?

They put her away in a place for people who can't speak, or speak in tongues. After many years she stopped being angry. Then she was calm, distracted, utterly amiable, But her foot moved constantly, involuntarily. And she had gained the ability to speak, but lost a life to speak of. . . .

SELECTED POETRY

"LETTERS FROM HOME"

MY FATHER TIED PACKAGES WITH WHITE WAXED STRING IN A SMALL TIGHT NET KNOTTED AT EVERY INTERSECTION SO THAT YOU WERE SURPRISED WHEN BEING CUT OPEN THE STRING CASE DID NOT STAND ALONE. THEY BORE ME PRESENTS THOSE BOXES CAUGHT IN STRING CANNED GOODS TO PARIS FEAST FOR POOR STUDENTS ELECTRIC BLANKETS WITH ENERGY GONE PILLED WOOL PENCILS SAYING BETHLEHEM STEEL COTTON DUCK STOLEN FROM HIS PLACE OF
WORK
FOR ME TO PAINT ON BOXES OF JELLO CONDENSED MILK. AND ONCE HE ARRIVED IN QUEENS IN THE DEAD OF NIGHT WITH AN OLD
WASHING
MACHINE WITH WRINGER ON TOP. HE HAD A NEW ONE.

WHEN I ARRIVED IN A NEW PLACE THERE WAS A LETTER WAITING

ARRIVED TWO DAYS BEFORE. DEAR MAY THE WEATHER IS COOL
RAINY. WENT TO LODGE LAST NIGHT DAMN CAT WON'T LET ME
WRITE WHAT DO YOU WANT FOR XMAS LET ME KNOW HAD A
 COOKOUT
ON THE FOURTH ADDIE CAME AND MAUDE AND BERT CORN
 HOT DOGS
WATERMELON THEN THEY WENT SWIMMING FOR CRISSAKES
 WHY DON'T
YOU CURL YOUR HAIR LOOK LIKE SOMETHING YOU LOOK LIKE
 SOMETHING
THE CAT DRAGGED IN WHY DO YOU WEAR BLACK ALL THE
 TIME WHAT
ARE YOU A WOP YOU KNOW YOU CAN BECOME AN AMERICAN BUT
 YOU HAVE
TO BE BORN A YANKEE YOU ONLY LIVE ONCE. YOU'RE DEAD A
LONG TIME CHEER UP LOVE RALPH

DEAR DADDY THIS IS A LETTER I SEND TO YOU WHERE YOU ARE NOW
DEAD A LONG TIME SINCE AUGUST AND NO LETTERS COME.

"Everybody Knows Me"

I
When I come after six months a year she waves
Moving from chair to bed to table she opens the
door to the field waits to receive words of praise
and affection The days of no figure crossing the
field have moved to this moment We are together
We drive off She has nothing to say She is humming
II
We are two women under a rod of light
The glasses have paper bags over them and
the toilet is sealed The mirror shows
we are old, one older than the other and
related by years of words and postcards There are no
other ways but these

We meet in this or another room We eat
We sleep We talk a little We spend
two days And then you ask is it you
who calls on the phone with the same name?

We slide the glass doors open Freshness

floods the room We pull two chairs to
face the rain and sit wrapped in a great
blanket
III
In the night she wakes and wanders
about the room One hand held up
the other fends the unknown shapes
What is this place? I find her glasses
light the lamp identify myself
Is that where you sleep? I take her
to my bed and lie one arm across
her body as I did forty years ago
telling her that I will never leave
her lying as I do now that I can
take her pain away rub out the fear
for more than a few unmoored
hours before I take her back
IV
Into the earphone flustered Good morning Good morning
and a pause to right the phone I am deeply consoled
by the life in her voice We discuss arthritis
and ointments I profess my love do rituals of
ending to hang the phone on The phone clicks
before my final variation But I think when she
walks back to her chair by the kitchen door next to the TV
when she hangs her cane on the chair post and sits down
In her usual place heads are still turned and she sits in
a buzz of contentment

The postcard says: Everybody knows me

"You Can Go"

I hug you close Take care of your ribs
Keep your arms in their hollows Don't talk
The milk that is spilled
 in the well of your neck
I will write white words with it
 if you'll be still
Unfold me layers of your skin
that let out a limb Make a pact with
brittle or pliant Under the blanket
ends of the ribs north of the saddle bone

up on the blanket sponge of your veins
chips of your fingers float like a shell
 sea's tissue to sea's stone
 End formally

Hold up your head on its hawkcords
Hood with your eyes the dark you see
ahead of me Scratch your nose a little bit
Tuck in your mouth over the drowsy gullet
Suck in the places your skin falls to dream
 under the jutting bone
 There is great beauty

Drink milk
 Color comes to the lips
 You thrum when I hug you and squeeze you
 as if you were my newborn daughter
Brush with your hand
the back of my hand
with faint desire

Don't eat Turn your head to the wall
Nothing has flavor: cold paste on a sharp-
edged spoon Not for you No You've decided
Serenely you smile In control of your life
You're safe deep inside Curl up in your cot
strapped to its sides Nothing can happen
You are washed changed pulled from slumber
 for riddles you have no time for
Close down your eyes Soon I'll be gone
Clamp shut your ears and jaw Find your way
 to the smallest light
Enter so softly
 It's not an event
 I won't even know

❦

"YOU'RE ALMOST 90"

You're almost 90 I say
She laughs
That's pretty old I say
Does it hurt I say How does it feel to be old?

What is it like? She searches patient with me
It's the way it is
She says and I know how
Simplicity and wisdom are the same
 the circle coming back on itself
Neruda: *The blood of the children in the streets is like
 the blood of the children in the streets.*

My life is not like it is unlike why pretend?
There are no mistakes only choices I want to get
to the bottom of things: How can I care about things
 when he took our life?
For he made fish hide and crabs scuttle the sun
shine on his skin seals laugh puppy dogs roll over
his father and I gasp at the splashing brightness
 of his arrogant life
The blood of my child is mixed with earth
 his ash on water; the things he liked
 go on past his liking
 How can they do that?

"Stopping the Flow"

It's simple I am my baby's swaddling
lifelines torn and dangling My breast hangs
to the bed snuffles among folds blind
dependent pokes towards its sheath your mouth

Your stone gums suck my titty gone hard
caked the milk waits dries
no trickle only the dry crack
In the heart of things Your dry mouth
my dry nipple a match a pair
a simple fit There's nothing to it When your mouth
was succulent and primed me all day long
I thought we would never come apart

I carry you now in my head
connected to all my systems
as once you swung in the womb
I rock you there in my brain
foaming in fluids, sloshed in nutrient dreams
I feel you kicking The membrane thins

It opens You spill out I weep you

> The womb is a limb
> It's a handle, a prop
> a tool that speaks It feels
> the fat pads on your small hands
> the place on your shoulder my head could reach
> your eyes, my eyes returned to me
> The womb is a limb, a handle, a prop
> a tool that speaks Mine listens:
> it hears your bright hallooo

"EXISTENTIAL POEM"

1. There was a child who loved her own breathing
Climbed each wave Teetered on top
Eyes lit Toes extended Hands holding on
Transfixed in terror Small as she was
Not believing The breath that was
Already leaving Was hers
To keep

2. She killed herself out of curiosity
She killed herself for joy
Por el gozo
Matate, linda

3. She wakes from her dream His body blocks the bedlamp
—what is it that you want, really?
She picks up the rips of her dream Slips it over her head
Wriggles it down where she left it Smooths the torn pieces
Slowly

4. *Now I lay me down to sleep*
I pray the Lord my soul to keep
If I should die before I wake
I pray the Lord my soul to take

5. She wanted to see her friends
The ones she had loved and the ones
She hadn't met. She wanted to tell them
About the joy

6.—What do you feel when I take you,
Do what I want with you?

7. She remembers the leaping moons, the constellations
Dropped behind the hill; moments of joining,
Clear passage; the feeling of not knowing
What she needed to know; how the feeling
Of knowing came at last, like moisture.

 The gap closes between breath and breath

"Standing in a River"

Light plays. The water deceives. The air's alive.
I watch the cottonwoods uprooted by the river's light,
My squat legs end in dead white feet.
I think how the river knows me but needs to be
met slowly. Each moment fixed in the body's custom
calls up another river, salt,—odorous ponds, crashing
sounds,—stood in, then swum, forgotten, the feel of.
My legs are yellow and flat as flippers.
I examine being. Time stands on its head. I live a long time
here now going in, know all. I hear the still hum.
Out of my body just where the river meets the crotch
and water laps the air two smoke colored ribbons
uncurl and rusty and protein-rich my monthly blood
feeds fishes as tiny minnows rise to the scent.
Clearly I am meant to be here.

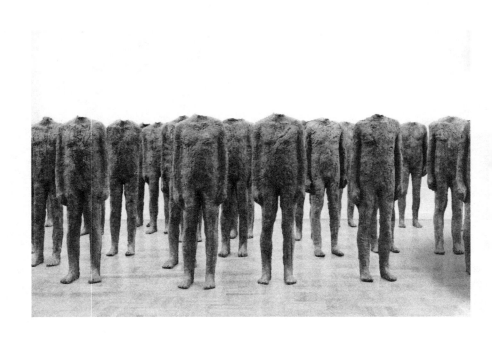

Crowd I, 1986-87. Burlap, resin; group of 50 standing figures, each 170 cm.
Photo: Artur Starewicz

MAGDALENA ABAKANOWICZ

B. 1930

HER CHILDHOOD interrupted by the destruction and brutality of the Second World War, Magdalena Abakanowicz is a survivor whose art speaks to both trauma and the possibility for redemption. A sculptor who has worked in diverse media—fabric, wood, and bronze—and on both large and small scales, Abakanowicz's art and her artistic development have not been conventional. Originally trained as a painter, she received her first acclaim as a weaver, although she subsequently pushed beyond the boundaries of that designation. Whatever their medium, Abakanowicz's works intensely express the ambivalence of the human condition, particularly as experienced in the late twentieth century. Abakanowicz is also a prolific writer, articulate about herself and her art. She has described how, as a child on her family's country estate in Poland, she sought refuge in the elements of the natural world abundant in the surrounding environment. Although she has emphasized that she does not "look for inspiration" in nature, it is clear that her internalized sensitivity to its rhythm, touch, and particularly to its processes of growth and decay, has informed her work through the years.

Born in Falenty, Poland, Abakanowicz spent her childhood at her family's estate, about 200 miles to the east. Both her parents came from the landed gentry: her father, who had fled to Poland from Russia during the Communist

Revolution, was a descendent of Genghis Khan. The second of two daughters, Abakanowicz recounts that she experienced a certain remoteness from her mother, which she later attributed to her mother's disappointment that she was not a boy. Abakanowicz experienced a lonely and isolated childhood, in close contact with the natural world to which she turned for solace. For her, nature was further animated with a magical dimension through the folklore transmitted by her family's servants, to whom she was strongly attached. In her autobiographical *Portrait x 20*, she paints an evocative picture of the intensity with which she explored and experienced the grass, water, rocks, and trees of the surrounding countryside.

Her life was radically transformed by the onslaught of World War II, beginning in 1939, when German tanks entered the premises of her family's estate. From then on, the house "exposed" the family and Abakanowicz gave up her forays into the forest, which was no longer safe. She has vividly described how, in 1943, drunken soldiers broke into the house and, before her eyes, shot off her mother's arm. By 1944, fleeing the advance of the Soviet army, the family abandoned their possessions and ended up in Warsaw (after having been separated for two months), where they were fearful of revealing their aristocratic origins. As a teenager during the war, Abakanowicz worked in a makeshift hospital caring for the wounded and, finally, completed her high school education.

Between 1950 and 1954, Abakanowicz attended the Academy of Fine Arts in Warsaw. The Stalinist regime prescribed a repressive course of study and strict adherence to Social Realism. Abakanowicz wanted to be a sculptor because she had "always molded massive heads, carved animals in bark, and produced dolls of sticks," but she failed her admissions examination in that medium. In order to be accepted, she studied painting instead, continuously chafing against the restrictive atmosphere of the academy. After graduation she "began to satisfy [her] desires hidden for years," by painting a series of huge abstracted insects and plants. To implement these works, her "rain forest," she returned to the academy during the evening hours (having no work space of her own) and executed them on bed sheets that she had stitched together, the only available large painting surface. In 1956 she married Jan Kosmowski, a civil engineer who now manages her career. She had her first one-artist exhibit in 1960.

The direction of Abakanowicz's career took a major turn in the early sixties when she began to work with fiber. The catalyst for this change occurred in 1962, when her work was seen and appreciated by the professional weaver Maria Laskiewicz, who placed Abakanowicz's name on the list of candidates for the First International Biennale of Tapestry in Lausanne. Laskiewicz's work was rejected while Abakanowicz's was accepted, but Laskiewicz offered to help Abakanowicz (who admits to knowing nothing about weaving at the time) execute her piece. For the next seven years Abakanowicz worked in the "experimental studio of the Polish Artists' Association," a euphemism for Laskiewicz's "damp basement." At this time she was part of an international movement of weavers, who wanted to close the separation between the

painters who designed tapestries and the weavers who executed them. The Polish artists, in particular, sought a "new expression" in which fiber could participate in the aesthetic of "contemporary conceptualist sculpture and painting." Abakanowicz says that for her, working with fiber was initially a struggle with both the materials and the discipline. Only after a time did she realize that she could "build a three-dimensional reality: soft, full of secrets," one in which "the secrets of the rope resemble the secrets of the flower stems" in her earlier rain forest paintings.

It was during this time while she was experimenting with weaving rope, hemp, and thick wool, that she created her first real breakthrough, the series of hangings called *Abakans*. The *Abakan* pieces were monumental works, woven of coarse materials such as sisal, hemp, and horsehair; they were huge, suspended from the ceiling or standing on the floor rather than hanging tidily on the wall. Resembling sculpture more than traditional tapestries, they invited the viewer to enter their mysterious cavities, with an unmistakable corporeal, and in some instances vaginal, correspondence. Abakanowicz herself has spoken of their bodily (and feminine) analogy: "I knew I would feel safe in such a form, safe like in the belly of one's mother." Her installation of *Abakans* won her the gold medal at the São Paulo Bienal in 1965, and launched her international reputation. That same year she was appointed professor at the Academy of Fine Arts in Poznan, Poland, a position that she held until 1990.

Over the next fifteen years, following the direction of the *Abakans*, her work moved farther and farther away from weaving, and ultimately from an exclusive use of fiber. As she later said, "I use [all] media in which I feel I can express myself." In the years immediately following her success at São Paulo, Abakanowicz continued to produce *Abakans*, while expanding into a series of *Black Garments*, huge, hairy, humanoid shapes that reached from ceiling to floor. In the mid-seventies, as part of an extensive series called *Alterations*, Abakanowicz began to make large cycles of figurative and non-figurative sculptures from burlap. The use of a ready-made fabric, rather than one of her own creation, marks an important shift in the direction of Abakanowicz's work, and in her artistic identity, from craftsperson to avant-garde *artiste*. However, her hand is quite visible in these works, for which she customized both the thread and material. *Alterations* comprised several different cycles of sculptures, all in some way evocative of the human body via the innovative use of fibrous materials. The first, *Heads* (1973-75), are three-foot ovoid shapes in which a tightly stretched outer layer sometimes contains and at other time yields to a bulgy stuffing that bursts through the seams, revealing what Abakanowicz has described as "the effects of artificial environment and unlimited stress." In their shape and relationship of exterior to interior, skin to guts, they are precursors of several later series—such as *Embryology* (1978-81), eight hundred pods made from stuffed gauze, that the artist describes as being "like stones, like a kind of gray fruit, or big seeds or brains," or the *Geminati*, made a decade later.

In 1974 Abakanowicz began to use a technique to which she returned

throughout the next two decades, in which she formed figures by dipping burlap and string into resin which she then pressed into a plaster mold, sometimes a cast taken from the body of a friend. *Seated Figures* (1974-79) and *Backs* (1976-82) were the first series to use this procedure. The two series are similar in that they each depend on the same three elements for their dramatic impact: the human figure is truncated, the figures are hollow, and they are repetitious—there are eighteen *Seated Figures* and eighty *Backs*. All three elements, but especially the extent of the series, evoke the chilling effects of the dehumanization of life in the late twentieth century. In each case the same shape is repeated many times, but given an individualized texture and surface through the unique handling of materials. Various installations, of *Crowds* and numerous images of standing and seated (sometimes caged) figures made in the 1980s and 1990s, employ this same technique and yield a similar impression.

In response to several commissions that she received for permanent installations, in the 1980s Abakanowicz began to use materials that were more durable than fiber. The first such work was *Katarsis*, commissioned by the Giuliano Gori collection for an outdoor sculpture garden in Tuscany. She made thirty-three cast bronze figures, each eight-and-one-half feet tall and hollow like her burlap figures. They are characterized by expressively pock-marked surfaces that seem to reflect the ancient, gnarled, seemingly barren olive trees that abound in the surrounding landscape. Her sculpture for the Israel Museum in Jerusalem, *Negev* (1987), consists of seven large yellowish disks, carved from stone found in the desert, each measuring eight-and-one-half feet in diameter and weighing ten tons. Abakanowicz has related the symbolism of these wheels to ancient rituals of making water and wine. The concept of creating ritualistic, sacred space characterizes one impulse underpinning all her outdoor works. The idea of activating, even sanctifying, the environment through her work has always been meaningful to Abakanowicz. She has described how it is important to oversee the installation of her sculptures, and how she creates her "own reality of space" and "special places where 'one has to take off one's sandals for meditation.' " Like Joseph Beuys (also from central Europe and whom she cites as one of the few artists whom she admires), Abakanowicz believes that the artist is a shaman who can confront and heal cultural wounds. As a child, she responded to nature in a magical way. She believes that art, too, must have a "bewitching power" and be "charged with energy," a characteristic that attracted her to the tribal art of New Guinea, where she lived for awhile. The title *Katarsis* refers in part to her conception of art as "catharsis, and a means to link man with powerful and mysterious forces."

In her next major series, *War Games* (1987-93), Abakanowicz worked in a different medium, recycling the huge trunks of felled trees from the deep forest, trees that were logged and then abandoned because their shapes were too irregular to turn into lumber. Although these sculptures seem to represent a departure from her earlier works in both medium and subject, in fact, they

have an intrinsic place in her overall vision. Like the *Abakan* pieces, they are extremely large and they activate the space in which they are placed. Less literally referential to the human body than some earlier works, they hover between figurative and abstract, their trunks and branches evoking amputated pieces of the human form. The burlap dipped in resin that reads as "bandages" and the "caps" of metal that cover their extremities insinuate a sense of the fragmented body, one of Abakanowicz's most frequently used motifs. While they are suggestive of the wounded corpus, they also seem to mutate into the very implements through which destruction is wrought. Each one is a ludicrous, yet menacing, war machine, its blades and wheels remarkably reminiscent of the mutating contraptions in Hieronymous Bosch's depiction of Hell. The themes of war, destruction, and amputation persist throughout Abakanowicz's working life.

Abakanowicz's works in all media are characterized by compelling corporeal references, regardless of the extent to which they are figurative or abstract (and she has disclaimed thinking in those oppositional terms). One reason for the *Abakans'* dramatic impact was their visceral quality and the extent to which they evoked skin, hair, folds, and fissures with an erotic tactility. On the other hand, for some viewers they were the body turned inside out. Although of a markedly different material and effect, the *War Games* images also suggest twisting and pulsating muscles and ligaments. All her works seem to depend on a tension between a layer of skin—the outer covering—and the viscera—the vessels, muscles, guts, and inner substance that is both revealed and concealed by the outer surface. One of the distinguishing variations among figures in all her burlap casts is found in the wrinkles of the skin, and the degree to which they imply underlying backbone, musculature, veins.

Abakanowicz's figures are mostly androgynous, their primary and secondary sexual characteristics de-emphasized. Thus, although we know that the model for *Seated Figures* was male, we concentrate on the humanity of the figures, rather than on their masculinity. Her more abstract, germinating forms are also characterized by a certain gender ambiguity. While it is clear that works such as *Embryology*, *Pregnancy*, and *Geminati* refer to fertility and growth and have an egglike, and even womblike, quality, they also are provocatively phallic, much like many of Louise Bourgeois's works that simultaneously evoke breasts and penises.

The fragmentary state of many of Abakanowicz's works is especially significant; because they are not descriptively complete, they depend on expressive shape to communicate. Before making her *Alterations* series, Abakanowicz experimented with covering mannequins with burlap dyed black, but soon abandoned this idea as too "elegant" because it oversimplified the human body's complexity. The series title *Alterations* implies a state of change and process that relates Abakanowicz's work to that of several younger artists such as sculptor Kiki Smith, whose images deconstruct the human body as an example of perfection and harmony, the "measure of all things," and focus instead on the tragedy of the body, the sad truth that human beings are

all "made of meat." In her writings Abakanowicz expands upon the theme of a living creature's sudden exposure, of its vulnerability: a rabbit, a frog, her own mother.

In her depiction of the body, the profound effect of surviving a war and living in a totalitarian state can be seen clearly. The repeated amputations express brutality and a sense of human expendability. Abakanowicz's understanding of the vulnerability of the human body, that it can be intact one minute, the connection between skin and vessels maintained, and a jagged, bloody mess the next, reflects her experiences of carnage during the war, especially by her witnessing her mother's arm being shot off. Her use of multiple figures, as in the *Crowd* series, effectively conveys the loss of individuality and the cheapening of individual life under a totalitarian regime or within a concentration camp. It could also be a metaphor for the loss of self in mass society where the individual will is so often without effect, where the individual is lost in the lonely crowd.

Yet Abakanowicz's vision, while stark and intense, is not wholly negative. Like the shaman in more ancient societies, she offers contemplative images for their cathartic effects. The pods are germinating, burgeoning with life. Likewise, the backs, while hunched over in submission, also suggest seed pods, waiting to explode. The bronzes in *Katarsis*, like the olive trees nearby, might look dead but they bear fruit. And the abandoned tree trunks in *War Games* have been born again as sculptures, their innards teeming with life, their shapes suggestive of mutating forms. Abakanowicz feels a visceral identification with nature's continual cycles that always make birth possible. In her art as well, her fecund imagination continuously renews itself.

SOURCES

Abakanowicz, Magdalena. "Portrait x 20." In *Abakanowicz*, edited by Jasia Reichardt and Magdalena Abakanowicz. Chicago: Museum of Contemporary Art and New York: Abbeville Press, 1982.

Brenson, Michael. *Magdalena Abakanowicz: War Games*. Exhibition catalogue. New York: Institute of Contemporary Art, P.S. 1 Museum, 1993.

_____. "Survivor Art," *New York Times Magazine*, 29 November 1992, pp. 47-54.

Dreishpoon, Douglas. "Monumental Intimacy: An Interview with Magdalena Abakanowicz." *Arts Magazine* 65 (December 1990), pp. 45-49.

Jacob, Mary Jane. *Magdalena Abakanowicz*. Chicago: Richard Gray Gallery, 1990.

Milosky, Leslie. "Art Essay: Magdalena Abakanowicz." *Feminist Studies* 13 (Summer 1987), pp. 363-78.

Princenthal, Nancy. "Abakanowicz: Memories and Monuments (Marlborough Gallery, New York Exhibit)." *Art in America* 78 (March 1990), pp. 178-83.

MAGDALENA ABAKANOWICZ—SELECTED WRITINGS

UNTITLED COMMENTARIES

ON HER METHOD OF CREATING, 1969

I like neither rules nor prescriptions, these enemies of imagination. I make use of the technique of weaving by adapting it to my own ideas. My art has always been a protest against what I have met with in weaving. I started to use rope, horsehair, metal, and fur because I needed these materials to give my vision expression and I did not care that they were not part of the tradition in this field. Moreover, tapestry, with its decorative function, has never interested me. I simply became extremely concerned with all that could be done through weaving. How one forms the surface reliefs, how the mobile markings of the horsehair will be put into place and, finally, how this constructed surface can swell and burst, showing a glimpse of mysterious depths through the cracks.

In 1966 I completed my first woven forms that are independent of the walls and exist in space. In creating them I did not want to relate to either tapestry or sculpture. Ultimately it is the total obliteration of the utilitarian function of tapestry that fascinates me. My particular aim is to create possibilities for complete communion with an object whose structure is complex and soft. Through cracks and openings I try to get the viewer to penetrate into the deepest reaches of the composition. I am interested in the scale of tensions that intervene between the woven form, rich and fleshy, and the surroundings.

I feel successful each time I reject my own experience. There are all too many fascinating problems to confine oneself to a single one. Repetition is contrary to the laws of the intellect in its progress onward, contrary to imagination.

ON IMAGINATION, 1974

In the unconscious of contemporary man, mythology is still buoyant. It belongs to a higher spiritual plane than his conscious life. The most superficial being is crowded with symbols and the most logical person lives through images. Symbols never disappear from the field of reality; they can change their guise, but their role remains unchanged.

Music or smell, a thoughtful pause, a casual word, a landscape, can release nostalgic images and dreams. They always express much more than the person who experiences them can in turn convey in words.

Most people do not know how to verbalize such mental experiences, not from lack of intelligence, but because they cannot give sufficient weight to analytical language. It seems to me that these images can bring people closer more effectively and in a more fundamental way than analytical language.

Contemporary man may make light of these mental images, which does not alter the fact that he lives with them and through them. They are a real and undeniable part of human nature—they constitute the imagination.

To have imagination and to be aware of it is to benefit from possessing an inner richness and a spontaneous and endless flood of images. It means to see the world in its entirety, since the point of the images is to show all that which escapes conceptualization.

ON FIBER, 1978

I see fiber as the basic element constructing the
organic world on our planet,
as the greatest mystery of our environment.
It is from fiber that all living organisms are built—
the tissues of plants, and ourselves.
Our nerves, our genetic code,
the canals of our veins, our muscles.

We are fibrous structures.
Our heart is surrounded by the coronary plexus,
the plexus of most vital threads.

Handling fiber, we handle mystery.
A dry leaf has a network reminiscent of a dry
mummy.

What can become of fiber guided by the artist's
hand and by his intuition?

What is fabric?
We weave it, sew it, we shape it into forms.
When the biology of our body breaks down,
the skin has to be cut so as to give access to the
inside,
later it has to be sewn, like fabric.

Fabric is our covering and our attire. Made with our
hands, it is a record of our souls.

On Mark-Making, 1981

I did not yet know how to write. I drew in the earth with a stick. The marks were deeply etched. Then the rain erased them until they disappeared.

I loved to look at the lines scratched in the clay as they dried in the sun, splitting into cracks with irregular edges. The sand closed behind the finger as it drew—fine, quick—until only a wrinkle remained on the surface.

I no longer remember when I received my first paper. I drew kneeling on the floor. The lines escaped from the sheet, running along the floorboards, losing themselves in the shadows of the furniture. The drawing could be charged with secret power.

The village women inscribed on their doors signs and letters with consecrated chalk or charcoal. This warded off evil. I wished to know the spells but they were inaccessible to me. Only their presence could divide places into those which were safe and those open to all sorts of forces.

Now, when I draw, areas of those unguarded spaces appear on the sheet.

FROM "PORTRAIT X 20," 1978–80

Introduction

When I learned to use things, a pocketknife became my inseparable companion. Bark and twigs were full of mysteries; and later so was clay. I molded objects whose meaning was known only to me. They fulfilled functions in performances and rituals which I created for myself alone.

I was born in the country and spent my childhood there. I had no companions of my own age. I had to fill the enormously long and empty days, alone, minutely exploring everything in the environment. Learning about all that was alive—watching, touching, and discovering—was accomplished in solitude. Time was capacious, roomy: leaves grew slowly, and slowly changed their shape and color. Everything was immensely important. All was at one with me.

The country was full of strange powers. Apparitions and inexplicable forces had their laws and spaces. I remember *Południce* [female ghosts who were said to appear on hot days at noon] and *Żytnie Baby* [rye hags]. Whether I had ever seen them, I cannot say; in the hamlet, peasant women talked about them. There were also some who knew how to bring about illness or induce elflock.

At home, these superstitions were not treated seriously. Yet they existed as an important part of my surroundings.

Imagination collected all that was impenetrable and uncertain, hoarding secrets that expanded into worlds. In anticipation, perhaps, that this font of truths accumulated without control, direction, or pattern would one day be of great use.

BEFORE

At the very beginning, women took care of me. There were several of them. They carried me in their arms, bathed, and fed me. I remember their cheerful faces. They played with me as a baby, and later, as an infant still unable to stand properly and uttering those first words incomprehensible even to myself. I knew that the women were there, would always be there, and that their merry and happy world was my place. But I also knew, and this was painful, that none of them was my mother.

Mother appeared rarely. She was beautiful. Tall with long hair piled up at the back of her head. Fragrant. She brought unease to my entire world: the women grew silent, I became timid, almost frightened. I wanted to please her, to deserve her attention.

Some years later, I learned and came to understand: she had passionately wanted a son. My birth was a terrible disappointment to her.

ENCOUNTER

Between the ponds and the pine grove was a fallow field. Sandy, white, overgrown with clumps of dry, stiff grass. It looked strange. The tips of each clump converged, forming a kind of tent. The whole wide area looked as if it were covered by minute bristling cones. No one ever changed anything there. Everyone knew it should be left alone. "They" live in the grass, it was said.

Only once did I see . . .

While prodding a clump of grass with my hands, he ran out. A tiny man, perhaps a little bigger than an acorn.

The sun was hot. It was time to go home. The bell was ringing for lunch.

SECRETS

That Place was in the very corner of a dark hall where, on the wall, there was a painted knight in armor with four horses. When silence and tranquility evoked an atmosphere of safety, I would bring over my objects, carefully selected among the grasses and the scrub. They wanted this from me. Slowly

they came to life. Slowly they began to communicate with one another, and with me. They were moving independently, approaching one another, approaching me, retreating, again and again. This took time. It grew slowly, then faster, until it turned into a dance. I was inside it, taken over by the movement and the changing image. Obedient to the rhythm, united with them. Overcome by anticipation of what might happen with these living stones and branches.

A large tree by the road was split lengthwise—black inside, burnt. By lightning, maybe. The interior was as strange as any darkness in which anything could happen. I was afraid to stand by the trunk. I felt that from some crevice something might creep out that I dare not name. A transparent, large *Południca* was shimmering in the sun, in that terribly hot air in which it seems impossible to breathe. One could think about her, imagine her, but one must not look. With the whole body one felt the danger of being in the open fields at high noon. Something would happen above the earth in which we cannot take part and which we dare not disturb.

In the evening, women knelt in the road before the Holy Virgin that hung on a poplar tree not far from the gate. They sang litanies. On the eve of feast days they plaited long wreaths of oak leaves and spruce twigs. They adorned with them the whole poplar tree and on the picture of the Virgin they stuck flowers and ribbons of colored tissue paper.

CHRISTMAS TREE

Growing, I was conscious of being a failure. I felt it. I knew it. In prayers, loudly repeating the words kneeling at the side of the bed, I was silently saying: make me become a boy.

Long before Christmas, the first gingerbread cookies were baked. Highly spiced, they had to be stored in a cool larder for weeks. Mother asked: What do you want from Santa Claus? Embarrassed, cornered, I whispered into her ear: I want him to make me a boy.

On Christmas Eve, excited, desperately worried, confused, I looked through the window as he was arriving. The light of a lantern could be seen approaching from the forest. Tall man with a white beard—Santa Claus. He entered brushing the snow off his boots, enormous, in a long coat with a hood. The kitchen maids giggled. I shook, unable to utter a word.

He brought toys, beautiful, unexpected. Then disappeared.

Father was never present then. He arrived later. He sat with us at the table.

EDUCATION

When I was six, I was given a teacher. A stranger. I was used to seeing strangers only from a distance. They made me uneasy.

He asked many questions. I was so frightened that I hardly replied at all, and the little I said did not make sense.

He told me to draw a sunset. I could not do this either. Mother asked him what he thought; he shrugged his shoulders.

After some time, a woman teacher appeared in the house and stayed. Everything she disclosed to me was alien and hostile. It refused to become a habit.

Like my prayers, I repeated formulas and facts, distasteful and daunting. I cried. I was so nervous when answering questions, that everything became confused. I wept, helpless in my own inadequacy, conscious of my shortcomings. I went to see mother. She consoled me: you will not have to take any exams or go to university.

I escaped outside.

With a long pole, I pushed a wooden canoe into the reeds. Without a thought I became one with the murmurs of the time of day and with this whole world of movement and stillness, growth and decay. There I belonged. With concentration, for hours I looked at the grass and the water. I wanted to subordinate myself to them, so that I might understand the mysteries which separated me from them.

NECESSITY

The urge to have around me, to touch, to hoard—twigs, stones, shards, bark—continued. They embodied stories with which I wanted to live. Later, I carved out faces with a knife. I wanted them to resemble people. They did not. I watched mud settle after treading in it with a bare foot, rising between my toes, greasy, soft. I squeezed clay—too obedient in the face of my lack of decision. Near the avenue of chestnuts, by the pond, in a yellow pit, there was a lot of it. I stood there, checking my desire: I was not allowed to get dirty, yet I needed to fill my hands with it. The heads I molded dried, cracked, and disintegrated. Father once brought me from town some plasticine. I molded faces, placing one next to another. All were in profile. But no one liked them—profiles did not look like this. I continued to mold and to carve although sometimes everything had to be thrown away when the nursery was being cleaned. I went to the rubbish heap to look for what could be retrieved. Began anew.

WAR

I was nine. It was autumn. On the very edge of the park, a road led from the mill to the avenue of alders. German tanks were coming. We stood on the terrace, taken by surprise, watching. They were looking at us, standing as if on parade. I saw them for the first time, faces, uniforms.

I did not know how to hate. I did not believe it. I could not understand why they should hate the four of us on the terrace.

They fired, aiming, probably on purpose, at a wall.

I stood fearless, suddenly humiliated by their violence, helpless in the face of injustice and the impotence of my parents.

Some years later, father taught me to shoot. To clean and assemble weapons.

At night, partisans would come. Poles, Russians, very often the same people known to us and friendly. Later, more and more frequently, just robbers. Germans by day. The house exposed us, it ceased to be a shelter. The forest also became alien. I no longer went there to talk to it as before.

KILLING

I remember, once upon a time. I was then still tiny. I sat near mother on the steps of the terrace. She was playing with my sister and I wanted to join in, clumsily, jealously interfering. Pushing me away, mother said mockingly: "I bought you from a Jew." I felt as if my insides had turned to stone, suddenly without the certainty of my situation, a stranger to myself, filled with the panic of doubt.

Moshe had a small shop in the village. His wife wore a yellowish wig. He delivered groceries to our house and bought things from us. He looked timidly around, bowed many times, his cap held awkwardly in both hands. In the autumn, he leased part of our orchard. With his son he lived in a makeshift shed. The boy had black curly hair, a flat nose. I was allowed neither to play with him, nor with other children who, wild and dirty, might carry lice. I longed for friendship but achieved it only in daydreams. I imagined myself, with excitement and clarity, walking with somebody across an immense plain, understood, sharing confidences.

It was several years later, on the day when it was already known that the Germans were going to deport all the Jews to their death, I was with father in the village. Almost stunned, I did not listen to what Moshe was saying to him. His face seemed to be smiling, but from nearby I saw that his skin was shaking and twisting.

To reach our sawmill, it took over an hour to walk through the forest.

Foresters lived with their families in wooden houses and, since the outbreak of war, other men had joined them. Allegedly they worked in the sawmill or helped father in other jobs and only father knew who they really were.

One day, after this conversation in the village, I saw Moshe's son carrying some timber between the houses in the forest. My father thought that there he would be safe. This lasted for about a month. Then he was killed by a man from the village called Bolek. It was said that he spied for the Germans. He did not get very far. Soon after, he was killed by our men who had seen him shoot the Jewish boy from behind. I went to the spot where Moshe's son died. There I found a small piece of flat bone. I picked it up. There were many similar bones scattered in the bushes near our outbuildings. I had seen farm animals being killed. I had not thought of it as death, and with human beings it was the same.

Once I wanted to have a frog's skeleton. The way to get this was to place a dead frog on an anthill. So I threw stones at a frog for a long time, yet it refused to die. I suffered with it most terribly until, at last, covered with sweat, I ran away.

MOTHER

They came at night, in 1943, drunk. They bashed at the door. Mother rushed to open it. One opened it to everybody. She did not make it: they began to fire. A dumdum bullet tore her right elbow. It severed her arm from the shoulder, wounded her left hand. The capable, wise hand suddenly became a piece of meat, separate. I looked at it with amazement. I had seen dead bodies, but they somehow had always preserved their completeness in front of others.

We had to wait until the morning to go by carriage to the small town where there was a doctor.

She survived in spite of a terrible loss of blood and excruciating pain.

When she returned from the hospital, maimed, I attempted to replace for her the hand she had lost. I never left her alone. It was thought at the time that I would become a nurse, yet I only wanted to make up to her for the great disappointment of my gender. I wanted to be both needed and loved, if only now, to attract her attention, and perhaps even praise.

"SOFT," 1979

ONCE UPON A TIME

I was a small child, crouching over a swampy pond, watching tadpoles. Enormous, soon to become frogs, they swarmed the bank. Through the thin membrane covering their distended bellies, the tangle of intestines was clearly

visible. Heavy with the process of transformation, sluggish, they provoked one to reach for them. Pulled out onto shore with a stick, touched carelessly, the swollen bellies burst. The contents leaked out in a confusion of knots. Soon they were beset by flies. I sat there, heart beating fast, shaken by what had happened. The destruction of soft life and the boundless mystery of the content of softness. It was just the same as confronting a broken stem with sap flowing out, provoked by an inexplicable inner process, a force only apparently understood. The never fully explored mystery of the interior, soft and perishable.

Many years later, that which was soft with a complex tissue became the material of my work. It gives me a feeling of closeness to and affinity with the world that I do not wish to explore other than by touching, feeling, and connecting with that part of myself which lies deepest.

BECOMING

Between myself and the material with which I create, no tool intervenes. I select it with my hands. I shape it with my hands. My hands transmit my energy to it. In translating idea into form, they always pass on to it something that eludes conceptualization. They reveal the unconscious.

INTERIOR

The shapes that I build are soft. They conceal within themselves the reasons for the softness. They conceal everything that I leave to the imagination. Neither through the eye nor the fingertips nor palm that informs the brain can this be explained. The inside has the same importance as the outer shell. Each time shaped as a consequence of the interior, or exterior as a consequence of the inside. Only together do they form a whole. The invisible interior which can only be guessed at is as important as when it opens for everyone, allowing physical penetration.

MEDITATION

To make something more durable than myself would add to the imperishable rubbish heaps of human ambitions, crowding the environment. If my thoughts and my imaginings, just as I, will turn to earth, so will the forms that I create and this is good. There is so little room.

COEXISTENCE

My forms are like successive layers of skin that I shed to mark the stages along my road. In each case they belong to me as intimately as I belong to them, so that we cannot be apart. I watch over their existence. Soft, they contain within an infinite quantity of possible shapes from which I choose only one as the right, meaningful form.

In the exhibition rooms I create spaces for them in which they radiate the energy I have imbued them with. They exist together with me, dependent on me, I dependent on them. Coexisting, we continually create each other. Veiling my face, they are my face. Without me—like scattered parts of the body separated from the trunk—they are meaningless.

CONFESSION

Impermanence is a necessity of all that lives. It is a truth contained in a soft organism. How to give vent to this innate defeat of life other than by turning a lasting thought into perishable material?

Thought—a monument. Thought—a defense against disappearance. Timeless thought. A perverse product of the soft tissue that will disintegrate, that one day will cease to connect. Expressed in material whose durability is related to the matter from which it came, it begins to really live—mortally.

CONTACT

I touch and find out the temperature. I learn about roughness and smoothness of things. Is the object dry or moist? Moist from warmth or from cold? Pulsating or still? Yielding to the finger or protected by its surface? What is it really like? Not having touched, I do not know.

EMBRYOLOGY

Carried for a long time in the imagination, shapes ripen. When out of pent-up tension, they have to be discharged, I become one with the object created. My body grows ugly, exhausted by bringing forth an image. My body gets rid of something that had been a part of it, from the imagination to the

skin. The effort of discharge makes it hideous.

In my belly life was never conceived. My hands shape forms, seeking confirmation of each individual specimen in quantity. As in a flock subordinating an individual, as in the profusion of leaves produced by a tree.

REMINISCENCE

But, at the very beginning, when I started to weave and to use soft material, it was from a need to protest. From a wish to question all the rules and habits connected with this material. Soft is comfortable and useful. It is obedient, wrapping our body. It deadens the sound of footsteps. It covers walls, decoratively and warmly. It is easy on the eyes. It is practical. Accompanying our civilization from its very beginnings, it has its roles, a definable range of tasks governed by our needs and habits. It has its own system of classifications.

That is why I found the struggle with these acquired habits so fascinating. That is why it has been so fascinating to reveal and disclose the organic quality of fabric, of softness. To show the qualities overlooked through the blindness of habits. The autonomous qualities. To show all that this material could be as a liberated carrier of its own organic nature. And later, the showing of objects which contradict the former functions of this material, broadening man's awareness of the matter which surrounds him, the objects which surround him, the world which surrounds him.

SOFTNESS

I touch my body. It still obeys me. It fulfills orders efficiently, without resistance. The muscles move wisely. When needed, they raise my hand, move my fingers. When needed, I lower and raise my eyelids. I move my tongue. Under the skin the flesh is precisely shaped. Springy. Everywhere, in the wholly enclosed, porous skin-covering-pulsation. All uniformly heated, saturated with moisture, with thick red juice, white mucus, jellylike secretion. All stretched on bones. Inside them—canals, intertwined with nets and thread, soft and fragile. Hot, greasy. It belongs to me. It is me. It causes me to be.

🌿

"K A T A R S I S," 1981

INTRODUCTION

From the very beginnlng man has created myths out of his longing for the lost state of balance, for the prehistoric existence called paradise which was a state without consciousness.

He tried to find in religion the explanation of himself, to compensate his defects by its commandments, to justify the sufferings of life by giving them purpose as does Christianity. In the practice of tantra and yoga, man attempted to gain control over his instincts.

This struggle of man with himself for control over his own nature, a struggle with a lack of internal norms of behavior, is reflected in the whole mythology, and ultimately in the vision of man seeking balance and perfection from the remotest time of the Assyrian poem "Gilgamesh" to the circular shape described by Plato of the first human being, to Balzac's book about Serafit—the only one of Balzac's works not based on reality but on his dreams—or in Goethe's considerations about the Demon as the creator of life in his poem "Faust." While reading about the structure and functioning of the human brain, which is formed of interdependent parts, but originating in different periods of evolution, I discovered how contradictory the factors determining our behavior are, how deeply rooted are the sources of permanent struggle.

To all the most ancient fears of men I add my own.

These can perhaps be glimpsed in my art as a story of the same fears and pains which have accompanied human existence as well as mine.

🌿

"QUANTITY - IRREPEATABILITY," 1985

I once observed mosquitoes swarming.
In gray masses.
Host upon host.
Little creatures in a slew of other little creatures.
In incessant motion.
Each preoccupied with its own spoor.
Each different, distinct in details of shape.
A horde emitting a common sound.
Were they mosquitoes or people?
I feel over-awed by quantity where counting no longer
makes sense. By irrepeatability within such a quantity.
By creatures of nature gathered in herds, droves, species

in which each individual while subservient to the mass
retains some distinguishing features.
A crowd of people or birds, insects or leaves is
a mysterious assemblage of variants of certain prototype.
A riddle of nature's abhorrence of exact repetition
or inability to produce it. Just as a human hand cannot
repeat its own gesture.
I invoke this disturbing law, switching my own immobile
herds into that rhythm.

〰️

"WAR GAMES," 1989

For a long time I couldn't use wood. I saw it as an entity finished in itself.
Some years ago, suddenly, I discovered inside an old trunk its core as if a
spine entwined by channels of juices and nerves. I found out the carnality of
another trunk with limbs cut off, like amputated.

As a little girl I once caught a rabbit. It breathed. Its ribs and chest
moved just like mine. Its eyelids fluttered just like mine. Otherwise it was dif-
ferent which justified killing it for human needs.

There are strange similarities between different creatures of nature; they
concern us also. The imagination of nature seems to be limited. As if not hav-
ing enough freedom, nature uses for building its creatures not only frag-
ments of existing ones but also their expressions.

Fascinated by the corporeality of trunks I decided to bring them into my
domain. I started to work on their personality. Doing so, I felt encouraged by
strange similarities between us, by a kind of relationship.

I bring out the features which struck me. I draw them out until I see no
longer the wood but an object of many meanings; an object which carries
similarities unknown to the imagination of nature.

〰️

"ABOUT LIFE," 1990

I was destined to live during times which were extraordinary for their
various forms of collective hate and collective adulation. As a small girl I
even envied those youngsters in brown shirts from the neighboring country
who so worshipped their leader and so firmly believed in his ideals. When
they marched in to kill us, everything turned to hate, until the killers them-
selves were defeated and killed.

Then other enthusiastic marchers appeared, worshipping new ideals that
would last for ever and another leader, great and good. However, at these
parades, carried on high, were huge caricatures of those who were now to be

hated and eradicated. I looked on, frightened, burdened with what was now a sin: descent from an old land-owning family which has just been dispossessed of its estate.

When it was noticed that the beloved leader was a mass-murderer, a succession of lesser lights from the followers of the founding philosophers sprang up to replace him. Parades continued marching to celebrate visions that would bring happiness to all.

With the enthusiasm of youth, I believed. With all my energy and dedication I tried to put into practice this radiant and wonderful ideal. I understood soon enough: the country whose model was imposed on us, deprived us of identity. Hating each other, we simulated fraternity.

The reality that followed was unreal. Thoughts and words diverged. Actions followed an alien liturgy and an alien ritual. Love and hate were enforced.

Finally, the common abhorrence of daily lies and a craving for truth prevailed. Those that were hated were made to yield to new leaders. Totalitarian oppression gave way to liberty.

Within it, now grasping ambitions have already started to hatch. Hand-to-hand fighting has begun, each against each, zealously trying to drag everything toward a private nest.

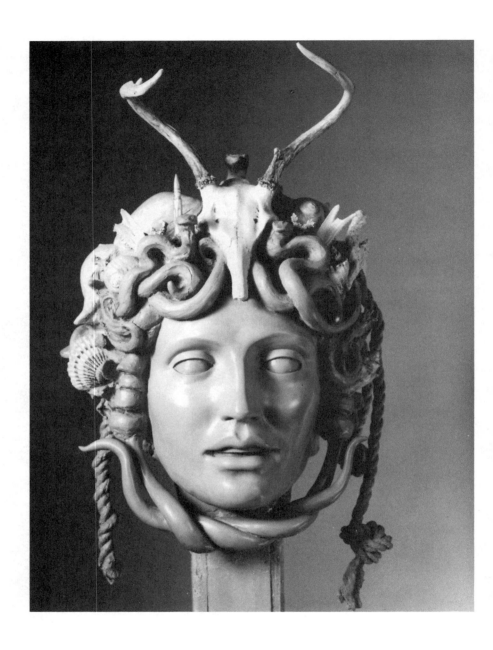

Colossal Head of Medusa, 1990. Polychromed terra cotta-colored fiber glass, 35 in. high with base. Courtesy Louis K. Meisel Gallery, New York. Photo: Steve Lopez

AUDREY FLACK

B. 1931

IN THE 1960S, Audrey Flack became one of the first artists to use photographs as the basis for her painting, yet her subject matter differed greatly from that of her male colleagues—jewelry and perfume bottles rather than the shiny surfaces of cars and motorcycles. Flack initially adopted the Abstract Expressionist style that was popular when she was a student, although she felt drawn to depicting veristic images of the natural world. In contrast to the purist aesthetic of her teacher Josef Albers, she was captivated by the rich, lush surfaces of Baroque art, as well as by its symbol-laden content. Her *Vanitas* still lifes of the mid-seventies embodied both her aesthetic and thematic concerns. After a period of intense soul-searching, in the early 1980s Flack took a daring leap in her work and began to translate her long-standing interest in creating positive images of women into monumental works of sculpture, currently her preferred medium. Over the years, she has written consistently about her art, her experiences as an artist, and her spiritual connection to works of art.

Audrey Flack decided that she wanted to be an artist as a child growing up in a middle-class family in the Washington Heights area of New York City. Despite her family's lack of enthusiasm about her artistic goals, she attended the High School of Music and Art and, after winning their St. Gaudens medal, she graduated from Cooper Union in 1951. As one of the top students, she was

recruited by Josef Albers to participate in the fine arts program at Yale, the direction of which he had just assumed. Although she received her B.F.A. from Yale in 1952, it was only after achieving an uneasy truce with Albers whom she believed wanted to force her into his way of painting. After graduating from Yale, Flack moved back to New York and studied anatomy with Robert Beverly Hale at the Art Students League, in response to her felt need to paint realistically, a technique that had been ignored during her previous art education. By the beginning of the next decade Flack had completed her period of artistic apprenticeship and had begun to come into her first artistic maturity.

During the 1950s Flack attempted to forge a personally satisfying style out of the Abstract Expressionist idiom that was so influential during her student days. Flack describes Abstract Expressionism as "the mythology of the time," and recounts that meeting her "idol" Jackson Pollock at the Cedar Bar was analogous to "a stage struck person meeting Clark Gable." Flack found the actual experience less than satisfying: rather than discussing his methodology with her as she would have liked, Pollock related to her only as a female, a narrow view typical of the macho character of the art world in general and the Abstract Expressionists in particular. Her ultimate dissatisfaction with the movement was not based on its preferred gender and life-style, however. She was directed instead by her deep-seated need to draw realistically in order to express her fundamental beliefs about the nature of art and its ability to communicate. While her works through 1952 were abstractions in which brush movement was conceived as an extension of inner emotion, soon after she began her studies with Hale, recognizable imagery began to appear in her work with greater regularity and visibility. One of a series of still lifes painted during this period, *Still Life with Apples and Teapot* (1955), shows Flack's interest in recording the things of this world at the same time that she was reluctant to abandon completely the Abstract Expressionist idiom. In this work, a prominent bowl of fruit and a coffeepot seem to stabilize before a background of fluid, painterly drips. During this period she also painted a series of self-portraits, very private images that she did not exhibit and through which she began to work out her conflict regarding both style and content. Beginning with the Abstract Expressionist *Self-Portrait* (1952) and culminating in *Self-Portrait: Dark Face* (1960), her work shows an increasingly stabilizing image of the artist executed with broad, sometimes dripping, painterly strokes.

The 1960s represented a period of artistic consolidation for Flack. In her personal life, she attempted to balance her art-making with marriage, children, and part-time teaching jobs. She abandoned her own image as a subject, painting instead those of her daughters, Hannah, born in 1961, and the autistic Melissa, born in 1959. In the mid-sixties she branched away from the private sphere, basing her compositions on photographs taken from the realm of documentary news, focusing on such public figures as Roosevelt, Rockefeller, even Hitler. Perhaps the most significant work of this series was *Kennedy Motorcade* (1964), her first work based on a color photograph, showing President and Jackie Kennedy, and Texas governor John Connally, just moments before

Kennedy was shot. Flack says about this work that it "confirmed the direction in which my art was going in terms of subject matter and style," as well as in her working method, which became increasingly based on photographic images. During this period, too, Flack painted numerous portraits of women, including Marilyn Monroe, Carroll Baker, two of Harry Truman's ex-teachers, and three nuns leading a civil rights march—all from public media sources.

Perhaps the most important breakthrough for Flack occurred during the painting of *The Farb Family Portrait* (1969-70). Flack has described how her impatience to move beyond the preliminary stage of blocking the drawing onto canvas with charcoal led her to project a slide directly onto canvas and to apply color through the projected image. Although she says that it took her a while longer to dispense with the use of line completely, the technique first used here quickly led to her mature style, in which she applied paint in layers with an airbrush, mixing primary colors directly on the surface of the painting and resulting in the achievement of a more intense luminosity than through conventional means. (This process is described in detail in her essay "On Color.") After the Farb portrait, Flack experimented with this photo-realist technique in works built from easily recognizable imagery: picture postcards of such tourist attractions as the Leaning Tower of Pisa and of the Macarena, a sculpture of the Virgin by Spanish artist Luisa Roldán. Her complex, monumental still lifes of the 1970s may be seen as the culmination of these endeavors. *Jolie Madame*, *Royal Flush*, *World War II*, and later pieces from the "gray border" series (such as *Spaced Out Apple*) use photography as an essential aspect of their composition and scintillate with internal light.

Flack's mature painterly technique bears an interesting relationship to her early Abstract Expressionist work. While her photo-realist work with its smooth patina and ultrarealistic recording of the visible world seems to stand in marked contrast to her earlier style, in fact, the two approaches bear several points of comparison. Flack's photo-realist still lifes recall her Abstract Expressionist works in their lush use of paint and color, their transparency, and their dependence on pure color and eschewal of linearity. Works in both styles are characterized by a glow that seems to pulsate from within the work. Also, Flack's later still lifes begin to take on an increasingly painterly surface. In a work such as *Marilyn: Golden Girl* (1978), the artist creates a tension between seamless illusion—in the images of Marilyn, the lipstick, the cupcakes, and the candle—and thickly impastoed strokes of paint in rainbows in the upper and lower parts of the canvas.

After the completion of the *Vanitas* series, emotionally draining for Flack due to its scale and content, she underwent another period of intense self-questioning. During this time in the early 1980s, as with her self-portraits thirty years earlier, she was able to break through to another level of consciousness by making a series of works for herself, watercolors of the landscape near her studio in East Hampton, New York. She particularly enjoyed these works because they enabled her to do things "one is not supposed to do." An immediate result of these exercises was seen in her subsequent still lifes, the most

recent that she has executed at the time of this writing. At the same time that these works present deliberately more "harmonious" content, they emphasize the tension regarding painterly illusion that Flack had played with five years earlier, contrasting layered illusions with very definite statements regarding the act of painting, such as minutely recorded completion times.

Finally, in the early 1980s, Flack made a change in her primary artistic medium, from painting to sculpture. She describes the change as a response to the felt need for "something solid, real, tangible. Something to hold and to hold on to." Her earliest piece was a small, bronze putto, *Angel with Heart Shield* (1981). Soon thereafter, she executed a somewhat larger work called *Black Medicine*, whose model was a seventy-five-year-old black woman. This was the first of a series of diverse, heroic women and goddess figures that formed Flack's major output over the next decade, culminating in her commission for the Rock Hill (South Carolina) City Gateway, four thirteen-foot "visions" of female strength. She was also commissioned to make a colossal statue of Queen Catherine of Bragante (the founder of the New York City borough of Queens) to stand opposite the United Nations. Her monumental works, like their sculptural predecessors, present strong, heroic feminine images. Yet while Flack's women are heroic, they depart from conventional images of femininity in that they are athletic, older, fierce. As Flack herself describes them, "they are real yet idealized . . . the 'goddesses in everywoman' " (in reference to Jean Shinoda Bolen's book of that title).

Her sculptures bear such a deep connection to several themes in Flack's earlier work, that it is tempting to read them as its culmination. From the time of her earliest work with recognizable subject matter, Flack explored the theme of femininity and its construction through various modes of presentation. The tension between woman as artist and woman as subject was a leitmotif in the important and private series of self-portraits executed during the 1950s with which she made the stylistic bridge from Abstract Expressionist to realist. In an early example, *The Anatomy Lesson* (1953), an obvious reference to Rembrandt's work, she shows herself seated, surrounded by the skeletons that mark the tools of the figural artist's trade, contemplating two skulls while a model relaxes on a chair. In several of these paintings she depicts herself at work in front of an easel, while also acknowledging her feminine attributes. In the most provocative, *Self-Portrait in Underpants* (1958), she stands at the easel, one hand on her tilted hip, confronting the viewer head on. Although she depicts herself with minimal cover as the object of the viewer's gaze, the image relates more to her experience as the speaking subject, a person who works in the privacy of her own house in casual attire or, as here, half-dressed.

When Flack began painting in a photo-realist style women were a central subject of her art. Harry Truman's teachers, nuns leading a march, two women grieving over Kennedy, an old Mexican orange seller were ordinary women placed in a social context. Shortly thereafter, Flack presented the female image in an extraordinary context in her several works inspired by the 18th-century Spanish sculptor Luisa Roldán's images of the Virgin and St. Dolores, idealized

female images, with smooth, perfect skin, even smooth jewel-like tears. This series culminated in the *Self-Portrait* of 1974 in which Flack idealized her own face.

Flack dealt with the construction of femininity in her monumental still lifes, without painting the actual likeness of a specific woman. A work such as *Jolie Madame* presents in hot, lush, red tones, the accoutrements of self-adornment of the beautiful woman, a theme to which she returned in *Chanel* two years later. Flack has discussed this work as her "only intentionally feminist painting," conceived in direct response to *Jolie Madame* in which she had "broken a silent code . . . merely by being true to [her] nature as a woman." As she points out, these works enabled her to explore the interest in reflective surfaces that male photo-realists had found so captivating in "cars, trailers, headlights and store windows." Yet the subject matter—"women's things"—is one that has been trivialized, seen as less appropriate or valuable in our culture. Her exploration of Marilyn Monroe as an icon of beauty, the second work in the *Vanitas* series, was also significant. In earlier portraits Flack dealt with women who were extraordinary because of their beauty—Monroe, Carroll Baker, an anonymous party girl. In the later Monroe image, Flack again confronted the duality of the beauty myth through a meditation on the transience and fickleness of the satisfaction that Monroe's beauty was able to afford her.

From the time she abandoned Abstract Expressionism, Flack sought a means of communicating expressive content through her work. While other photo-realists claimed that the subjects of their works were irrelevant, Flack chose to base her paintings on photographic imagery that communicated a particular sociopolitical point of view, culminating in the *Vanitas* series of the mid-seventies. These works make direct reference in structure and motif (the candles, the hourglass) to the Vanitas paintings of the Baroque period with their didactic, symbolic purpose, and engagement with broad philosophical issues, such as the passage of time and the meaning of life. She continued to explore "iconic images for a secularized age" in her most recent paintings, such works from the early 1980s as *A Course in Miracles* and *Fruits of the Earth*, in which she deliberately attempted to create a harmonious integration of paths towards spirituality. Flack's sculptural works fulfill the purpose of her artistic endeavor in that they make a comprehensible statement through manipulation of "readable" iconographic elements. In her sculpted goddess figures she seemed to be expanding upon two earlier paintings—an idealized portrait of her daughter (*Hannah: Who She Is*, 1982) and an image of Isis based on Fayum effigy portraiture (1983). Like Isis, Flack's goddesses are all given symbolical and mythological attributes—the *Egyptian Rocket Goddess* wields a snake, *Islandia* offers a conch, an eagle perches atop *American Athena*'s head. Some of these figures, like the Rocket Goddess, are hybrids, synthesized by Flack; others, like Athena, Diana, and Medusa are reinterpretations of traditional mythological figures, from a contemporary, feminist perspective.

Flack chose to adopt a realistic style, and ultimately three-dimensional media, out of her firm belief that art's purpose is to communicate. Her consistent involvement with the written word has been a means of further expanding her desire to make meaningful statements about being in the world. She has written several essays about artists with whom she identifies in her own work. In her book *Audrey Flack on Painting* she discussed her methodology and the iconography of several important still lifes, and in *Art and Soul* she presented stories and meditations related to her artistic development. She is currently working on a lengthy autobiography from which "Alone in Paddington Station" has been excerpted here.

SOURCES

Flack, Audrey. *Art and Soul: Notes on Creating.* New York: E. P. Dutton, 1986.

_____. *Audrey Flack on Painting.* New York: Harry N. Abrams, 1981.

_____. *Audrey Flack: The Daily Muse.* New York: Harry N. Abrams, 1989.

Gouma-Peterson, Thalia. *Breaking the Rules: Audrey Flack, A Retrospective, 1950-1990.* New York: Harry N. Abrams, 1992.

Nemser, Cindy. *Art Talk: Conversations with 12 Women Artists.* New York: Charles Scribner's Sons, 1975.

Rubinstein, Charlotte Streifer. *American Women Artists.* Boston: Avon Books, 1982.

AUDREY FLACK—SELECTED WRITINGS

FROM *AUDREY FLACK ON PAINTING* (1981)

FROM "COLOR"

Color does not exist in and of itself. All through my life as an artist, until I began to experiment with the airbrush, I accepted color as a fact—something to be squeezed out of a tube and resupplied when the tube was empty. It could be a crayon, a pastel chalk, jars of Rich Art tempera, but always "color" was "color." "Cadmium Red" was a fact. I was well aware of the subtle differences between brands—Shiva Alizarin Crimson was oilier than Winsor Newton Alizarin. Winsor Newton Cadmium Red was richer than Grumbacher Cadmium Red. My concept was that color was a material substance. It is not!

Color should be thought of in terms of light. Webster's dictionary says that color is "the sensation resulting from stimulation of the retina of the eye

by light waves of certain lengths." My definition of color is: "Color is created by light waves of various lengths hitting a particular surface. The surface may be absorbent, reflective, textured, or smooth. Each surface will affect the wave lengths differently and thereby create different colors. These wave lengths will affect the retina, and the eye will perceive color."

Each color has its own wave length, or better still, each wave length has its own color. The light which Newton separated into seven distinct colors with individual wave lengths is called a spectrum—red, orange, yellow, green, blue, indigo, violet. Light travels at 186,000 miles per second in wave lengths and as it travels it *vibrates*. It is these reflective rays or vibrations we perceive as color. Color does not exist in and of itself. Objects themselves are colorless. They appear to be colored because they absorb certain wave lengths and reflect others. In 1969, while analyzing a projected slide on a white, smoothly sanded canvas, I noticed that what appeared to be color really was dots of red, yellow, and blue, mingled together to produce all other shades. Nowhere was there a flat opaque mass of color; rather, there were dots or globules which gave the effect of color. As I stood in my semi-darkened studio I realized that all of this color was being produced by a single light . . . being projected through a gelatinous slide. Without the light there would be no color. Physicists use the term "excited." They say color becomes excited by light. Color is not stable, it changes as light changes . . . daylight . . . bluish light . . . sunlight . . . moonlight . . . neon light . . . bright light . . . half shade . . . darkened room . . . hazy or misty light . . . clear filtered light, and so on. It is chameleon-like, changing with the properties of light. . . .

When I began working with the airbrush, I realized that spraying . . . produces a completely different color than applying it with a brush. Spraying produces small beads of color and the density of the application affects the intensity of the color. . . .

Compare the brilliance of a slide with the opacity of a photograph. The photograph is dull in comparison. I wanted to make a painting as luminous as a color slide. I had to deal with light in order to accomplish that. . . .

Being concerned with the surface that light hits, I later established "base colors." These colors are a median tone and are applied as flat areas over which red, yellow, and blue are sprayed. Working in the three-color process I would have to spray Acra Violet from a great distance to get a pink. The dots of spray would necessarily have to be quite far apart. In the "base color" technique, I would apply a flat pink, over which I could create every nuance with red, yellow, and blue. . . .

In the last phase of the painting I spray pure white light . . . highlights appear . . . the final bright light gets turned on. . . .

The entire spectrum is possible. The colors seem to get mixed in the air, but the final mix takes place on the canvas.

From "*Vanitas*"

The Vanitas is a form of painting which was popular in the seventeenth century and refers to the temporality of life. The word comes from the first chapter of Ecclesiastes: "Vanity of vanities, saith the Preacher, vanity of vanities, all is vanity. What profit hath a man of all his labor which he taketh under the sun? One generation passeth away, and another generation cometh: but the earth abideth forever."

We can have wealth, great beauty, and material pleasures, but eventually we all must die. The king, the queen, the rich, the poor, the priest, the layman, the lawyer, the doctor. Vanitas paintings encourage the viewer to think about meaning and purpose of life. They have long been a favorite of still-life painters, who have used a variety of objects to symbolize their thoughts: an hourglass, a burning candle, or a watch, each signifying the passage of time.

I found myself using the Vanitas form in both old and new ways to communicate with the viewer and to express my views on life. When I began the series, I had done no research on the subject and the objects I arrived at came from my own mind after months of deep consideration. What amazed me later was that many of the symbols I chose were identical to those used by the Renaissance masters. This has reinforced my belief in Jung's theory of the Universal Archetype and Collective Unconscious. It is as if these objects are part of a common store of symbols available throughout history. An important aspect of art is communication. This idea has been cast aside by much modernist thought, which has emphasized "Art for Art's Sake" and has disregarded the popular audience, leaving it to "commercial" artists. The modernist attitude is that the public must be "educated" to understand art. It has thus followed that museums have taken on the role of public educators, attempting to uplift a bruised and art-shy audience. This has intimidated many highly intelligent minds who, when confronted with an abstract canvas, say: "I don't know anything about art" ("but I know what I like" usually added shamefacedly). They have lost faith in their ability to tell good art from bad—whether it be abstract or realistic—and have accepted their "ignorance" as fact. . . .

I saw the *Vanitas* series as the most important paintings of my career, major works. The modernist establishment did not seem to comprehend what I was trying to do. The question of taste has constantly been raised in relation to my work. Somehow the attacks seem related to my background and my personal life as they are reflected in my art.

The problem seems to be that I am involved with life, trying to reveal the human condition as it has touched me rather than adjust to some establishment criteria. The questions are: What is taste? Whose standards do we use? Who sets those standards, and who publicizes them? Why has my work upset the modernist mainstream, when the public is so overwhelmingly responsive?

A painting has its own power and its own life. It exists in time, an expanse which is far longer than our lifetime. A great work of art lives on, it takes on dimension, it has its own lifespan. It can have many births and many deaths, not just the birth the artist gives it. It gets born again when it goes out into the world, it gets buried—sometimes for thousands of years—and then resurrected. But the truly great works of art outlast all and shine through the murk of stylistic changes.

FROM *"WORLD WAR II"*

My idea was to tell a story, an allegory of war . . . of life . . . the ultimate breakdown of humanity . . . the Nazis. After reading *Dawn and Night* by Elie Wiesel and *The Survivors* by Terrence Des Pres I was convinced of the existence of pure evil as well as the existence of beautiful humanity as exhibited by many of the survivors of the concentration camps.

I wanted to create a work of violent contrasts, of good and evil. Could there be a more violent contrast than that? I decided to use a Margaret Bourke-White photograph of the liberation of Buchenwald. The prisoners in their striped uniforms—hollow faces—stunned beyond expression as an example of Nazi brutality. I chose specifically not to show blood or injury. Too much blood has been shed already. I did not want to capture the audience that way. But I wanted to shock. I did this by contrasting the image of the survivors with the sickeningly sweet pastries. I found a quote from a Hasidic rabbi in Roman Vishniac's book *Polish Jews* that deeply touched me. The innocence, the beauty and trust in God and humanity was overwhelming. I decided that would be a good contrast to the Bourke-White photograph, for the viewer could look at what happened to these people who could see, hear, and speak no evil.

I thought no viewer could stand to look at the true horror of the Holocaust if I graphically illustrated the blood, bones, crematoriums, operations, etc., in my Super-Realist style. One would have to cover one's eyes against the pain. Yet I had to get my message across somehow.

I also wanted to make a "beautiful" painting. Another contrast—beauty and horror. I wanted to seduce the viewer into the work and hold his attention long enough for him to read the quotation and then become involved with interpreting the symbolism. I am involved with the audience. I want them to become involved with the work. The silver dish with embossed roses, the lavishly flowing pearls, the sickeningly sweet petit fours are part of contemporary life—the vanity of the *Vanitas*. Offering still another contrast— opulence and deprivation. Many people were disturbed by the juxtaposition of the pastries with the starving prisoners. It was meant to raise consciousness but in many cases it raised guilt. Were we not all eating at that time? Are we not all eating now? . . .

From "Marilyn Monroe"

Marilyn Monroe is a universal symbol. She was not destroyed by Hollywood. She died from a basic deprivation of love in her early life. The movie world gave her the vehicle with which she could communicate. She reached out to the masses for that love.

She was fragile, vulnerable—in desperate need—and willing to do almost anything to fulfill that need. Like a moth's attraction to a flame, she was addicted obsessively to reaching out for love. More even than the rest of us, she needed it to survive.

She exposed a humanness with which we all identified. We were touched by some deep pain and deep beauty in her. Sex was only her vehicle, her contact was far deeper. Both men and women loved her—she affected both equally. It is strange that of all my works, this is the most androgynous. I remember specifically purchasing the Timex watch—I had many others in my prop cabinet, but they all seemed too feminine. The candle holder, though glittering, is smooth and plain—unfrilled. The rhinestone-studded compact is Art Deco and reads more designed and hard than soft and pretty.

I chose a photograph of Marilyn that shows her character in transition. Her face retains qualities of Norma Jean and has not yet fully become Marilyn Monroe. Her hair is still soft—it curled and flowed along with my air-brush. In the future the blond hair would become brittle, brassy, yellow. That would break and would have had to be painted in a totally different way. The mouth is beginning to look like plastic but has not yet firmly set, although the lips are beginning to crack. The eyes retain a touch of softness and inno-cence. So far only a trace of pain has lined her brow. . . .

Like an icon she sits, the tools of her trade surrounding her. The rouge jars and powder puff form a crown around her head. I had to have a peach—they were out of season when we were shooting, and Jeanne and I opened many to find the right and beautifully formed erotic pit. The orange is begin-ning to shrivel . . . decay is setting in . . . the sand is slowly trickling down inside the pink plastic hourglass. In our first shooting I used a white rose, but later changed it for this very specific coral pink one, open and delicate, perched precariously over the book and very intentionally placed beside a deep violet satin sheet. Violet is a healing color. That particular pink suggests softness and love.

Marilyn painted herself into an "instrument of her will," using lipsticks, powder puffs, rouge, perfumes. I have used oils, acrylics, canvas, brushes. Each of us has found a way.

Marilyn succeeded—she got her message across. I see her as an iconic figure. She is a Universal Archetype.

"Wheel of Fortune"

It is hard to tell where the Wheel of Fortune will stop in our lives. This is perhaps the most personal of all of the *Vanitas* paintings. It deals with various aspects of my life . . . the personal tragedy of my autistic daughter Melissa framed in the upper left corner of the painting. It is also why I write the least about this painting.

The poem "Invictus" held great meaning for me from childhood on. I memorized it in my early teens and used it as a source of strength to carry me through some difficult days. "My head is bloody, but unbowed" . . . lipstick . . . skull . . . claret wine. The skull is reflected in the Baroque mirror on the left, as is the small hand mirror. But the reflected image of the hand mirror momentarily exposes a rainbow, signifying the beyond, the afterlife. I am reflected with tripod in the silver crystal-gazing ball, upper right along with some acid grapes and flash spots of light.

I was insistent about the color of those grapes, though it was difficult to achieve the strange orange shade I wanted. A year later in the National Gallery in Washington, while viewing an Edvard Munch exhibition, I stopped sharply in front of a painting which held that *exact* color. The picture was called *The Smell of Death*. Munch had sought the same shade, and for the same associative powers.

In the painting a duality exists between the Wheel of Fortune that casts one's fate and "I am the master of my fate, I am the captain of my soul." Life is a mixture of the two.

I wanted to create a Renaissance mood. A friend borrowed a skull for me, and I enlarged the worm holes. It took a while to locate the correct hourglass, which I had to rent at a high price, for the shooting. I now have a collection of hourglasses. I wanted to evoke the atmosphere of Faust's study . . . tampering with one's fate . . . dealing with it . . . overcoming it.

All of the *Vanitas* paintings are a protest. *Wheel of Fortune* may be the strongest in those terms. They are saying: "Resist! Fight back!" We are subject to Fate, and like Job we are afflicted with pain. But we do have some degree of control over our lives . . . over our fate . . . however slight. Paint yourself into an "instrument of your will."

"Do not go gentle into that good night. Rage, rage against the dying of the light."—Dylan Thomas

FROM *ART AND SOUL* (1986)

"Galaxies of Linoleum"

In a way, the persona of Jackson Pollock was as important as, and perhaps more important than, the art he produced. The archetype he embodied affected all artists, and spread out into the general public in the form of spattered linoleum, lampshades, and clothing. The embodiment of his energy was transmitted through his canvases.

I consider him the first "space artist" in that he took up the mantle of the tilted picture plane from Cézanne and the Cubists and finally raised it to a fully upright position, where he then punctured it. The interlaced sprawling drips flash and flicker like a galaxy of stars. The spaces in between the loops and lacework read as the universe. Art and science always mutually reflect man's knowledge of the world. Pollock, who was attuned to this, took the existential leap, jumped off the cliff, and soared into outer space. He was never to return.

"Making History at the Cedar Bar"

When I was a young art student, I frequented the Artists Club and the Cedar Bar. The club held Friday-night panel discussions and served syrupy black coffee, made by Phillip Pavia, who collected the dues and kept the place running. The site of the club was wherever Pavia found a cheap loft. Both places were hangouts for the Abstract Expressionists. You could always find a heated intellectual debate, lots of liquor, and incessant art talk. Art! Art! Art! It infused everything, it was a passion!

When Jackson strode into the Cedar Bar, a hush took over the place. Whispers, glances, fingers pointing: "There he is." Everyone knew we were in the presence of someone or something important.

I was seated at a small round table opposite the bar. Jackson was leaning on his elbow at the bar, with his hand holding his forehead. In his other hand he held a drink. The heel of his shoe dug against the rail. He glanced around the room, and his eyes stopped abruptly at my table. He stared at me intensely—strong, piercing eyes, burning inside and out. A straight, uninterrupted beam of vision held the space between his eyes and mine. We had come across each other several times before. I knew that there was something about me he both liked and needed. I had to break the stare and look down; he was overwhelming and frightening, and I was young and not that tough. I was getting scared and high, this time something was happening. I loved his work; here was the man. I wanted to talk art, ask all kinds of questions, find

out about him, his work and life. Finally he walked over to my table. He was drunk. A prickly stubble covered his flushed, alcohol-puffed face. I looked into those sad, sad eyes. I shall never forget them.

It was fashionable to be a drunken artist then. Pollock cut a romantic, swashbuckling figure, pissing in fireplaces of rich collectors, insulting them, acting macho and unafraid—a hero. That was his myth, and I had believed it too, but what I saw here was a desperate man, despairing and terribly unhappy. I felt his pain. I still do.

He saw something wholesome and vulnerable in me. Something bourgeois, young, and not yet spoiled or sordid. Maybe I could help him. He had had enough of art talk, galleries, collectors, and critics. His soul needed mending.

He tried to connect. He hung over me, unsteady and wavering, his face close to mine. We talked and talked, and there was a lot of looking at each other, scanning, examining, and searching. Looking into each other's eyes—looking was more important than talking. It was the talking. Then he tried to kiss me, to rub his cheek against mine. Then he belched, and that embarrassed him, so he tried to pinch my behind. He was using machismo as a coverup for his pain and fear of rejection.

I wanted so much to help him. I felt such a profound connection with him, but to kiss him would have been like kissing a Bowery bum. I could not do it. I was terribly upset with the whole situation, and never returned to the Cedar Bar after that. I realized much later that he must have been in the throes of a total breakdown.

Ruth Kligman was given the job of curating a show for a small gallery on Fifty-sixth Street. She saw my work on exhibit at the City Center Art Gallery and selected me and two other artists for her show. She was young and pretty, and even though there was something about her that disturbed me, she had a great eye and could talk about art in a way that wove a spell. . . .

The gallery showed borderline art, and some higher instinct in Ruth recognized my work as the "real thing." She wanted to be close to me. She asked me to give her art lessons. She wanted to know who the other artists were, where they met, and who were the most important of them. I told her. She pleaded with me to take her to the Cedar Bar. I was finished with that part of my life, and refused. I lived on the fifth floor of a walkup apartment building in Chelsea. I drew a map for her showing how to get from West Twenty-first Street to the Cedar Bar, on University Place. On it I wrote the names of Bill de Kooning, Jackson Pollock, and Franz Kline. "Who is the most important?" she asked. "Pollock," I replied.

I walked her down the stairs and pointed her in the right direction. (She was from New Jersey.) That night she met Jackson; the rest is history.

The news of his sudden death sent shock waves throughout the art world. I remember the place and the moment when I first heard the news. East Hampton . . . someone's house . . . a gathering of artists . . . a door bursting open and someone breathlessly yelling, "Jackson just crashed his car on

Montauk Highway. He's dead!" We were stunned. At first there was silence, then, "He can't be dead." Shocked disbelief. A later report said two people were in the car with him; one was dead, one was still alive. Ruth Kligman was with him and was badly injured, but was still alive. A great sense of loss . . . chill . . . grieving.

The same feeling pervaded the country when John F. Kennedy died. These men went beyond their defined roles as artist and president. Jackson Pollock was a magnetic force, both attracting and repelling, holding within his being electrical energy, power, and meaning that reached far beyond his physicality.

Like all great beings do, through some form of osmotic transmission he shared the particles of his structure and his very essence with us. He remains ever present.

"JOLIE MADAME"

Like all still-life painters, I am a passionate collector of props. When I have a particular idea in mind for a painting, it can take a year to search out and gather them.

Jolie Madame started with a concept. I wanted to capture the elusive non-color of glass and the changes that occur in a half-filled bottle, in this case a bottle of Jolie Madame perfume.

I went into my jam-packed prop closet, wandered around the house and studio (which looks like a giant collection of props), and gathered objects for my new painting. I was fascinated with reflective surfaces and textures, so I selected mirrors, jewelry made out of silver and gold, crystal beads, a compact, the velvet smooth petals of a deep red rose, a porcelain figure, an apple, and a Nippon vase. These were all familiar objects, many of which I personally used and loved, such as a favorite ring and bracelets. I set up a complex and carefully lit still life, and proceeded to paint *Jolie Madame*.

Upon completion, the painting was exhibited in a show called "Women Choose Women" at the Huntington Hartford Museum, now known as the New York Cultural Center. This work, which I thought of as just a still life, albeit of epic proportions, created a sensation. It was both hailed and attacked as a feminist rallying cry. It was called "the ugliest painting of the year" by a *New York Times* critic, and "the ugliest painting of the decade" by an even more pretentious magazine reviewer. I was also referred to as a greedy person, since I included an abundance of objects as well as jewelry. What is the price of a rose?

It took me a while to unravel the true meaning hidden within the reviews, since greed had no part, and my motive was beauty, not ugliness.

What I realized was that, as a woman, I had instinctively chosen props that a woman would use. My friends, the male photo-realists, were also inter-

ested in reflective surfaces, but they painted cars, trailers, headlights, and store windows.

By merely being true to my nature as a woman, I had, at that time, broken a silent code. These objects were not to be painted or taken seriously.

Vision is male and female. Until recently, the history of art has been the history of male vision. Women dress, look, feel, and see differently. Their vision must be incorporated into the history of art.

"Chanel Breaks the Collection"

The reviews of *Jolie Madame* really got to me. I decided that if I was going to be criticized and labeled a feminist, I might as well give the critics cause. I had long been fascinated with the makeup counters in department stores—glass trays, mirrors, colored pencils, disks of wondrous colors in the form of rouge pots, and golden tubes of color in the form of lipsticks. I had also felt that some of the most innovative still-life photography at that time was being presented in the fashion magazines. Some of these photographers influenced me, and I influenced some of them. I painted *Chanel,* one of my most feminist and abstract paintings.

Morton Newman, the famous collector, heard that I was to visit Chicago. He telephoned and invited my husband and me to visit his home and view his collection. I was reluctant and slightly annoyed, because I was not in his collection, even though many of my photo-realist colleagues were. Those days were hard for me. I was left out of a lot of shows and collections because of my subject matter. I didn't paint cars, and I was not fashionably dispassionate. I did not fit into that narrow and artificially created definition of photo-realism, yet I did not belong with the other realists either. Louis Meisel, the photo-realist dealer and writer, was later to augment and create a broader and truer definition of photo-realism.

After several tries, Morton Newman persuaded Bob and me to pay him a visit when we were in Chicago. His brownstone was unassuming, even modest-looking, but the inside was astounding! Paintings were everywhere, floor to ceiling; windows and fireplaces were boarded over and covered with art. Wall-mounted security cameras were constantly rotating and scanning the environment. The first floor housed a vast collection of Mirós and Picassos, and as one ascended the stairs, more recent work was displayed, a wonderful collection of Abstract Expressionists and finally a full complement of realists—all except me. I mumbled and grumbled to myself, chin down, getting angrier and angrier. Why was it so important for him that I be invited to view but not be part of his collection? Morton's charming wife, Rose, escorted me, pointing out paintings as we climbed to the top floor. Upon our descent, I noticed a swinging door on the third-floor landing. Hanging on it was the

smallest Louise Nevelson I had ever seen—ten by ten inches. It was hanging on the door to the kitchen.

Suddenly it dawned upon me. "Is this the only woman in the collection?" I asked. Rose Newman nodded and replied, "Morton doesn't think women can make it—they are not good investments."

By now I was in a silent rage. They both were really sweet people, and I did not want to upset them, since they were trying so hard to be gracious. However, I managed to make my opinion known.

The next day my dealer, Louis Meisel, received a call from Mr. Newman requesting a small Flack. I said to Louis that if he sold him a small Flack it would hang on the other side of the kitchen door, opposite the Nevelson—the women's room. I told Louis never to sell him a small painting; I'd sooner not be part of the collection. To my pleasure and surprise, Louis agreed completely. He has always seen art beyond gender. He told Mr. Newman that if he was ever to own a Flack, it would have to be a large and major painting, and he would have to pay a record price.

My exhibition was on at that time. Mr. Newman came in the next day and purchased *Chanel*. It broke the collection. After that he bought the work of many other women artists. Ironically, he owns my only intentionally feminist painting, and he loves it.

"ALONE WITH MARILYN MONROE"

Music has an important place in an artist's life. Most artists listen to music when they paint, and the feel of the music gets into the painting. It is interesting to notice how the styles of music selected change during the course of the artist's development and with the needs of each individual painting.

Earlier, I listened exclusively to chamber music. My favorite pieces were Mozart's G-minor Quintet, Beethoven's Grosse Fugue, and Schubert's Trout Quintet. Later, WBAI, a New York FM radio station, became a lifeline. They broadcast interesting talk shows, political discussions, and an incredible assortment of ancient, Third World, and New Age music. Then popular, folk, bluegrass, and American Indian chants and drumming entered the picture.

I played Elton John's recording of "Candle in the Wind" (a song he wrote for Marilyn Monroe) over and over again while I painted Marilyn. I felt the song deeply.

It was in the middle of a cold winter when I moved from New York to my studio in East Hampton for a month to complete *Marilyn*. I was totally alone except for Angela Kaufman, my small but energetic poodle.

Suddenly the sky opened up and we had one of the worst blizzards East Hampton has ever known. Everything froze; the Long Island Expressway was closed due to the hazardous icy conditions. It was hard to get out of the

house, and two local gardeners would come by in their four-wheel-drive truck to see if I had enough food and water. The isolation was intense and invigorating. During my painting breaks, Angie and I romped in the snow. She's so small she would get buried, totally submerged, and then rise up like a dolphin, up and down, up and down.

Music sustained me. The pace of the painting was steady and intense. I listened to a local radio station, WLNG, which broadcast local weather and road conditions. I called in requests to the disc jockey, Rusty Pots, which he then played for me. My human contact was through the radio. When WLNG went off the air, I played Elton John's "Candle in the Wind."

One frosty night, the night of the completion of the painting, I was standing on a scaffold, painting the drape at the top of the canvas. I must have lost all sense of time. The radio went off the air, the record player stopped, and I worked and worked in a state of total absorption. My right arm was stretched upright all that time, gripping a fine brush to control some delicate areas. Finally the last stroke was applied and the work was completed. I stepped down from the scaffold and backed away to gain perspective and look at what I had done. With a sudden sense of shock and fright, I realized that I could not lower my right arm. It was locked into its upright painting position—rigid, frozen.

I had to calm myself. I walked around the studio and gently massaged the muscles of my arm until it slowly lowered itself.

My arm recovered by itself, and Elton's song is in the memory bank of the painting.

"CLAUDEL AND RODIN"

We arrived in Paris on May 15. This was a time for art—looking, visiting museums, and sketching. I saw a poster announcing an exhibition of Camille Claudel at the Musée Rodin.

I had never felt drawn to visit the Rodin Museum in Philadelphia, though I passed it frequently. Rodin is an artist I kept at a certain distance, although I never knew why, and I always felt slightly guilty about it.

Here at last was an opportunity I would take to pay tribute to, and finally deal with, Rodin. And I have come more and more to believe that everything happens for a reason.

I had never heard of Camille Claudel, and had even forgotten about the exhibition announcement. So, upon entering a hall of the Musée Rodin, I was surprised to come upon some sculpture that was new to me, superficially Rodin-like, yet possessing a totally different energy. I began to respond empathetically; I liked the work. I became excited by the forms, the images, the weight and balance of the figures against each other. The limbs were a bit thin, I thought, almost spindly in comparison to Rodin. The proportions and

dimensional sensibility reminded me a bit of my own sculpture. I felt reassured. I had always felt Rodin to be a bit heavyhanded—too thick, massive, forcing issues too aggressively. This exhibit confirmed my feelings. I had discovered a new artist! Why wasn't he known? I liked him better than Rodin. We bought a catalog as we left the gallery, and my husband said to me, "From what I see in the catalog, Camille Claudel appears to be a woman."

Indeed she was. The name Camille had reminded me of Camille Pissarro, but this was a feminine Camille, a woman about whom many French artists say, "Claudel was Rodin." She worked in Rodin's *atelier*, was his lover, and sculpted many of his pieces. The hands and feet of *The Burghers of Calais* were Claudel's, and they were the parts I most liked in that work. Her energy was strong, unnerving. She was later to go mad (so they say) and was institutionalized for thirty years.

I am sure I picked up her energy from the poster I saw announcing the exhibition. Another woman artist is discovered. . . .

"JOSEF ALBERS"

Josef Albers was both a good teacher and a bad one. He was good because of his intense love and respect for art. He infused Yale with this feeling. He had superior vision and recognized talented students.

Albers had just left Black Mountain College to take over and revitalize the waning and old-fashioned Yale School of Art. When he arrived, he found that the students he had inherited did not understand his language—the language of modernism. He had the brilliant idea of bringing in talented students who could relate to him and infuse the school with new energy. I was one of the ones he chose. He gave me a scholarship and a studio, both of which I needed and appreciated.

I had just graduated from Cooper Union and was spending many nights at the Artists Club and the Cedar Bar. I was a wild and rebellious Abstract Expressionist. I had developed a technique of loading a brush with paint and flinging it onto the canvas from thirty feet away. Once I lost my grip and the brush went flying though the air, pierced the canvas, and left a gaping hole.

I wore tight button-up blue jeans, at a time when the few graduate women who were permitted to attend Yale were instructed to wear skirts. This did not appeal to the man who painted in a white suit and wanted me to wear one too.

Albers wanted me to paint squares, as he did. Painting squares was not my nature; consequently, there was friction between us. A distance was created between us . . . but a respectful one.

He could have taken my scholarship away, but he didn't. I acknowledged him for that. I knew he respected me as an artist and I always felt the pressure of his watchful eye on my work. We had a silent but meaningful

relationship. How much better if he could have used his abilities to bring out mine, rather than to try to reproduce himself. A great teacher not only teaches skills, but recognizes originality and encourages it.

FROM "ALONE IN PADDINGTON STATION" (FROM AN UNPUBLISHED AUTOBIOGRAPHY, 1984-85)

I have come to England alone for a two-week sketching trip. I am excited about indulging in an orgy of work with no responsibilities or restrictions as to time, food, or sleep. No one knows my whereabouts . . . even I don't know what hotels I'll be staying at . . . no address, no telephone . . . a brief interlude out of the boundaries of normal time. . . .

Tuesday, May 18 . . . 8:45 AM I arrive at Paddington Station and buy a round-trip ticket to Penzance, the end of the line on the Cornish coast of England. I've had to take an oversized valise in order to fit a large water color pad into it. It is particularly heavy because of the supplies I've taken for my sketching trip, a special sectioned metal box which holds my palette, 30 or so tubes of assorted colors, scissors, pencils, ruler, right angle and erasers. Brushes are held in an expandable plastic tube which protects the hairs at the tip from getting bent or broken. . . .

Paddington Station was cold and damp. Even the pigeons flying around were looking for warmth. I was glad when "Track 3 to Penzance" was finally posted on the departure board. I pulled my unwieldy valise along, hanging my carry bags over my shoulder.

A young British boy sat next to me, anxious to make contact, we struck up a conversation. His name was Craig, he was 16 years old. His family sent him on a camping trip to Liskeard, a small town in Cornwall. It became clear that each of us was to be alone for two weeks. He tried to act self-assured but I could see he was frightened underneath, and the contact with me eased his anxiety as well as my own. I was apprehensive about traveling alone with heavy luggage into a new area. . . .

"Penzance," the conductor called, "end of the line." The only time I had heard the name was in the Gilbert and Sullivan opera "The Pirates of Penzance," which makes the town sound like a bit of a joke. Actually, Penzance means the holy head: Pens-sans. . . .

There are sacred parcels of land on this earth and Cornwall is one of them. This is a place touched by God, where the elements are stronger than man, who must listen to earth, sea and sky in order to survive. The winds chill your bones and the sun chafes your skin. I looked down at my hands as I was sketching and they had become rough and turned ruddy, quite different from sunburn. I had begun to get a weather-beaten look from being out from morning till night.

I had gone mad with the joy of seeing. I fell in love with the landscape, the seascape, the boats, the fishermen, the pubs, the chimneys, and the stone

houses. I felt the power of this ancient Celtic land and I worked as I had not done in years, forgetting to eat, driven to capture the wild beauty all around me. I sat on rocks and stone fences, and in the late afternoon when my body began to tremble from the chilling winds there would appear before me a tea parlor or restaurant pub where I would warm my body over cream tea and paint a view from the window. My eyeballs ached from the intensity and hours of looking but I couldn't stop. I pushed on knowing I had only five days left. I hiked to the next town, Mousehole, a dot on the map, a village out of another century. I painted a view from the hilltop and another of the harbor. The first watercolor of Newlin Harbor didn't turn out well but I hit it on the landscape of Mousehole. Ah, that felt good, I could do it. Watercolors are a world unto themselves. Sometimes you have to make a lot of bad ones till you hit the first good one, and then you're off on a run. Watercolors don't tolerate mistakes. You don't use opaque colors and therefore can't cover up errors or cancel them out. Everything is transparent, see-through, any flaw shows. The hand must be sure, every stroke carries its image. Timidity looks weak and washy, and yet any brazen application can easily destroy the balance of the work. Too much water, and the paper buckles, too little and it looks dry and scruffy. You're on your toes at all times. I made controlled drawings and sketches, and loosened up with watercolor washes. The yin and the yang. Painting a watercolor is a cleansing of the mind. What a joy to work outdoors, to smell the air, feel the spray of the ocean and the warmth of the sun on my face.

Outdoor artists attract onlookers. I always know how I'm doing by the comments they make. When I hear nothing from them, I know I'm in trouble. When I hear that's good, beautiful or lovely, I know I've got it.

People have different techniques in looking at an outdoor artist's work. Some glance down at the work, and continue on their way. Some are embarrassed, and use roundabout methods to get close. Some are considerate, and stand back. Some come up from behind and startle me. Mothers bring children over, "See the lady paint?" Some don't look at all and pass by as if I were invisible. There is always one who stands right in front of the subject I am trying to paint, pretending unawareness. Those people desperately want to be noticed and get their attention in a negative way by making me say, "Would you mind, you're standing right in my way."

After two whole days working, sitting in the howling wind at the edge of the ocean I began to tremble. I was working feverishly, bundled up in whatever I had, undershirt, sweatshirt, sweater, denim jacket and plaid scarf wound around my neck, and a headband wrapped around my ears to protect them from the hours of gruelling winds blowing into them. Trying to capture the long shadows created by the late afternoon sun before it went down. Weary and beginning to shiver, I saw out of the corner of my eye coming toward me, two British punks dressed in tight black leather pants lined with silver studs. They were a matching pair, male and female, his arm wrapped around her waist, hers around his neck. They had weird hairdos, part shaved,

part sprouted, tattoos, earrings, boots, and they were chained together . . . very menacing indeed. They headed straight for me. I continued working nervously, keeping a peripheral eye on them. They came closer and closer, now they were looming over me. Plop. They stopped six inches from my shoulder and dropped their heavy leather bag down right next to my equipment bag, which also held my wallet, food, train ticket, and credit card. This was an approach I had never seen before. I was on alert. Were they going to steal my bag in broad daylight? I thought. There was no one else in sight. I continued to work trying to appear calm, unable to stop, still trying to capture the shadows of the setting sun. They were standing too close, they watched for two or three minutes but it seemed much longer. It was unsettling. I must not appear to be afraid. I quickly glanced up, attempting to get a better look at my invaders. I had to conceal my horror as I read the words the man had tattooed across his neck. There was a horizontal dotted line and then the letters C - U - T - H - E - R - E imprinted under it.

I rapidly returned my glance to the painting. My body was on full alert, not a word passed between us. They bent over and began rummaging through their bag. Now what are they up to? Will they accidently put their hands into my bag I thought.

The woman brought out the largest can of lager beer I have ever seen and gently placed it on the bench next to my palette. They then strolled away, arms wrapped around each other's waists. It was their way of giving thanks for my watercolor, they had approved. The work was good, and I knew it. "Thanks!" I yelled. "That was very nice of you, thank you." They turned and waved, as they continued on their journey.

I'm headed back to London with a scrambled egg sandwich for the five-hour trip. Will I be able to work in Naples? Somehow this trip is as much about being alone with myself as anything else. My work has become my friend again. Work is a friend and a comfort for Sunday painters. Yet I'm surely no Sunday painter. But all artists may have something to learn from them. What is happening to me? I must trust my instincts and my path. Perhaps the time for heroic paintings has to be put aside for awhile.

Perhaps we all need time for personal transitions, time for loving and being with nature, time out from the rapid passing of styles and the accelerated pace of modern society. Maybe that's what this trip was all about.

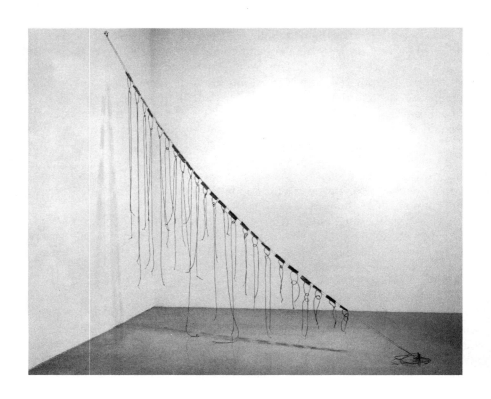

Vinculum II, 1969. 23 rubberized wire-mesh plaques stapled to shielded wire, with 23 hanging extruded rubber wires, knotted; 9 ft. 9 in. x 2½ in. x 9 ft. 7½ in. Collection: The Museum of Modern Art, New York. The Gilman Foundation Fund

EVA HESSE

1936-1970

EVA HESSE'S POWERFUL sculptures give physical form to seemingly unspeakable emotional states. A participant in the New York art scene in the late 1960s, Hesse synthesized many of the significant aesthetic principles of that period in her work. She died of a brain tumor at the age of thirty-four, less than six years after she had begun to work in three dimensions. Despite her short life, Hesse had an important impact on art history; at the time of her death she had achieved artistic maturity and had made a major statement with her work. Her early death has led to readings of her life that exaggerate its self-destructive aspects, and she herself described her life as characterized by extremes, which she attempted to resolve through long-term psychotherapy and by writing a series of "psychological journals," begun in her teens, in which she kept a record of both external and internal events. These diaries constitute a major piece of writing in which Hesse's "writing self" can be heard clearly. They are private documents, never intended for an audience, that chronicle a process of self-actualization that has general relevance. Hesse used her diary as a safe place in which to construct both her artistic and personal identities, as have so many other women artists.

Hesse's early years were marked by family trauma. Born in Hamburg, Germany, to a Jewish lawyer and his wife, Hesse and her older sister, Helen,

fled the Nazis late in 1938 on a children's train. They met their parents in London and the family moved to New York City, where they settled in Washington Heights. (All of Hesse's relatives who remained in Germany, including her grandparents, were exterminated in the Nazi death camps.) In New York, Hesse's father trained as an insurance salesman to support the family since he had no license to practice law in the United States. In 1945, after receiving American citizenship, her parents were divorced and her father remarried, a woman also named Eva (sometimes referred to as "Big Eva" in Hesse's diaries). Hesse's emotional situation intensified when her mother committed suicide in January 1946. As many diary entries reveal, for the rest of her life Hesse felt that she had been abandoned. She was also concerned that she might have inherited her mother's instability and often recorded her profound need to escape, at first physically but ultimately emotionally, from family stresses. The angst of her early life and its record in her diaries probably contributed to the subsequent erroneous interpretation of Hesse as a tragic figure.

Despite the internal anxiety Hesse experienced during her formative years, she played the role of a good girl and achieved well in school. Having decided to embark on an artistic career, she attended public high school at the specialized School of Industrial Arts. Upon graduation she stayed in New York and enrolled in an advertising design course at Pratt Institute of Design which she soon left to take classes at the Art Students League and to work at *Seventeen* magazine. She also studied at Cooper Union, graduating in 1957, and for the next two years she studied painting at Yale University, primarily with Rico Lebrun, Bernard Chaet, and Josef Albers, receiving a Bachelor of Fine Arts degree in 1959. She moved back to New York, her primary residence for the remainder of her life, and supported herself through various jobs as she attempted to establish her artistic career. During the next few years, she became friends with a group of young artists and critics who were soon to become influential figures in the art scene, particularly Sol LeWitt, Mel Bochner, Ruth Vollmer, and Lucy Lippard. She also met the sculptor Tom Doyle, whom she married in 1961, the same year that she participated in her first group exhibitions. Her first one-artist exhibition occurred in 1963.

A major change in the direction of her work occurred in 1964 when Hesse and Doyle moved to Kettwig-am-Ruhr, Germany, for a little over a year. Doyle had been offered the opportunity to live rent-free in an old factory owned by the German industrialist Arnhard Scheidt in exchange for several pieces of his sculpture, and Hesse went along for the ride. At first she was essentially paralyzed, unable to work and suffering from nightmares at being back in the country her family had been forced to flee twenty-five years earlier. She began to work her way out of her inactivity by making drawings of the factory's abandoned machines, and soon found that she was more interested in these drawings than in painting. Doyle suggested that she use some of the materials lying around the factory, such as plaster and wire; she worked these into her first three-dimensional relief in about December 1964, leading to a major artistic

breakthrough, documented by Hesse in her journal. Until that time, Hesse had conceived of herself as a painter, albeit one who had not yet found her characteristic style. During the remainder of her stay abroad she made only drawings and wall reliefs and, upon her return to the United States, she worked only in three dimensions, abandoning painting completely. Although she continued to feel insecure in other areas of her life, she often remarked that for her, art was easy, that it was an arena in which she was secure enough to take risks.

When Hesse returned to New York in the summer of 1965, she began the most successful phase of her career. Because she no longer had to worry about transporting her pieces, as she had when temporarily in Germany, she was able to construct in larger formats some of the ideas she had conceptualized abroad. To her amazement, her work began to find an audience; she noted with surprise that critics even took an interest in pieces she had not yet exhibited. In Europe Hesse had shown three drawings in the Dusseldorf Kunsthalle where she and Doyle had tandem one-artist shows. In the United States, Hesse's work was included in several major group exhibitions that were organized around avant-garde artistic concepts, and the Whitney Museum and the Museum of Modern Art each acquired one of her works. She seemed to be well on her way to public success with a one-artist exhibition at the Fischbach Gallery in New York in 1968. This turned out to be the only solo exhibition held during her lifetime. In early 1969, after a period of mysterious illness, she collapsed with what was finally diagnosed as a benign brain tumor, and was operated on in April; by August the symptoms recurred and she underwent a second operation. Following another recurrence of the symptoms in early 1970, she died in May of that year. In 1972, the Guggenheim Museum held a posthumous retrospective of her work.

Hesse's art bears a challenging relationship to the conflicting modernist trends that were current as she came to artistic maturity. While she was a student, Abstract Expressionism was the prevalent style, but at Yale she was exposed to a more structured approach to art-making; once she moved back to New York, many of her associates were in the Minimalist vanguard. Although her work does not fit comfortably into either category, it combines the primacy of repetition found in Minimalism with the oneiric quality of Abstract Expressionism. Charlotte Rubinstein describes Hesse's work as "orderly forms deflating into limp chaos." The tension between structural integrity and disorganization can be seen in *Accession* (1968), a geometric cube smooth and orderly on the exterior, the gridded sides of which have been woven with rubber hoses that grow into a wild, tangled interior, and in *Untitled: Seven Poles* (1970), in which seven, seven-foot units, constructed of fiberglass over polyethylene over wire mesh, are suspended from the ceiling like giant worms or distended legs and feet.

Hesse's refusal to accept the traditional conception of the art object as something precious, permanent, or beautiful is an attitude first articulated in the 1960s, and now held by many contemporary artists. Hesse sought to express life's absurdity through unconventional and unlovely materials, as

exemplified by several works made right after her return to the United States that seem to grow off the wall, notably *Hang-up*. She continued to use materials uninhibitedly to evoke strange organic forms in works such as *Ingeminate*, in which cord-wrapped balloons are connected with surgical hose, and *Total Zero*, an innertube encased in a variety of materials including rubber, epoxy, and polyurethane. A photograph of her studio taken in 1965 or 1966 evokes both a butcher shop and a bomb factory. In 1967, Hesse discovered fiberglass and latex, malleable but highly unstable materials that she used in some of her most effective works, including both versions of *Vinculum* and all versions of *Sans*, *Addenda*, and *Repetition 19*. Hesse's attitude toward these works expressed her world view: while she was ambivalent about the impermanence of the latex medium, feeling "a little guilty" about selling something that was bound to self-destruct, she was also convinced that "life doesn't last, art doesn't last, it doesn't matter." Not only were her pieces made out of perishable materials, but their appearance varied from installation to installation. Hesse, like many contemporary sculptors, gave process a privileged position over finished objects.

Although Hesse never overtly addressed gender issues, many of her works seem to deal with sexuality in their evocation of body parts. Her earliest paintings and drawings contain configurations that suggest vaginal imagery, particularly a series of ink drawings made in 1960-61. The drawings of machine parts that she made in Germany have some overtly phallic and vaginal elements. She herself described the early relief, *Ringaround Arosie* (1965)—two circles with centered protrusions painted in bright colors varying from orange to pink—as reminding her of "a breast and a penis" (although Lucy Lippard sees both circles as breastlike forms). Hesse used these breastlike circular forms again in a series of works from 1967, sometimes combined with penile projections. Even those later sculptures that cannot be considered overtly sexual have a somewhat shocking sensuality because the skinlike nature of their material suggests the tactility of loose flesh.

Whether or not her work's physical, tangible quality is related to Hesse's femaleness is problematic. While it would be simplistic to conclude that Hesse's emphasis on organic forms was exclusively "feminine" in contrast to her friend Sol Lewitt's "masculine" concentration on hard-edged, rigid forms, the presentation and manipulation of organic elements in sculpture is especially frequent in the work of women. Louise Bourgeois, active in New York throughout the period of Hesse's career, often made eloquent statements with works that were loosely suggestive of body parts, such as *Hung Piece* and *Le Trani Episode*. Lee Bontecou's pieces, seen and admired by Hesse, are similar to hers in their centrifocal orientation and painful evocation of the body. It would seem that these women sculptors may have done what their foremother Barbara Hepworth said about her own working process, that is, "always worked from [their] bod[ies]." In her essay in the catalogue for a Hesse retrospective, Anna Chave compares Hesse's works with their obvious sexual allusions to Hélène Cixous's concept of *"l'écriture feminine,"* writing the body, but

points out that Hesse's sculpture shows "less a body vibrant with libidinal feeling, than a body in pain."

Hesse used writing it out as a response to the pressures of her life, a way in which to find her own voice in the midst of external stress. Hesse's diary (as Susan Stanford Friedman said about Anaïs Nin's) "functioned as a safe word-shop for self-creation, a place where she could attempt to integrate [her] multiplicity of selves . . . into a meaningful whole." Marianne Werefkin's journal had served a similar purpose for her earlier in the century. The apparent relationship between the events in Hesse's life and her journal entries is interesting. For instance, her move to New Haven to study at Yale, her breakup with Doyle, her father's death, and her tenuous health after her operations all seem to have precipitated an increase in her writing. On the other hand, she wrote less often and less discursively during her and Doyle's courtship and the first years of their marriage, and also during the two-year period of her greatest artistic success. In August 1961, while spending the summer with Doyle, she wrote: "My journal has not been written in. I cannot write as in the past, since then it was a person writing seeking love. . . . A young girl in search of herself . . ." Lippard specifically attributes her later hiatus in journal-writing to Hesse's increased awareness of her public persona.

Especially significant in Hesse's writing is her construction of her persona as an artist. She conceptualized the artist as a heroic outsider in two early pieces, an autobiographical essay and a letter to her father, both written shortly after she left Pratt Institute. The image of the artist as a person who was not bound by society's restrictions appealed to her; it allowed her to accept herself as "a little different from most people" because the "true artist" was also "the true personal misfit." This view of the artist had been held since the Renaissance, but several male artists associated with Abstract Expressionism were particularly identified with the image of artist as outsider. For the most part, Hesse saw this image as a male-oriented one and she never fully resolved the conflict between this definition of the artist and her existence as a "more than socially acceptable . . . young lady" who desired to "have a home, a family." Although her diaries and letters reveal that she read and was moved by Simone de Beauvoir's *The Second Sex*, Hesse wrote that "excellence has no sex."

Hesse's diaries reveal the extent to which she linked her identity as a competent and functioning adult with her identity as an artist. Despite her early interest in and decision to study art, she still did not define herself as an artist in her first sustained journal, begun in 1955 when she was nineteen. At that time, she agonized that she could not perceive herself as an adult although she longed to take a stand in the adult world, to overcome her feelings of mental illness, emotional paralysis, and insecurity. In the volume that covers her years at Yale and subsequent move to New York (1958-60), she saw herself as a more secure, mature, emotionally stable person and then began to believe herself an artist. At twenty-four, she wrote, "I have become a painter, working in isolation, constructively, even productively." The next major group of writings, from

the period in Germany, when she was almost thirty, documents that significant point in her artistic career when she changed from painting to sculpture. Her journals reveal just how she stumbled into sculpture and tell the internal dialogue that allowed her to free herself from preconceptions about the kind of art she should make. "If painting is too much for you now, fuck it. Quit. If drawing gives some pleasure—some satisfaction—do it," she wrote in February 1965, when she had begun to work on machine images. Once she was sure of herself as a professional, she discontinued regular self-analytical writing until she felt the need to write down her experiences after each of her operations, perhaps to convince herself that she was still (or would be) capable of working.

Although such questions cannot possibly be answered, it is tempting to speculate about how Hesse's work would have developed had she lived, and to wonder to what extent her reputation would have survived the next decades. In this respect, it seems significant that her work does not look dated, and that contemporary artists—including those represented in this volume—still grapple with the issues that she raised. Calling her "one of the most important artists of the century," Harmony Hammond notes Hesse's impact on her own work in "her sense and use of materials, the handmade aspect of the work, images of inner forms and feelings given visual form." Howardena Pindell's process of cutting, sewing, pasting can well be compared to Hesse's process of art-making through "obsessive repetition." Hesse's journals provide an exemplary illustration of some strategies used by women artists in constructing their artistic personas. A catalogue raisonné of her works was published in 1988; this, along with a major retrospective of her work in 1992, suggest that her work is finally achieving the recognition it deserves.

SOURCES

Barrett, Bill. *Eva Hesse, A Catalogue Raisonné*. New York: Timken Books, 1988.

Eva Hesse: A Retrospective. Exhibition catalogue (essays by M. Berger, A. Chave, M. Kreutzer, L. Norden, and R. Storr; exhibition organized by Helen Cooper). New Haven, Conn.: Yale University Press, 1992.

Friedman, Susan Stanford. "Women's Autobiographical Selves." In *The Private Self: Theories and Practices of Women's Autobiographical Writings*, ed. Shari Benstock. Chapel Hill: University of North Carolina Press, 1987.

Hesse, Eva. Diaries and papers, 1955-1970. Archives of American Art, Washington, D.C. Microfilm, rolls 1475-77.

Lippard, Lucy. *Eva Hesse*. New York: New York University Press, 1976.

Nemser, Cindy. *Art Talk: Conversations with 12 Women Artists*. New York: Charles Scribner's Sons, 1975.

Rubinstein, Charlotte S. *American Women Artists*. Boston: Avon Books, 1982.

EVA HESSE—SELECTED WRITINGS

EVA HESSE TO HER FATHER, 1953 or 1954

. . . If I want to be an artist, a real artist, I must give myself, my mind and heart to study, not a few hours a day but always. Living on Park Ave., a wife of a doctor or lawyer then one must play the part of a Doctor's wife. . . .

I am an artist. I guess I will always feel I want to be a little different from most people. That is why we were called artists. More sensitive and appreciative to nature. . . .

AUTOBIOGRAPHICAL SKETCH, 1953 or 1954

I am not a writer nor might you say should I be that pretentious to write down my thoughts. An autobiographical sketch of a nobody. But it is precisely because I feel like a nobody, when I should be feeling like a somebody that I shall write. It is precisely because I have felt for the majority of my life in rather unpleasant ways, different, alone and apart from others that my case would be of interest. If fiction is of interest to people for reasons of the life-like qualities centered in the protagonists . . . it can be of great interest for one not to have to fictionalize a character but bring forth from reality such as one is without any make believe. The joys and sorrows can be reexperienced with deeper intensity since the convictions of its occurrences are real and not fabricated.

It is a story of one whom from the outside reveals a rather pretty picture. Attractive with a congenial smile and an immediate amiable personality. The stature is not that of a Vogue model but preferable to those men who admire more flesh and less bone. At this time it is only important in so far as I want to impress on the reader the picture of a more than socially acceptable view of a young lady. Pretty face, pretty body, pretty dress, pretty picture. However, the person does not feel pretty inside.

Furthermore, the nature of experiences in this young life as I have recently been made aware of, has been extremely out of the ordinary. . . .

To complicate the matter some, for the last year our friend has shown and developed talents as a painter, a good one at that. Hence she confronted herself with the universal question regarding the artist and his "special temperament." Was it in her being and feeling estranged and different that she could claim the title of "painter?" The rebellion presently is a direct outcome of what for the time being she has accepted as the answer. That is, that the artist in society, the true artist, is paradoxically also the true personal misfit. It is he by his very nature of being different that he first finds himself having the desire to create a picture, a piece of prose, or a musical composition. . . .

🖋

JOURNAL ENTRIES, 1955-70

January 9, 1955

Felt terrible—just about the worst anxiety in a long time. Each birthday I feel worse . . . I'm sicker than anyone knows. Yet I'm not . . . maybe afraid to see what will come of it. I could almost scream now. It's quiet, scary and only 10:45. . . .

February 18, 1955

I would have been so different if I would have had my mummy, a companion, security, a real person who loved me not in a purely selfish way and would have sincerely told me when I was wrong, would have corrected me with an example or explanation of the right way. Then, now it wouldn't be so hard. I do get hurt easy am revengeful, want to be loved by all and not love in return. . . .

March 30, 1955

. . . I've been all tied up in knots again. Excited, irrational, irresponsible, anxious, in fact this is the first moment I can partly relax tonight to write a few words. An art school is conducive to this way of being. My morning class was incredibly dull with nothing accomplished nothing learned. We stand by like a group of idiots while the instructor walks around explaining, demonstrating, developing, a fear concerning pictures. . . .

The more I see of life, day to day experiences, the more dissatisfied I am with the conditions and with myself. I know so little, how can I really paint or just paint? What am I painting? What do I have to say that's worthwhile and if I spend all my time saying and feeling when will I learn more which in turn will be told? It's like writing memoirs without a previous life.

Fri April 1

Fear of fellow man.

Why do I stay away [from home] these last few nights? I want to help myself get well—to learn to meet and have healthy relationships with others, to keep myself going without cracking up in this house. . . .

Tuesday, April 5, 1955

. . . I don't have to be afraid if I'm different, older—I can be safe and don't have to feel stupid say I have time to catch up. . . . There is absolutely nothing I feel stable or adequate about.

April 27, 1955

Things are turning out OK. Problems of course but I can better understand and cope with them. . . .

Although I did work the last two evenings for almost the first time this year, I am doubting my creative abilities, either their being tied up by some emotional inability to let go, being afraid I'll be making a fool of myself as concerning public relations and in my art work wasting time or some such thing. I see this lack now in 3 kinds of work. . . . I will try still. . . .

September 1958 (second year at Yale)

. . . My book, for whatever I see fit to write in it. I hope it becomes my closest friend since I want it to hold my most honest thoughts whatever they might be. I'm sure this will take time since I feel now apprehensive and awkward, self-conscious, you know like I'm trying to be an Ann[e] Frank, 9 years her senior or something like that.

I'm alone now—finally! So what do I feel but hunger! This time I will choose to fulfill this sensual desire so that hopefully I can return to my new apartment alone and safer to do some constructive work like maybe thinking reading writing and perhaps cleaning and that sort of thing.

I'm sure it's because you're like a new friend I took you along to where I went to eat. Like a new friend or a new dress which you want to confide in or wear all the time.

It's amazing how many new things I'm beginning to do and like doing alone. Maybe after all I'm growing up—maturing if you please—. . .

September 6, 1958

. . . How can I abstain from the most normal functions of all humans? I enjoy and need the comfort and affection I can easily receive from men. The point I guess for me is to find out to whom I really can sincerely return my love. It's not that I don't return affection, I do but I can't deceive myself for long. . . . I need to exchange views and ideas and have the feeling I and my partner can learn from each other and grow intellectually. This view point has been for me at one time more sick than healthy since I felt simply inadequate and wanted plainly to be taught and be intelligent even intellectual vicariously.

If still today I am overly conscious of this the balance has swung greatly to the healthy side. There is truth in that I fear the men who are further in their studies or greatly accomplished in the academic world. They are too great a strain or challenge for me to even try to speak with. I frighten and hide and lose complete confidence. . . .

. . . I think it is good for the public to see a film about an artist, I approved of *Lust for Life*. It was well done and I sympathized and cried and reacted warmly to the familiar actions and discussions Van Gogh and Gauguin indulged in. I never expect any acknowledgment from laymen and it made me realize that potentially we could be respected and treated with regard as any other professional.

Are my inner struggles related primarily to the creative act of painting?

My way of life and my painting being inseparable, does this conclude constant struggle, search and never rest?

Sept 9
. . . I hope I will be able to restrain from the competitive involvements, the exhibitions, prizes and so forth. The less pressures and strains that personally affect me the more relaxed and thoughtful can my powers be directed to constructive meaningful work. Too bad I need any of this type of attention to sustain ego. I will try hard to abstain from these needs. . . .

Oct 17
. . . I am looking forward to having children, home and all these rich significant relations with real meaningful touches of life. If I could in what I do now feel I am touching upon some of these real abstractions I could feel it all had more than superficial meaning. . . .

January 3, 1959
The New Year has come and with it the year of my commencement. . . .
Essentially I am afraid and this is quite disconcerting. I feel I need emotional support of one whom I love and loves me, and some financial security besides. I feel a need of recognition of sorts and yet neither quite know how to achieve this nor do I want to diverge from an essentially honest and sincere approach to painting.

Monday (February-March 1959)
I get so discouraged in painting.
What do I want to do.
What does the image mean for me and what am I trying to attain.

Wednesday, April 15, 1959
Albers' lecture was a summary of all that he believes. It is a doctrine of thought, all inclusive based on one idea. That all past is said and done, this is now and from this only should new ideas and vision come forth. However, how much more can be done with this notion. If every new work is based on this conception it is not new but variations on a theme. He is terribly limited but really maintains one point of view throughout. This is a paradoxically strong and weak attribute and shortcoming.

January 21, 1960
. . . I have so much stored inside me recently I *need to* paint. This would imply painting to be an emotional outlet for me which would be fine evidence to prove so very many cliches.—Certainly a great part but I am overflowing also with energy of the kind needed in investigating ideas and things I think about.—This is a positive creative notion very likely I want also to encourage, develop, bring out, reach into this thing of maturity—to be a big

person—mainly as a person and then as a painter, finally as a *whole being*.

Sunday, April 24, 1960
 Chet is getting married!
 Not to me—
 I am hurt, stunned, regretful, *frightened*!!
 I am though so well contained and controlled these days.
 I am numbed.
 I have now so much fear and anxiety, I really refuse to let go and enter
that horrorful domain again.
 I will fight now harder than before.
 Fight to be a painter
 Fight to be healthy,
 Fight to be strong and enter a real relationship when it finally comes
about.

Sunday (May-June 1960)
 . . . Something is also quite wrong in my work,—it is a fear to really
work it—like with a certain abandonment and discoveries I am almost mak-
ing it too much, molding it, rather I should also let it speak back to me, let-
ting it move and grow.
 I am enforcing a notion on it—and not letting it evolve from itself.
 There is yet too much need for immediate gratification.
 I cannot accept the slow process of development.
 Fear of my own potential, to live, to explore its possibilities.

Thursday evening (July 1960)
 My paintings (last 2) look good to me, for how long this sentiment lasts is
questionable. I just completed 2 in 2 days. They were in progress one month.
 They are painterly.
 They are developed images, they were really built, made and came into
being. Both of them spoke back.

August 8 (1960)
 Monday morning! And with this entry I shall close this book—and hope
that over the two years I have grown and matured. They have probably been
the 2 most eventful years with their ups and downs, the most traumatic for
me—with the greatest of change,—deep inside of myself.
 . . . My own development has progressed rapidly this last year. I have
grown quite independent, psychologically as well and have settled much of
the unnecessary turmoil so persistently afire within. I have come to learn
loneliness but also to live with it. I had been alone previously, but sought out
others; now I live with it alone.
 I have become a painter, working in isolation, constructively even pro-
ductively.

I have become a reader. The thing I've always wanted most but was in too great a conflict with myself to do. I could not turn out of myself, of my conflict to concentrate on the outside world with any real attention.

I have become less selfish and more objective in many of my contacts with reality. . . .

I hope mine are not merely dreams but goals that I will reach.

That of being a real person, a painter—

of getting to Europe.

of having a happy love relationship and family—children

of attaining an inward peace.

Friday, June 19 (1964; in Kettwig, Germany)

Started work in oil paint today. That's new since last 1-1/2 years I used magna paints. Did 2 tiny very expressionistic paintings. Feel rather enthused since I enjoyed them and they seemed real for me. Somehow I think that counts.

What counts most is involvement and for that to happen one must be able to give lots. . . .

It just seems to me that the "personal" in art if really pushed is the most valued quality and what I want so much to find in and for myself. "Idea" painting is great if it truly belongs to a person. However fails when it is externally acquired. I must drop that from my mind, leave it behind, that shadow is superfluous.

—I am afraid to commit myself. I must really learn to forget anything and everyone and let it just take its course on the canvas.

June 28 (1964)

. . . The first 2 weeks here I had terrible, gruesome nightmares. That having lessened I now catch myself daydreaming, fantasizing long involved situations and acting them out, rendering all speeches of the characters. . . .

Friday, July 3 (1964)

Sunday we are here a month; it is hard to believe. I'm still not working right, as I know in my mind one should, but I have been more consistently at work than ever before. There will never be more adequate a situation more created for work than now. Tom feels this also.

Tuesday (July 14, 1964)

Yesterday was very bad, today better but just a little.

Am wondering if not my reasons for working are all wrong. The need for recognition, praise, acceptance is so excessive a need it causes an impossible pressure to live with. My feelings of inadequacy are so great that I oppose them with equally extreme need for outside recognition to establish some equilibrium. I think it is so in everything but greatest in art. Tom can achieve both in the right way, that is he can find himself in his work and then and

therefore achieve recognition. With this I then compete and find no success. No wonder I get anxious. I keep going downhill then, finding failure with myself in my appearance, mentality, abilities, and finally there is nothing at all left of myself.

Monday, November 16 (1964)

Loss again in studio—Made drawings for children on Saturday. They were colorful. Red, Blue, Yellow, Green in squares each one a letter of alphabet—Today made one with numbers 1-10. They are clean, direct, powerful. It set me off again because they are different just enough to make me wonder where am I going, why and is there an idea or too many different ones? Do I know what my vision is. Am I working toward something or the best of all possible worlds—Hard, too hard on myself again—

Why is it that I cannot see *objectively* what I am about. My vision of myself and of my work is unclear, clouded. It is covered with many layers of misty images. Inconsistent.

I do want to simplify my turmoil. I do want to know where I stand in relation to myself so I'm not in for constant shocks.

Thursday, November 19 (1964)

I have turned over a new leaf. I will try another way. If nothing seems to change—I decided to make the change. . . .

In my work too—If crazy forms—do them outright—strong, clear. No more haze.

Like I just never knew anything but compulsions, fears, anxieties. I'll show myself another form. If play acting eventually I'll feel it. Without trying I'll never know.

Simone D.B. [de Beauvoir] writes—woman is object—has been made to feel this from first experiences of awareness. She has always been made for this role. It must be a conscious determined act to change this. Mine is not as much the acceptance of object role as it was insecurities from a broken, sick, unsupportive home. I survived not happily but with determination, goals, and an idea of a better way. Now cope with it no longer hide from the consequences but faced them. To face them, give more in all aspects of living and working. *Risk nothing <—> nothing gained.*

Saturday, November 21 (1964)

. . . In competing with Tom I must unconsciously be competing with my alter ego. In his achievements I see my failures. Thus when I watch him reading I witness my own inner fears of stupidity. Resentments enter most precisely if I need be cooking, washing or doing dishes while he sits King of the Roost reading. . . .

December 10 (1964)

Plaster! I have always loved the material. It is flexible, pliable, easy to

handle in that it is light, fast working. Its whiteness is right.

I will take those screens. Finish one I began in lead. Then get cloth cut in strips and dip in plaster and bring through screen. I needed a structure that is perfect.

When I get sleepy I can fall asleep any place anywhere but when I go to bed having brushed my teeth and hair and turned lights out I immediately wake up. It is not for sleeping all those preparations. It means "go to sleep."

Like "be happy." It works not.

Looking forward to a party—good times—extravagant preparations and fantasizing is bound to be anti-climactic. For me, painting has become that. Making art, painting a painting, the Art, the history, the tradition is too much there—I want to be surprised. To find something new. I don't want to know the answer before but want an answer that can surprise. Now in the morning it sounds not so good but I will try. Told Tom, he said I will get cold hands. I understand why he said that, he is right but I think I must find out.

December 15 (1964) Wednesday

I am so tired and lonely. Conflicted between anger and guilt. Anger at Tom, for not coming home for dinner because he is in studio sleeping. He reads and sleeps and eats occasionally and works. He is very self-sufficient in those areas and needs me not. Since he partakes of nothing else he relies on his own resources. For the rest, he figures I will take care of it. Not feeling capable of this I am constantly worried. We really don't get along so well. Maybe people just can't make it better than this but that is hard to take. *Maybe* the "artist's life" makes for insurmountable tensions.

Fuck it. I sometimes most of the time just want to quit, to give up. Lately even reading has again become difficult. I can't seem to concentrate. I wander into 2 areas of thought or should I more honestly put it worry. One the home front, or responsibility, the other is my work or non-work my so-called commitment to art.

February 5 (1965) [very intense handwriting]

If painting is too much for you now—fuck it—quit—if drawing gives some pleasure—some satisfaction do it—go ahead it also might lead to a way other than painting, or at least painting in oil.—first feel sure of idea—then the execution will be easier.—

Same evening later [more calm handwriting]

I did a drawing. I really like now at moment. Will eagerly await tomorrow, with hope that it will still mean something to me then—I will continue drawing. Push the individuality of them even though they go against every "major trend." Fuck that. So did everyone I admire at the time they started, go against. I must now build on something and the work is, can be, a good point from which to build. . . .

March 26 (1965)

. . . It is now 12:30 A.M . . . I am alone. I feel alone I have nothing—and am afraid. God I no longer believe I have a chance in this world—everything looks bleak to me and I am afraid. I want to die—in that I cannot live. If I felt I could be happy ever I would want to live. I see the beauty, love, happiness, fulfillment and children, families, but I feel I will never have any of it ever. So I want to die. I do now think I am just like my mother was and have the same sickness and will die as she did. I always felt this. I have almost never had a day in my life since memory allows me to recall—had a day without this kind of suffering described today. . . .

April 1965

Copy of letter to Sol LeWitt [Minimalist sculptor and friend]

It is to you I want to talk to about what is on my mind. It is because I respect and trust you and also in this case you are one who understands somewhat me personally and my art existent or non-existent. Also, we strike some diametrically opposed balance reacting emotionally so differently yet somewhere understanding. . . . I want to explain (try to) what I am going through in my work or non-work.

I trust myself not enough to come through with any one idea; or maybe a singular good idea does not exist, and if there would be one among the many I don't think I could recognize it. So I fluctuate between working at the confusion or non-working at the confusion. When not actually at work I nevertheless struggle with the ideas. . . . At this time I can no longer see what I have done nor distill the meaning. I want to too much and try too much—the joke is on me, constant frustration and failure. . . .

What drives us to work. It seems to me some kind of recognition which maybe we can't give ourselves. Mine seems to be disproportionate like I respect myself too little so too much must come from the outside. . . .

One should be content with the process as well as the result. I'm not! I find nothing I do gives me the feeling that this is right—go at it—do it— explore and ye shall find and I am I see and so it should or shall be. I am constantly at ends with the idea, myself and or what I am about.

I mean to tell you of what sits in front of me. Work I have done, drawings. Seems like hundreds although much less in numbers. There have been a few stages. First, kind of like what was in past free, crazy forms—well done and so on. . . .

2nd stage contained forms somewhat harder often in boxes and forms become machine like, real like, and as if to tell a story in that they are contained.—Paintings follow similarly.

3rd stage—drawings—clean, clear—but crazy like machine forms larger and bolder articulately described so it is weird they become real nonsense.

So I sit now after two days of working on a dumb thing which is 3 dimensions supposed to be continuity with last drawing. All borders on pop at least to the European eye. That is anything not pure or abstract expressionist is

pop-like. The 3rd one now actually looks like breast and penis—but that's o.k. . . .

. . . How do you believe in something deeply? How is it one can pinpoint beliefs into a singular purpose? Or then to accept if this is impossible a feat how to just grin and bear it. Grin and bear it. Why it seems to me others do more than bear it they actually can grin. How grand to state a cause or to be ambivalent and ride the waves and feel no serious pain. Or those who do act and are fooled by their own actions and never the wiser shall be. Anything is better than the inactive or no ending suffering of not knowing and trying to know, to decide on a purpose or way of life—a constant approach to even some impossible end—even an imagined end. . . .

April 13 (1965)

The desperation has increased manifold. I have been less anxious regarding my work, a little but there never seems to be an upward slope. Now Tom and I are at the worst point we have ever been. That is I am more dissatisfied than ever, have tantrum fits—it at least gets me some attention and he withdraws more. . . . Never on his own accord anything to have, say, communicate, do with me. He has not once offered to write, cook, walk, cuddle, speak, take me to eat, to a movie, anything for us. . . . Never once a thought of either a dream or a reality or anything practical.

It seems ever so pointless we are beyond the point where either can objectively or in any other way change the situation.

. . . Funny thing—I was so that for two months I could not go to studio. The last two weeks I have gone practically daily, and I saw although I can hardly believe.

May 11 (1965)

I have been working harder than ever in my life and under a lot of pressure. Tom fucks me up over and over again.

December 12, 1965 (loose sheet, back in New York)

I feel the letdown, countdown—my yearly fall into the pit of darkness upon me—It is growing inside and as I am working constantly with a great intensity it is mounting inside. The intensity with which I work is translated then into the gloom of despair. I feel I have nowhere to turn. All my stakes are in my work. I have given up in all else. Like my whole reality is there I am all there. When then I am rejected it is an entire loss,—like all of me. . . .

Thursday? (April/May 1966)

Incredible! Spent evening with Giles and Lee Bontecou. Dinner, they here—we there—I am amazed at what that woman can do—Actually the work involved is what impressed me so. The artistic result I have seen and know—This was the unveiling to me of what can be done what I must learn,

what there is to do—The complexity of her structures, what is involved absolutely floored me—.

Sunday, May 22 (1966)

. . . It's wild. I have many critics writing, believing in me and my work before I have really shown.

Lucy [Lippard], Mel [Bochner], Gene [Senson], [Robert] Smithson all want to write about it! Wild. Mel said he has heard much talk about my work.

Maybe I will be able to live alone,—with work reading and friends—I'll make it.

August 16 (1966)

DADDY IS DEAD.

He is in Switzerland.

August 17 (1966)

Eva will fly home tomorrow.

Daddy will be flown here Saturday.

The day they were to arrive.

I received a postcard this morning. He sent me flight number. Also airport information number.

He wanted me to meet them.

I am numb.

I will help Eva all I possibly can. All she will let me.

Lucy and Mel stayed with me last eve. Mel stayed here.

Sol and Mel and I walked N.Y.C. today. There is not a thing I can do.

Stanley called Tom. Not a word. Dr. called me. . . . last eve. I felt alone. . . .

I find it hard now being alone and Tom not being with me. His not calling now becomes magnified and leaves me with a huge vacant empty feeling.

My daddy is gone.

I will never see him again.

I cannot much longer stand being alone.

The loyal friends and I could not have better friends cannot help me void that fear.

It is true, my books [journals] in a sense are also like your [her father's] books were. Yours were for me to me about me. But you wrote them they were therefore you and about you.

Daddy I will try.

I will try hard.

—It is really only happiness I must learn. . . .

Happiness we all never learned.—

2:00 A. M. (August 24, 1966)

I cannot sleep.

I am exhausted. Hours and hours of people, tension, doing nothing but

going over and over same material. Life, death, sickness. People coming going

I stood tall at my father's funeral. I was big inside, not the scared, help-less child. I loved my father. It showed. That is the best way I can express my behavior.

. . . My only weapon is art, my friends, my accomplishments which they don't understand or I don't feel they respect because they don't respect art nor understand in the way that I do understand. But I guess that I don't respect this yet myself. . . .

My daddy is dead . . . I must go on from here. This point in my life. All say it is so crucial. It is a crucial year for me. My work. 30 years old.

January 24 (1967)

Haven't been able to write. . . .

Now I have much to do and am reticent. Scared of tonight. Yves Klein at the Jewish [Museum]. I have lousy cough sore throat, and do nothing for it but smoke cigarettes. I guess the discontent in my notebooks is the self hate always manifest, in short—sad.

My work surprised Lou. It does this to everyone. . . .

November 1967—Finch College Museum (separate sheet)

Title: The title of this work is *Addendum*; a thing added to or to be added. A title is after the fact. It is titled only because that is preferred to untitled. Explanations are also after the fact. The work exists only for itself. The work must then contain its own import.

Description: The structure is five inches high, nine feet, eleven inches long, and six inches deep. A series of seventeen, five-inch diameter semi-spheres are placed at increased intervals. The interval progression is as follows: $1/8$, $3/8$, $5/8$, $7/8$, $1\text{-}1/8$, $1\text{-}3/8$, $1\text{-}5/8$, $1\text{-}7/8$, etc. The semi-spheres are attached to the structure. They become unified with the structure by means of the repetition of form, and progressive sequence of placement. Equally unifying factors are the surface texture and the rope pulled through the center of each form. The three separate units are then made into one. The monochrome color is a light neutral grey. The chosen nine-foot, eleven-inch structure, the five-inch diameter semi-spheres and the long thin rope are as different in shape as possible. The choice of extremely different forms must reconcile themselves. To further jolt the equilibrium the top of the piece is hung seven feet high.

The cord is flexible. It is ten feet long, hanging loosely but in parallel lines. The cord opposes the regularity. When it reaches the floor it curls and sits irregularly. The juxtaposition and actual connecting cord realizes the contradiction of the rational series or semi-spheres and irrational flow of lines on the floor.

Statement: Series, serial, serial art, is another way of repeating absurdity.

Loose sheets (Summer/Fall 1969)

I feel I need to be high to write this because I feel I don't write well enough and or don't know enough. No one knew what condition I would be in after the operation there were so many possibilities. Also in terms of my personality—and my psyche. To myself I seem pretty much the same. At times the demands I put on myself are impossible. That again is when I become overwhelmed. Why can't I just be. In this last year and now since my illness I just want to live, let go, call the past, past and have another try. My God anyone who knows my history and knows me knows I deserve it. It's true. There has never been a time or scene that qualifies as any norm. Extremes on every side. O.K. It's not that I want averages or norms now, just feel wanting some of what I've needed before but denied, or couldn't cope with or screwed up. I can't work yet, not even sure that I could cope with the possibility as yet

Loose sheet (Fall 1969)

No pathetic gestures, arbitrary crap, injurious insults,—words with all their meanings—words are so hard for me to find, to use to place to put together and then to mean to express—what—am constantly confounded by the attempt. Communicate how else to do this. To manage without especially now when other means are also not as available. I wish I could with words do what I do with my materials. When I become blank I say it's not true speak thus are thoughts, imagine a dialogue, just put it down. Say it then write it.

Loose sheets (December 1969)

If I could go back to the beginning where it all began. I was at Donald's. With students. We finished the box, for Larry Aldrich they went home I went to sleep.—such a long sleep. I did not wake till April 18, evening, not really. I spoke, they say mostly as if I were cognizant of life or what was going on. But I was not. I remember only Monday April 6th finishing the box and going to sleep. A few isolated images and sounds . . . were the only things I knew until the evening I woke then I seemed to know everything. I knew, I recognized I spoke, I smiled, I fantasized, I had visions, I loved, I could not speak enough. I saw faces, I saw their love, happiness. I knew all but not really. I knew I was very ill, I thought concussion not tumor. But I knew my head, serious—no fear—no fear, amazing when fear has a right to be there I did fear death. I knew it was there, could be but I did not fear. Felt drugged knew that too was there. Saw images color, flashes very very beautiful—but despite awareness of high, drug, was not afraid. Wanted to touch, connect with those with was very in touch with them they with me. That is a special in touch. . . .

It's been a long time. April 6th. Today is Tuesday December 9th. Now 1:30 P.M., a long, haul. Today is 3rd day I feel a little better. A little stronger, a little more hopeful, a little less sickness. How grateful I am. I really can be pleased, made happy, and can be so grateful. I can do the other too. Go down,

so easy. Become soulful, but sad, lonely, depressed. But I'm up. Sitting up but the other up because I'm sitting up. Playful but I am because it does mean much to me now. To be up,—I have much to do.

A day lapsed. Sorry about that. Two reasons. Would like to write each day. A challenge. More than a challenge. It has a special meaning for me, I think I would rather be able to do that than anything else. . . .

Have a lot of work waiting for me to get done. Other people. Waiting. Exhibitions. I don't mean I feel pressure. I don't. It's kind of nice. Waiting for each thing I do. It is better than doing and no one waiting to see at all. That is no problem. Artist thinking working doing. Doing is out for now. But that should not matter so. I must learn to transfer doing to another. When one is confident and can act, decide, do—then—no problems. Problems exist where one is indecisive, fearful, reluctant. Therein lies the hassles. Where I worry I cause worry and something goes or can go amiss. For life to go as clear as art.

. . . So much days weeks have passed.

I have not kept writing.

I will try a tape recorder after I get one.

There certainly is the desire to write and work (draw) I can't get started.

Days pass.

I do so very little.

Amazing to see time pass.

So fast.

Doing so little.

I admit to a little more activity now than baths but not much. . .

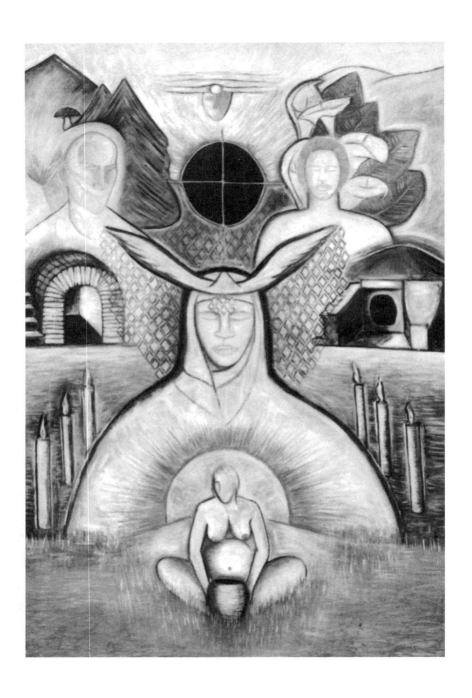

My Sons in the Otherworld, 1989. Oil on hardboard, 4 x 6 ft.

MONICA SJÖÖ

B. 1938

A **LEADING** **FIGURE** in the international Goddess movement, Monica Sjöö has painted numerous images of strong, powerful female figures, often inhabiting ancient worship sites. A self-taught artist, Sjöö was born in Sweden but spent most of her adult life living and working in England. She first received attention from the art world in 1973 with the exhibition of her controversial painting *God Giving Birth* (1968), a large female figure of indeterminate race depicted in the midst of the birth process, "showing the Cosmic creative power of us all." Sjöö is also a prolific writer, the author of two books and numerous articles and poems. Both her written work and her visual art are inspired by her contact with the Goddess, as manifest in visions and dreams and experienced at sacred places. For Sjöö, the Ancient Mother and Earth Spirit is a source of rejuvenating energy that has been denied by centuries of patriarchal culture but to which she believes we humans must return if we are to survive.

Born in northern Sweden, Monica Sjöö was the only child of Gustav Sjöö and Harriet Rosander, who had met while attending art school in Stockholm. Sjöö has described how the differing trajectories of their careers had an important impact on her subsequent development of a feminist point of view. That is, while her parents had started out as equals—two struggling artists—her father ultimately achieved success and respect (despite his lower-class background),

while her mother ended up dying at the age of fifty-four in bitter obscurity. Sjöö recounts how her mother used to tell her "stories of failed women artists," and how she stood back and let her father have the solo exhibition that resulted in the launching of his career. Her parents separated when she was three and from then on she lived with her mother, spending summers on the Swedish coast with her father. Although Sjöö has asserted that her entire effort has been driven by her desire to avenge her mother's life and her destruction by the male-dominated art world, it was not until she was sixteen that she decided that she wanted to be an artist herself. By this time she had run away from home (her mother had remarried and had another child) and she had to support herself as an artist's model.

In 1957 Sjöö's adult life began to take shape. While traveling with a friend in Europe, and supporting herself with odd jobs including modeling, she met the silversmith Stevan Trickey in Paris and, when she became pregnant, married him in Sweden and moved with him to Bristol, England, his hometown. With the exception of two years when she returned to Sweden and several years in the mid-1980s when she lived in Wales, she has lived in Bristol ever since. During her first five years there, Sjöö worked with Trickey making and designing jewelry, while pursuing part-time studies in sculpture and painting at the Bristol Academy of Art. In 1964 she studied theater design at Bristol's Old Vic Theater School, where she first encountered Brechtian theater, which had an important influence on her subsequent artistic development. She spent two years of the mid-1960s back in Sweden, during which she participated in the movement against the war in Vietnam and had her first one-artist exhibition there.

After her return to England in 1967, Sjöö became involved with the women's movement, like many other women artists of her generation during that time period. Her participation encompassed both political and artistic projects. She was active in groups such as the Women's Abortion and Contraception Campaign, Wages for Housework, and the Bristol Gay Women's Group, while also writing, with Anne Berg, a Feminist Arts Manifesto (1971) and three issues of a newsletter, "Towards a Revolutionary Feminist Art." She also began exhibiting her work in group shows with other women artists, culminating in an exhibition at the Swiss Cottage Library, "Five Women Artists—Images of Women Power." It was then that she was accused of "obscenity and blasphemy" for her monumental painting *God Giving Birth* (this and other works had already created a stir when exhibited in St. Ives in 1970). The impetus for this germinal piece in the development of her artistic vision and mission came from the desire to express reverence for women's power. Viewed by Sjöö as a "sacred painting," it was inspired by the home birth of her second son in 1961, a very powerful and spiritual experience, one of the peak events in her life, which she describes as her first mystical experience of the Great Mother's power. The work expresses her "experience both as a physical mother and [her] belief in the Cosmic Mother." During the 1970s, Sjöö participated in "Women's Lives," an ongoing, traveling exhibition that included the work of

several other women artists and was shown in various Scandinavian venues between 1974 and 1976, and in "WomenFolk," an exhibition that traveled during 1975 and 1976. She has described her work at this time, large paintings of powerful female figures, as "appearing archaic" with "an ancient feel."

Another transformative experience in Sjöö's life that had an important impact on her artwork occurred in 1978 when she felt the tangible presence of the Goddess at ancient worship sites around Avebury. She perceived the Silbury mound as the womb of the earth, and "truly experienced the Earth as a living and grieving Spirit and Mother-being," seeing "the hills undulating and breathing for weeks after." That year she also visited the neolithic temple of the Goddess at New Grange, Ireland, to which she responded as if "coming home." Since that time, Sjöö has made pilgrimages to various ancient sacred sites (stone circles, mounds, holy wells) in Britain, Brittany, Crete, and Malta, where she has found the "ancient energies of the Goddess alive and vibrant." She believes that these places are "gateways" to an alternative reality. Her participation in the long-term traveling exhibition "WomanMagic—Celebrating the Goddess within Us"—organized with Marika Tell and Beverly Skinner and later joined by Anne Berg and Lynne Wood—grew directly out of these experiences. Between 1979 and 1987 this show, which consisted of art centered around reverence for the Goddess, traveled to nine British and numerous continental cities. It was usually displayed at alternative exhibition spaces, and the artists frequently offered accompanying presentations. Sjöö's paintings from this period reflect her mystical interactions with the earth, focusing on landscapes of the many holy sites she visited and their inhabitation with figural expressions of the Goddess.

The 1980s brought increasing success to Sjöö's professional life, accompanied by intense personal pain. As a result of her empathy for the earth, in the early 1980s she moved to a cottage near the Irish sea in Wales, in order to escape the devastation of urban blight and to live closer to the natural rhythms that she worshipped. Professionally, it was a period of consolidation. Her works were included in other exhibitions besides the still-traveling "WomanMagic." Her work in Goddess lore was becoming more well-known and, as a result, she was asked to make presentations at several important spiritual workshops investigating the eternal presence of the Goddess. Additionally, she had reached a mature point in her artistic style. While her paintings from this period retained the "ancient feel" of her earlier work, they were more completely realized as vehicles that expressed the mystical union of spirit and earth.

The illusion of well-being was abruptly shattered in August 1985, when Sjöö's fifteen-year-old son, Leif, was hit by a car in front of her eyes while they were vacationing in southern France. She has described how his death plunged her into a state of despair, one that only intensified because shortly thereafter she learned that her oldest son, Sean, was suffering from cancer. She moved back to Bristol to be with him until his death, in July 1987, almost exactly two years after his brother's. Sjöö was plunged into a devastating period in which she experienced the dark side of the Goddess. However, she came

through to the other side of grief—partially through her eloquent writings exploring her extreme pain and the feeling that she could not go on—and has integrated those experiences with a renewed sense of the preciousness of life and reverence for the Goddess of both dark and light. This awareness has also been expressed in some of her most powerful paintings, *Lament for My Young Son* (1985) and *My Sons in the Spirit World/Spiderwoman* (1989). Her rededication to work has been reflected in her paintings' inclusion in several exhibitions since the late 1980s, including "The Goddess Reawakening" (1989), "Stones and the Goddess" (1990), and, most recently, "With Your Own Face On" (1994).

Monica Sjöö has made especially important contributions as a writer. Like many other women included in this volume, she has felt the need to express her "thoughts and visions" via the written word, and writing has provided her with another means of exploring the major themes in her artwork. During the early 1970s, she responded to "the urgent need to communicate through writing" in order "to clarify to [her]self and others where [her] images came from." Her desire to better understand some of the images in her early paintings led her to the research that was first published in pamphlet form as *The Ancient Religion of the Great Cosmic Mother of All* (1975). The original text went through many transformations, during which time the American poet Barbara Mor became her co-author, and the book was finally reincarnated as *The Great Cosmic Mother* (first published in 1987 and revised in 1991) with reproductions (some in color) of many of Sjöö's paintings. In her introduction, Sjöö explains that because of her sons' sufferings, she was unable to focus on the book when it needed to be rewritten, and consequently Barbara Mor is its main author. Sjöö's experiences with her son's unsuccessful attempt to find alternative treatments for his cancer led her to the five-year project resulting in her latest book *New Age or Armageddon: The Goddess or the Gurus* (1992) in which she exposed the reactionary patriarchal prejudices of many New Age thinkers. (Many of these ideas were also explored in shorter articles and poetry published in alternative periodicals, which is how they are represented in this volume.) She has authored another book based on her pilgrimages to ancient sacred sites, *Spiral Journey: Stages of Initiation into Her Mysteries*. Several of Sjöö's essays have been anthologized and she is a frequent contributor to numerous Goddess-oriented publications. Also, Sjöö's importance as a thinker involved with the Goddess movement extends beyond her influence as an artist and writer. Since the mid-1980s she has participated on both sides of the Atlantic in many workshops dedicated to exploring women's spirituality and connection with the Goddess.

An important consideration related to Monica Sjöö's paintings concerns the tension they display between their aesthetic form and political content. The political message is particularly evident in some of her earlier works in which the image is accompanied by a stenciled textual phrase, such as "Women's Work" or "Celebrating the Goddess in Crete 2000 B.C.–Europe 1973 Serving Man." In a 1984 interview, Maria Vincentelli asked Sjöö about the relative

importance of her desire to use her art to convey specific political meaning and to make an aesthetic statement. Sjöö stated quite emphatically that propaganda was not good art, but that she was "seeking a form which expressed what [she] wanted to say about [her] experience," essentially the goal of all artists. She continued: "Without that excitement and tension in an image it does not convey the message you want to get across." In their literary quality, their ability to be "read" descriptively, Sjöö's paintings contradict many aspects of artistic modernism. Sjöö, in fact, sees this as a strength, and is grateful that her lack of formal education allowed her to circumvent the European modernist tradition and its internalized, patriarchal self-censoring restrictions about what is artistically permissible. The alternative aspect of her aesthetic is consistent with her own self-identification with the working class and the fact that she was self-taught, both artistically and aesthetically.

Sjöö considers herself a shaman and painting a "shamanistic act, a spiritual activity." While this sentiment is shared by Magdalena Abakanowicz, Harmony Hammond, and Cecilia Vicuña about their own artwork, for Sjöö there is an identification between the ecstasy of artistic creation and the evocation of the Goddess's presence, as there is with some other women artists, including Mary Beth Edelson, Buffie Johnson, and Ana Mendieta. A primary purpose of Sjöö's art is to "stimulate the sort of life-participatory dreams that may awaken us to the creative evolution of consciousness." As Gloria Feman Orenstein has pointed out, in her paintings Monica Sjöö has created a "contemporary iconography for the Great Cosmic Mother." Drawing upon goddesses of many cultures who have spoken to her in dreams and visions, Sjöö has created images of female strength to empower contemporary women, much as Audrey Flack has done in her recent sculptures. By reconnecting with the manifestations of the Great Mother, she has contributed to the process of reclaiming both the earth and women's bodies from their subjugated position in the dominant culture.

SOURCES

Orenstein, Gloria Feman. *The Reflowering of the Goddess*. New York: Pergamon Press, 1990.

Sjöö, Monica. "Journey Into Darkness." In *Glancing Fires: An Investigation in Women's Creativity*, ed. Lesley Saunders. London: Women's Press, 1987.

_____. *New Age or Armageddon: The Goddess or the Gurus?* London: Women's Press, 1992.

_____. "Tested by the Dark/Light Mother of the Other World." In *Voices of the Goddess: A Chorus of Sibyls*, ed. Caitlin Mathews. Wellingborough, England: Aquarian Press, 1990.

_____. "Thoughts Inspired by Reading *Gender and Genius: Towards a Feminist Aesthetic* by Christine Battersby and *Voicing Our Visions: Writings by Women Artists* edited by Mara R. Witzling." *From the Flames* 7 (Autumn 1992), pp. 28-32.

Sjöö, Monica and Barbara Mor. *The Great Cosmic Mother: Rediscovering the Religion of the Earth*. San Francisco: Harper San Francisco, 1987; revised edition, 1991.

Tucker, Michael. *Dreaming with Open Eyes: The Shamanic Spirit in Twentieth-Century Art and Culture*. London: Aquarian/Harper San Francisco, 1992.

Vincentelli, Maria. "An Interview with Monica Sjöö." In *Visibly Female: Feminism and Art Today*, ed. Hilary Robinson. New York: Universe, 1988.

MONICA SJÖÖ—SELECTED WRITINGS

❧

FROM "TESTED BY THE DARK/LIGHT MOTHER OF THE OTHER WORLD" (1988)

It is not easy to write of my experiences of Her, the Crone, Hag, Dark Lunar Mother of Winter, death, and rebirth. She who has taken back to Herself two of my precious sons in the last four years. Now approaching my fiftieth birthday, on New Year's Eve 1988, I am becoming like Her, who is, paradoxically, also white—as white as the silver hairs and the white bleached bones.

The Patriarchs fear the Dark Mother the most, they fear Her lunar-menstrual powers as well as the post-menopausal woman's clairvoyance and Otherworld powers. They refuse to be recycled by the life-in-death Goddess and seek bodily immortality from a "father God" who never created them nor gave them birth. They have forgotten that the Universe is born, not made or manufactured, in a process of becoming. The Birthing Woman is also Thought Woman or the Cosmic Spider who weaves our beings and destinies. She creates the great webs of luminous fibres that vibrate spirit into matter in the beginning and return us back into Her spirit realms at the end. The great Mother is not an "archetype" created by the human mind. If anything, we are thoughtforms emanating from Her dreams.

Paradoxically, in a world where the patriarchs blame the Mother for the existence of death and physical mortality, they have themselves set the stage for the worst possible deaths and the possible annihilation of all nature. These would be sterile deaths, that is, without hope of transformation and rebirth from Her magical womb. Patriarchal societies are anti-evolutionary, static, and antispirit and are based in alienation, separation and loss. Barrenness is a patriarchal condition and the wasteland is the man-created desert in which the blood-waters from Ceradwen's magical and menstrual cauldron have dried out—the sacred wells forgotten and left untended, the oceans dying, the rivers and serpentine underground waters polluted.

In the mysteries of Demeter and Persephone in ancient Greece, dark

Persephone dwelt voluntarily in the Underworld as the Queen of the Dead for six months of the year and then returned to Her grieving mother Demeter as Kore, the Maiden of spring, bringing with Her rebirth, new life, light and joy to all nature. It was Demeter's grief at Her daughter's absence that caused the death of nature in the winter months. In patriarchies, where daughters are turned against and separated from their mothers, Persephone never returns as Kore and Demeter's grief blights the Earth.

In the Celtic world, Brigid/Bride returns from Her mother Cailleach's mountain fastness at Imbolc (which means "Ewe's milk") in the early spring-time—She is the Serpent that emerges from the mound. When She dips Her finger in the waters of wells and rivers, they start to warm. She is the white milk cow, the Milky Way, the white sea foam and the white mare of shaman-istic otherworld journeys. She is White Buffalo woman of the Lakotas who taught the people the sacred pipe ceremony. She is the "White Lady" often seen ghost-like, by the sacred wells and trees. She is the electromagnetic ser-pent-power of the life-creating waters and She is also Kundalini, the cosmic generative sexual fire. She is the sacred flame within the mother's womb, as well as of the hearths, temples, kilns and ovens, She is Solar fire, She is mind, clairvoyant powers and inspired poetic utterance, She is the radiant Moon in the dark night. Hers is the white astral light of the spirit realms.

Cailleach, who is Her own mother, Crone-self, is a northern Kali and is as black as the fertile black soil and as blue as the Underground waters. She is the enormous old woman of the mountain ranges, of the Scottish highlands and islands who raised the stone circles, cromlechs and mounds according to legend. She is the ancient chthonic Mother of Earth, stones and the under-ground winter realms of the lunar neolithic cultures.

These last three years I have lived through a winter grief and darkness of mind. My young son Leif, only 15 years old, was run down and killed by a car in front of my eyes, on a busy road in the Basque country in the south of France, in August 1985. My oldest son, Sean, just 28 years old, died from non-Hodgkins lymphoma, a cancer of the lymph system, in July 1987. I have expe-rienced a great deal of fear, uncertainties and doubts these last years. I have feared the Mother Goddess, strange as this may sound, and even my own work. I have not been able to understand the sequence of events that led up to my young son's tragic death. . . .

I know that even before my young son died, I had felt an increasing despair at what is happening in this world. I had lost much of my hope and optimism from the earlier days of the women's movement when I believed in the inevitability of women rising up and the Goddess re-emerging within us. I had also felt that I was going into the Dark, aging aspect of myself. When we buried my son's ashes, in the centre of the medicine wheel in the Tipi village in the Black Mountains in South Wales, I had screamed, "Dark Mother, I who am seeking you. Why have you taken my young son? Why, oh, why?" I also

whispered, "I hope you know what you are doing."

I had not been able to understand why I had seen the awesome face of Wyrd, the Ancient One, on the rock wall of the cave underneath Cerrig Cennan castle near Llandeilo in Dyfed. We had gone there—six women—to celebrate Imbolc in the early spring of 1985. Down inside the rock there is also a holy well and we were sitting by it, meditating and singing, when suddenly I turned my head and "saw" in the candlelight the hooded white ancient face of the Crone. Heavy black crevices in the rock created an impression of eyes, nose and mouth. I remember my feeling of utter astonishment and awe, a sense of chill running up my spine and my hair standing on end. The woman sitting next to me also "saw" Her face and we both did a drawing of Her, but when we went up closer, the face was simply not there.

Thinking back on this after my son's death later that summer, it felt ominous that I should have seen the face of the Dark Mother/Crone on the very festival day/night of the Bride, the Maiden daughter. However, I should have understood, as I do now, that all of the Lunar Goddess's Quarterday Festivals of the cosmic and seasonal year are also the times when we encounter the magical ancestors and undertake shamanistic journeys into the otherworld realms. From the Spirits of the Blessed Dead we receive powers of prophecy, clairvoyance and healing. Also, Brigid and Cailleach are, of course, one and the same. . . .

The child grows in the dark womb; the seed germinates in the black fertile soil during the winter months. It is in the dark night that we can see the stars of Cosmos. All ancient words for mind and mental visionary activity come from words for Moon, the greater Mind. Life was created in alternating darkness and light: without dreams and the night-time we cannot live. The combined electro-geomagnetic energies of Earth and Moon stimulate the pineal gland, our third eye centre of vision into dreamtime and the spirit world. It is in lucid dreams that we communicate with our beloved dead ones. The neolithic peoples celebrated their Goddess in the light of the full Moon—or in the dark of the Moon for more secret mysteries—in the stone circles and by the sacred wells. Light is born from womb of darkness. The human child travels through the dark birth passage out into the light and the newly dead travel through the dark tunnel into the light of the astral world. Women shamans guarded the passage between these realms both ways.

The ancient neolithic Irish would witness the death and rebirth of the Sun child, from the earth and stone womb of the Mother at New Grange, at the dawn of the winter solstice each year.

Patriarchies, on the other hand, are founded in matricide and the denial of the lunar dreamtime consciousness (now called the "unconscious") that links us with the greater mind of Earth and Cosmos. With divisive patriarchal religious thinking, one has the absurd and obscene spectacle of male solar light gods attempting to slay and conquer their own Mother and Creatrix, now called monstrous Leviathan or Dragon of Night and Darkness. Without our night-time third eye awareness we become, however, dangerous aliens

on this planet whose Mother heart and Lunar mind we are no longer able to be in tune with.

I somehow feel that my young son's death is part of a larger tragedy, a reflection of a general illness and/or an omen of things to come. When he died, it was as if time froze and absolutely nothing made sense any more. I was, and still am, in a state of shock. . . .

I felt that, ultimately, my own work and exhibitions had harmed my son. I, who had for so many years written and talked of the living dead in the Mother's magical other world, now felt that all this had been just so many words, that I had understood nothing and had no right to speak, write or paint any more. I am now doing some work again.

Unfortunately, I had been involved in a women's Full Moon celebration in the house we had visited in the Basque country the very night before my son was killed. This does not help matters for me now. The celebration had sparked off hostilities against me and my son in some of the women who had felt uneasy about such magical work. I had also not been aware that there were quarrels and difficulties among the British women who had rented the large house for a holiday, nor had I known that my son would not be welcome because of his age, size and gender. There were other boys present but they were younger. It seems that my son became the focus for the already bad feelings going around. An argument the morning after the Full Moon ritual left my son upset and therefore more vulnerable and accident-prone. The fact is that this connection became firmly embedded in my mind and I have felt fear at the thought of being in a women's gathering doing any spiritual work. This fear goes against the grain of anything I have ever believed in, but I have had to stay with it for now. . . .

During a number of years before the birth of the new women's movement and before feminist and Goddess artists came together, I felt a great isolation. What kept me going and gave me confidence to do my work—living as I did then in poverty, with no formal art school training and having at that time two small children—later they were three—was the memory of my wonderful and dreamy artist mother and having a sense of being used as a medium by ancient women. Painting became to me a shamanistic journey into other realities where past, present and future coexist and bringing back with me visions from ancient women cultures as well as those of a possible future. . . .

The second initiation into the Goddess [she described her first, the home birth of her second son, in an earlier passage], which changed my life and work, took place early in February, 1978, at Avebury/Silbury. I had gone there that day with a lover and we had taken some magic mushrooms. The ancients used mind-expanding substances to gain vision into other realities as do present-day tribal peoples. This is what I wrote at the time:

"Five days after Imbolc we arrived on a beautiful late winter day at Avebury village, which is built within the stone circle—the largest in Northern Europe. Amazing, rough, squat, colossal stones seeming like

human bodies and gigantic heads. Here, one feels, is the centre of the Mother Goddess. What would it be like living in this village, being part of Her living body? The earth around the stone circle is shaped and moulded in ridges and ditches. Many of the stones are mutilated, like half a head chopped off—painful to see. Many are missing and ugly-looking triangular shaped stones have been positioned to mark where they fell and once stood. They look like the gravestones they really are. During the Burning Times/Witch-hunts, the stones were also tortured, split apart and buried. The Church feared their power as they feared the power of women. There still remains a great power, beauty and mystery in this place and these stones.

"We followed the earth-works around the entire circle and then slowly followed the remains of West Kennet stone avenue as it winds its way across the fields. I now long to arrive at Silbury mound, the great pregnant earth womb. We have seen Her in the distance on the road from Bristol and from the village.

"I clutch a stone in my hand for safety as we plod across the ploughed and muddy fields, having always to cross barbed-wire fences. By now, gripped by panic, unable to either remain this side of or to cross over the ugly, now seemingly so offensive fences, wanting to find comfort and refuge with the breast/eye/womb-belly rising out of the landscape so naked and vulnerable yet so powerful, we scramble through what seems like marshland and wilderness. I feel as if transported thousands of years back in time.

"We come closer to the womb and discover that on the road by Her side there is parked a square, bright red lorry with the name "Peter Lord" written on its side. "Lord," oh no, is there nowhere, not even in the Mother's presence, when one is allowed to forget about patriarchy's deadly god?

"Nearer the mound we discover notices saying 'The monument is closed due to erosion.' Silbury, surrounded by water at this time of year, is everywhere enclosed by treble layers of barbed-wire fencing. Feeling stunned, the earth appears to move and flicker. Some swans are frozen motionless as they swim in the waters of the moat and I feel trapped in eternity. Some teenagers scramble past us up Silbury and we follow them, hoping that they will not talk to us, we who are of another time. I feel fear at treading on my Mother's belly, the grass matted like hair and uncared for. A man shouts from the road, 'Get down from there.' We sit down on the side of the mound furthest from the road, the teenagers disappearing out of sight and hearing.

"I am overtaken by a sudden unexpected and enormous grief. The Mother, the entire mound, cries through me, I feel Her pain in my own womb. I am at one with Her, grieving for our lost women cultures, for the pollution and death of Her nature all around us. What have they done to you, Mother, what they done? Man shouts from the road. I feel overwheming fear—I am a hunted female animal, I've got to flee, get down from Her womb and away from the road, away. The road appears to stand for everything alien and evil—cars, men with patriarchal authority, oppression. Shots are heard

regularly in the distance, coming from Salisbury Plain, which is Ministry of Defense land and used as a firing range. Aeroplanes are overhead—evil, evil danger.

"We almost run, slide down, walk slowly with great effort, tracing our way back around the moat and into the fields from where we had come. We feel a sense of victory because we have been able to avoid the road—we are safe, we are still within Her Nature. I look at the mound—it's so exposed and vulnerable, like veins of a breast streaking the sides—again there are tears and grief.

"I now understand what Mother Earth means—something so enormous and powerful. My body is like Hers—gentle and violent, powerful and vulnerable, dynamic and peaceful, matter and other world spirit.

"Slowly we follow the river Kennet, feeling myself to be floating along with Her, flowing with the wonderful water formations, dancing along with her serpentine rhythms. Suddenly I come to a sharp halt at the sight of the pollution of the waters and the rubbish accumulated here—anger, anger. More barbed-wire fences. We follow the direction leading to West Kennet Long barrow and walk up the muddy track. We see the huge stones covering the entrance. We walk around them and suddenly we see the stark blackness from the entrance into the dark—this time underground—womb. Fear being swallowed up by the so intense darkness, but I overcome the fear and enter. It's a totally other world in there, one of mystery, power, peace. Sounds are amplified in here and the stone chambers appear for a timeless moment to breathe and beat like a great heart. I feel like gyrating, feel like a spiral, then I have a great urge to sleep on the floor in the innermost uterus chamber. There is a great stillness in Her living darkness. Feeling infinitely 'higher' within this tomb-womb-temple than when reentering the daylight world outside. This is not just a grave, it is the place of journeys into the spirit realms to connect with the ancestors. I feel strange and powerful vibrations. Here there are no feelings of sorrow or vulnerability—this is the abode of Cailleach, the gigantic Crone Grandmother. It seems that we are welcome.

"We walk down the muddy track and have a feeling of great tiredness—just want to sleep. We retrace our way back to Avebury village and around the stones, then we drive off. We had been there in all seven hours. . . ."

"THOUGHTS INSPIRED BY READING
GENDER AND GENIUS: TOWARDS A FEMINIST
AESTHETICS BY CHRISTINE BATTERSBY" (1992)

Christine Battersby writes that "the way generations of scholars, creative writers and critics have given a male gender to genius is a field still almost entirely unexplored." In fact it has been taken as some kind of fact of nature that "genius" or great talent does not reside in women, and as an artist I have

been on the receiving end of that assumption all of my life. It was a more bla-
tant and undisguised assumption when I started out doing my painting as a
self-taught artist in the end of the '50s than it is now.

I want here to give the background for where I come from and why I
find this book important. . . . I am what you could call a "Goddess," Earth
Mysteries artist and am a founder of the Feminist arts movement in this
country [England], even though I am Swedish by birth and grew up in
Sweden where both of my parents were practicing artists. My mother left my
father when I was 3 years old and I grew up with my mother who I loved
dearly. She was a woman of great intelligence, talent, kindness and integrity
who couldn't bear domesticity or what is required of a woman for her to be
thought of as "feminine." She was a dreamer and early feminist although she
didn't know it. She was an early "drop-out" from a northern bourgeois family
and had married "below her class" to my father who was from a southern
Swedish peasant/working-class family and had grown up in poverty and
hardship. It was with great difficulty my father managed to work his way to
support himself through art school and academy in Stockholm where he met
my mother. Many years they painted side by side as comrades, they were
both talented painters. My father, however, was put down a lot by the arts
establishment and critics of the time for not following fashions and obstinate-
ly remaining faithful to earth colors and his love of the land and ordinary
working people. The contradiction was that in spite of this, his unprivileged
background, he still identified totally with the bourgeois myth of the male
genius. By this I mean the "artist bohemian" who in the name of "greatness
and genius" was forgiven for his ruthless exploitation of all around him . . .
mainly the women in his life; women who made love to him, posed for him,
bore and looked after his children, cooked for and nursed him, etc. Of course
this is what all men did, but the male artist often even more so.

I heard my mother speaking of women who had been her friends during
the art academy years who like herself had married their contemporaries and
had ended up either as glorified housekeepers in their artist-husbands' ever-
so-tasteful homes, or they had been driven crazy or committed suicide. Even
though my own mother insisted on carrying on painting even after I was born
(in 1938) she did stand back when they were offered an exhibition that
turned out to be the turning point in my father's career. He made it and
became a respected and well-known artist while my mother and I, after her
divorce from him, lived in poverty. She never made it and died at the age of
54 from unhappiness and in obscurity. It was also basically after I was born
that frictions developed between them as I was unwanted by my father who
then became jealous of me and treated me badly. Neither of them had any
idea of how to look after a small child nor did they have the domestic setup to
do so. They were poor and just wanted to paint. My father was also jealous of
my mother's painting and had been known to turn her paintings against the
wall when buyers came to see both of their work. In spite of his working
class background he could still point to and identify with the European tradi-

tion of "great male artists" while as a woman artist my mother could do no such thing. My father's toughness and obstinacy stood him in good stead in the male competitive art world while my mother lacked confidence, was very sensitive and proud, and felt insults and indignities very badly. She could not take the way women were/are at all times diminished, marginalized and ridiculed.

At the time it was extremely rare to find a woman-identified artist—this was also so when I seriously started to paint in the late '50s, early '60s—and patriarchal attitudes towards women in the art world, as everywhere else, were undisguised and rampant.

Women's artwork was supposed to be pleasant, small, emotional and decorative . . . it was not supposed to speak of universal matter from a woman's point of view, women were not to define reality, either on Earth or in other realms. It was unacceptable that we base our women's creative art in our actual women's experiences and spirituality, and from the beginning I suffered many insults and put-downs from other artists (male), from critics and the male art establishment, for precisely refusing to conform to their projections of what a woman artist is meant to be. I was tougher than my mother and survived to fight back.

The odd successful woman artist in the recent past was generally of a privileged family, childless, and could therefore be treated as a token "man" in the artist's circles. . . .

I remember my father bragging to me when I was only 12 years old how he "screwed" his models. No wonder I refused ever to pose in the nude for him and was mortified when at the age of 16—homeless, having run away from home and a cruel stepfather, and penniless—I found myself having to earn a living doing casual work as a nude model in art schools and privately. At the time I was incapable of holding down any kind of job being as I was in a permanent state of depression and trauma. I have many stories to tell of the predatory sexual attitudes of male artists and the way they viewed the model as cross between an object, like a chair or an apple, and a part-time prostitute.

In the Western bourgeois male arts tradition the male artist plays at being "God the Father" who masterfully forms and creates the female object/nude on canvas, in clay or stone. John Berger, the socialist art historian, wrote in *Ways of Seeing* in 1972 that women are meant to be the passive object that is seen and observed by the male artist, viewer and buyer, and he points out just how similar are the images of women in pornography, advertising and "art." I for one am sick to the teeth with the thousands of female nudes that hang in museums and art galleries posing as "great art."

But . . . when in 1968 I did my painting *God Giving Birth*—in which I stated my then growing understanding of the Goddess as the great cosmic and creative power who gives birth to all of life from her womb—I was nearly taken to court for "obscenity and blasphemy." The image is large, it is not pleasing or seductive, it is stark in color, it is based in my own experience of

natural home birth (in 1961) and the Goddess is not a white woman. All of which makes it unacceptable apparently. . . . An expression in Sweden for a powerful and dynamic painting is that it has "prick" in it! My father whole-heartedly agreed with Renoir, the French impressionist painter, when he said that he "painted with his prick."

I am convinced that the reason I have been able to do my painting and think my own thoughts is because I am self-taught, never having been to either university or art school where mostly all the rules and standards are defined and decisions made by patriarchal males or tutors. Many an art student has had to recover from her training, as if she's been on a constant battlefield.

Christine Battersby writes that the Latin word "genius" originally meant "the begetting spirit of the family embodied in the Paterfamilias (the father as owner of women, children and servants/slaves) in the male gens or clan, and that even in English the word is associated with male sexuality. The Romans were very patriarchal (rule by the fathers) and militaristic. To them the symbols for fertility, the harvest and the very land itself were metaphors for the father's seed and the "genii" were male protective spirits. Greek classical philosophers such as the Stoics had thought that "the fiery creative breath" was "an active forming principle analogous to the male seed" and that the universe reproduced itself like an enormous male animal ejecting sperm.

In fact all patriarchal Iron Age peoples along with the Romans and the Greeks wanted to believe that a supine and passive Earth Mother was but the receptacle for male potency, a Sky Father's fertilizing and masterly powers. They denied the creative, lifegiving and transforming powers of the dark soil and of the Dark Mother of the spirits, She of the Under-the-Earth or Otherworld realms. They denied women's active and powerful menstrual and lunar sexuality and they denied the Lunar Mother, Queen of the night sky, who gives the powers of mind, psychic powers, visions and dreams. . . .

Relevant to this discussion about "genius" and women as creative artists is the fact that women who were the original potters would presumably also have created the figurines, carvings and statuettes of the Goddess in pale-olithic and neolithic times. No one knows for certain the gender of the cave artists, but we know that the cave itself was the womb of the Mountain Mother who was the Mother of the animals portrayed in there, a place of death and rebirth and shamanic initiations. Shamanism is a women's ancient technique of ecstasy and trance states and (as Vicki Noble writes) the original shaman is the birthing woman who brings the spirit from the Other realm and risks her own life doing so. Shaman women acted as midwives and also as guides to the dying. . . .

Christine Battersby writes that over the centuries "genius" became creative rather than procreative and "he" wrote, drew and painted reality into existence and Goddess Nature does his bidding. By the end of the 18th century "genius" had acquired romantic grandeur. The monotheistic christian religion had swallowed the Goddess, and Her qualities had been appropriated by

Jehovah, the ancient Wisdom Goddess of the Hebrews had been incorporated into the Jesus figure and now the male artist/creator desired the male-defined "female qualities of receptivity and passivity." Psychoses, hysteria and the troubled unconscious were female domains and the great male cultural creator desired to be an inspired madman, a "feminine" degenerate, a super-human androgyne god who included within himself all realities and both genders. Women found that men were even seeking to appropriate their status as "Other." Battersby points out that "the notion of the great Outsider serves to camouflage the achievements of creative women." The Romantic view of genius and creativity is that the exceptional creator is LIKE a woman who procreates . . . but is NOT a woman who "procreates" and a creative woman is seen as a contradiction in terms in patriarchal societies where creative energy in itself is defined as male and originating from a male godhead. But of course . . . men would not have insisted that creativity is a male prerogative unless women created—and unless men were afraid that women's creations would be taken seriously. . . .

Because I take it for granted that conscious, creative, clear-thinking, intellectual women—who were also artists, dreamers and psychics—were the initiators and creators of ancient cultures, I find it extremely difficult to get my head around the discussion of "nature versus culture," and gender in relation to this, which seems to be so popular in academia. There it seems to be taken for granted that woman equals "nature" (passive, silent, inarticulate and purely instinctual are the assumptions) and man equals "culture" (divorced from and opposed to nature, rational, individualistic, etc.). . . .

The French surrealist artists praised the femininity of male creators, they admired "female madness" but found it difficult to handle actual powerful women artists such as Leonora Carrington. As Battersby says, men can be "feminine" and superior at the same time, passivity and egolessness is only a failing in the oppressed and in inferior types. She says that yet again so-called post-modernist art marginalises feminist art and that we still lack a vocabulary for describing female productivity in a non-reproductive way . . . art works are still called "seminal," "virile," "masterly," etc.

Most of all we seem to find it so mindbogglingly difficult, after thousands of years of patriarchies and the diminishments of women, to envisage the women in their full powers who laid the foundations for human cultures . . . woman who bled, who gave birth, who created, built, planted and harvested, spoke oracles, communed with the ancestors and had visions, raised stones, tamed animals and watched the stars. . . .

SELECTED POEMS

"NEW AGE OR ARMAGEDDON?"

When the patriarchal god rules
you get the mothers bored out of their minds
sitting in their formica-topped kitchens
watching televisions and living on tranquilizers.

> Poisons on the land
> poisons in the seas
> poisons in the minds

A world ruled by geriatric old men
who say: "After us the flood,"
or is it the nuclear furnace,
and who cynically care less
that the Earth—our Mother—is now dying.

> "Praise the Lord" they mumble and pray
> to a sterile and death-dealing god
> within whom we never dwelt
> and of whose being we never partook.
> Having never known the cost of life
> as the mothers do
> they easily dispense of it too.
> They send the sons of the mothers to die
> and they rape the daughters
> sterility and violence being a patriarchal condition.

Separatist brotherhoods banding together
against mother-produced and abundant life
watched over by the radiant Lunar Mother
who gives us visions, oracles and dreams.

> We are living under the reign of left-brain terrorism
> and vengeful entities created by the patriarchs
> who can only fathom the most unsubtle connections.
> They set out to override and straighten out
> the spirals and labyrinths of psychic paths
> and lunar convolutions into linear motorways
> on which their intellectual tanks
> can crush anything that aspires to live and dream

in this beautiful Goddess-born Universe.

Beware that the Light from Summerland,
Her magical astral Otherworld,
isn't brought forth perversely
in the blinding light of nuclear devastation
"fathered" by the priesthoods of a death-dealing Solar god
who, by now, denies that he was ever born.

 I say, by now, because the Ancients
 clearly perceived that he, the Sun/Son,
 was born anew each year
 when at Midwinter the dying rays of the Sun
 were seen to enter the cave and tomb/womb
 dwellings of the Universal Mother.

Amongst many ancient peoples the Sun, itself,
was the life-giving and benevolent Goddess
in Her golden and embracing radiance.

 Never, never forget that Light is born out of Darkness . . .
 that we, ourselves, dwell in the protecting
 and nourishing darkness of our mother's womb
 before expelled into the harsh light of day
 that seeds are nourished and survive the winter
 within the dark soil before the coming of the spring
 that it is in the night-time that we are given dreams
 and visions and psychic intuitions
 that the Ancients re-entered the caves
 and within the dark womb of the Mother of the tombs
 went on shamanistic journeys into the Otherworld
 thereby experiencing death, dismemberment and rebirth
 and returning with powers of precognition, healing and mediumship

was from women's deep dark psychic menstrual powers
that human cultures arose.

 Don't also forget that the Ancients
 joyously celebrated the glorious Full Moon—
 Mother of mind, wisdom, visions and fertility
 within stone circles under the dark sky
 and its myriads of immortal stars.

Perhaps the patriarchs felt insignificant
in this vastness.

Perhaps their inflated egos
needed the obviousness of the day-sky
and its one solitary heavenly body?

> Beware that when meditating on the "Light"
> we might not bring in the "New Age"
> but simply a mega-death of nuclear holocaust.
> An inevitable and miserable outcome
> If we continue denying the Goddess.
> —written 12 Sept 87, on the Isle of Lewis, Outer Hebrides

"Sean"

suicide
> is a luxury for me
>> who has to stay here
>> watching over my son
>> who is dying a thousand
>>> deaths
>>> daily
>>> nightly
> despair and a sense of defeat
> gripping at my heart, at our hearts—
>> In my dreams
>> I'm with you my son
>> already lost . . .
>> I awake to a grey dawn of memories
>>> Who am I
>>> Why oh why
>> Leif, my beautiful young son
>>> with me in forgotten dream
>>> where are you
>>> oh, who are you now?

Sean, my oldest son, ill and in fear
>> from cancer
>> living in a shared twilight world
>>> him and me
>> crucified together—

Every day
>> days and days go by . . .
>> how long, oh, how long?
>>> cancer eating us both away

Perhaps we will live or perhaps we will not . . .
 —January 10, 1987

"FULL MOON AT CALLANISH—SEPTEMBER, 1987"

Waiting, waiting patiently
inside the dark womb of Callanish stones
Stones so gracefully slender
appearing like flames of silvery light
striped and patterned in pink, grey and black,
 Now in the deep darkness
 they look like ancient Hooded Ones
 petrified women and men,
 the Trolls of my Viking ancestors.
 We sit here two mortal women
 and a young boy-child
 waiting for the Full Moon to appear
 meanwhile huddled together against the wind
 on this bleak isle
 and its ever-present sea.
Holding our breaths as She rises
in huge and yellow fullness,
on this summer of the major Lunar standstill,
slowly so slowly beyond the Stones.
We watch Her movements many hours
wide-eyed and mesmerised
as She changes into silver radiance
truly the magical Queen of the skies is She
climbing higher and higher.
Light-patterns emanate from behind a stone
and then . . . She hangs suspended
between two hooded crones
stones looking like majestic old women
in communication with Her.
 Deep in my being, beyond the waking mind,
 in some ancient dream-time
 I feel that She has imparted to us,
 yet again, some very great knowledge beyond words.
 Memory re-awakening of who we truly are . . .
 Spirit-daughters of the Lunar Mother,
Do you know, Mother, that my two sons,
now in your magical Otherworld,
in the Light of Summerland,
both left their physical bodies
on a Full Moon
within these last two years?

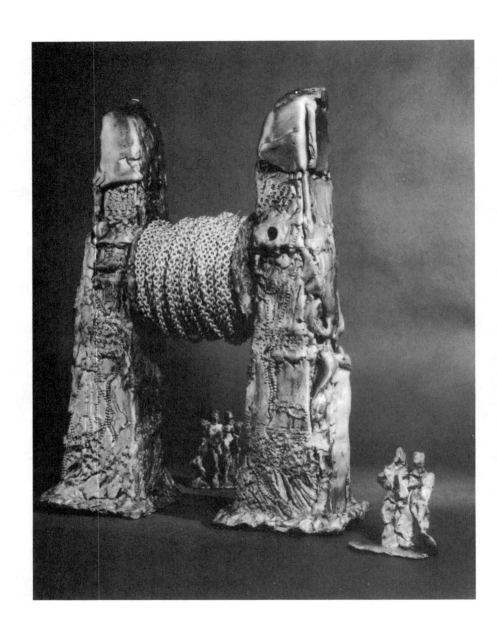

Harrar: Middle Passage Monument, 1994. Scale model #1. Bronze, 39 x 27 x 24 cm.
Courtesy of the artist

BARBARA CHASE-RIBOUD

B. 1939

BARBARA Chase-Riboud has achieved acclaim for her work as both a sculptor and a writer. Her sculpture is characterized by a unique blending of seemingly disparate materials, most frequently bronze and fiber. As a writer she has published both historical novels and volumes of poetry. Although American by birth, Chase-Riboud has pursued her career in Europe, primarily Paris, where she has lived for the full period of her artistic maturity. Her heritage as an African-American has had a significant impact on her writing and visual art. Most of her novels are reinterpretations of history in which black protagonists are given central place and voice. The format of her sculptures is derived from African mask-making traditions where soft and hard, permanent and impermanent materials are freely combined. Despite Chase-Riboud's long-standing distinguished reputation, to date there have been no full-length critical assessments of her written or visual work; such analysis is long overdue.

Barbara DeWayne Chase was the only child in a middle-class African-American family from Philadelphia. She has described her father, a building contractor, as a "frustrated painter and architect" whose race kept him from establishing an architectural practice. Her mother, the daughter of a jazz musician and the great-granddaughter of a slave who escaped via the Underground Railroad (as described in the poetic sequence "Anna"), did not pursue her own

career in pathology until she was in her forties. A self-described "theatrical brat," Chase-Riboud began her art education while still quite young. By the time she was eight she was taking art classes at both the Fletcher Art School and the Philadelphia Museum School, as well as studying piano and ballet; she had already won her first art prize. Although she subsequently abandoned piano and dance, she continued her art studies through high school, and her talent received early recognition. She sold some prints to the Museum of Modern Art, received a *Seventeen* magazine prize for a woodcut, and was offered several college scholarships. She decided to attend Temple University's Tyler School of Art, where she was the only black student. After a classically-oriented education that included the study of anatomy and medical drawing, she received her B.A. in 1957. Upon graduation she moved to New York City, having won the *Mademoiselle* guest-editorship award, the first black to do so. Shortly thereafter she was offered a position at *Charm* magazine which gave her the opportunity to pursue a career in the fashion world.

The first major step in Chase-Riboud's career occurred in 1958 when she received a John Hay Whitney Foundation fellowship for a year's study in Rome at the American Academy. This provided her first trip to Europe, where she ultimately settled and has lived most of her adult life. During this time she was introduced to non-European art when, on a whim, she traveled to Egypt with a couple that she hardly knew. Although initially she found herself abandoned in Alexandria, through a series of fortuitous incidents, she ended up spending three months in Egypt, living in Cairo with the (black) American attaché to Egypt and his wife. Chase-Riboud has described the powerful impact of encountering an art that was so separate from the Greco-Roman tradition in which she had received her training. She found "the blast of Egyptian culture irresistible" for its "sheer magnificence." "After that," she said, "Greek and Roman art looked like pastry to me." Her response to a different visual vocabulary was similar to that of many other African-American artists who encountered nonwestern art after having been trained in a classical tradition. Faith Ringgold, for example, has said about the successful resolution of her quest to create an art that expressed her ethnicity: "Instead of looking to Greece I looked to Africa."

Chase-Riboud returned to Rome and made application to the Yale School of Art and Architecture. She was accepted with financial aid and, shortly thereafter, returned to the United States to pursue her graduate studies. When she arrived at Yale, once again the only black woman, it was near the end of Josef Albers's long tenure at that institution. (Audrey Flack and Eva Hesse also studied at Yale with Albers; Howardena Pindell arrived there soon after he had left.) Chase-Riboud says that although she "fought like hell" with the Bauhaus discipline, "it stood [her] in good stead later." For Chase-Riboud, the best aspects of Albers's tutelage were his stress on being committed to one's career, to being professional, and to thinking clearly and logically. However, she felt that as a black woman at Yale, she was expected to be grateful just for being there, a provincial expectation impossible to fulfill, at least in part because of her

already-broad experiences in Europe. By the time she received her M.F.A. in 1961, Chase-Riboud had already developed her own ideas about making art, to wit, that she need not restrict herself to the western mode. "The Greco-Roman heritage was only a part of a vast reservoir," she has said. "There were other ways as important for me, as valid intellectually, deeper, and as beautiful. I could turn to the nonwestern arts for ideas without feeling I was working with folklore." Even in her more recent works in which she draws upon neoclassical motifs and uses such traditional western materials as marble, she maintains communication with these other traditions.

After receiving her degree, Chase-Riboud went back to Europe which she has made her permanent residence ever since. While in Paris she met and then married the journalist Marc Riboud with whom she had two sons. There was a hiatus in her work during the period in which she was more involved with raising her children and traveling with the family than in the production of art. Her travel experiences exerted a strong impact on her subsequent work, however, particularly a trip to China in 1965 and attendance at the Pan-Africa Festival in Algeria in 1968. As so often occurs with artists who experience a break in their production, when Chase-Riboud went back to making images in 1967 her style had gone through a major change. Whereas her bronze sculptures from the late 1950s were somewhat surrealist, figural images, in her work a decade later, Chase-Riboud deliberately eschewed figural reference in order to imbue her works with the magical presence of the African masks she had seen at the Pan-Africa Festival.

During the early 1970s, her first mature style emerged, with particularly successful evocations of powerful shamanistic forces. Their effect depends on two technical breakthroughs that evolved while she attempted to reconcile the contradictory materials of bronze and fibers. The first came from Chase-Riboud's observation that the ceremonial masks hid the dancers' legs in such a way that they appeared to be otherworldly beings rather than mere humans; the masks were "no longer pieces of sculpture, but a personage, an object of ritual and magic." Working with Sheila Hicks, a former classmate from Yale who by then had a fiber atelier in Paris, Chase-Riboud developed a method of combining with bronze, knotted and wrapped ropes made of silk or wool that cascaded curtainlike to the floor. By eliminating the visible "legs" of her bronze sculptures she was able to hide their structure. One unexpected aspect of these pieces in which Chase-Riboud delighted was that the rope, the softer more pliable substance, seemed to be supporting the bronze, and hence became the "strong element" of the work, contrary to usual expectations.

As her work developed, she deliberately attempted to imitate the visual effects of the bronze with the fiber sequences. Thus, she achieved her second breakthrough in which she created a visual unity out of contradictory material elements. In *Confessions for Myself* (1972, an imposing presence ten feet tall), a seemingly soft capelike form made from bronze sits above a wide flaring support, consisting of woven black wool strands that echo the vertical folds of the cape. By combining these media, Chase-Riboud subverts the traditional

hierarchy in which fiber is associated with craft—a lesser, "feminine" medium—while bronze-casting has its virile, heroic history within western art. Bronze is also associated with the African Benin sculptural tradition. The effective aggregation of diverse materials is an important aesthetic element in African art, as has been discussed by Howardena Pindell.

Many works in this style were exhibited together in 1973 in Chase-Riboud's first important one-artist exhibition at the University of California at Berkeley art museum. Their meanings are multiple and shifting. The title *Confessions for Myself* implies an ideal self-portrait, for example, while *Zanzibar* evokes her East African roots. Chase-Riboud has said of this piece with its coils of blond silk that "if beauty can be called 'black' in the same way that humor can be called 'black' then *Zanzibar* can be described as such." She continues: "There is a mysterious and not far from threatening underbelly to this beautiful surface which has the same emotional effect as some African sculptures have on Westerners—displaced in time and space, taken out of their real environment, they assume a certain impenetrability that can disconcert and repel as well as please and attract." Chase-Riboud executed four monuments to Malcolm X in this style, saying that she wanted them to "embody the idea of Malcolm X." These works are essentially political, with their masklike form and their subversion of western expectations, rather than through an external narrative device.

Chase-Riboud's next stylistic development was stimulated by her reaction to a newly discovered Chinese burial suit that was made from a myriad of small jade pieces stitched together. She felt a special affinity with the concept of sewing hard, nonpliable materials, a feature of her own works. In *Cape* (1973), she pieced together with copper wires many small squares of bronze, individually cast with variegated patinas, to create a looming, ceremonial form. In a slightly earlier sculpture, *Bathers* (1972), she had already experimented with the idea of piecing her work from smaller elements, in this case aluminum segments placed on the ground with silk ropes visible at the interstices, communicating the effect of sunlight on rippling water broken by the movement of bodies or seaweed. This work has also been compared to a Chinese form, the typographic blocks of archaic Chinese calligraphy, seen by Chase-Riboud on her trip to China in the mid-sixties.

During the eighties, Chase-Riboud continued to piece together smaller segments to build works that were now characterized by an incorporation of architectural elements: neoclassical doors, columns, and windows. The early eighties was a time of personal change, in which she divorced her first husband and married the Italian art dealer Sergio Tosi. Charlotte Rubinstein suggests that Chase-Riboud's use of more classical forms derives from the fact that she now divides her time between Paris and Rome, with an atelier in a Renaissance palazzo. *Cleopatra's Door* (1983) shows her style in flux. In this work, Chase-Riboud combined small, variegated bronze pieces with beams of wood, as in earlier works playing off the contradictions between soft and hard, rigid and pliable. Instead of reflecting the softness and irregularity of rope,

however, the bronze is merged with a wooden post-and-lintel doorway.

Barbara Chase-Riboud is a prolific writer with four novels and two volumes of poetry to her credit. Additionally, she has incorporated textual elements of varying legibility into several of her drawings. Her writing is bold and gutsy, her poetry encompassing both violence and sensuality. The relationship between her artwork and poetry is especially close, and several poems and sculptures appear to be variations on the same theme. Her poem "Han Shroud" could refer to *Cape* (1973), her sculptural reinterpretation of the jade Chinese burial shroud, in the description of "jade fragments / I weave / With golden threads." Similarly, the poem "Bathers" gives further dimension to the sculpture of the same title, the lovers "separated by a / Gritty breeze / That winds down / The space / Between us," a space similar to the gaps between the aluminum segments of the sculpture. The sculpture *Cleopatra's Door* (1983) relates to her book of narrative poems, *Portrait of a Nude Woman as Cleopatra* (1987), Cleopatra's door being the portal to the feminine, to Africa. This "complex and continuous narrative" in poems, inspired by a drawing by Rembrandt, has been incorporated into a novel published in France, *Les Nuits d'Egypte* (1994). Cleopatra is an important figure in Chase-Riboud's project of reinterpreting western history from the point of view of people on its margin. Like Martin Bernal in *Black Athena*, Chase-Riboud sees Egypt as more closely tied to African than to western civilization.

Chase-Riboud's interest in retelling history, particularly the history of the African diaspora through black narrators and protagonists, links her work with writers Toni Morrison and Alice Walker, and with artists Faith Ringgold and Howardena Pindell, among others. Sally Hemings, and now Hemings's daughter (in Chase-Riboud's 1994 novel *The President's Daughter*), are incidental figures in the dominant accounts of American history but primary to the focus of Chase-Riboud's work. Like Faith Ringgold's narrative quilts, Chase-Riboud's novels and poetry give central voice to black women. Ringgold once said that the one question she would ask her ancestors if she could summon them up was what it was like under slavery. Chase-Riboud's mother's forebears escaped slavery via the Underground Railroad and, in her novels and particularly in the extended poem suite "Anna," Chase-Riboud attempts to find an answer to that question. Her use of fiber and other nontraditional material is related to Ringgold's work and also to that of Betye Saar who used her art as a means of connecting to the "black magic" of the African aesthetic heritage. With *Harrar: the Middle Passage Memorial*, Chase-Riboud has proposed a monument consisting of two fifty-one-foot-high bronze obelisks to commemorate the victims of the African diaspora.

Chase-Riboud's feelings about living in Paris, a congenial environment for many African-Americans, should be considered in this context. Although she says that she does not consider herself an expatriate because she still "loves [her] own country," it is clear that she also enjoys the freedom from racism that Paris has traditionally afforded. She links herself to the blacks of the Harlem Renaissance who came to Paris to "define and consolidate their own American-

ness outside of racial stereotypes and strife." It is interesting that the circumstances of Chase-Riboud's life reflect Ringgold's fictional protagonist in her *French Collection* series: a black American woman artist who came to Paris, married a Frenchman, and forged a successful career, speaking from her unique perspective as an African-American woman and citizen of the world.

SOURCES

Chase-Riboud. Exhibition catalogue (essays by F. W. Heckmanns, Françoise Nora-Cachin, and Geneviève Monnier). Berkeley, Cal.: University Art Museum, 1973.

Chase-Riboud, Barbara. *From Memphis to Peking.* New York: Random House, 1974.

_____. *Portrait of a Nude Woman as Cleopatra.* New York: William Morrow, 1987.

_____. *Echo of Lions.* New York: William Morrow, 1989.

_____. *Sally Hemings.* New York: Viking Press, 1979.

_____. *The President's Daughter.* 1994.

_____. *Valide.* New York: William Morrow, 1986.

_____."Why Paris?" *Essence* 18 (October 1987) pp. 65-66.

Munro, Eleanor. *Originals: American Women Artists.* New York: Simon and Schuster, 1979.

Rubinstein, Charlotte Streifer. *American Women Sculptors.* Boston: G. K. Hall, 1990.

BARBARA CHASE-RIBOUD—SELECTED POETRY

"FOR MARC ROTHKO"

You are no musician
Your glowing squares stand still
Like Moses' tablets ignited
In startled righteousness
No African
You cannot sing or dance in rhythm
You do not borrow black from our race
It is your color
And that of your ancestors
As much as it is mine
And you are right

Have it . . .
For if anyone has earned it,
You have . . .

Even when you paint in blue, red and yellow
It is still black
No music
Only fine-grained writing on the wall
A history of those other niggers
Death in those other ghettos
Your offering to an always angry, rarely just God
As temperamental as a palette
Unloving and unforgiving balance sheet bureaucrat
When will He learn there are no accounts to be tallied
No way to measure the evil stupidity of His Creation
No rule by which the just can be judged
No scale on which sin can be portioned out.
There is only the infinity of the Square

As black as it is indescribable
The Old Testament
Is but a child's drawings
All foreground and no perspective:
When will He admit
There is no color
Man has invented it.

"For Mary McCarthy"

We met coming in opposite directions on the Rue de Rennes
Shadowed by the Tour Montparnasse, that parody of Pan Am
The sun was in those blue-eagle eyes that rarely if ever
Believe that they learn in this unremorseful & imprecise
World, bestowing that dazzling Mid-American smile, polite
& smashing, the smile that stuns the most armed & vigilant
Intelligence though you flash it in warning just before a
Philistine & exquisitely posed pretension is squashed under
your raised eyebrow like a baby squab underfoot, in delight
You gossiped housewifedly *illuminated contentedly* in another
Land, arms full of flowers for the flat, veal chops in your
Shopping bag for lunch, Mary, contrary to consensus it is not
Your flowing and just mind I love, but your center of gravity.

"For Anne Sexton"

You shopped for Death
Like a housewife shopping for avocados
You pinched it, weighed it, smelled it
You pummeled it and chewed it
And worried it to Life
It kept you good company
Until one holiday week-end
You put on your best Pucci
and served it for dinner.

"For Louise Nevelson"

Politeness forces one into Nothing
Those Nothings I build into my own
Private cathedral
Who are you to say that one cannot
Believe in something
Beyond the pale downcast liveries
Of the soul?
Today I am not one day older
But one thousand
I am Sphinx
I turn and twist in that knowledge
But whatever the price
Of this demi-glow tapping at
My chapel window
Whatever the price
Of this onrushing wind
I am ready to pay that price
& with interest
What more can a woman strive
Than to love once more?

"Harrar"

And out of Omega we came
Out of the womb of the world we came
All pleasure in feast and love forgotten
All rancor in feud and war forgotten
All joy in birth and circumcision forgotten
We came, Blackbodies
The negative of the light
The perfect absorber of radiant energy
Our black bodies
The only merchandise that carries itself
A column of jet quickening
Gyrating in one celestial tribal dance
Rolling and spreading like a giant blastoma thickening,
Spinning itself into the fireball of a new planet
Rending the cosmos
In a season of stars, we came
Out of Omega.
Groaning across deserts and the pyramids of Kush
A lunar landscape of mountains and sand
Of Basalt and Obsidian, biotite and barium
Rock and mineral, bone and brimstone
From the underground pebbled with diamonds and gold scum
Into the Hell of ghostly White we came,
In eclipsed sun we came: the negation of time
Our women a nation of Banshee
Conned from every bankrupt and ravished Kingdom
Zeila & Somaliland, Galla & Abyssinia, Tigré & Shoa
Wading waist-deep across black rivers:
Niger & Nile, Orange & Congo, Cubango & Kasai
Strung out in caravans, we came, a stunned string of
pearls like a centipede: one thousand,
One thousand thousand, one million, three, six, nine million
Sprawling over the badlands
carrying death in every heart
Across frozen wastes: the negative of earth
Torn like belladonna lillies from our roots,
We came
In one savage wail whirling soundlessness,
Lashing the hot sand of Ogaden
The red flag of slavery
Blotting out sky hope and memory

granite phalli
marking graves strewn backwards
Fingers clutching
a chilled sun in cyclone
While murder moved . . .

Move murder move!
Sacred vultures pick flesh skeleton white
The Gods sit mute and horrified on their
Polished haunches, silent and powerless while we labor under
An armour of glinting sweat through petrified forests
Our mouths stuffed with pebbles so that no cry escapes
Our bloodied lips beaten back at every step by clouds
Of insects that clinging to flesh like leeches in love
Undisturbed by our shackled hands and necks that bend and sway
In malignancy, metal oiled with pus grates silently: the songless Mass
Its distant verse a children's chant muffled in
Barren dust that shifts and bursts underfoot
As light as charcoal, as deep as genesis
Move murder, move!
Orphans sway like clinging monkeys suckled at wet nurses' breasts
Their mothers drowned in their own after-births
Dazed tribes of virgins trample hot rock
Believing this to be their only travail
Stupefied magicians and priests
Bangled and weighted down with fetishes,
Stumble blindfolded, chained one to the other in perfidy
Empty mouths rail empty supplications
Why isn't Belshazzer here?
But then we have no writing and no walls . . .
Our outraged deities wheeze and groan, carried on slippery ebony
 shoulders whipped by sand
Their Godheads still roseate in the gathering dusk
Magic is vanquished, no more will the Tribes
Prostrate themselves before Amon, Save, Seto and Whoot, Legba and Ogun
No longer will the Nation swallow the burning sperm
Of warlocks for they have allowed
Us and the Gods to fall into this abomination
The multi-colored powders of the Rites
Have blended into that which is all colors: Black
Boulders of our grief block our way like the
Palm of Shango and the weight of Blackness undoes us all . . .
In the brazen glare
Of Harrar's beach
One collective scream

Rams the sullen sea
Vibrating the python
Of the continent
As tremors of our earthquake
ripple back towards Africa and in that last moment
With the sea and slavery before us.
The Race, resplendent unto itself dissolves and
All biographies become One.

SELECTIONS FROM FROM MEMPHIS TO PEKING (1974)

"ALL REVERENCE TO HER"

I

When the last cock crows and the last bell chimes and
The morning star excommunicates night and the moon
Pales and the last nightmare fades and the sun
Rises intact watching as we spit morning
Blood: Mouthwash of the Western World
I'll turn my head on my pillow and
Salute *that power that exists*
In all of us in the form
of Illusion Reverence
All Reverence to
Her Reverence
Reverence to
Her all
Rever-
ence
to
H
e
r .

"BATHERS"

Bathers
In a new and unpolluted sea
Fresh from vision
You and I
You and I
New

New
Emerging
Clinking like metal
Shiny on the sand
As wave-washed copper pennies
Anchored by beach lizards
Weighted in shrouds of
Smooth rose pebbles
Attached to
Slow-rolling flying kites
Separated by a
Gritty breeze
That winds down
The space
Between us
As irrefutable as
The Great Chinese Wall . . .
Evaporating sea tears
On you
Sea tears that dry
Leaving small white
Circles of brine
Not like my tears
That remain
Forever
Undried
As I walk back into that
New and unpolluted sea
Fresh from vision
You and I
You and I
Old
Old
Converging
In the ooze of
Radiolarian skeletons
On the bottom
Of the Arabian Sea.

"ANNA"

2.
I remember

You
Anna
1945
You must have been
Eighty-five or even older
It hardly matters
And I?
I was six
Could I have known the word for
Empress?
Imperious old lady
Amber-colored
Chinese perfume bottle
Engraved with jewels
(Beautiful jewels, I thought)
Set off by black crepe
Hair straight as a song
Disciplined
Into a silk cap
You looked at me and murmured
"Too dark.
She'll never be beautiful."
Oh Great-grandmother
The blood
You let
With that
Offhand remark
The absolute wound
That saw
My life flow
Out
Sweet dreams of myself
Shot free like stars spinning
From another galaxy
Great-grandmother
Did you know?

.
I remember
You
Anna
Queen
How could you have begun
In slavery?
Staring with unfocused infant eyes

As your mother dipped her hand into
Blood and drank
And fled
Swaddled like a tiny Egyptian on her back
Clinging to her frightened heart
Did you feel the stars rush by?
Feel your mother's straining lungs
Exhaling frosted panic onto the night?
How does one run to
Fate?
Why do some not
Bend?
What made your mother
Bloody herself?
An overseer's rape?
A husband sold?
A child born not free?
The ache of the African sun in her eyes?
The white sand of Nairobi
Shifting under her feet?
Did she remember
The Nile?
Was it a hot breeze off
The Sahara?
Could it have been a sigh from
The Indian Ocean?
Great-grandmother
Did you know?

6.
I remember
You
Anna
You
Who mixed your strange and
Raging blood
Raga scented with
Islands and oceans with
Some Scottish farmer
Seeking warmth and sunlight
In your amber skin
Seeking respite from the wilderness in
Africa and India
Did you love this man?
Walking barefoot to that barren homestead

Your wedding dress strapped to your back
Clinging to a frightened heart
As you clung that night some twenty years ago
Did you love this man?
Pale and silent and Northern
Exhausted by Canadian winters
Who gave you your only child
Agnes
Fair and freckled farm girl
With dark eyes and red hair
White
Beautiful
At last
Isn't that what you wanted me to be?
Did you love this man?
Out of the Canadian winter?
Who gave you your only child
I try to find a face for him
A laugh, a voice, a walk
Great-grandmother
Did you know?

8.
I remember
You
Anna
Agnes
Ran away with an American
And broke her father's heart
Turned it to stone
Against you both
Bad blood
Raging blood raga scented
With islands and oceans
Uncontrollable
Unpredictable
Uncivilized
Love!
There must have been some
Love!
Kid Ory/Fate Marable/Albert Nicholas
Papa Celestin
Love!
Zutty Singleton/Ollie Powers/Fletcher Henderson
Trixie Smith

Love!
King Oliver/Barney Bigard/Ma Rainey/Carroll Dickerson
Bessie Smith
Love!
Before Agnes came back the first of many times
To leave then reclaim and leave again
The fruit of her love
Oh Great-grandmother
Could you not have bent a bit for her?
And finally the last return, the ultimate exhaustion.
The two stones of your heart
Side by side in their wheat fields
Great-grandmother
Did you know?

12.
I remember
You
Anna
Agnes
Vivian
I am the end
Of our line
A single row of wombs
Each with a single fruit
Was there another fate?
Some other destiny murdered
On that damned island
Zanzibar?
And thrown across
The Atlantic?
Did you live love in the
Canadian wilderness
Or did you dream it all?
Betrothed in your mother's womb
To some African kin
Marriage contract written
With a finger in fresh sand
Did you call out
That night long past
Clinging to a frightened heart
While stars rushed by:
Cousin!
I am
Gone!

Who was your mother?
Empress
And who was your father?
Orphan
And who am I?
Great-grandmother
Did you know?

"To Gloria"

Dear
Gloria
Steinem
I have
A
Problem
I
Am
Female
And
I
Am
Liberated
But
I would rather be
Beautiful
Than
Not
I
Would rather be
Made love to
Than
Not
I
Would rather be
Lover
Than
Friend
In
Other
Words
I

Am
A
Backsliding
Man-loving
Crotch-gazing
Phallus-adoring
Counter-revolutionary
Renegade
Handkerchief head
Sexist
Slave
I feel like some
Good nigger
Southern white folks
Haul out to
Prove
Their niggers
Are
Happy
Niggers
Some liver-lipped
Honky loving
Uncle Tom
Rolling my eyes
(contact lenses by Horning and Colt)
And
Shuffling my feet
(loafers by Gucci)
Shaking my hips like tambourines
(dress by Pucci)
Knocking my knees in a Gospel jump
(body stocking by Christian Dior)
My carpetbag rattling
(Louis Vuitton)
My hands clapping
(nails: Revlon; rings: Tiffany's;
watch: Piaget; gloves: Hermès)
Rolling on the ground
(fur rug by Jacques Kaplan)
And shouting to high Heaven
(gargle by Listerine)
Teeth grinding
(caps by Dr. Klaie)
Hopping and sweating
(deodorant by Vichy)

Throwing myself around
(perfume by Guerlain)
In the burning bush of a
Southern sun
(sun-glasses by Givenchy)
Head ticking
(hair spray by Coty)
A Sunday bone-crack
(shampoo by Carita)
Bandana
(by Pierre Cardin)
Waving like a witch doctor's
Monkey fur switch
(got to get me one)
Gloria
I
Just
Can't
Seem
To
Get
The
Hang
Of it
Trembling at some
Baritone voice
Gut-snapping at some
Broad-shouldered
Embrace
Swooning at some
Sycophant's
mustached Kiss
I
Am
The
Absurdity of
Absurdities
A
Backsliding
Man-loving
Crotch-gazing
Phallus-adoring
Counter-revolutionary
Renegade

A handkerchief head
Sexist
Slave
Gloria!
Hold
My
Hand.

"HAN SHROUD"

<div style="display:flex">
<div>

Jade
God's juices
Solidified
Shield against mortality
I cover you drop by drop
Like grains of rice
Run from
The silos of my favorite
 domain
I cover you as
I covered you in life
With my body still warm
From the hunt
Ardent heat
Now

As cold as
These jade fragments
I weave
With golden threads
Round you
Beloved wife
Princess!

Jade
Power over life and death
Solidified
Imperial seals of the Middle
Kingdom
I'd forgotten
Emperors die too
We are side by side but
I am too weighted down with

</div>
<div>

Jade
Love's juices
Solidified
Smooth as your own flesh
I cover you drop by drop
Like emerald perfume
Running from
My favorite silver and ivory
 gourd
I cover you as
I covered you in life
With my body still warm
From the sun of my terrace
Ardent heat
Now

As cold as
These jade fragments
I weave
With golden threads
Round you
Beloved husband
Prince!

Jade
The green of June wheat
Solidified
As tender as my silks brushing
your hand
I'd forgotten
Empresses die too
We are side by side but
I am too weighted down with

</div>
</div>

winding sheet	winding sheet
To take your hand	To take your hand
Too weighted with jade	Too weighted with jade
To move my heart	To move my heart
Jade closes my eyes and my nostrils	Jade closes my eyes and my nostrils
This suffocating green	This lily-leaf green
That prevents me from seeing	That prevents me from seeing
My empress	My emperor
Love	Love
Take this mask from me	Take this mask from me
So that I may see your face	So that I may see your face
For the last time	For the last time
Beloved friend	Beloved friend
Princess!	Prince!

FROM *PORTRAIT OF A NUDE WOMAN AS CLEOPATRA* (1987)

III. "CLEOPATRA"

I shall be Venus Genetrix and greet
With chaste lips this Dionysus I first saw at fourteen.
I shall trap his quintessent heart and waltz it round
My own Gods quivering in unmarked graves.
For so long as one dank breath escapes from Karnak,
So long as one brace of bones, churns like rolling dice,
Away from Delphi's oracle, so long as one
Handful of red earth crumbles under the
Saturnine & Equatorial sun of Ethiopia's Pharaohs
I refuse to be eclipsed by Caesar's shadow & Caesar's sex,
For, so long as Egypt rests its shaven head
On my Cleopatrian breasts,
Caesar's manhood curled loosely in my hand,
Rome, don't cross me.

XIX. "ANTONY & CLEOPATRA"

Whatever violence
I have done thee,
You've done to me tenfold.

And so we stand quits and quivering,
Two fools,
In love without faith.
For the honest love of one other
Has made every man hate
The dishonest love of another.
For reasons of our own
That tender thread
We've lost
Now I'll leave
You alone.

XLIX. "Cleopatra"

O friendly enemy, we have loved,
Loin and haunch, limb and flank, truth and lies,
Tressed like a pair of ancient Armenian vines
Grown together root and branch in stunted
Commingling without End or Beginning.
If we part, you will leave with half of me,
Or I with half of you, and nothing will kill
The pain of dismembering.
That ache like some rare jewel
Will hang round our necks to touch,
In tender tremulance, an old wound of amputation
That burns and groans in limbs no longer existent
But splintered and crushed
In some long-forgotten and useless War.

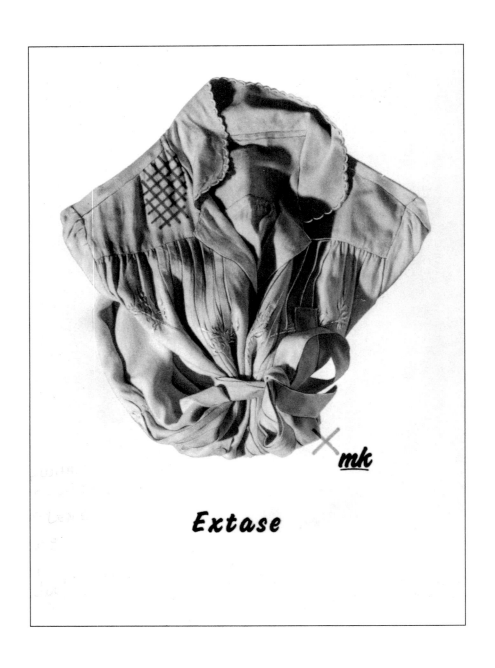

Extase

Interim. Part I; *Corpus*, 1984-85. Detail: Extase. Laminated photo positive, silkscreen, and acrylic on Plexiglas, 36 x 48 in. Photo: Ray Barrie

MARY KELLY

B. 1941

SINCE THE 1970S, Mary Kelly has been an active voice in the feminist, postmodern critique of art history, both as a theorist and a practitioner. An American, Kelly spent the developing years of her career in London where she became associated with a group of British artists, critics, and thinkers who shared her interest in political and psychoanalytical theory. Through her two major long-term projects, *Post-Partum Document* and *Interim,* Kelly sought to deconstruct the western art historical tradition's positioning of women as the object of the male gaze. The written word has been of central importance to Kelly's work and, typical of postmodern practice, her work has incorporated a diverse array of textual elements. She has written numerous important essays in which she analyzes the intersection between feminist and postmodernist theory, particularly regarding the construction of gender and its reflection in visual art.

Mary Kelly was born in Minneapolis, Minnesota. She received her bachelor's degree in 1963 from the College of St. Teresa in Winona, Minnesota. In 1965, she earned a Master of Arts at Pius XII Institute in Florence, Italy, after which she taught at the American University of Beirut. She moved to England, studying at St. Martin's School of Art between 1968 and 1970 and marrying the English artist Ray Barrie.

While in London in the early 1970s, Kelly became involved in the women's

movement. During that period, she participated in a discussion group with several other women who subsequently became influential feminist theorists, including art historians Griselda Pollock and Rozsika Parker, and filmmaker Laura Mulvey. Kelly views her political commitment and early movement experiences as influential to her ensuing artistic development. "My involvement with the women's movement has determined my practice as an artist," she has said. The impact on her art was immediate. Between 1970 and 1972, with a group called the Berwick Street Film Collective, she participated in making the film *Nightcleaners,* concerning the unionization of women office cleaners. While the film was clearly sympathetic to the cleaners' struggle, it also offered a critique of their endeavor and of the documentary medium itself. Partly as a result of working on this film, Kelly became affiliated with the then-recently established Artist's Union and was elected its first chair.

Kelly's next major project, *Women and Work* (1975), was a collaboration with Kay Hunt and Margaret Harrison that grew out of the union's Women's Workshop. The purpose of this endeavor was to investigate the effect of the Equal Pay Act of 1970 on the workers in a Southwark, London, factory, particularly in regard to its differing impact on men and women. The project was presented as a mixed media installation with graphs and health reports, as well as photographed and filmed documentation, and a sound track, to enable the viewer "to come to understand the workings of the sexual division of labor under capitalism in the early 1970s." In *Women and Work* Kelly introduced several strategies that she refined in her later works. Rather than simply visualizing and depicting her subject, Kelly presents a range of materials with which viewers must interact in order to construct the "picture" for themselves. Furthermore, these materials are often not visual; although we do see some images in these earlier works, here, as in her later projects, Kelly depends on textual and other material documentation.

In 1973, with the birth of her son, Kelly began her first long-term project, *Post-Partum Document,* an examination of the development of the mother-child relationship based on the idea that the mother's, as well as the child's, personality is formed at the "crucial moment of childbirth." She continued working on this piece, which eventually grew to contain 135 individual units presented in six sections, until 1979, when her son began school. Each of the first five sections of *Post-Partum Document* consisted of a series of "fetishes" (in Kelly's words) incorporating diverse memorabilia from various stages of the child's development: used diaper liners, accompanied by descriptions of the child's food intake and the resulting state of his feces; plaster handprints; fragments of his baby blanket onto which she had typed excerpts from her diary in which she ponders her changing relationship with him; slate plaques inscribed with a letter made by the child; the mother's commentary, and thoughts (from her diary) regarding the child's experiences at nursery school and his process of socialization through language. Like *Women and Work, Post-Partum Document* was built from fragments of images and text that forced the viewer's own construction of meaning.

Post-Partum Document presents a radical departure from other artists' works of art on the subject of motherhood in that it is completely devoid of visual images of either a mother or a child. Kelly has avoided "the literal figuration of mother and child" as a "historical strategy . . . in order to cut across the predominant representation of woman as the object of the look . . . and to 'picture' the woman as subject of her own desire." For Kelly, any use of the female body is problematic and unlikely to depict successfuly woman as subject, because the image of woman has been overdetermined in western visual art. It is more productive, she believes, "to foreground instead [femininity's] social construction as a representation of sexual difference within specific discourses." In this context it is especially illuminating to consider the role of the "mother's memorabilia" with which the work is constructed. Kelly writes that whereas, according to Freud, castration anxiety for a man is expressed via fear of loss of some body part, a woman's anxiety is often expressed as loss of love objects, particularly children, because the childbearing woman has the illusion of possessing the phallus, i.e., power within the "Order of the Father." In *Post-Partum Document,* this loss is conceived as the inevitable separation between mother and child that occurs as a baby grows from total dependency to relative independence, and the mother's subsequent loss of authority. According to Kelly, the stained liners and handprints "were intended to be seen as transitional objects . . . in Lacan's terms, emblems of desire," the mother's fetishes of her transient relationship with her child, and hence with the illusion of power.

In the concluding segment of *Post-Partum Document,* Kelly asked the question "What will I do?" which, as Mulvey suggests, "poignantly foresee[s] the gap left by the end of the work as well as [by] the loss of the dyad." She answered that question in *Interim,* her next major work (executed between 1984 and 1989), a consideration of the "woman-as-subject as she enters middle age," a time of "increasing invisibility and powerlessness in the masculine world." It is significant in light of Kelly's feminist agenda that both works are concerned with crucial passages in a woman's life—motherhood and middle age—experiences that have been devalued within a male-dominated social order. Like *Post-Partum Document, Interim* consists of several segments comprised of multiple units created over a period of time. Another similarity is the absence in both of an actual depiction of her subject, offering instead a variety of visual and written materials (referred to by Norman Bryson as aniconic images) that enable the viewer to construct, or "picture," the subject. In both works, Kelly's spurning of the female figure was a deliberate strategy meant to represent women's subjectivity apart from what Emily Apter has called "the reifying regime of scopic masculinism."

Interim is comprised of four pieces, each of which presents social conditions against which a woman's subjectivity is defined: *Corpus* (the body), *Pecunia* (money), *Historia* (history), and *Potestas* (power). *Corpus* (1984-85) consists of five groups of three Plexiglas panels each with a photograph of an item of clothing presented in three states (neatly folded, loosely disheveled,

and tightly tied). Each image is paired with a panel embossed with a narrative text d
cussing some aspect of living in a middle-aged female body. Each of the five group
identified with one of the five states of hysteria identified by J. A. Charcot, and wh:
provide the works' titles. *Pecunia* (1989) is subdivided into four sections, each of wh:
describes Foucault's schema of a woman's familial relationships: *soror* (sister), *co*
(wife), *filia* (daughter), and *mater* (mother). Each section's five units of galvaniz
steel are bolted to the wall, folded in a greeting-card format, on the outside of wh:
is a letter of the title and on the inside, a text that refers to material possessions a
economic status. *Historia* (1989), "the history of the political body," consists of fo
large steel "books," each displayed as if open to a page. Their right-hand pages con:
of three columns of text, the narratives of women who were, respectively, twel:
seven, twenty, fourteen, and three years old in 1968, each analyzing her relationship
the women's movement; on the left, two columns of gloss juxtapose moments of c
laboration when women "see" each other with interchanges between women a
party who cannot see each other clearly. Finally, *Potestas* (1989) presents what appe
to be a giant bar graph in which women (a) are compared to men (A) in terms of po
ulation (*populus*), productivity (*laboris*), and wealth (*bona*). (The schema associat:
A/a with gender relationships is from Lacan.) The graph is based on a 1985 Unit
Nations report that established that women did two-thirds of the world's work,
received only one-tenth of its income and owned one-hundredth of its property.
plaques printed with narratives accompany the graph; those above the "A" bars a
about women who have achieved success in the masculine order, those related to
"a" bars are about those who have not.

As in Kelly's earlier works, the entire ensemble is reminiscent of an archaeolo
cal or ethnological display, comprised of multiple representations arranged by cate
ry. Consistent with her belief that gender is a social construct, in *Interim* she has ma
available the instruments through which various aspects of feminine identity ha
been constructed. Kelly acknowledges the influence of Foucault's ethnologi
metaphor, referring to her work as "archaeology of everyday life," and she emphasi
the importance of "polyvocality," the many layers through which subjectivity is b
constructed and comprehended. Kelly's use of Latin in titling various parts of *Inter*
reinforces the concept of an archaeological "dig" in which Latin phrases are unc
ered and decoded. These Latin categories, a "father tongue" as it were, have the eff
of situating contemporary feminine subjectivity within the context of a historical pa
archal order and thus challenge the "apparent neutrality of our social arrangemen
"Like institutional facades inscribed with hortatory sententiae or classical maxi:
Kelly's gallery walls approximate a frieze of dead paternal letters," writes Emily Ap
who considers the process to be "counter-monumental . . . a joke on Moses's table
The juxtaposition of Latin text with the verbal "artifacts" of constructed femininity p
sents an intrusion of women's time (Julia Kristeva's term) into patriarchal conventio
analogous to Kelly's calling the slate tablets onto which she inscribed her child's t
tative letters "Rosetta stones."

Kelly's incorporation of Lacanian and Freudian psychology into her work is
approach for which she has been both praised and criticized. For the most part,
criticism has suggested that Kelly reinforces the very order she seeks to deconstruct

depending so heavily on the model of Lacan, who said that woman could only be conceptualized as a lack in the symbolic order. Some believe, along with Cassandra Langer, that by basing her work on male-identified theory, "women's voices are prevented from speaking for themselves," and that Kelly "has not challenged the defining of women but only the definitions given by men." Kelly has argued that the influence of Lacan has hardly been the only one on her work, and that she has drawn upon the writings of numerous other cultural theoreticians such as Bertolt Brecht, Kristeva, and Foucault, as well as psychologists Juliet Mitchell (who was a member of Kelly's discussion group in the early 1970s) and Michele Montrelay. She has also emphatically asserted the underlying subversive purpose in her use of Lacan and Freud. As she told Hal Foster, "I use the insights of these texts . . . to articulate their 'lack' . . . problematic metaphor intended . . . of ability to deal with feminine sexuality." "For me these texts are a means of working through a difficult experience," she wrote in the introduction to the book *Post-Partum Document*. "[The works] are representations of the difficulty of the symbolic order for women, the difficulty of representing lack."

The written word has been very important to Kelly, as both a critical tool and a strategy in her art. Craig Owens distinguishes between the feminist, postmodern use of textual elements as strategic interventions in the art itself and the older, modernist approach in which writing was considered supplementary to the primary work. Kelly has written numerous persuasive theoretical essays in which she examined issues related to female spectatorship and representation. In 1979, she joined the editorial board of *Screen* magazine, a post she held through the early eighties, which further extended her influence as a critic. But it is in the area of "strategic intervention" that Kelly particularly excels, and she is one of the foremost exemplars of the postmodern "scripto-visual" practice of embedding text in visual works of art. Although the narrative elements in both *Interim* and *Post-Partum Document* are eloquent and moving, they are subversive in intent and cannot be taken at face value. Kelly writes that "although the mother's story is my story, *Post-Partum Document* is not an autobiography." Likewise, it would be a mistake to interpret the narratives in *Interim* as pertaining to any one individual, or even as "chapters" of the same linear story, just as one cannot find a one-to-one correspondence between the visual and textual elements, and the text does not explain the imagery. Nonetheless, the conversations and monologues are keenly observed, based on conversations participated in or overheard by Kelly. They allow us to hear the genuine voices of women, and as such to construct a female subject. At the same time, however, the urge to find a single heroic protagonist is constantly thwarted and the author's position vis-à-vis the material is shifting and playful.

Kelly's association with a group of British theorists represents the context in which her mature work developed. It is perhaps inevitable that some critics have contrasted the British and continental feminist artists whose work stresses theory and the social construction of gender with Americans whose art is

pragmatically based, sometimes on the idea of a universal female experience. While these positions represent two different ways of attempting to redress the gender imbalance in western art, such a dichotomy is far too facile. As Maureen Sherlock points out, there have been numerous American artists who have followed a postmodernist agenda comparable to that of the Europeans, such as Barbara Kruger, Lorna Simpson, and Trinh T. Minh-ha. There have also been Europeans who can be best described as cultural feminists, for example, Monica Sjöö.

In 1989 Kelly moved to New York to teach in the Whitney Museum's Independent Study Program, where she is director of Studio and Critical Studies. The last three pieces of *Interim* were completed while she lived in New York and bear a visual resemblance to works of such Minimalist artists as Donald Judd, something that was absent from her earlier pieces. Several critics have commented on their slick surfaces and have attempted to reconcile their visual "seductiveness" with Kelly's desire to disrupt the tyranny of the possessing gaze. That they are (as Mulvey says) "unashamedly beautiful and satisfying to the spectator" is not inconsistent with Kelly's intent, however, even regarding her earlier work. As Kelly said in reference to *Post-Partum Document*: "For me it's absolutely crucial that this kind of pleasure in the texts, in the objects, should engage the viewer, because there is no point at which it can become a deconstructed critical engagement if the viewer is not first . . . drawn into the work."

SOURCES

Adams, Parveen. "The Art of Analysis: Mary Kelly's 'Interim' and the Discourse of the Analyst," *October* 58 (Fall 1991), pp. 81-96.

Apter, Emily. "Fetishism and Visual Seduction in Mary Kelly's 'Interim.' " *October* 58 (Fall 1991), pp. 97-108.

Kelly, Mary. "Desiring Images/Imaging Desire," *Wedge* 6 (Winter 1984), pp. 4-9.

_____. Kelly, Mary. *Interim*. Exhibition catalogue (essays by M. Tucker, N. Bryson, G. Pollock, and H. Foster). New York: New Museum of Contemporary Art, 1990.

_____. "On Representation, Sexuality and Sameness: Reflections on the 'Difference' Show," *Screen* 28 (Winter 1987), pp. 102-07.

_____. *Post-Partum Document*. London: Routledge, 1983.

Langer, Cassandra. "Mary Kelly's *Interim*," *Woman's Art Journal* 13 (Spring/Summer 1992), pp. 41-45.

Mulvey, Laura. "Impending Time: Mary Kelly's 'Corpus.' " In *Visual and Other Pleasures*. Bloomington: Indiana University Press, 1989.

Pollock, Griselda. "Screening the seventies: sexuality and representation in feminist practice—a Brechtian perspective." In *Vision and Difference*. London: Routledge, 1988.

Pollock, Griselda and Rozsika Parker. "Back to the twentieth century: femininity and feminism." In *Old Mistresses: Women, Art and Ideology*. New York: Pantheon Books, 1981.

Rubinstein, Charlotte S. *American Women Sculptors*. Boston: G. K. Hall, 1990.

MARY KELLY—SELECTED WRITINGS

FROM *POST-PARTUM DOCUMENT* (1973-79)

FROM "DOCUMENTATION II" (1975)

```
UTTERANCE    /MA-MA/
GLOSS        HELP ME, SEE THIS, BE THERE
FUNCTION     EXISTENCE
AGE 17.0     JAN 26 1975
```
CONTEXT: M(other) getting K (son) ready for bed. 21:20 HRS.
1.1. M. Is that Kelly the baby? (looking in the mirror together)
 K. /ma-ma/ ma-ma/
 M. What, who's the baby? (pointing to K)
 K. /da/ da/ da-da/ da-da/ (father not there at the time)
 M. No, it's Kelly.
1.2 K. /ma-ma/ (looking at object on M's desk)
 M. What is it?
1.3 K. /ma/ ma-ma/ ma/ (crying and reaching for desk)
 MOST FREQUENT UTTERANCE: /ma-ma/ da-da/ eh/ no/ dere/
 MEAN LENGTH OF UTTERANCE: 1.42 17 months

FROM "DOCUMENTATION IV" (1976)

His words are so clear now . . . so demanding. He's less convinced by my plots. I keep on saying . . . 'you're not a baby but a grown up boy.' All my songs, jokes, rhymes, threats . . . seem to center on the difference between 'babies' and 'boys' . . . an apposition introduced by R and subsequently taken up by me.
T1 27.1.76 AGE 2.5

Coming back from work this week, I realised that I wasn't thinking about K so often when I was out, or walking faster as I got near the house. I felt a bit guilty but when I expressed this to R in the form of . . . 'maybe K's difficult because we leave him with other people a lot' . . . R said 'on the contrary, it's

because we're on top of him too much'.
T2 8.2.76 AGE 2.5

I did'nt [*sic*] see K much this week because of the Brighton show. Now I've
noticed he's started stuttering. Dr. Spock says it's due to 'mother's tenseness
or father's discipline'. My work has been undermined by the appearance of
this 'symptom' because I realise it depends on belief in what I'm doing as a
mother as well as an artist. I feel I can't carry on with it.
T3 27.2.76 AGE 2.6

If R spends just as much time with K as I do, then why doesn't he feel guilty
about the time he spends away? I think it's because I feel 'ultimately respon-
sible'. For what? . . not for discipline or Doctor's appointments or even the
shopping, but for providing 'love and attention'. I feel . . . or I need to feel . . .
I'm the only one who can meet this demand and I remember when I realised
it . . . the first time K said "I love you, Mummy".
T5 20.3.76 Age 2.6

❦

FROM "DOCUMENTATION VI" (1978)

(age 3.5) X IS FOR X. He calls it "a cross". He substitutes different letter
names for the same marks. It seems to mean writing in general. X is arbi-
trary but not indifferent. X is the body—repressed, represented, enjoyed. X IS
FOR ALLIGATORS X-INGXS, X IS FOR A XENURUS HAVING A X-RAY. GOOD
NIGHT LITTLE X. XENOPHON XERXES XEPHOSURA, GOOD NIGHT LIT-
TLE X.
January 25, 1977: Parents (i.e. mothers) are required to help supervise chil-
dren at the playgroup once a fortnight. How I dread it. I don't really want to
know what he's like at school. I'll only worry about it if he doesn't get along
with the supervisors or the other children. Today I noticed they blamed one
boy constantly for starting trouble and I felt sorry for him. Two little girls
(twins) seemed to need special attention but the supervisors usually became
impatient with them, no wonder, there were just too many children. Another
little girl (barely 3 yrs. old) was trying to write her name. I was amazed. I told
her how clever she was and made quite a fuss over her. Kelly watched very
intently and that evening he asked Pauline to show him how to write.

(age 3.8) I IS FOR INK. He calls it a dot and an i. Sometimes he points to his
eye but seems to know it's a pun. He's facinated [*sic*] by it. Little 'i' the object
watched by 'I' the subject. I IS FOR ALLIGATORS IMITATING INDIANS. I IS
FOR AN IBEX IN AN INDIAN OUTFIT CHASING INSECTS ABSCONDING
WITH AN ICE CREAM CONE. GOOD NIGHT LITTE [*sic*] I. IGOR ILLYCH
IGUANA GOOD NIGHT LITTLE I. GOOD NIGHT.

April, 1977: Today I was told about the 'gang of six' (troublesome boys of which Kelly is apparently one). The supervisor said they were 'very loud' but tried to assure me that he wasn't any worse than the others. I was wishing that I wouldn't have to witness it, but at the same time I wanted to get to the bottom of things. In fact, almost all of the boys ran about the hall incessantly shouting and imitating batman, spiderman, bionic man, and an assortment of 'monsters' and 'badies.' Most of the girls sat at the tables playing with puzzles and legos. Obviously, the supervisors including myself, didn't encourage them to do anything else, we were so relieved that at least some of the children were sitting down. We occasionally tried to get the boys to do 'something constructive' but they'd do it for about 2 mins. and then rush off again. It seems to be more difficult to handle boys, but then the teachers are always women, I've never seen a father at the playgroup or a man on the staff of any nursery I've visited.

(age 3.9) E IS FOR ELEPHANT. He's discovered a system of combining what he calls "a straight one and another straight one." He usually makes capital E, but by subtracting he gets F and by an excessive addition-E! It's as symptomatic as "ə" but derived from X rather than O. E IS FOR ALLIGATORS ENTERTAINING ELEPHANTS. E IS FOR EIGHT ELEPHANTS WITH ENORMOUS EARS. GOOD NIGHT LITTLE E. EDWARD ELMER ELEPHANT. GOOD NIGHT LITTLE E.
October 5, 1977: Kelly had his 4 yr. old check-up to-day at the nursery (I felt like I was having a check-up myself). The doctor asked me if he dressed himself yet. (I thought, well yes, but I usually haven't got the patience to wait). I said 'yes'. Then she asked if he could use a knife and fork properly. I said 'yes' again (but in fact although he can he usually doesn't and I don't insist because I'm so pleased if he's just sitting still and eating). Then he had to identify pictures, count, draw circles and squares and build a bridge with blocks. (I was holding my breath, thinking he might not do it because I was there). I was so pleased when she said he was the only boy in his class to do all the tests correctly, (I wanted to tell her about his wonderful writing too, but decided it wouldn't be discrete to boast about your own child). Then she said he would be ready to start infants school soon.

(age 4.4) K IS FOR KETTLE. And now he always says "K is for Kelly." He writes his name out so purposefully from left to right, trying hard to stay on the lines and almost always completing it without a mistake and then showing it to me proudly. K IS FOR A KIWI AND TWO KOALAS CARRYING A KETTLE. GOOD NIGHT LITTLE K KEVIN KASPER KANGAROO. GOOD NIGHT.
April 12, 1978: It was his first day at "proper" school today. Ray and I went along and waited with all the other anxious parents and neat children for our turn to "check-in" with the head-mistress. She called out Mrs. Barrie and I lept up and tried my best to sound cheerful and articulate. (Ray acted ultra-

casual which infuriated me). I went into the classroom with Kelly he was a bit reluctant so I thought I should stay for a while. (Ray disagreed and went home). Finally Kelly was distracted by a boy who showed him a red racing car and I left feeling very unhappy but thinking at least he was still coming home at lunchtime. When I brought him back in the afternoon, the playground seemed to be running in accordance with the principle 'survival of the fittest'. Children were rolling on the ground, punching, hitting, shouting and small boys were chasing small girls into the sanctuary of the girls toilet. I think its definitely too rough and Kelly is still too little.

(age 4.5) B IS FOR BALLOON. This is the first letter he has constructed with the express purpose of writing a specific word—his surname. He draws P and carefully adds "ɔ". Learning to write 'Barrie' has also sorted out his backwards 'b' and the upside down 'e'. B IS FOR ALLIGATORS BURSTING BALLOONS. B IS FOR BEARS PLAYING BAGPIPES IN A BAND. GOOD NIGHT LITTLE B. BERTRAM BULLFINCH BASSETHOUND.

April 19, 1978. Now Kelly is at school all day. Ray insisted that he was ready to stay for school dinners. He said Kelly was quite happy and I had to admit it did seem to be true so far. When he comes home I try to ask him what he does at school, what he has for lunch, but he's usually not very informative he's in such a hurry to change his clothes and go out to play with Ronnie. They've become very good friends. Once he said he didn't think he needed a mummy and daddy because he and Ronnie could live together and look after themselves. He brought home some flash cards which seem to take the place of our 'a.b.c.' sessions and he keeps a little notebook at school which I can go and look at from time to time. Things have definitely changed and so quickly. When I told Rosaline that he had started infant's school she said "well, you're a real mother now."

<div align="center">❧</div>

FROM *INTERIM*

FROM *CORPUS* (1984-85)

Appel

It's late and I'm looking up an emergency treatment for cystitis in a self-help manual called "Woman's Body." The index directs me to L 23. En route I catch a glimpse of a hideous diagram, keep going, then turn back, M4: The Process of Aging. What do I find so compelling about his graphic destruction of the female figure from age 0 to 80. I resist. She looks much too old for 50, obviously based on the down-to-earth-had-a-hard-life-and-glad-it's-over type. I will never look like that, or will I? Brutal, statistical fact, there it is. I am reducible to example d) middle age: muscle strength and mental capabilities past their prime. So my son had a point asking me if I would still be able to

play with him when I was 40. Though it could be worse, e) fertility ceases, and then f) old age: spine drops, hearing impaired, character changes and brain disorders possible. God why go on. It's already started. Is it irreversible? Anne told me she could remember the exact day, hour even, when she became an older woman. One morning she woke up, looked down at her breasts and realized they had lost their independence. She was laying on her side, she emphasized the importance of her vantage point since it was in that very position she had previously observed two perfectly autonomous hemispheres defying the laws of gravity. That day, they sloped, no, she said slithered to the right as they surrendered to some imperious genetic signal saying "take a break." I asked how old she was and had to laugh when she said 25. But now, reading in reverse I notice c) continuous loss of nerve cells from the age of 25, then b) peak of physical energy over at 12. Finally their optimistic introduction, "The aging process begins surprisingly early and efforts to slow it down are simply guesswork." Organic, inevitable, yet we are obsessed with avoiding it. Anne is right, women are not at one with nature, they are at war with it. The victor becomes a legend like so many aging film stars, forever "Fabulous and Forty-two;" meanwhile, the vanquished who refuse to dye their hair or just don't give a damn become old bags, or possibly old ladies if they smile.

Supplication

Phone rings. Jo's on her way. Glad she's coming, though I met her only once before at the museum. Winter, ground covered in ice, everything about to crack, fragile, intense—her performance, my ordeal with the director, our conversation over breakfast. Wonder if she still remembers, if she's changed. Lovely dancer's body in baggy pants, huge leather jacket, lace-up boots, all carefully battered like her face, small features more defined with some success, emblazoned: live alone, a loft downtown of course, no nonsense baby, if you want to be an artist you must pay. I am in debt, no doubt about it, overdressed and uncommitted, wishing I could seek asylum in her duffle bag. Stunned by the "rightness" of that image first, then intrigued by every detail, but especially by the boots. They had a presence much like hers, older but not dated and attractive without trying too hard. They haunted me. I had to have them, kept on looking for months after, finally found some that were similar, not soulfully worn out but stylishly distressed at least. In these I could do anything, wore them all the time, have them on now in fact. Will she be wearing hers? The door. I let her in, look down—the boots are different, lighter, higher heels and polished. Then look up—astonishing, a dress, small flowers, forties, second-hand, cut on the bias, screaming: what the hell, feels good to be a woman sometimes, give me credit I'll pay later. And the jacket, padded shoulders, Persian lamb, not black but very much like mine, the one that I was wearing when we met. She senses this and says that's why she bought it, tried to look smart, stylish even, just to please me. Can't help

smiling, "See these boots," I ask, "have I succeeded?" "Well, almost", she laughs.

Extase

The white dress is part of a plot to escape. From what I'm not quite sure, but all through the cold, dark and indifferent winter I have been planning it. Learned academic by day, and by night, secret reader of holiday brochures and eater of maple sugar candy, planning how the three of us would meet in Miami, happy family reunited—father, mother, child, against a backdrop of blue sky and pounding surf of course. I have told no one. Finally, the day arrives. I pack the suitcase with devotion, the way a bride would do her trousseau: no jeans, no boots, no leather jacket or coat of any kind and nothing black, only brightly colored blouses, loosely fitting trousers, shorts, halters, high-heeled shoes and all the jewelry I ever wanted to wear and didn't have a chance to. And the dress. I refuse to wear a coat even to the airport in anticipation of the happy metamorphosis that will inevitably take place when I emerge eight hours later. And it does. The air is hot and thick. I feel it soldering the bits and pieces of my body into something tangible, entire. I can be seen, imagine men are looking at me, even look at them sometimes. Soon, they arrive, seem much shorter, fatter, whiter than I had remembered, but it doesn't matter. Naturally, I'm wearing the white dress—simple, silk, embroidered bodice, gathered at the waist, full skirt falling just below my knee, and thinking thank god no one will see me, (I mean everyone is in New York) and wonder—who *am* I wearing this for anyway. Not *him*, he doesn't notice and the prospect of negotiating Disneyland has already given him a headache. Then my angelic son tells everyone, "Look at my Mommy." The riddle solved. I am transported in a halo of fluorescent light to the land of "good-enough-mothers." The motel manager waves his magic wand and says, "Please come with me in the dining room where you will feast on champagne, strawberries and cream, the seven Dwarfs will play the Brandenburg Concertos and I'm quite sure you will live happily ever after." And we do.

FROM *HISTORIA* (1989)

II
(first panel)
I was twenty in 1968. I'd gone to university, having read the *Feminine Mystique* because my father picked it up at an airport. Perhaps I also had some sense of a feminist tradition from my mother. I knew that she and her friends had struggled to get some kind of an education. At Oxford, the term feminism was in use, but bracketed off . . . as a term of abuse.

I have a vague recollection of the women's conference at Ruskin in 1970,

but I was preoccupied with the student occupation then which was becoming quite militant. I remember people from Ruskin coming to support us, but I didn't get involved in a women's group until I left university and went to London.

In 1971, maybe it was January 1972, some of us formed The Women's Lobby. Our reference point was the traditional suffrage movement. We wanted to do something that would have an immediate political impact, as we decided to try to get the Equal Opportunities Legislation out of the doldrums. . . . one of the Labor MPs had presented it four or five times to the House of Commons and it had been laughed out. So we mobilized a whole range of women's support groups . . . to write letters, to speak at meetings, to give the issue a public identity and keep it from continuing as an in-joke in Parliament. Out of this came the *Women's Report*. We thought that unless we could provide women with regular information on current affairs and how this affected them, then we wouldn't be making much progress. Eventually we got into a kind of workshop production of the *Report*. It covered legal parliamentary and social issues, as well as the arts. Some of us were interested in the question of cultures, so we started a section called "images." We used this wonderful typeface, where women's bodies were shaped into letters and we made these lovely banner headlines. I was involved in that until 1974.

Then came the Women's Art History Collective. The very first meeting took place around that time, and we met regularly for almost three years. We were aware of the women's workshop of the Artist's Union, but we weren't directly involved in it. We wanted to explore new ways of doing historical research about women artists, so we did projects . . . like self-portraits . . . exploring the historical and political implications of looking at ourselves. We read Nochlin, Berger, and that sort of thing . . . finally, after we had been meeting for quite awhile, we decided to try teaching collectively. We advertised ourselves and were asked by a number of polytechnics to give presentations. The plan was to make sure that everyone had a chance to speak, that no one dominated, and then to avoid becoming a collective authority as well, so that the audience could feel involved . . . but, in fact, the whole project was never resolved. I remember it was really amazing going to art schools . . . you would present your material and you would see women in the audience gasp, eyes popping at the possibility of someone daring to come out with this, and then back it up with these astounding statistics. It was a horrendous picture . . . one that you could see there and then, sitting in front of you . . . here there were these massed ranks of silent women controlled by these, you know, macho, or at least anxious men at the back.

Our efforts to understand these kinds of stereotypes kept bringing up the question of sexuality and, in our group, there was some interest in psychoanalysis. But I remember my first encounter with the Lacanian lot at the Edinburgh Film Festival in 1976: it absolutely enraged me . . . made me feel so disabled, so ignorant, sort of castrated by my inability to place myself with-

in that discourse. Yet, it really intrigued me . . . I wanted to translate our material into this other language. But none of the Collective would follow me down that road . . . everyone went off to develop her own work and it became defunct as a meeting group.

By then, I was committed to writing the history of our projects and some of the other feminist activities of the seventies, because it seemed to me that there was a process of amnesia in the eighties which was so rapid and wide-spread that the immense revolution initiated earlier was already disappearing. People felt, or were ideologically pressured to feel, they had to erase it. So I made myself its immediate archivist . . . feeling that the documents we had collected had to be made available in a certain form, within some kind of framework, that underlined their significance.

(second panel)
"Each article had to be discussed in detail, then corrected and okayed by the entire group. Most of us had never written anything before. So, one by one, frogs in the throat, knees shaking and all that we read our contributions. I remember Lorna's. She was hesitant, apologizing first for all the faults we would encounter, and then, finally, after we had coaxed her to continue, she began. The clarity, yes, that's the way it was, we thought. But more, her turn of phrase transported us into a realm of . . . well, collective ecstasy, I guess, since when she finished no one said a word."

(third panel)
(continued from page 41)
They are interrupted by a man, presumably a friend, in a black silk shirt (presumably washable), but no grey hair (probably dyed). "How old are you?" One Earring asks immediately. The Shirt is taken aback. "Ah . . . same as you, I guess. What difference does it make?" "No, no, you're younger," she persists. "Never mind," No Lipstick, coming to his rescue, "I think he qualifies. So tell us, what about your students then?" "Mine? . . . Well, they're too young to remember or perhaps don't want to . . . take the concept of repression, Freud's, that is . . . One of them said to me, 'You mean you want to do something, nobody stops you and you still don't do it? That sucks, sir.' " "Amazing," says No Lipstick. "Tragic," adds One Earring. Then, exchanging The Look of Utter (and Tragic) Amazement, they proceed with their complaints. Meanwhile . . .
(continued on p. 45)

FROM *POTESTAS* (1989)

Bona (detail)

They stared at her impassively, as if she were a pet. What did she want? And

why complain to them? The proof was her receipt, but did she have a Drivers License? A credit card? An address, income, assets or investments? Some insurance surely. An employer then, or an attorney, eight clean shirts, a shiny nose, a will? She pressed her lips into a narrow line and looked at them as if they were . . . she was . . . her father had . . . her friends or someone would . . . tell them who was who.

Populus (detail)

Introductions were dispensed with sherry and a round of erudite remarks. Should she mention someone that they knew, or let them do the talking? "You sit here," she overhead [*sic*] them say. "Your wife, she could sit over there." Thus over there she sat. In front of her three forks, five glasses and a qualmish silence. Would they introduce the mayor or the chancellor first? The gong, then: Benedicto. Benedicatur. Should she spit out the olive pit or swallow?

From *PECUNIA* (1989)

From *Conju*

He was gone. Now, everything would be her way. First, the newspapers—fossilizing in her precious cupboard space. She'd throw them out. Then, the receipts, itineraries, tickets, lists—a little mound of crumpled pasts that grew, insatiable and fungus-like around her telephone, devouring two volumes of the Shorter Oxford Dictionary and a Franklin Spelling Ace. She'd put an end to that. Finally, but most emphatically, she plotted to clean the bathroom, to remove the sallow wreath encrusted on the toilet bowl, the gilding spray inside the seat, outside the tank too for that matter and, when she looked more closely, on the wall behind it all the way up to the light switch. She wondered what evolutionary lapse had shaped such an improbable, undignified anatomy and felt annoyed. She was alone. At last, she could open all the windows without arbitration and embrace the cold, emancipated air. She was surrounded by nothing, nothing but an arc of abstinent light and the smell of palest blue. The house effused a canny silence and the bathroom was so clean, *so* clean.

Flowers on her birthday for chrissake, that's all she wanted.

From *Soror*

Someday, when she was older, she would leave the city. Leave the dirt, fumes, noise et cetera, and move to the country. There, she would live sim-

ply, grow her own alfalfa, zucchini, tomatoes, and so forth, and savor the last morsels of unpolluted air before they escaped through the terrible hole. Meanwhile, she resolved to invest her savings in a plot of land, upstate—small lake, tall pines, rolling hills, and so on. She could not afford to build a house, but at least she could go there on weekends with a tent, a picnic basket, and a friend—ideally, an architect—and plan. Where to begin—perhaps a swimming pool and two cabanas, the rest could come later, later when she was ready to leave the city, when she was older, and *if* she met the right person. Until then, she decided to put on her leather jacket, chain bracelet, lace anklets and the like, and live complexly a little longer.

She wanted her *and* she wanted all of her clothes.

FROM "DESIRING IMAGES/IMAGING DESIRE" (*WEDGE*, 1984)

In the matter of images of women . . . it would seem that everything is doubly labyrinthine. Desire is embodied in the image which is equated with the woman who is reduced to the body which in turn is seen as the site of sexuality and the locus of desire, a familiar elision, almost irresistible it would seem, judging from the outcome of so many conference panels and special issues devoted to this theme. Nevertheless, it is a dangerous and circuitous logic that obscures a certain "progress," a progression of strategies, of definitions made possible within feminist theory by the pressure of a political imperative to formulate the "problem" of images of women as a question: how to change them. The legacy is not a through-route, but a disentangling of paths that shows more clearly their points of intersection and draws attention to the fact that it is not obligatory to start over again at the beginning.

Discourses of the body and of sexuality, for instance, do not necessarily coincide. Within the modernist paradigm, it is not the sexual body, but the phenomenological (Husserlian) body that takes precedence; what belongs to me, my body, the body of the self-possessing subject whose guarantee of artistic truth is grounded in "actual experience," often deploying the "painful state" as a signature for that ephemeral object. Thus, the contribution of feminists in the field of performance has been, exactly, to pose the question of sexuality across the body in a way which focuses on the construction of the sexed subject, and at the same time problematizes the notion of the artist/*auteur*. The body is decentered, radically split, positioned; not simply my body, but his body, her body. Here, no third term emerges to salvage a transcendental sameness for aesthetic reflection. Yet, these artists continue to counterpose a visible form and a hidden content; excavating a different order of truth—the "truth" of the woman, her original feminine identity. Although the body is not perceived as the repository of this truth, it is seen as a hermeneutic image; the enigma of femininity is formulated as a problem of

imagistic misrepresentation which is subsequently resolved by discovering a true identity behind the patriarchal facade.

The enigma, however, only seems to encapsulate the difficulty of sexuality itself and what emerges is more in the order of an underlying contradiction than an essential content. The woman artist sees her experience as a woman particularly in terms of the "feminine position," that is, as the object of the look. But she must also account for the "feeling" she experiences as the artist, occupying what could be called the "masculine position," as subject of the look. The former she defines as the socially prescribed position of the woman, one to be questioned, exorcized, or overthrown, while the implication of the latter—that there can be only one position with regard to active looking and that is masculine—cannot be acknowledged and is construed instead as a kind of psychic truth: a natural, instinctual, pre-existent, and possibly unrepresentable femininity.[1] Often, the ambivalence of the feminist text seems to repudiate its claim to essentialism; it testifies instead to what extent masculine and feminine identities are never finally fixed, but are continually negotiated through representations. This crisis of positionality, this instability of meaning revolves around the phallus as the term which marks the sexual division of the subject in language. Significantly, Lacan describes the woman's relation to the phallic term as a disguise, a masquerade.[2] In being the phallus for the other, she actively takes up a passive aim, becomes a picture of herself, erects a facade. Behind the facade, finally, there is no "true" woman to be discovered. Yet, there is a dilemma: the impossibility of being at once both subject and object of desire.

Clearly, one (so-called post-feminist) response to this impasse has been to adopt a strategy of disavowal. It appears in the guise of a familiar visual metaphor: the androgyne. She is a picture; an expressionistic composite of looks and gestures which flaunts the uncertainty of sexual positioning. She refuses the lack, but remains the object of the look. In a sense, the fetishistic implications of not-knowing merely enhance the lure of the picture, effectively taming the gaze, rather than provoking a deconstruction. Another (and perhaps more politically motivated) tactic has been to self-consciously assume the "patriarchal facade;" to make it an almost abrasive and cynical act of affirmation. By producing a representation of femininity in excess of conventional codes, it shatters the narcissistic structure which would return the woman's image to her as a moment of completion. This can induce the alienating effect of a misrecognition, but the question persists: how can she represent herself as subject of desire?

The (neo-)feminist alternative has been to refuse the literal figuration of the woman's body, creating significance out of its absence. But this does not signal a new form of iconoclasm. The artist does not protest against the "lure" of the picture. In another way, however, her practice could be said to be blasphemous in so far as she seeks to appropriate the gaze behind it (the place of gods, of *auteurs,* and evil eyes). In her field of vision femininity is not seen as a pre-given entity, but as the mapping-out of sexual difference within

a definite terrain, a moment of discourse, a fragment of history. With regard to the spectator, it is a tactic of reversal, attempting to produce the woman, through a different form of identification with the image, as the subject of the look.

A further consequence of this reversal is that it queries the tendency of psychoanalytic theory to complement the division of the visual field into sexually prescribed positions by rhyming repression/perversion, hysteria/obsession, body/word . . . with the heterosexual couplet seer/seen. . . .

When Freud describes castration fears for the woman, this imaginary scenario takes the form of losing her loved objects, especially her children; the child is going to grow up, leave her, reject her, perhaps die. In order to delay, disavow, that separation she has already in a way acknowledged, the woman tends to fetishize the child: by dressing him up, by continuing to feed him no matter how old he gets, or simply by having another "little one." So perhaps in place of the more familiar notion of pornography, it is possible to talk about the mother's memorabilia—the way she saves things—first shoes, photographs, locks of hair, or school reports. A trace, a gift, a fragment of narrative; all of these can be seen as transitional objects, not in Winnicott's sense, as surrogates, but in Lacan's terms, as emblems of desire. The feminist text proceeds from this site; not in order to valorize the potential fetishism of the woman, but to create a critical distance from it—something which has not been possible until now because it has not been generally acknowledged.[5] Here the problem of images of women can be re-formulated as a different question: how is a radical, critical, *and* pleasurable positioning of the woman as spectator to be done?

Desire is caused not by objects, but in the unconscious, according to the peculiar structure of fantasy. Desire is repetitious, it resists normalization, ignores biology, disperses the body. Certainly, desire is not synonymous with images of desirable women; yet, what does it mean, exactly, to say that feminists have refused the "image" of the woman? First, this implies a refusal to reduce the concept of the image to one of resemblance, to figuration, or even to the general category of the iconic sign. It suggests that the image, as it is organized in that space called the picture, can refer to a heterogeneous system of signs—indexical, symbolic, and iconic. And thus, that it is possible to invoke the nonspecular, the sensory, the somatic, in the visual field; to invoke, especially, the register of the invocatory drives (which, according to Lacan, are on the same level as the scopic drives, but closer to the experience of the unconscious), through "writing." Secondly, it should be said that this is not a hybrid version of the "hieroglyph" masquerading as a "heterogeneity of signs." The object is not to return "the feminine" to a domain of pre-linguistic utterance; but rather, to mobilize a system of *imaged discourse* capable of refuting a certain form of "culturally overdetermined" scopophilia. But why? Would this release the "female spectator" from her hysterical identification with the male voyeur?

Again, the implications of suggesting that women have a privileged rela-

tion to narcissism or that fetishism is an exclusively male perversion should be reconsidered. Surely, the link between narcissism and fetishism is castration. For both the man and the woman this is the condition for access to the symbolic, to language, to culture; there can be no privileged relation to madness. Yet there is difference. There is still that irritating asymmetry of the Oedipal moment. There is Freud's continual emphasis on the importance of the girl's attachment to her mother. And there is Dora.[4] What *did* she find so fascinating in the picture of the Sistine Madonna? Perhaps, above all, it was the possibility of seeing the woman as subject of desire without transgressing the socially acceptable definition of her as the mother. To have the child as phallus; to be the phallic mother; to have the pleasure of the child's body; to have the pleasure of the maternal body experienced through it; perhaps, in the figure of the Madonna, there was a duplication of identification and desire that only the body of another woman could sustain.

For both the man and the woman, the maternal body lines the seductive surface of the image, but the body *he* sees is not the same one *she* is looking at. The woman's relation to the mother's body is a constant source of anxiety. Montrelay claims that this relation is often only censored rather than repressed. As a consequence the woman clings to a "precocious femininity," an archaic oral-anal-vaginal or *concentric* organization of the drives which bar her access to sublimated pleasure (phallic *jouissance*).[5] Similarly, with regard to the artistic text, and if pleasure is understood in Barthes's sense of the term as a loss of preconceived identity, rather than an instance of repletion, then it is possible to produce a different form of pleasure for the woman by representing a specific loss—the loss of her imagined closeness to the mother's body. A critical, perhaps disturbing sense of separation is effected through the visualization of exactly that which was assumed to be outside of seeing; precocious, unspeakable, unrepresentable. In the scopic register, she is no longer at the level of concentricity, of repetitious demand, but of desire. As Lacan points out, even the eye itself belongs to this archaic structure since it functions in the field of vision as a lost object.[6] Thus, the same movement which determines the subject's appearance in language, that is, symbolic castration, also introduces the gaze. And the domain of imaged discourse.

Until now the woman as spectator has been pinned to the surface of the picture, trapped in a path of light that leads her back to the features of a veiled face. It is important to acknowledge the masquerade that has always been internalized, linked to a particular organization of the drives, represented through a diversity of aims and objects; but at the same time, to avoid being lured into looking for a psychic truth beneath the veil. To see this picture critically, the viewer should be neither too close nor too far away.

1. Mary Kelly, "Re-Viewing Modernist Criticism," *Screen* 22, no. 3 (1981), pp. 53-56.

2. See Jacques Lacan, "The Signification of The Phallus" (1958), in *Feminine Sexuality,* ed. Juliet Mitchell and Jacqueline Rose (London: The Macmillan Press, Ltd., 1982).

3. See Mary Kelly, *Post-Partum Document* (London: Routledge & Kegan Paul,

1983).

4. See Sigmund Freud, "Fragment of an Analysis of a Case of Hysteria" (1901), *Standard Edition*, vol. 7, trans. James Strachey (London: Hogarth Press, 1968).

5. Michele Montrelay, "Inquiry into Femininity," *m/f*, no. 1 (1978): 86-99.

6. Jacques Lacan, "What is a Picture," in *The Four Fundamental Concepts*, ed. M. Masud, trans. R. Khan (London: Hogarth Press, 1977), p. 118.

FROM "ON REPRESENTATION, SEXUALITY AND SAMENESS: REFLECTIONS OF THE 'DIFFERENCE' SHOW" (*SCREEN*, 1987)

. . . What I am suggesting is that feminism may have privileged the relation to the mother's body in a way which did more than explain a different relation to castration; it also asserted our difference from men. Perhaps in the process we made the mother too real, too close, and consequently blamed her for too much.

At this point, we might ask, is there no outcome of the Oedipus complex for the girl which is without neurotic consequences? Does, for instance, as Catherine Millot suggests in "The Feminine Super-Ego," the pre-Oedipal identification with the father always entail a regressive transference of the demand for the phallus from him to the pre-Oedipal, hence phallic, mother? [Catherine Millot, "The Feminine Super-Ego" (trans. Ben Brewster), *m/f* 10, 1985, pp. 21-38] Is it inconceivable that the "masculinity complex" be considered, in some sense at least, as a resolution of the conflict? It does, after all, necessitate the internalisation of demand and the setting up of a super-ego. This process can lead to inhibition and anxiety, as Millot indicates, but at the same time it makes possible what is generally referred to as a profession, or less mundanely, as the kind of sublimated pleasure associated with creative work. And significantly, it is for this manifestation of "virility" that women propose to make themselves lovable. As Millot points out, "the object of desire—and not the object of love—is feminine." I find this an intriguing distinction, one that seems to underline the particular dilemma of the older woman: how to represent her femininity, her sexuality, her desire when she is no longer seen to be desirable. She can neither look forward, as a young girl does, to being a woman, having the fantasised body of maturity nor can she return to the ideal moment of maternity—ideal in that it allows her to occupy the position of the actively desiring subject without transgressing the socially acceptable definition of the woman as mother. Rather, she is looking back, at something lost—acknowledging, perhaps, that "being a woman" was only a brief moment in her life.

In *Post-Partum Document* I asked myself what it was that the woman feared losing beyond the pleasure of the child's body and concluded that it was the closeness to the mother's body she experienced in being "like her." Now, in *Interim*, I am asking how the woman can reconstitute her narcissistic aim, and consequently her pleasure, her desire, outside of that maternal rela-

tion. Significantly, the stories in Part I begin with the decision not to have a child and then continue to explore other forms of identification around which the feminine/masculine terms revolve. In effect, *Corpus* reiterates the hysteric's question: am I a man or am I a woman? So, with the loss of maternal identity, I feel that a different order of fear emerges. And this, once again, concerns the importance of the repressed pre-Oedipal identification with the father: the desire to be "like him," but the fear of being *the same*, that is, being like a man.

Here, perhaps, a less obvious question imposes itself. Is the boy's resolution of the Oedipal drama really as unproblematic as we assume? Could Millot's distinctions regarding the masculinity complex for women be usefully inverted to reconsider a man's relation to the feminine position? For example, does the woman who fantasises the possession of a phallus parallel the man who acts out its absence (transvestism)? Is the woman who masquerades as the feminine type, who disguises the lack of a lack, but makes no demand on her sexual partner, comparable to the man who "does what he's gotta do," who "acts like a man," although he senses the fraud and, in fact, has no sexual desire for the woman? Also taking up what lies on the cusp of the complex—the woman's desire for the child as phallus and the man's desire to give her this "gift"—and what lies outside it—the failure to internalise demand which results in Don Juan's (or Don Juanita's) continual search for "something better"—all of this begins to give substance to the Lacanian view that for both men and women there are as many forms of identification as there are demands.

Finally, I am not proposing this as an answer to the third objection. I am suggesting that the way this exhibition frames the questions of sexuality and representation allows us to rethink, rather than repeat, the feminist arguments on which that issue is founded. In this sense, the show's strategic sameness makes present and meaningful what is often only a rhetorical plea for a postmodernism of resistance.

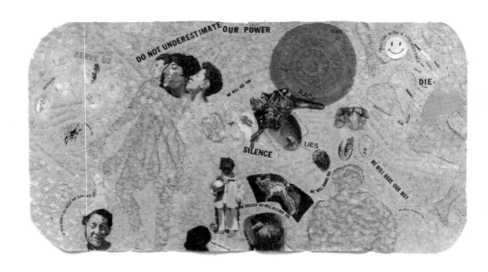

Autobiography: Scapegoat, 1990. Acrylic, paper, polymer-phototransfer, gouache, watercolor, and vinyl type on sewn canvas, 72 x 141 in. Collection: The Studio Museum in Harlem, New York. Photo: D. James Dee

HOWARDENA PINDELL

B. 1943

THOUGH **HOWARDENA** Pindell has explored many different forms and media in her works, all are characterized by a layering and weaving of disparate parts into a coherent whole. A painter who has experimented with several distinct stylistic approaches, Pindell has used her artwork as a field in which to reconstruct the fragments of her experiences and perceptions. As such, much of her recent work is autobiographical, "to get at the guts of [her] own past." She has said that "since autobiographical themes are endless," she is "never at a loss for ideas." An additional aspect that connects her work over the years and in various media is her labor-intensive approach to art-making, in which the picture surfaces are constructed from small pieces that have been punched, cut, glued, and sewn. The written word has also been important to Pindell as part of the same process of retrieval and reclamation. She has used textual fragments in her works themselves, and is also a prolific essayist. In a twenty-year retrospective, her writing was displayed alongside her paintings, in order to give her "full voice."

Howardena Pindell was born in Philadelphia, the only child of middle-class, African-American parents (he was a statistician; she, a teacher) to whom she was born rather late in life. Pindell knew that she wanted to be an artist from the time she was eight when she took Saturday drawing classes at the

Fleisher Art Memorial in Philadelphia. She continued taking art lessons there and at Temple University's Tyler School of Art and the Philadelphia Art College until she graduated from high school; her first exhibition was at her parents' church in Philadelphia. In 1961 she went to Boston University where she majored in painting, graduating in 1965. She went on to Yale University to study for her Master of Fine Arts, which she received in 1967. Pindell moved to New York and began to work as an exhibition assistant at the Museum of Modern Art, where she remained for the next twelve years, working her way up to the position of associate curator in the Department of Prints and Illustrated Books.

During her years at the Museum of Modern Art, Pindell also was able to pursue a career as a painter. Although she had worked originally in a figurative style, at Yale she had begun to experiment with abstraction. In the years immediately following her graduation from Yale, she stained dark colors into unstretched canvases to create luminous fields, patterned after Ad Reinhardt's black paintings. She soon began spraying paint through holes punched in paper stencils which led to her first important stylistic breakthrough in the early 1970s, when she began to recycle the dots from the holes that she had punched into a series of independent works. (In fact, she had already used dots in some works from the late 1960s.) For some works she used dots made from unpainted paper and created visual variety by numbering them, while she built others from paper she had colored with paint or crayon before punching the dots. The visual texture of the works from this period differs accordingly: some are characterized by a flat, orderly surface constructed on a grid, and others seem to be a jumble of confetti-like parts. Soon she began to add other elements to these collages, such as printed fabric, thread, string, glitter, and sequins, all of which added to the layered effect and visual complexity. In the mid-seventies Pindell also experimented with video drawings in which she manipulated photographs of sporting events by drawing on them seemingly scientific diagrammatic lines. At this time, too, she began to travel extensively: to Africa in 1973 in her capacity as curator at the museum, to Egypt in 1974, to Paris and India in 1975, to Brazil in 1977, and to Japan in 1979. Her travels had a far-reaching impact on her subsequent art.

Pindell's life changed radically in 1979 for two reasons. In August of that year, having resigned from the Museum of Modern Art, she took a position as an associate professor in the art department at the State University of New York at Stony Brook, a change that enabled her to devote more time to artistic creation as she was no longer tied to a nine-to-five job. At Stony Brook, she was promoted to full professor in 1984 and has remained there. Only six weeks after she began at Stony Brook, however, Pindell suffered a head injury, that resulted in memory loss, while she was a passenger in a car accident. As a consequence of the accident and the ensuing, unsettling gaps she experienced in her memory, she began to work on her *Autobiography* series "as a desperate struggle to heal [her]self." Her first work in this project was her video "Free, White and Twenty-One" (1980), a twelve-minute presentation in which she

created a dialogue between an African-American woman who wrapped her face in gauze while recounting tales of racial abuse, and an allegedly white woman who accused the first speaker of paranoia, while denying the accuracy of her perceptions. Pindell played both roles, the latter in white face.

During the 1980s Pindell evolved two distinct formal vehicles for mining and reconstructing her memory. At first she began making collages out of post-cards collected during her travels, which subsequently developed into a series of works in which she would cut first the cards (and then later the photographs that she took) into strips and then fill in the blanks with acrylic paint, a metaphor for the process of filling in the gaps in her memory. Slightly later she began to work on irregular, unstretched canvas which she stitched together and encrusted with her signature dots and glitter, but into which she also embedded figural elements, text, and even her own hair and blood. By the mid-eighties the dots were replaced by short, thick paint strokes that Pindell has characterized as representing "both notes and sounds of a mantra as well as scarring, echoing both a rupture and a healing." She has continued alternating these two approaches into the 1990s, using photographs that she took during her extensive travel in the previous decade, particularly to Japan and to India (four trips).

The idea of piecing together fragments of her experiences and thought processes continues to be an important part of Pindell's artistic endeavor. More recent paintings are characterized by a dramatic increase in scale and the incorporation of her own silhouette and photographed image into their thick-ly textured layers, as in *Autobiography: Scapegoat* (1990), in which she "sym-bolize[s] and illustrate[s] issues of abuse within the family as well as in society systems." She has received two public commissions thus far: one, a mural showing landmarks and people for the Social Security Building in the New York City borough of Queens, and the other, a mosaic for the Sky Harbor International Airport in Phoenix, Arizona.

Pindell is most definitely an activist, and her art is informed by her politi-cal awareness. In the late sixties and early seventies, along with about twenty other women artists, she participated in the founding of the A.I.R. Gallery, a cooperative women's gallery. Pindell recounts that she was catalyzed by the exclusion of women from the Whitney Museum of Art and her own rejection by the former director of the Studio Museum in Harlem, who refused to show work by women. After resigning from A.I.R. in 1975, she was a major partici-pant in a 1979 protest against an exhibition of charcoal drawings, gratuitously titled "Nigger Drawings," by a white artist at an alternative exhibition space. She continued her fight against racism in the mid-eighties in her statistical reports on the complacent racism in the art world, as exemplified by the min-imal gallery representation and museum exhibitions of artists of color, which she characterized as censorship by exclusion.

It is interesting, in light of her fervent political dedication, that at the beginning of her career Pindell's art was politically detached and she felt her-self criticized for creating formalist abstractions instead of works with overtly

political content. Over the years, as she has increasingly made her self the subject of her art, this has changed so that now virtually all of her works make strong political statements against far-reaching issues, including war, racism, slavery, and child abuse. The turning point in her career was marked by her video "Free, White and Twenty-One" in which, as Lowery Sims points out, she showed how "she was constantly confronted by the white establishment to deny and denigrate her blackness, to demand complacency in return for limited access to the establishment." Pindell's travels to so-called Third World countries provide one explanation for her increased use of art as a means of political expression. She has indicated that her cross-cultural experiences have kept her from adopting what she calls the American "pathology," although, as her writings indicate, she has also been appalled at examples of sexism and racism in several countries that she visited. Her own multi-ethnic background might also have contributed to her visceral understanding of the pointlessness of greed and domination of one group over another.

Despite their diverse media, most of Pindell's works are unified by several aesthetic characteristics. Perhaps the most significant of these is her use of labor-intensive processes of construction with the resultant effect of an accumulation of parts. Process has been very important to Pindell, in her early use of numbered, punched holes, in her detailed drawings on photographs of television screens, in her cutting of photographic strips, and in her sewing together of pieces of canvas. She has stated that she finds the rote work "a form of meditation." Some critics have suggested that her approach relates to the tedious and repetitive nature of women's traditional work, although Pindell resists this interpretation, pointing out its stereotypical assumptions. Although there are similarities between her works—in the repetition of small units and their constructed feel—and those of some artists who have been associated with the Pattern and Decoration school, Pindell cannot legitimately be considered a part of that group, as her work involves so much more than surface decoration. In fact, the surface pattern in Pindell's works forces the viewer to look more deeply into the layers beyond the picture surface. Lowery Sims finds an analogy between the surfaces of Pindell's earlier works and Pindell's own description of "the creation of surface tension in African textiles through the application of beads" in which the visual surface tension is heightened "as the sense of background and foreground dissolve." A similar analogy could be made with the complex, encrusted surfaces of her recent large canvases, which have been seen by Sims (and other critics) as a reconstruction on canvas of "the various atomized parts of our existence."

That she creates these by stitching together separate parts enhances this concept of binding together disparate pieces, of weaving fragments into a whole. The existential nature of these autobiographical works is enhanced by the fact that the pieces she connects have been torn or cut. That is, Pindell is literally working for her life; as she has said, her art is her process of healing. In this context, the cut pieces, splinters, and shards of photographs, of text, of canvas, of staccato paint strokes have a symbolic resonance. Through their

integration in the work, that which has been ruptured, that which is incomplete, harmed, or fractured, is made whole and healed.

From an early point in her career Pindell began to subvert the traditional European picture surface in terms of both the integrity of its canvas support and its resulting spatial illusion. Even the stain paintings from her first days in New York exhibit this tendency as the color appears to be rubbed into the surface. Conversely, in her next series of work, the dots and other materials sit on the surface in actual relief, projecting into the viewer's space. Pindell continued to construct the picture surface in her later work where, as discussed above, in both series from the 1980s and 1990s she pieced together her field from fragmented parts. Thus, rather than manipulating a totally flat and inviolate plane solely through the application of paint, Pindell plays with actual fissures and protrusions. The irregularity of her fields should also be considered in this light. Although she used unstretched canvases in her works from the early 1970s, by the 1980s, in her *Oval Memory* series, she claims to have "completely abandoned the rectangle" to use more natural shapes. The biomorphic, circular quality of these compositions, based on her trips to Japan and India, increases the sense of a traveler's multisensory experiences and the process of piecing together a mental landscape, unencumbered by the western conventions of a single horizon or point of view. In her large, recent paintings on unstretched canvas, Pindell uses irregular fields in a similar way, to show a multiplicity of perceptions and influences. Their asymmetrical shapes greatly enhance their communicative power.

Pindell is an artist for whom writing has been especially important, and her written work has taken several forms. She was a prolific writer prior to her accident; subsequently, writing became part of her process of autobiographical investigation, another means of weaving together the fragments of her existence. She has written extensively on her travels and her cross-cultural experiences, generally and as they pertain to specific works of art. She has written analyses of other artists and forms of art, such as her essay on African adornment, that are often revealing of her own aesthetic. She has offered analyses of the imagery and intellectual content of numerous paintings, in which she fleshes out many of the textual elements that are embedded in them. It is significant that the organizers of the 1992 retrospective included extended written passages as part of the exhibition in order to present a comprehensive picture of her creative mind.

Writing has also played a significant role in her political activism. A persistent and perceptive critic of American complacency, she has challenged the racism of the artistic establishment, the hypocrisy of the quincentenary celebration of Columbus's alleged discovery of America, and the duplicity in the reporting of the Persian Gulf War. Like her artwork, her cultural critique is not comfortable or pleasant, but challenging and profound. Her statistical survey of the severe underrepresentation of artists of color in New York museums and galleries in the mid-eighties was an authoritative piece of research that conclusively substantiated her accusation of censorship. (At that time, 38 galleries

were 100% white—including some of the most prestigious in New York—and another 15 were between 90% and 95% white.) Pindell is currently working on an update.

SOURCES

Howardena Pindell: Odyssey. Exhibition catalogue (introduction by Terrie S. Rouse). New York: Studio Museum in Harlem, 1986.

Howardena Pindell: Paintings and Drawings, A Retrospective Exhibition, 1972-1992. Exhibition catalogue (essays by Holland Cotter and Lowery Stokes Sims). Potsdam, N.Y.: Roland Gibson Gallery of Art, 1992.

Kozloff, Joyce, ed. *Interviews With Women in the Arts, Part 2.* New York: Tower Press, 1976.

Pindell, Howardena. "The Aesthetics of Texture in African Adornment." In *Beauty by Design: The Aesthetics of African Adornment*, edited by Marie-Thérèse Brincard. New York: The African-American Institute, 1984, pp. 36-39.

_____. "An American Black Woman Artist in a Japanese Garden." *Heresies* 15 (1982-83), pp. 54-55.

_____. Pindell, Howardena. "Art World Racism: A Documentation." *New Art Examiner* (March 1989), pp. 32-36.

_____. "Breaking the Silence, Parts I and II." *New Art Examiner* (October 1992), pp.18-23; (November 1992), pp. 23-29, 50-51.

Rosen, Randy et al., eds. *Making Their Mark: Women Artists Move into the Mainstream, 1970-85.* New York: Abbeville Press, 1989.

Since the Harlem Renaissance: 50 Years of Afro-American Art. Exhibition catalogue. Lewisburg, Pa.: Center Gallery of Bucknell University, 1985.

HOWARDENA PINDELL—SELECTED WRITING

"A BLACK AMERICAN'S AFRICAN DIARY" *(HERESIES,* 1977*).* REPRINTED IN *HOWARDENA PINDELL: PAINTINGS AND DRAWINGS* (1992).

A game park borders the road to Nairobi. It is 1973, the year of the drought. They say that when the animals have too much thirst they will come into the city. Full face image of Col. Sanders revolving slowly over Kentucky Fried on the right hand side of the road. The Europeans who remained . . . many joined "White only" country clubs and refused to learn Swahili while others married women of the ruling tribe in order to retain their positions of

power. We were the only Blacks staying at the New Stanley Hotel. White children ran from us in the hall. Spoke a few words of Swahili to the African women who worked in the hotel. Their reaction was warm but puzzled. . . . "What are you? Are you married? You have no children? What is your room number? I will send a man to your room tonight and you will come back."

Waking up is difficult, slow labored . . . a struggle to gain consciousness because of the high altitude. Walking up and down the stairs is difficult because gravity has multiplied. A friend of a friend, a Kikuyu, visits and asks, "Are you traveling alone? With a White American? No! Good . . . Then I can have you for lunch." At lunch the next day I meet her husband, a tall, blond British fellow.

Women of the Masai are silent and distant, draped in red-ochre cloth . . . green, blue, red beads encircle their necks. They are trained to work while the men tend the cattle. See aged women of their tribes used as beasts of burden while men trifle idly at conversation.

Morning tea and toast at the New Stanley. News item: "Man burns wife to death . . . should he be tried under parliamentary law for murder, or should the case go before a tribal tribunal which may rule in the man's favor since he has the right to destroy his property?"

Lagos, Nigeria—morning headline: "Women, you should be proud to be first wife. Think of all the joys of being first wife in charge of all your husband's other wives." Women who attend Ibadan University are called names, but my friends (who live there) say that men in "high posts" prefer them because they can converse with "westerners." There have been women stoned to death in Ibadan for being "witches." Self-policing—the women . . . if one breaks the tradition of silence, one may be killed. A man enters the plane for Ghana followed by his first, second, and third wives and their eight children. The women in Ghana are forming women's groups . . . they speak . . . they have professions . . . yet there is a taboo against speaking in the company of men. Although the children speak, they speak of men's work and women's work. Abidjian, Ivory Coast: The French women look at us with contempt. In Ghana the women looked at us with pity because we were of mixed blood and had no tribal language.

A French woman demands to be served ahead of me in a store. I tell her to go to hell, and I am served first. Sister Doctor, nun who has worked with the lepers for forty years, visits me as I am circled by a Nigerian. She says men see a glass of water and must drink. She speaks of working with the leper women of Adzope . . . women who carry their children on their backs until they are three years old and also lepers. She has tried to change the tradition for forty years. She is beginning to show signs of the disease. Remember my first night in Lagos . . . large fires, milling people at midnight. Women wrapped in cloth with gold and silver threads plucked by headlights and firelight. Drums—sounds—cooking smells. Women moving as if they are navigating a field of stone eggs.

Dakar, Senegal: Wolof women in yards of cloth . . . enigmatic Ingres por-

traits. There were no African women in the hotel, only French women, cold and tanned. Every delicacy imported from France makes me feel as if I slapped someone who is starving. Diplomat women tell us of loneliness and how repairs are difficult to arrange because the men will not take orders from women. The Wolof men beg us for money so that they may come to America: their women look at us with ice. We cannot face the Isle of Goree where the (en)slaved were imprisoned before being shipped to America. The ocean is the same as it was then. We will be crossing again, but fast this time. While packing I discard a pair of pink checkered pajamas which have survived the trip and me since I was sixteen years old. They are now too short in the legs . . . to be left behind. From a cab window I see a woman meticulously hanging my pink pajamas out on a line to dry.

"AN AMERICAN BLACK WOMAN ARTIST IN A JAPANESE GARDEN" (*HERESIES*, 1982-83)

My first June day in Tokyo, I wandered confused, dazed by the 12-1/2 hour flight, the 13-hours-ahead time change, and the blitz of words I could not read. My previous trip to Japan in 1979, courtesy of a Japanese newspaper, had been an eastern Cinderella story complete with adoring prince (the semi-honorary white male status bestowed on a Black woman represented, to the Japanese, a formidable institution). Reentry as the artist, without the protection of "benevolent" corporate sponsors, was what one might imagine it would be like for a non-white person granted temporary white status in South Africa only to find herself stranded unannounced in the wrong restroom.

The pointing at close range, the stares and the laughter, took courage to face daily. Central Tokyo, around the Ginza, was one of the few places where non-Japanese faces did not produce unexpected responses. Wandering out of a small radius of the tourist mecca revealed another Japan—not the polite one of the package tour propaganda, but a sometimes harsh, fragile and unhappy, brittle reality. (My short afro often brought crisis to the public bath. Before I could undress, women would run screaming, thinking a foreign male had strayed into the wrong place.)

On the long wooden stairs of a small shrine near Taiyiun Mausoleum, Nikko, was a sign which read in English: "Please take off your shoes." I removed my shoes and ascended. A young woman sitting in a glassed-in room, left of the entrance, waved violently to me to go away. At first I thought there was a private ceremony in progress, but the shrine was small and open enough for me to see that it was absolutely empty. I decided to ignore her and proceed, seeing no activity. The attendant became extremely agitated and relayed to me as best she could that it was absolutely forbidden for me to enter. I felt angry and puzzled. Why have a sign in English, if foreigners are

not allowed to enter? Several experiences later it struck me that she perceived me as defiling her precious shrine as I was a non-white foreigner—hence "impure." I later read in Mikiso Hane's *Peasants, Rebels, and Outcasts* (New York: Pantheon, 1982) that the *brakamin* (Japan's "untouchable class") are not permitted to enter temples and shrines as they are considered "unclean." They are relegated to earning their living in professions the Japanese consider dirty, such as butcher or tanner. The *brakamin* are Japan's scapegoat group, along with the Koreans and all non-Japanese Asians. For them it has been a seemingly endless history of discrimination and segregation in education, housing, and jobs. Some say, according to Hane, that it is because "they" are descendants of vanquished clans like the Tiara (Heike) who were defeated by the Minamoto, or that it is because "they" are descendants of the Koreans or Ainu (Japan's original "native" people, who are referred to as Caucasian because they have more body hair than the "Japanese"), or that it is because "they" eat meat in a vegetarian, Buddhist, fish-eating nation. (Several people I met during the course of my seven months—in some odd attempt to reassure me—stated point blank with pride, "I am racially pure Japanese!")

I stumbled constantly over taboos and codes of behavior deeply embedded in a rigidly hierarchical society. Rich was superior to poor, old superior to young, men superior to women, with few questions asked in passive obedience to the demands of conformity. One moment, I felt I had grasped the system—the next, I was thrown into confusion by some new pattern of behavior that did not fit what I thought were their rules. I learned to carry the conspicuous signs of the temporary tourist, the camera and the map. People would scurry to my aid, taking me by the hand to my destination, or would lash out at me, the intruder, in ridicule. (One male child on a country road in Nara tried to kick me as hard as he could. Fortunately he missed and lost his shoe in mid-air.)

The person in charge of my grant arrangements, a man in his late twenties, told me soon after I arrived that it was forbidden for me to speak directly to an older man in authority, that I could speak only to the women in the room, and that it was forbidden for me to visit certain places because I was a woman. I was the first Black woman and the first single woman to have participated in the program. The married women who preceded me were white. They were never told these things. I often felt I was faced with a Jekyll and Hyde dilemma in which the same person would act in a diametrically opposite way depending on who he was dealing with. Grant money would be withheld from me for long periods of time, whereas the other grantees received their money unhindered—except for one, a young puppeteer who encountered questions about whether or not his puppets, "because of their big noses," were Jewish. When I showed my videotape "Free, White and 21" privately (I was not offered a public screening, although other grantees were invited to show their tapes), the remarks were always accompanied by laughter at how Jewish I looked in white-face.

Women, along with "non-Japanese," were used as a target for all the rage that had not been deposited elsewhere. Late evening TV burst with images of women being raped, mutilated, stabbed, hanged. It seemed as if all classes of Japanese men devoured comics filled with sadomasochistic pop images of the rape and torture of Japanese and foreign women. White women, in an odd contradiction in terms of the preferential treatment I saw them receive, were used in very much the same way that non-white women are used in the American media—as stereotypes of the reckless wanton, the prostitute, the mistress. The Black woman was portrayed as the cold, aloof, high-fashion model.

After World War II, children of a Japanese mother and Black father were deported to In fact, to this day, children of Japanese mothers and non-Japanese fathers are not born with Japanese citizenship. This is a "gift" which may only be bestowed by a Japanese father. The Koreans, although they were made citizens during the war to add to the cannon fodder, are denied citizenship today unless they are willing to give up their Korean heritage and adopt a Japanese name. An article last summer in the *Japan Times* revealed that during the war the Japanese planned to build death camps modeled on the Germans' extermination camps for Jewish people in order to rid the world of "impure" races, starting with the Korean people.

I think often about the Japanese and their frantic attempts to emulate the white man's more negative aspects—magnified by their own singular history of repression and harsh, discriminatory feudal laws. Their franticness to emulate seems to root itself in an unconscious realization that they too are the targets of racism—and the "if you can't beat them, join them" game. They cannot forget that twice they received the bomb that whites at the time would never have dropped on their own race.

The first few days home I was struck by superficial differences—the cleanliness of Japan versus the filth of New York; the raw emotions displayed by Americans as opposed to the ritualized repression by the Japanese of thoughts and feelings, punctuated by outbursts of rage at scapegoats or the internalization of anger turning into suicide. The elation at being home gave way to a feeling of despair over the changes which seemed to have taken place during the seven months I was away. I read about immigration authorities raiding Spanish, East Indian, and Asian communities for illegal aliens: about the detention of Haitian refugees in prisons while Polish refugees were detained in churches. I heard on National Public Radio about a white fraternity at the University of Cincinnati that held a Martin Luther King trash party—a costume ball where white students were invited to wear KKK sheets or a costume parodying Blacks. And I see the antics of the "art world," tribal as ever in their tall huts in Soho and on Tiffany Run—still whiter than white—tucking their hooded designer silk sheets behind slick, insincere, "sympathetic" nods.

What drew me home was the relative freedom to protest and to work toward positive alternatives, a freedom I have rarely witnessed elsewhere. I

have been asked why I stayed in Japan if after the first two months my hair had begun to fall out—why I didn't come back sooner. What kept me alive and alert in the midst of intense stress was a determination not to cave in to other peoples' unfortunate behavior—what nourished me and gave me energy was the extraordinary beauty I found in the traditional Japanese way of organizing space, images, and color and the brief refuge of peace I found in the Japanese gardens resplendent with the change of the seasons.

FROM "THE AESTHETICS OF TEXTURE IN AFRICAN ADORNMENT" (1984)

When I was asked to write about the objects in this exhibition from an artist's perspective, I realized that heretofore I had not "experienced" adornment as a "serious" art form, perhaps owing to my correlating adornment with the vagaries of fashion-world sensibilities. Western objects of adornment, when viewed within the context of an exhibition, seemed to me to be detached, even when imagined within a living context, as if they belonged to a remote, prosperous, yet "archaic" recent or distant past, rather than to a vivid living culture in which the adornment-enhanced body interacted with the flow of nature. . . .

The best approach to the challenge, I believed, was to choose a sensibility in the construction and appearance of the objects to which I felt closest in my own work—that of the textured accumulated surface. The comments that follow are therefore to be understood as the subjective reactions of a practicing artist, rather than as the outcome of scholarly research. . . .

In Africa, the geometry and texture of the individual human body engages in an ever-changing dialogue with the adornment selected by the wearer. Placing the objects on zones of the body, the wearer is able to convey messages not only of beauty or sexual allure, but also of status, rank, age, tribal identification, and aesthetics, as well as of a state of mind or a desire to placate or seek protection from the environment. This intricate interaction between inner thoughts and outer body reality—hair texture, tone of skin, proportion, height, angularity, and flexibility—is further augmented by sculptural hair arrangements or permanent alterations of the body's surface, such as scarification. Permanent or temporary modifications of the teeth, lips, earlobes, and nose, as well as tattooing and skin painting or tinting, further complement the adornment. The placement of weighty accessories such as heavy metal belts, bracelets or anklets affects or restricts gesture, modifying the movements of the body as well as adding the possibility of creating sound. . . .

Materials such as beads, shells, metals, raffia, and feathers when used to create everyday and ceremonial adornment, can produce a rich textural surface meshing the physical with personal, cultural, and "supernatural" components. In *African Accumulative Sculpture* (New York: Pace Gallery, 1974),

Arnold Rubin discusses the concepts of "power" and "display," which may also be applied to objects of adornment. "Display" elements include beads and cowrie shells used as currency in trade, as well as belts, fibers, and reflective surfaces. "Power" elements, their efficacy often acquired over a period of time through incantations, include, for example, horns, claws, skulls, hair, etc., thus creating charged surfaces and structures endowed with "special" powers, as well as with the survival life force of the animal part included. The Bamana hunter's tunic from Mali, for example . . . with its densely textured surface of protective amulets, fiber, leather, and claws, was "accumulated" over a period of time to maintain its harnessed "power.". . .

The accumulation and aggregation of element is a distinctive character-istic of African aesthetic. The Fon cosmetic container from Benin . . . with its elaborate combination of shells, beads, nuts, and seeds, is a perfect example of a more genteel form of this sensibility. The components of this assemblage can be rearranged so that its visual textural drama is altered by both light and motion. A direct antecedent of this aesthetic is the surface tension that is built up by the aggregated elements.

Surface tension is also manifest in flatter, more planar, less aggregated forms, such as beadwork objects, in which the clustered and rippling effect is caused by the beads' relation to the support fabric, as well as by the building up of tension in the warp and woof of the network armature of threads. As a result, geometric images do not adhere to a rigid mathematical boundary, as perhaps is the case in the beadwork of other cultures, such as the North American Indian.

Once the basic geometric formula has been established, the design may expand or contract, inhale or exhale, according to the whim of the artisan or the demands of the object's irregular shape. Figure and ground relationships also scintillate and may reverse, heightening the visual surface tension as the sense of background and foreground dissolve. One set of geometric forms will seem to shift position through contrasts of light and dark or color, aug-mented by occasional unexpected shifts of color or a slight variation in pat-tern. . . .

The textural surfaces of African objects of adornment add variety, excite-ment, and drama to the cultural codes that they convey from the wearer to the environment. The body with its pattern of movement is enhanced and given the dimension of a living canvas, on which each individual constructs his or her own image.

FROM "ART WORLD RACISM: A DOCUMENTATION" (*NEW ART EXAMINER*, MARCH 1989)

NOTE: The following material is excerpted from a larger research document compiled by Howardena Pindell and originally presented as a lecture at the

Agencies of Survival conference at Hunter College in New York, June 27,
1987. The conference was sponsored by the Association of Hispanic Arts and
the Association of American Cultures. The information used to compile the
statistical data was supplied by the public relations offices of these institu-
tions and is available to the general public. [Addresses and phone numbers of
the institutions have been omitted here.]

There is a closed circle which links museums, galleries, auction houses,
collectors, critics, and art magazines. A statistical study relative to artists of
color and art magazine articles and reviews, as well as the critics' statistical
record in terms of reviews, articles, books, and curated exhibitions would
also be revealing.

The institutions which were opened to address the needs of artists of
color, because of the racial bias which closed them out of the primary net-
work, are rarely if ever permitted to enter this closed circuit, thus closing
access routes to broader documentation of artists of color's activities and
achievements. This omission creates a false and rather fraudulent impression
that only artists of European descent are doing valid work. (Some Latin
American male artists have a slightly easier access to the network. Japanese
male artists seem recently to be a little less reluctantly incorporated into the
so-called mainstream.)

Black, Hispanic, Asian, and Native American artists are, therefore, with a
few, very few, exceptions, systematically excluded. The mainstream's focus in
exhibitions and publications is therefore on artists of European descent who
are referred to as the "American" artists. Artists who are not Caucasian of
European descent are somehow not considered to be American and are
thought of as "outsiders," yet white artists from Europe or Australia are
immediately brought into the fold.

A young student from the West Coast exploring bias in the art world was
understandably reluctant to let herself be identified in my report because of
her vulnerability. She revealed to me, however, that a major New York art
critic, in an interview with her for her paper, stated that he was not interest-
ed in "minority structures . . ." and that non-white artists had their own insti-
tutions that were set up to "take care of them." Additionally, he said that he
was only interested in "quality." The individual critic in question has a record
of curating exhibitions which are 100% white. His attitude is common to
most critics of European descent reviewing and curating exhibitions.

Some of the galleries that incorporated a fair percentage of artists of
color have closed: Monique Knowlton Gallery, Lerner-Heller Gallery, and
Semaphore Gallery. One hundred percent white galleries have also closed,
such as Willard Gallery. In the 1980s a number of galleries owned by Afro-
Americans have opened throughout the country to address the closing out of
black artists. Invariably they have all been visited by a white critic at least
once (who usually does not return), who asks why they do not represent
white artists as well. The unified response by the majority of the galleries

questioned has been, "Have you asked the 100% white galleries the same question and why do they refuse to show artists of color?" . . .

GALLERY STATISTICS

The following New York City galleries are 100% white. (Artists represented as stated by the gallery in the following reference source: *Art in America*, "Annual Guide to Galleries, Museums, Artists," August 1987-88, pp. 121-50.) The galleries listed represent the major pool from which artists are selected for inclusion in exhibitions and publications, and private, corporate, and museum collections.

The following galleries are 100% white: Brooke Alexander Gallery, Massimo Audiello Gallery, Josh Baer Gallery, Baskerville & Watson Gallery, Blum Helman Gallery, Mary Boone Gallery, Diane Brown Gallery, Cable Gallery, Cash/Newhouse, Leo Castelli Gallery, Castelli Graphics Gallery, Paula Cooper Gallery, André Emmerich Gallery, Xavier Fourcade Gallery, Fischbach Gallery, John Gibson Gallery, Gimpel and Weitzenhoffer Gallery, Marian Goodman Gallery, Jay Gorney Gallery, Graham Modern, Hirschl & Adler Modern, International with Monument, Michael Klein, Inc., M. Knoedler and Co., Lorence Monk Gallery, Gracie Mansion Gallery, Curt Marcus Gallery, Metro Pictures Gallery, Annina Nosei Gallery, Pace/MacGill Gallery, Marcuse Pfeifer Gallery, Max Protetch Gallery, P.P.O.W. Gallery, Stux Gallery, Germans Van Eck Gallery, Edward Thorp Gallery, Barbara Toll Fine Arts, Althea Viafora Gallery. **The following galleries are 95% white:** Charles Cowles. **94% white:** Ronald Feldman Gallery, Allan Frumkin Gallery, Sperone Westwater Gallery, John Weber Gallery. **93% white:** Louis K. Meisel Gallery, Holly Solomon Gallery. **92% white:** Barbara Gladstone Gallery, Phyllis Kind Gallery, M-13 Gallery, Salander-O'Reilly Gallery, Pace Gallery. **91% white:** David McKee Gallery, Post Masters Gallery, Anita Shapolsky Gallery. **89% white:** O.K. Harris Gallery, Maeght-Lelong Gallery. **86% white:** Rosa Esman Gallery. **84% white:** Sidney Janis Gallery, Bernice Steinbaum Gallery. **82% white:** Marlborough Gallery. **80% white:** Sharpe Gallery. **75% white:** Nancy Hoffman Gallery, Pat Hearn Gallery. **69% white:** Semaphore Gallery (in process of closing) . . .

TESTIMONY

Over 50% of the citizens of New York are people of color: Asian, Black, Hispanic, and Native American. More than two thirds of the world's citizens are people of color. I am an artist. I am not a so-called "minority," "new," or "emerging," or a "new audience." These are all terms used to demean, limit, and make us appear to be powerless. We must evolve a new language which

empowers us and does not cause us to paticipate in our own disenfranchisement.

In the 1980s we have witnessed the continuing proliferation of a backhanded, understated racism in the public and private sectors. The racism when expressed is not as in the 1970s covered with a veil of excuses other than a lie, that it is *not* a reflection of racism. Somehow this lie and denial if expressed enough times is believed to become the truth. Therefore, the art world will state that "all white" exhibitions, year after year with few-and-farbetween tokens in both the public and private sectors and ghettoized, segregated art communities tangent to the so-called mainstream, are not a reflection of racism. The lie or denial is cloaked in phrases such as "artistic choice" or "artistic quality," when the pattern reveals a different intent.

Bob Jones University lost its tax exemption for stating that it discriminated against Blacks, barring them from admission. In the 1980s, the "mainstream" art world continues to exclude people of color; however, they are more clever than Bob Jones. They will not state it, but will *practice it*. The public sector is even craftier and will state that they do not discriminate and will roll out the word "quality."

When I called Volunteer Lawyers for the Arts concerning racial discrimination in the galleries, public institutions, and relative omissions from art magazines, I was told that artists are independent contractors and have no rights under Title 7. "You cannot prove racism when it comes to 'artistic choice.' And, if you can prove it is racism, 'So what!' There is nothing you can do about it." This individual used the same argument when referring to women trying to prove discrimination.

In preparing for this testimony, I called "Socrates Park," an outdoor, large-scale sculpture group show installation which opened this summer in Queens. They received money for the project from the New York State Council on the Arts by way of the Queens Consortium. The exhibition was also held on public land along the Queens waterfront. When I called I asked if they had included artists of color. They said "no"—that they were "private." I pointed out the fact that their printed announcement listed public funding. Their response was, "Oh, they only gave us $1,000." . . .

I have experienced the art world from the "outside" as an artist of color and from the "inside" working at a major New York museum where I was an associate curator. I worked there for twelve years. Some members of the curatorial staff virtually closed me out of important professional interactions, many of which took place at private yet "professional business" social gatherings from which I was often excluded. (Some of my co-workers were very generous and open, but as I rose in the ranks it became more and more closed.) In retrospect, the racism I encountered was very subtle, petty, and underhanded. In the beginning I was basically fresh out of school and "gungho," but over the years the pressures of subtle and not-so-subtle, unassuming, casual racism and my changing needs made me break away in 1979. I was no longer very polite about what I was encountering. I did not feel that

relocating and changing jobs within the profession would make any difference. In retrospect, I also feel I was too intimidated by the sheer power behind the people who wished to enforce their beliefs and felt too isolated to pursue other options under Title 7.

As a result of the closed, nepotistic, interlocking network, artists of color face an industry-wide "restraint of trade," limiting their ability to show and sell their work. The Internal Revenue Service's pressure on artists to sell their work as proof of their "worthiness" or seriousness as artists puts artists of color under additional pressure.

The museums often let the galleries do the primary sifting of artists. If you are locked out at this level you are locked out at all other levels because each feeds the other. The excitement and "growth" that comes from producing and showing work in an everchanging broad spectrum of options is therefore blocked and limited for the visual artist of color. The institutions that will show the artist of color are rarely reviewed by the art publications; thus, the artists of color are often deprived of the benefit of minor or major articles and wider exposure. If they are included as tokens in an exhibition, frequently the reviewer overlooks them. Occasionally the art world will focus on one or two tokens for an instant, then pull back, feeling they have "done their duty." It is as if they have reviewed *all* artists of color by reviewing one, thus implying we have no breadth or diversity and that they need look no further.

Artists of color are often relegated to showing during the month set aside for highlighting their cultural heritage, such as Black History month. Institutions will often feel they have integrated their schedule when they have "paid their respects" for one month in a "segregated" show. This usually happens in the case of university galleries or smaller museums.

I have learned, over my twenty years in New York not to "romanticize" white artists, expecting them to be liberal, open, or necessarily supportive because they are creative people. Pests, a group of non-white artists, had hung a poster in SoHo on Broome and Broadway last spring which read, "There are 11,000 artists of color in New York. Why don't you see us?" Someone had written on the poster, "Because you do poor work." Unfortunately, many white feminists, artists and critics often are patronizing and condescending toward women of color and will make statements such as "sexism predates racism" or "racism is not their concern." When the women's museum was being organized in Washington, D.C., I was contacted by a New York art historian and asked to make some suggestions. I told them that they needed to have women of color on their board as policy-makers. I was told, a few months later, "no." (Guerrilla Girls, a feminist group, has begun to address issues affecting artists of color, but it is amazing to see how articles written about their activities in white publications always omit this fact.)

Some white artists use us as subject matter, but we are not permitted to interpret ourselves in the same platform. When we are included in exhibi-

tions we are at times asked stupid questions about our looks, such as "Why does a light-skin Black paint dark-skin Blacks?"

In the 1970s one white artist went so far as to change his name from a "bland" name to an Hispanic name because he wanted to "attract grants." Perhaps in the 1980s he has selected another name to fit his opportunism.

There have been exhibitions by white artists which used racial slurs as titles such as "Nigger Drawings" (Artists Space) and "No Japs at My Funeral" (The Kitchen). The art world closed ranks around the artists when people of color protested. The white artists and their supporters felt they had their First Amendment right to express their racism. (We did not, on the other hand, have the First Amendment right to express our outrage.) Protest was viewed as censorship, yet they were not concerned that artists of color were censored out of the system. The white artists could only experience this issue in terms of their need for dominance at any cost to anyone, especially if they were of color. As one white artist said to us during one of the protests, "How dare you come down here and tell us what to do? This is a white neighborhood!" (It is interesting to note that the exhibition space that exhibited "Nigger Drawings" received Expansion Arts money, public funds which, at the time, were earmarked for outreach into multi-cultural, non-Euro-ethnic communities. It was also revealing that on the day of one of our protests they had installed an exhibition of works shipped in from Scotland.)

As artists of color we must not be apathetic in the face of an endless wall of indifference or direct, blatant acts of hostility. We must organize and work together and lobby if necessary. We must support the institutions which have stood by us in spite of others' attempts to frustrate and demean them. We should not feel discouraged or isolated. This is what "they" want us to feel in hopes that we will give up. We should encourage the upcoming generation not to turn away from the visual arts because so many doors are now closed. The visual arts are not a "white neighborhood!"

"SOME REMINISCENCES" (1991). REPRINTED IN *HOWARDENA PINDELL: PAINTINGS AND DRAWINGS* (1992).

When I was eight, I decided to be an artist. I was sent to the Fleisher Art Memorial in Philadelphia for Saturday classes in drawing. I felt very intimidated as I was the youngest person. I do not remember if I was the only person of color. I continued to take Saturday classes in various programs in the Philadelphia area . . . until I graduated from high school when I was sixteen.

I was determined to be an artist and was inspired by the presence of work by Henry Ossawa Tanner in the home of one of my friends who was one of his relatives. There were many Black artists in Philadelphia plus excellent collections (mostly European art). There was not much of a gallery system. I

did not feel it was odd for me to be an artist and was frankly quite amazed at how closed the art world was once I left Philadelphia. Not that Philadelphia was open, on the contrary, but people were working and there was not the massive commercial gallery and art-trade publication network we have today. I felt there was always someone to appreciate your work. My first exhibit was in our neighborhood church which was a black church (the Presbyterian Church was segregated at the time). I spent a lot of time in the Philadelphia Museum in the Louise and Walter Arensberg [sic] Collection.

I was very fond of Duchamp's work. I was also very fond of landscape painting. There always was a split for me between traditional painting and the avant-garde. I was fond of them both. I was primarily trained in traditional oil painting but gave it up (the use of oil) after becoming allergic from using too much lead white. . . .

I sustain myself through sheer tenacity as the art world does not want artists of color to be full participants. I work because it is my life's work. I have no other choice. I do not get bored with it or impatient unless I am overtired. I could have been a classical musician but hated to practice and had terrible stage fright.

My work was primarily about process until in 1979, I was a passenger in a freak car accident. After 1979 my work becomes autobiographical as part of my desperate struggle to heal myself. I had a brain injury because of a concussion and not everything was working right . . . plus I had severe headaches as a result and had a very short fuse as a result of being very uncomfortable. I had trouble walking for a long time. Because of the residual effects of the injury, if I drink alcohol my face still becomes numb as if I were given novocaine at the dentist's.

Since autobiographical themes are really endless and there are so many things that I want to explore: I find that I am not at a loss for ideas. More at a loss for time. I do a lot of reading and research and now do almost as much writing as I do painting.

My work repeated itself more with subtle variations when I worked with process in the late 60s and 1970s. Now there is not that much repetition as each painting is sort of an odyssey or epic. One unrelated tangent I am following is an interest in science. I loved science as a child (biology and balancing chemistry equations) and I am particularly interested in new physics and quantum mechanics and how it ties in with spirituality.

I do not feel a part of the present new generation; I guess because I was brought up in a different time frame. I was born during WWII in 1943. I remember the atomic bomb and dark window shades for blackouts and the rationing of food. I remember segregation and the aggressive oppression as opposed to its more subtle form now. I remember the civil rights movement. I was basically brought up on radio not TV. I thought TV was frivolous and can only really remember *Ed Sullivan, This is Your Life, Ernie Kovaks, You Asked for It* and the Mouseketeers, Howdy Doody, or Flash Gordon. They certainly had nothing to do with my life. The difference also is that there was not the

massive advertising or the horrendous violence that has been so normalized. The violence of racism was there but there was a silence around it because no one in power wanted to acknowledge it.

Travel has made a big difference for me in that I did not get isolated in the American pathology. I lived in Sweden, and Japan, and India, and spent a fair amount of time in varying degrees in parts of Europe (England, France Denmark, Norway, Italy), Brazil, Mexico, Egypt, Kenya, Nigeria, Ghana, Ivory Coast, Senegal, the Caribbean, parts of the United States and Canada, and U.S.S.R. I have always been concerned about the world at large and spent some of my summers during my years as a teenager in an international kibbutz-like environment in the hills of Pennsylvania. The ideal for me was international cooperation as each culture has so much richness to offer. I also worked in a factory for one summer and got a taste of what could happen if one gave up one's education. I am from a very racially mixed family (some are liberal and some very conservative) and have tried to understand or appreciate this. I have been puzzled by the need for one culture to be obsessed with domination of another.

The goal of my work is to share knowledge. This is the reason I have also been writing as well as painting, teaching, and giving some public lectures. I do not feel very much part of the art world because of the restrictive environment that is brought to it by people who are pathologically indifferent. I do not see art and life as separate.

WATER/ANCESTORS/MIDDLE PASSAGE/FAMILY GHOSTS (1992). REPRINTED IN *HOWARDENA PINDELL: PAINTINGS AND DRAWINGS* (1992).

My ancestral background is a vast stew. The painting symbolizes this mixture and the fact that Africans kidnapped and held hostage in this country were massively tortured and sexually abused by their captors who drew up laws to prevent those they had enslaved from protecting themselves. The text of one of the laws is included in the painting. The following law was enforced in North Carolina during the first quarter of the 1800s:

" . . . if the master attempt violation of the slave's wife and the husband resist his attempts without the least effort to injure him, but merely to shield his wife from his assaults, this law does not merely permit but authorizes the master to murder the slave on the spot."

An image of a ship with enslaved Africans during the Middle Passage is located on the lower left. Eyes throughout the painting represent witnesses, even if silence was the only testimony permitted because of the fear caused by the abject abuse of the slaves by the enslavers. During a program in late February 1992 at New York's Brooklyn Slave Theater, three hundred slides were shown by Nommo X concerning the abuse of Africans who were kidnapped and enslaved by the Europeans. According to an article in the New

York *Amsterdam News* by Ma'Ishah Asante, slaves were tortured and dismembered. "Many were shocked at the endless devices used to instill fear and subordination into the ancestors of the African-Americans. Skull crushers squeezed until eyes were forced out of their sockets, knuckle crushers which forced bone marrow out of fingers. . . . A 'cage' called the spider forced slaves into hunched positions, after they were left for weeks until muscle spasms and finally paralysis set in."

The head of the African woman in the upper center represents the one African woman back to whom all human life is traced by scientists. The double head to the left of the diagram of the ship represents twins. My family on both sides have an unusual amount of twins, something I heard was common for families in Nigeria.

Charles L. Blockson's *Black Genealogy* is very helpful in understanding the conditions under which African people lived in the South. He cites "enforced illiteracy," constant name changes by the enslaver of the names of their captives. He cites how Africans who had been enslaved, their children and the children of the enslaver from the African women he had raped and held in bondage were sold to other families as chattel. He cites the abuse and torture of the slaves, which is even more devastatingly portrayed in *American Slavery As It Is* (based on eyewitness accounts). Blockson also cites how public libraries were restricted as well as access to organizations that kept records of family genealogies. It would be interesting to chart the dates when public libraries across the country began to allow access to people of color.

In the fall of 1991 Robbie McCauley presented a performance work about her family history and slavery at The Kitchen, a performance space in New York. It was called *Sally's Rape*, and it documented family members' memories and their oral history. She spoke of the rapes of her ancestors by the enslavers. The farm animals were also sexually abused and raped at night by the enslavers. Seeing her performance has helped me to look further at some of the terrifying history of this country that has been carefully manipulated to cover the crimes committed against the African people as well as the people who were the originial inhabitants of the land mass now called the United States. Generations have carried this pain with them. The perpetrators of the crimes have been protected. The black members of their families were simply sold off. Men of color have been presented as the perpetrators of rape while the Europeans were the original abusers. An elaborate mythology has been developed to sanitize the history of the country. Although many may not acknowledge it, the facts do not change. Those who perpetrated the crimes carry the memories through the generations. This may explain the prevalence of addictions, child abuse, battering and rape throughout all levels of American society. This may explain the demand for silence on the subject.

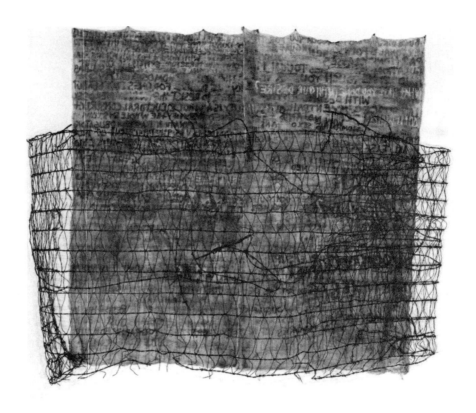

Bed of Text: A Pleasured Disturbance, 1993. Latex rubber, acrylic, metal, and cloth, 77 x 84 x 32 in. Collection of the artist. Photo: Herbert Lotz

HARMONY HAMMOND

B. 1944

IN 1983, Sandra Langer expressed surprise at the lack of critical analyses of Harmony Hammond's work, in light of her many years of serious artistic production. Her further achievements during the next decade reinforce the need for a comprehensive consideration of her contribution. Hammond has dedicated her life to exploring woman-centered themes and imagery in sculptures, paintings, and painted assemblages. As she has said, her work "is for and about women" and her purpose in creating is to "give form to my female feelings" by working with "women's materials—cloth, thread, hair." Additionally, Hammond has identified herself as a lesbian and, in fact, came out through the art-making process. Over the years Hammond has committed herself to articulating her ideas about art and artists in numerous pieces of writing.

Born in Hometown, Illinois, Hammond came from a lower-middle-class family. She has described how, growing up in the fifties, her attraction to art stemmed, in part, from her desire "to escape the pain of lower-middle-class life." A high school boyfriend introduced her to the jazz and poetry of the Beats and, at the same time, she began to take courses at the Saturday School of the Art Institute of Chicago, where she encountered the work of the Abstract Expressionists. She was particularly attracted to the freedom afforded the artist, and the seemingly "universal world of the muse." Upon graduation from

high school, she went to Milliken College in Decatur, Illinois, despite its limit-ed art department "because that is where [she] got a scholarship," and dropped out to marry at nineteen. Subsequently relegating her painting to the evening hours, she worked at a number of menial jobs to support her husband so that he could go to school. (She later received her B.F.A. from the University of Minnesota in 1967.)

By this time Hammond had begun to realize that women were as oppressed by the world of culture as they were within the middle-class society in which she had grown up. This awareness translated into a change of direc-tion in her art. She had begun by painting lush, richly layered images of women. By the late sixties, however, she felt that if she wanted to be taken seri-ously as an artist, she "had better paint what the boys painted," which meant, at that time, making large, shaped, hard-edged canvases devoid of figurative or symbolic meanings. Ultimately, she came to feel that she had "painted [herself] out of [her] work," a sentiment almost exactly echoed by Judy Chicago in her autobiography, *Through the Flower*, in which Chicago discussed her response to similar pressures during that period. "Underneath were feelings of not hav-ing the right to work in the first place," wrote Hammond, "so we hid our sources and disguised the meaning of our imagery in formal concerns."

The circumstances of Hammond's life changed drastically in 1969 when, divorced and pregnant, she moved to New York City. By the early seventies she had begun meeting with a consciousness-raising group of women artists and continued to do so until 1974. Her first show, in 1973, was at A.I.R., a feminist New York artists' collective of which she was a founding member (as was Howardena Pindell). Also in that period she became associated with Heresies, a collective of New York women artists dedicated to nurturing their talents and promulgating their work. Hammond became a frequent contributor to the *Heresies* journal and, in several germinal articles, articulated the theoretical underpinnings of her aesthetic endeavor.

For Hammond, as for May Stevens and Judy Chicago, association with a community of feminist artists helped her to gain access to her "true content," the material that she had previously repressed. This immediately showed itself in the new direction that Hammond's work took, in which she began once more to emphasize a female presence. Significantly, her first works after her move to New York were a series of *Bags* and *Presences*, hangings made from the discarded and paint-spattered clothes of her friends. These works embody important precursors of several issues that she explored throughout her sub-sequent art: in their content as female personages; in their use of nontradi-tional, "inappropriate," and female-associated materials; and in their inherent tension between interior and exterior. Hammond continued working with woman-identified themes and materials in her next work, a series of "floor pieces." Also made from found rags, these were essentially braided rugs enhanced through the addition of paint. Hammond has described the process by which she made them, sitting on the floor and spiraling out from their cen-ter. While they make obvious reference to a "low" craft form, the braided rug,

they also could be related to Carl André's flat metal grids—often referred to as "rugs," yet indisputably accorded high-art, avant-garde status. Hammond continued to explore the woman-centered implication of "the stitch" in a series of heavily layered abstract paintings that she exhibited along with objects with a female resonance, such as small bags made from the hair of women in her consciousness-raising group. (In this context it is interesting to note that the hair wreath was a popular form of women's art in nineteenth-century America.)

By the mid-seventies Hammond had exhausted this line of inquiry, and had begun to question assumptions about the enforced "political correctness" of particular kinds of art by women artists. She came to the conclusion that abstract art could also have feminist import and content, a theory that she expressed in a series of articles first published in *Heresies* (and reprinted in *Wrappings* in 1984). Her concept took form in a series of large-scale, monumental, extremely dramatic sculptures executed between 1979 and 1984. These looming, abstract forms shared several characteristics with her earlier works. They had an overwhelming sense of presence and in fact could be considered personages, and they were built out of rags; however, in the later pieces Hammond wrapped many layers of rags around a central armature. She then further transformed her materials by painting their surfaces and coating them with a "skin" of Rhoplex. Although abstract and nonreferential, each of these pieces embodied a particular personality. *Kudzu* (1981), for example, made in North Carolina and inspired by the weed of the same name, is menacing and aggressive. *Hunkertime* (1979-80) could be a gathering of nine different women, some dressed in frilly pink pinafores, hunkering down for some nurturant conversation. The symbolic implications of the binding that is part of the creation of these sculptures is significant to Hammond's oeuvre.

While still continuing to make her large, wrapped sculptures, in the early eighties Hammond began a series of relatively small-scale paintings inhabited by a repeating cast of pictographic figures, "spirit forms," as she calls them. As in her sculpture, these characters are predominantly female: Fan Lady, Cactus Lady, and Chicken Lady. Although their visual impact is quite different, the paintings are reminiscent of the sculptures in at least two ways. First, they, too, show evidence of the importance of layering to Hammond, as they are built with thick surfaces, out of which the figures seem to emerge. It is also clear that they use the same lexicon of motifs: "spirit dots," spirals, branching forms. During this period Hammond began to study southwestern Native American art forms, and the relationship of these paintings to the petroglyphs of New Mexico is apparent, in their style and surface, and also in their evocative spirituality. By the mid-eighties she began to work with similar imagery on a larger scale, in order to (as Judy Collischan Van Wagner describes) "plumb unconscious depths of human psychical being" through "idiosyncratic signs [that] conjure emotions and insights."

Frustrated with the fragmentation of her life in New York City and drawn to Native American culture, Hammond moved to New Mexico in 1984. The

move enabled her to concentrate more intensively on the painting process, which resulted in an increased scale and a greater level of experimentation with mixed media, such as latex, tin, hair, and wood. Her work from the early 1990s shows this influence: huge mixed-media pieces with embedded narratives, some based on the sorrow of the numerous abandoned farms she encountered in the southwest, others less literally dealing with what Hammond has characterized as "a negotiation of desire and pleasure in the age of AIDS." Although these works have a less obvious female presence than her earlier pieces, Hammond still says her purpose in her work is "to give voice to those who cannot speak," an awareness that she relates to her feminist experience of examining the representation of women in its cultural context.

Hammond has said that she likes to work in "a state of peripheral control," in which she "create[s] situations for wonderful accidents and revelations." In this approach, her endeavor is related to a long line of modernist and post-modern artists, beginning with Marcel Duchamp and Kurt Schwitters and extending through Robert Rauschenberg and Anselm Kiefer. Throughout her career, Hammond, like the above artists, has used eccentric materials and found objects that she transformed in her work. The rags that she incorporated in her floor pieces and monumental sculptures, the armatures that, as in *Hunkertime*, were made from discarded ladders, and the pieces of old tin, burnt wood, and rusty gutters that are used in her more recent work, are all examples of Hammond's interest in giving new life to discarded materials by transforming them into works of art. The element of chance is an important factor in Hammond's working process, in the changes to which the found materials are subjected, and in the serendipity of her finding them. Hammond is willing to stay on the edge of control, and she refuses to overdetermine the form her work will take or how these found objects will be transformed. One reason that she stopped making her large-scale sculptures was that she felt she had too clear a sense of the final product. Hammond has referred to one series as *Uneasy Juxtapositions*, in which she combines traditional fine-art materials and found objects to create "a space of unfixed meanings and possibilities."

Although her working method is similar to twentieth-century avant-garde practice, the meaning of Hammond's work differs radically from most artists associated with it. As she has said, "feminist art is outside of, something other than, the modernist tradition." Whereas other artists who built their works from found objects (including Duchamp, Schwitters, and Rauschenberg) spoke to the absurdity of life, Hammond is more interested in addressing its profundity. She is particularly interested in the evocative resonances of the discarded items that she transforms and believes are imbued with a spiritual presence. Hammond has said that one reason she likes to use recycled materials is that she doesn't like "wasting things that have histories and reference other time, places, and peoples." In this sense her work can be more meaningfully compared to that of Joseph Cornell, Betye Saar, or Cecilia Vicuña who also believe in the spiritual power of reused discarded objects. The influence of the Japanese martial art Aikido, which Hammond has been studying for many

years, can be discerned in her entire oeuvre and its means of production, a dancing on the edge of possibilities. "Aikido affects the way I approach or try to approach everything in my life," she has written. "Not blocking or confronting, but trying to remain strong in a flexible and yielding way, with clarity and *ki* (internal life energy)."

Hammond has also said that she is particularly concerned with making an art that speaks to women and the female experience, an element of commonality that connects her work in different media. In several essays, she has described her positive response to images by other women artists in which women are depicted in their bodies as they really are, not as sexual objects for male contemplation or dominance. In her own work she wants to evoke "a female presence in all its power," in contrast to the western tradition's concept of beauty in which "women who are healthy, active, and powerful become threatening and are made into monsters." As Langer has said of Hammond's work, it "defends a female's right to be a gallivanting, uncouth, straddling, intoxicated, and aggressive being." Through the significant question of whether a woman can be both subject and object, in recent years Hammond has also become engaged with the issue of lesbian self-representation, of what might constitute the lesbian gaze.

The motif in her art and practice that best indicates Hammond's sensibility as a lesbian, feminist artist is that of binding and wrapping. In her essay "Spiral," she makes the connection between the practice of the martial and the visual arts; in each, form grows from the "repetition of a ritual gesture." This is evident in her early floor pieces that she literally pushed out from the center. It is also clear in her large sculptures of which she has said, "wrapped, coiled, spiraled, and layered, they build from the inside out, creating out of self." In these works in particular can be seen the influence of the works of Eva Hesse, which grew in a similar manner. Hammond's sculptures were given a coating of liquid latex, a metaphorical "skin," suggestively sensual in itself and also reminiscent of Hesse's sculptures. Hammond points out the organic connection between interior and exterior in these works in which "a felt not seen content" alludes to female sensuality. Less obviously, the sense of organic growth from inside to outside, also functions in her spirit paintings, in which the images seem to emerge from the many layers in which they are executed. The spiral is also a key attribute of the Fan Lady, "the woman warrior."

Hammond has expressed herself in writing with outstanding consistency and articulateness. The pieces collected in *Wrappings* (1984), unfortunately out-of-print, constitute a major statement of aesthetic intent. Excerpts from several of these essays are included here. Since the publication of that volume, Hammond has continued to write essays that eloquently articulate her philosophy of art, sometimes in the course of reviewing work by other artists. In 1985, along with artist Jaune Quick-to-See Smith, Hammond curated the exhibition and co-authored the germinal catalogue for *Women of Sweetgrass, Cedar and Sage: An Exhibition of Thirty Indian Women Artists*. Her essay "A Space of Infinite and Pleasurable Possibilities: Lesbian Self-Representation in Visual

Art" (1994), a major statement of her aesthetic that presents a persuasive argument for bringing "sexual preference into the current discourses on difference and representation," is being expanded and updated into a book with the working title "The Art of Lesbian (Re)Presentation," (forthcoming from Bay Press, Seattle).

Sources

Hammond, Harmony. "A Space of Infinite and Pleasurable Possibilities: Lesbian Self-Representation in Visual Art." In *New Feminist Criticism*, edited by Joanna Frueh, Cassandra Langer, and Arlene Raven. New York: HarperCollins, 1994.

_____. "The Mechanics of Exclusion," *THE Magazine* (April 1993), pp. 41-43.

_____. *Wrappings: Essays on Feminism, Art, and the Martial Arts.* New York: TSL Press, 1984. (Contains most of Hammond's early published writings.)

Harmony Hammond. Typescript guide to exhibition (essay by Judith Rohrer and Andrea Miller-Keller). Hartford, Conn.: Wadsworth Atheneum, 1984.

Harmony Hammond: Farm Ghosts. Exhibition catalogue (essay by Lucy R. Lippard). Tucson, Ariz.: Tucson Museum of Art, 1993.

Langer, Sandra L. "Harmony Hammond: Strong Affections," *Arts Magazine* 57 (February 1983), pp. 122-23.

Lippard, Lucy. "Binding/Bonding," *Art in America* 70 (April 1982), pp. 112-18.

Malkonian, Neery. "Interview with Harmony Hammond," *THE Magazine* (October 1992), pp. 9-11.

Van Wagner, Judy Collischan. "Harmony Hammond's Painted Spirits," *Arts Magazine* 60 (January 1986), pp. 22-25.

HARMONY HAMMOND—SELECTED WRITINGS

FROM "CREATING FEMINIST WORKS" (1978).
REPRINTED IN *WRAPPINGS* (1984).

At thirty-four, it sometimes seems amazing to me that I am still making art. I always feel that I am not working, but when I turn around and catch myself by surprise, I see all this work I've done. Like many women I always think I'm never doing enough.

For a woman to make art in patriarchal culture is no easy matter. It is considered not only an active act, but an aggressive one—a refusal to partici-

pate in male ritual. Those women who take their work seriously are pun-
ished by isolation and separation from other women. To focus on their work,
to even continue making it, women have often had to remove themselves
from the world of women. Between us and George, Agnes and Louise, is a
silence as wide as the desert, an absence of touching.

This is the choice I grew up with, but did not want to choose. My story is
not unique; it is the story of many women. Feminism has broken the silence,
has given me the intellectual and creative support which not only allowed me
to keep working, but helped me to develop work which comes from my expe-
riences as a woman in this society.

As a lower-middle-class teenager, I went to college in Decatur, Illinois,
because that is where I got a scholarship. They had a three-man art depart-
ment. At nineteen I got married. Through seven years of marriage, while I
worked full-time as a waitress, an office clerk, an artist's model, a gallery
director, and one choice job counting toilet paper for army survival kits, I
supported my husband so he could go to school and painted in the evenings.

I painted large pregnant women, masked mothers and daughters and
later androgynous figures and hermaphrodites. I moved from traditional
glazes and scumbling, earth tones of umber and ochre to the garish and
macabre, a visual *Our Lady of the Flowers*. Mother and daughter on carnival
day. Lover and I, only the canvas had but one person. I could not paint male
figures. My husband, an artist, stopped painting.

Unsupported by the male-dominated academic and art worlds, and
embarrassed by the emotional outpouring in my work, I removed myself
from the paintings and began to do proper hard-edged shaped canvases like
a good artist in the sixties should. Little by little, I was beginning to realize
that the art world wasn't an alternative to the middle-class society in
Hometown, Illinois, where I grew up, but that women (and, I was to learn
later, especially mothers and lesbians) are also equally oppressed in the
world of culture. I knew that if I wanted to be taken seriously as an artist, I
had to paint what the boys painted, and I had to do it bigger and better. I pro-
ceeded to do just that. Slowly, but consciously, I painted myself out of my
work.

Although I could not articulate it, on some level I knew that the working
was necessary for my survival—that the paint literally held me together. A
strong relationship was formed between me and my work then, and not just
in reaction to the bad circumstances of my life; rather, the work was a focus,
the place where I confronted myself, learned about myself. The work got me
through those circumstances. Working felt good, and I learned that it was as
important as dreaming or exercise. I learned that my work, like a lover,
would not go away, and to trust the process of going into the unknown, get-
ting scared, and coming out on the other side. My work, like my body, would
not take me some place I could not handle.

Like the early work of many women my age, my work was personal. But
we learned to hide this aspect for fear that the work would be ignored or

ridiculed. Underneath were feelings of not having the right to work in the first place, and the fear that our work would be taken away from us. So we hid our sources and disguised the meaning of our imagery in formal concerns. . . .

It wasn't until 1970, when I began to meet with a group of women interested in exploring the relationship of feminism, art and work, that my sources and processes were uncovered and validated. Never before had I talked about how my work functioned for me. The work was the center, and when we talked about other things in the group, it was always in terms of how they affected the work or our ability to work. Using consciousness-raising techniques, we started with our personal associations—or the way a piece made us feel—and then looked at how these associations were implemented through visual means. The right to make work was assumed, as was the choice of content, so the work was critically dealt with on its own terms. Criticism was aimed at each of us to make the best possible work, to achieve an honest clarity. . . .

Feminist art symbolizes the confronting and gaining control over one's own life, as opposed to control over the lives of others. . . . The feminist work process is linked to, not separated from, the meaning of women's work. Most women's lives are made up of fragments: left-overs, hand-me-downs, bits of selves, bits of stolen time. For centuries journals, letters and the needle arts have been primary forms for women's creativity. It was when women tried to make men's art that they were forced into isolation. The journal connected one day to the other, the letter connected one to family and friends. Stitches composed women's language, and the needle wove the story of women's lives and made them into garments and things for the home. . . .

When critics talk of feminist art as the avant-garde of the modernist tradition, they miss the point. Feminist art is outside of, something other than, the modernist tradition of art. We are exploring not one but many areas of feminist art-making, and it is not a linear process. There is not one central theory of feminist art, and I don't know of any feminist who wants one. Our definitions of feminist art must include process, change and growth. Labels are a limitation only if you make them so. The unlimited mind, what Agnes Martin calls the "untroubled mind," is a vital precondition of inspiration and creativity. Labels in themselves are separate from the work.

Matriarchal history, women's traditional arts, craft techniques and materials, primitivism, decoration, central imagery, redefining one's body and relationship to nature, women's sexual imagery, journalistic marking: these are just some of the things that appear over and over in our work. It can be argued that men, too, work with these concerns: feminism has made them acceptable and the art world has co-opted and assimilated early feminist positions on art. However, the real point is that these ideas do recur over and over in women's art and consciously in feminist art, and for this reason, they are of interest to us.

We should not make assumptions about who makes art, who sees it, and

what its function is to be, but rather work to remove esthetic hierarchies and allow the different experiences of women to be accessible. This will only happen by demystifying the creative process and making it less private. When making art as well as owning art ceases to be a privilege, and the art-making process itself is available to women of different classes, races and geographic backgrounds, we will begin to see the political potential of creative expression. . . .

Art is a surplus commodity in this society and is not shared or used by the majority of people. Artists are not part of the paid work force. Like most artists, I cannot support myself directly by my work, so I try to find a job for twenty hours a week. That way I can still have time for working. I'd rather earn less money and have more time for painting. I've noticed that being a mother affects the way I use time—that I use it differently than women friends who do not have children. I use every little scrap of it. Continuous time is a privilege for me, but it is important. I feel best if I can work a little every day, otherwise I lose my train of thought. There is an image in Tai Chi Chu'an of pulling silk from a cocoon. You must pull evenly and consistently, without stopping, or the thread will break and you must start over. . . .

Taking yourself seriously means making a commitment to your work, even when it gets rough and scary or you feel depressed. There is a point in the creative process that is hard to talk about. It is the point of transformation and means giving up control and self—therefore being in control and finding self. It is simultaneously feeling very powerful and feeling the power of something much larger. It is important to stay with your work then, to let it take over for a little while. This point of creativity is the "shaman's edge," the point where the form becomes real. I say point, because you cannot stay there very long—through a few pieces maybe—for once an idea gets developed, you must be willing to leave its safety, change with it, or move on.

Survival does not merely mean money, but surviving psychologically as an artist: survival as continuing to work. I am very good at undermining myself so I must be suspicious of my own reasons for not working. "It's too personal," "It's been done before," "It looks too much like somebody else's work," and "It doesn't fit in with my other work" are a few of the defenses which may keep me from working. There's nothing productive about them. So I say, learn what is helpful to you, and what isn't—what affects you negatively and keeps you from working. This might take the form of professional approval, showing or deadlines, other activities or relationships. Be selective. Your studio is an important place and it is a privilege for anyone to come into it. Be clear what you want from those you show your work to. If they have a negative effect on you and keep you from working for two weeks, then they aren't worth having in your studio at all. As Louise Fishman advises in her article in *Heresies*, "How I Do It: Cautionary Advice from a Lesbian Painter," "Keep the creeps out of your head and out of your studio. . . ."

I have been rejected in some of the most unpleasant ways—often reminiscent of witch hunts—from galleries and teaching jobs because I am a les-

bian or because I am too "political," whatever that means. As painful as this is, I try not to let it or my anger get confused with my work. Art world power, career, critical responses are all separate from the work, and sorting them out is necessary to continue working.

〰

"LESBIAN ARTISTS" (1978). REPRINTED IN *WRAPPINGS* (1984).

What can I tell you except the truth? We do not have a history. We are not even visible to each other. Many well-known women artists of the twentieth century have been lesbians, but if they are famous as artists, it is never mentioned that they are lesbians, or how that might have affected the way they live, their work, or work processes. The best we have is Romaine Brooks, but she was rich and ensconced in villas, surrounded by monocled countesses. As wonderful as this sounds, it is unrealistic on my $360 a month. Rosa Bonheur lived with her Nathalie for forty years and dressed in pants, but she didn't think that other women should.

In my search for contemporary lesbian artists, I spend much energy wondering and fantasizing about women who rejected passive female roles and committed themselves to art. After all, they did have young women as assistants and companions. But there is a space between us—time . . . a silence, as large as the desert, because history has ignored lesbian visual artists. The patriarchy has taken them.

The silence, the words omitted from the biographies of lesbian artists, have denied us role models and the possibility of developing work that acknowledges lesbian experience as a creative source for art-making and a context in which to explore it. I refuse to let them dispose of me in this way—to obliterate my existence as a lesbian and as an artist. I refuse to be quiet; I want lesbian artists to be visible.

Art not only reflects but creates and transforms cultural reality. Cultural reality is a whole, made up of individual realities. I first came out as a lesbian through my work. I knew and identified myself as a lesbian before ever sleeping with a woman. My work is the place where I confronted myself, gave form to my thoughts, fears, fantasies, and ideas. I had been drawing on a tradition of women's creativity in my work, so it was only natural to acknowledge my feelings and desires for women. My work is a lover, a connection between creativity and sexuality. Since I came out as a lesbian through my work, I came out as a lesbian artist—meaning the two are connected and affect each other. This was relatively easy, perhaps as a matter of evolution. As lesbians we have the possibility of the utmost creative freedom to make the strongest, most sensitive statements. Passion gives substance.

I believe that there is something as yet indefinable in my work, and other work that we might call "lesbian sensibility," but for the most part it is hidden. As our work becomes more visible recurring themes and approaches

will emerge and we can examine and develop them. How can lesbian sensibility exist in the context of patriarchal art? In some works, lesbian imagery is overt—at least to other lesbians. In others, it is hidden or perhaps less important. That is okay; it's there and will come out. We do not need to define or limit it.

I feel that we are at a very important time, with new creative energy coming from political consciousness in our work. To be a lesbian artist is not a limitation or a box any more than being a feminist is, unless you make it so. It is a statement of commitment, energy, interest, and priority. As a feminist, and as a lesbian, I can express myself in any medium, and I can use any technique or approach to art-making. But whatever I do, be it overt lesbian imagery or a more covert statement, it will come from a consciousness of myself as a lesbian and an artist. It is a question of where you get your support and whom you give your energy to and not just a matter of whom you sleep with, nor your life-style. Where I put my creative energy is a political decision. It is important that we identify ourselves as lesbians as well as artists. No one is going to give us space or visibility. We must take it. Since we have no history, we can begin to paint, draw, weave, and write our own. In sisterhood. . . .

FROM "A SENSE OF TOUCH" (1981).
REPRINTED IN *WRAPPINGS* (1984).

While sexual imagery has played a role in the art of many cultures, until recently very little of it reflected sexuality from a woman's point of view. In the last ten years, however, within the context of the feminist movement, women—lesbian and heterosexual—have been getting in touch with and reclaiming their bodies, their sexual feelings, and expressing these feelings in their art. While we can find a few early examples—Georgia O'Keeffe's shells, flowers, and landscapes; Louise Bourgeois's abstract sculptural references to women's bodies; Emily Carr's forest caves; Romaine Brooks's portraits of female friends and lovers; and Isabel Bishop's depictions of working women spending intimate time together—now there is an abundance of visual art dealing explicitly with women's sexuality as experienced by women.

Since a woman's sexual experience is not the same as a man's, only women can truly express women's sexuality. Any art that is really about women's sexuality as experienced by women is woman-centered. Yet often "women's sexuality in art" and art by lesbians are confused. They are not the same thing. Perhaps all expressions of woman-focused sexuality contain some lesbian feeling, regardless of whether the artist is heterosexual or lesbian, but all art by lesbians is not sexual by nature. Lesbians, like other artists, make art about many different subjects. But people continue to define lesbians only by their sexuality, as if compulsive, uncontrollable sex were the

only preoccupation in their lives, which is like saying that Gertrude and Virginia never wrote, or that Romaine and Emily never painted. Visual art by lesbians is not always overtly lesbian in character and woman-centered art may or may not be made by lesbians.

If we look at woman-centered work, we can see recurring characteristics, themes, and approaches. In this work women are not shown as weak, sick, or passive. They are not objectified or exploited. Nor are they shown in conflict with each other. Instead, they appear strong, healthy, active, and comfortable with their bodies. This is in contrast to the misogynist attitudes toward women's bodies and bodily functions that we observe throughout the history of western art. Woman-centered sexuality is not portrayed through S & M, violent, pornographic, or victim images. . . .

First of all, women are no longer being defined in relationship to men. The male presence is gone. Women do not depict each other as sex objects to be dominated or possessed, or as objects of any kind. Nikki de Saint Phalle's *Nana* and Kate Millet's *Naked Ladies* are powerful women who take up and fill space. Hardly the ideal of the classical, contained nude, these women are big—often ten feet tall—out of proportion (out of control?), have lumps and bumps, and seem to be totally here and in touch with their physical selves. They are not passive, but active, full of energy and exuberance, and, in this sense, erotic. . . .

As women, we are exploring our erotic imagination, often connecting it with our sexual and creative selves, and to do so is political, for it challenges the basis of male supremacy. . . .

Women artists are creating images of women making love or openly showing affection for each other in a way that is not voyeuristic or exhibitionist. These images are meant for a female audience and are meant to turn women on. On to each other. On to themselves. Specifically erotic images were first visible in the work of lesbian photographers and in the illustrations in many lesbian-feminist publications; they have now been extended to painting, sculpture, and many graphic forms. It is interesting to note, though, that while art reflecting woman-centered sexuality is made by lesbians and heterosexual women, as far as I know, explicit images of women making love to each other are made only by lesbians. . . . Many heterosexual women have fantasies of making love with another woman, but none of them depict it. Perhaps this has something to do with the power of art to turn fantasy into reality. . . .

[A] masturbatory feeling of organic blending, of a heightened erotic sense, appears frequently in woman-centered art. The feeling of touching oneself is directly connected to women's art-making and is at least partially the function of the art-making. While I hesitate to state this publicly for fear that it will be misunderstood or ridiculed, I think it is highly significant that in private conversation many women artists will mention that they frequently masturbate and enjoy masturbating in their studios and in the process of working. Could it be that this is the place where we are most comfortable,

unthreatened, and most in touch with our inner selves—with the erotic life-force Audre Lorde speaks of? . . .

In our art we are depicting women's bodies as they really are—in different shapes, sizes, and colors. We are painting women of different ages so that all the freckles, wrinkles, and stretch marks show. Joan Semmel paints close-up landscape examinations of her own body, the body of a middle-aged woman stretching, folding, and falling where it will, warm and sensuous. It is not the firm, glossy body-replica on record album covers, or the thin asexual threads we find in fashion magazines. . . . In Semmel's paintings the feeling is one of a woman's body following a natural cycle, the body as nature itself. The image is focused downward; what we can see is framed by the canvas edge, as if to show us an intimate secret—not viewed from the outside, but examined up close. . . .

I have been primarily discussing woman-centered sexual imagery in figurative art. However, for many women a strong body sense is indicated through their use of materials and the physical manipulation of those materials. Like many artists, women have played with the sensuousness of thick paint, but it is most often with an awareness of the paint being a "skin" of paint, and therefore a body/skin metaphor. . . .

Similarly, a skin of paint or liquid rubber literally holds my wrapped sculptures together, becoming a metaphor for how my art-making functions for me—literally holding me and my life together. Wrapping the fabric is in itself a very physical activity, involving the whole body, and ultimately contributes to the abstract sensual sense of the finished piece. I find that materials which suggest direct hand manipulation (clay, plaster, papier-maché, and fabric) or paint used to suggest finger painting, as well as materials actually taken from bodies—hair, nail clippings, teeth, leather (skin)—seem to carry with them sexual references. . . .

For a long time, and in varying degrees, women have been denied sexual imagery in their work. Too threatening to be taken seriously, woman-centered art that is overtly sexual is still trivialized, ridiculed, or ignored. However, consciousness and claiming of one's self, sexual as well as intellectual and spiritual, open a powerful creative source for men. If we are to make art that has meaning, it must be honest, and to make art that is honest, it is essential that we do not cut off any part of ourselves. Sexuality is something we all possess.

A sense of touch is necessary. For art. For revolution. For life.

❧

FROM "SPIRAL" (1982). REPRINTED IN *WRAPPINGS* (1984).

In many Eastern countries, Budo (martial arts) is placed alongside painting, poetry, calligraphy, dance, music, flower arranging, and the tea ceremony as an art form. Art is part of the cultural heritage and plays an impor-

tant part in daily life where it is believed to contain the power to place individuals in harmony with the universe. It is in this context that many people study and practice some form of martial art daily. . . . Many masters of the sword are also painters and poets.

In the West, however, the hierarchies of fine art have not included many things—among them Budo or martial arts. Martial arts in the United States have tended to focus on self-defense without spiritual understanding. They usually have been associated with fighting, violence, aggressiveness, and machismo. This image has changed somewhat in recent years as greater numbers of people have become interested in Eastern religion, philosophy, and culture. . . .

While an Eastern sense of spirituality has certainly influenced contemporary Western painters like Agnes Martin and Morris Graves any specific influence of martial arts is much less apparent in the visual arts than in theatre and performance. . . . Instead of providing an image . . . martial arts have provided a process and approach to art-making—a relationship to one's work that ultimately touches on the function of why we make art. The function becomes part of the meaning of the piece. While this is probably true in varying degrees in most art forms, I am particularly aware of it as a painter and sculptor.

I have been making art for over eighteen years. I have studied Tai Chi Chu'an for six years, and Aikido for nine years. Both of these activities, making art and practicing a martial art, overlap and form an important part of my life. I do both every day. Aikido affects the way I approach or try to approach everything in my life—not blocking or confronting, but trying to remain strong in a flexible and yielding way, with clarity and *ki* (internal life energy). The two are not separate but connected, and in fact give power and energy to each other as well as other areas of my life.

While working on the *Floorpiece* (1973) I would literally sit on the floor in the center of one of the pieces, coiling the fabric, pushing it out from the center to fill a space and create a circular boundary. In the afternoon, I would take a break and practice Aikido for an hour or so. Aikido is based on circular movement, and includes much rolling and spinning. Then I would return to work on the sculptures. It was all part of the same thing. Now, in recent work, the wrapping process has become the repetitive circular gesture, the spiraling.

The martial arts are not about fighting but about harmonizing or becoming one with the total universe. Moving from the fragment to the whole. Morihei Ueshiba, the founder of Aikido, said that "Aikido is a way to sweep away devils with the sincerity of our Breath instead of a sword. That is to say to turn the devil-minded world into the world of the spirit." Mastering a martial art requires years of focused training, practice to refine, to be done effortlessly. Discipline. Basic techniques are practiced over and over again until they are absorbed into the body. The repetition of the ritual gesture takes you beyond the gesture. The small movement leads to the larger movement.

Making visual art is like practicing a martial art. In both it is the doing, the practicing, the making, the being of that moment that is most important. Through the repetition of the ritual gesture, the form becomes real. Work grows out of work. The focus is not on the final technique or the end product. In the end there is no end. The spiral is the path with no beginning and no end. The answer is in the work. The answer is the work.

While I am interested in the finished painting or sculpture—what it says, and how people respond to it—the first layer of meaning comes from the fact that it is the act/process of making it that is most important. It functions to bring me in touch with myself and how I relate to/in the world. Art as meditation. Call it centering if you wish. Beyond that, at the second level, it affects other people—can inspire, move, give information, confront, outrage, beautify and decorate. Like feminism, it has a personal base that is political in its expansion. It can be used to elicit response. And yes, art can be used as a weapon. But its power is in its magic. It is more than a tool. Even good political art goes beyond the literal function and embraces, transforms, and shares the magic in some way. The magic is not mystification. As such the art has meaning. Something ongoing, something changing. Not a finished perfected form.

The ritual situation gives meaning to the material. Accumulation. My sculptures are made of recycled cloth/rags wrapped around a wood or metal armature/skeleton. Wrapped, coiled, spiraled, and layered, they build from the inside out, creating out of self. The physicality of self and female nurturance. The surfaces are given one coat of gesso, then a skin of liquid latex or acrylic paint which literally holds them together. A metaphor for the function of my art in my life—holding me together, the process showing but not intellectualized. The physicality of making the pieces is part of their physical presence. In some, it is as if the skin has been peeled back revealing the insides. And there is more of the same further in. A coat of Rhoplex and spirit dots for protection. (Gives meaning to the abstract.)

The surface grows out of this painterly process that is essentially additive. The surface is activated by the wrapping. Dense with weight dropped. The center is low. Solid but not hard. Like the bamboo, rooted in the earth yet flexible on top. The presence is more than the physical space of something. Presence is essence made visible. The form becomes real. Not mummifying or bandaging, but rather layers building out of creation out of self. They come from a female world and allude to female sensuality. A felt not a seen content.

With *Hunkertime* they hang out, marking time. Waiting for the moment of activism. They lean on each other. Touch. Serious, their ruffles reveal a sense of humor about life and themselves. The intention to know. Planes of nature. The edge.

A commitment to risk is necessary. To go beyond what one knows and to trust. Focus, concentration, and a sense of the larger whole. Like the swordperson, who cannot fear dying, the artist cannot fear loss of control, but must

use her total whole. You cannot do what you know. That is not art. What you know, the form, the ritual, is only the means.

Spinster. A woman who whirls and twirls and turns things upside down. Wrapping/spiraling. The spiral of the oval braids and floorpieces, the spiraling of the wrapped shapes. The spiral becomes Fan Lady's box. Fan Lady is a female warrior. An artist. She has a life of her own. Insidious. Outrageous. She goes where she wants and opens herself. She does not take herself too seriously. Spinning. Female. The spinster Spiral—the path with no beginning and no end. The one looking at self becoming the subject and the object. To seek perfection of the warrior spirit. Control/abandonment of self. Balanced energy.

FROM "MONSTROUS BEAUTY: THE WOMAN GONE WILD" (1983). REPRINTED IN *WRAPPINGS* (1984).

Beauty and notions of beauty have been mostly male-defined. Universal beauty as a basis of a belief system called esthetics is a concept of rich, white men. Those in power. Those who have a vested interest—themselves and their kind—in validating that which reflects and benefits their lives. Art which reflects this interest they call universal. It is based on institutionalized beauty, that is beauty as one more patriarchal construct.

Institutionalized beauty is what white western men decide is "good to look at." . . .

When we talk about beauty or its philosophical extension, esthetics, we are talking about a belief system that has been used to subjugate certain peoples. Images of beauty that are woman-centered or created by Third World people are examples of images that are either ignored or ridiculed, although occasionally they are temporarily adopted by mainstream culture. . . .

According to patriarchal concepts, images of women in art and media, and therefore women themselves, must fit certain male descriptions/limitations in order to be considered beautiful to look at. However, in these images, women are unhealthy, passive, and powerless. The patriarchal concept of female beauty is a passive one—the female being acted upon rather than acting on, or even acting at all. . . .

The traditional concept of beauty is one that is bestowed and institutionalized by patriarchy in its own interests. Women who are outside of this concept—that is, women who are healthy, active, and powerful—become threatening and are made into monsters like the women in de Kooning's and Picasso's paintings. The woman who is herself with power, passion, and direction must not be considered beautiful. Render her ugly and gross. When beauty and power combine, the result is called a monster, a vampire, a witch,

a lesbian, a mad woman, Medusa, a woman gone wild. . . .

Medusa is found to be ugly, terrible, and repulsive. A connection is suggested between beauty, power, and the woman as monster. But in Wittig and Zeig's [in Monique Wittig and Sandra Zeig, *Lesbian Peoples: Material for a Dictionary*] description, Medusa is a powerful and active agent—she can turn you to stone with her looks *if she so chooses*—it doesn't just happen because of the way she looks. Medusa is a woman of power, a fighter, and that fighting spirit of hers and the other Gorgons, still appears in women today.

In going out of control she takes control and becomes more than a representation of that fear of the powerful female. She becomes powerful.

The Medusa. My first etching as an art student was a head of Medusa. I was always fascinated by her, even though I didn't know who she was exactly, mythologically speaking. But somehow, that image of the woman—slightly mad, passionate, with her hair swirling out from her head and tangled, was a powerful image for me—daring, and strong. She seemed intense, right here, focused—exactly who she was—in her own self—a truth and in that sense beautiful.

In art history classes I was always attracted to the *femme fatale* from the turn of the century. I didn't understand that like the vampire or monster, the *femme fatale* is a man-made phenomenon created in order to match and control the awesome power of the female who bleeds but does not die. I loved who she was and simultaneously thought I was her. I didn't understand how she was both temptress and victim, how she was a male fantasy created to validate the subjugation of female power. I did not understand that she was supposed to be a monster.

It was her madness. I identified with madness as power repressed/expressed. Madness giving me room outside the stereotypical female role. A woman could be powerful and affect others if she was a bit mad, I thought. Or her powers came out of her madness. Out of control. Am I too powerful? If a woman is mad you can dismiss her seriousness (but not her danger) unlike a madman who, of course, is a genius. But then women are dismissed anyway, I intuited, so at least with madness—they just call creative women mad—at least with this you could go ahead and do what you wanted to do—to be your total self.

Later, when I was making sculpture by accumulating and recycling old rags that women gave me into female *Bags* and *Presences*, I wanted my work to be so beautiful that it demanded your attention. A beauty out of the raw fragments of women's lives. A wholeness of survival. In a statement accompanying my first New York exhibition in 1972, I wrote: "I want to demand your attention because I can get it no other way. Is this not part of my women's madness?" While I meant this ironically, I think it reflects how, even then, making work that reflected women's experience in this culture, work that connected me to a line of female creativity before me, work that was about women taking personal and political space—even then I was uncomfortable with actively taking that space. There was still a part of me, as with

many women artists, which did not feel I had the right to make art, to create new and powerful images of women. And so it was easier to associate myself with that disease—women's madness. . . .

And so, like the kudzu vine imported into the south by the patriarchs to control nature (soil erosion) and hide their government research plants and their nuclear reactors . . . like the kudzu which has now gotten out of control and which wildly wraps around, covers, and feeds off anything it so chooses, the monster (the mad/creative woman) is out of control (actively creating art in her own image). In going out of control, she takes control and becomes more than a representation of that fear of the powerful female. She becomes powerful.

<div align="center">❧</div>

FROM "MECHANISMS OF EXCLUSION" (*THE MAGAZINE*, 1993)

"As our government applauds the destruction of walls in Eastern Europe, a new cold war is intensified here against people of color, gays and lesbians, women, the working class, as well as artists in general." Given this statement by the *Artists' Coalition for the Freedom of Expression* in 1989, the recent resistance to President Clinton's attempts to issue an executive order rescinding the ban on gays in the military should not come as a surprise. It follows on the heels of right-wing fundamentalist attacks on federal funding of artists who produce work that is explicitly sexual in nature, and institutions which exhibit, publish or present this work. Understanding all too well the power of expression and representation, the religious right, according to *Village Voice* critic Elizabeth Hess, has developed a strategy to roll back gay, civil, and reproductive rights by limiting the content of art in this country. After the initial attacks on artists such as Mapplethorpe, Serrano, Wojnarowicz, Miller, Hughes, and Finley, it became obvious that most of the work being targeted was homoerotic in nature. Soon after, it became clear that it wasn't an issue of sexual imagery in art at all, but simply gay identity and creativity that the right was after. . . .

Basic civil rights are linked to the rights of expression and representation, be it the voice or images of a specific sex, class, race, or culture. For art (and I mean fine art, media, and other forms of popular culture) reflects who we are. Without a visible culture, a people do not have an identity, and therefore do not exist. . . .

I see art-making, especially that which comes from the margins of the mainstream, as a site of resistance, a way of interrupting and intervening in those historical and cultural fields which continually work to exclude me, a sort of gathering of forces on the borders. For the dominant hegemonic stance that has worked to silence and subdue gender and ethnic difference has also silenced difference based on sexual orientation. Just as it is necessary to add "sexual orientation" to the list of civil rights for all citizens, it is

essential that as art-concerned peoples, we bring it into the current discourses on difference and representation, along with race and gender, for they are parallel exclusions. Artist David Wojnarowicz wrote about censorship and self-censorship: "The once unspeakable can make the invisible familiar. To speak of ourselves in a climate and country that considers us, our bodies, our thoughts taboo, is to shake the boundaries of the illusion of the ONE TRIBE NATION. To keep silent, even when our individual existence contradicts the illusion of the ONE TRIBE NATION, is to lose our identities and possibly our lives. If people don't say what they think and feel, those ideas and feelings get lost, and if this is the case often enough, they never return."

"How do members of a minority or oppressed group establish identity without being limited or stereotyped?" asks Trinh T. Minh-ha, a Vietnamese-American filmmaker and theoretician. "And how do we negotiate multiple identities?" (Being gay and Hispanic? Being lesbian and mixed-blood Indian?) "Which comes first? Which is most important?" Negotiating these multiple identities is what filmmaker Marlon Riggs brilliantly addresses in *Tongues Untied* when he discovers that as a gay man he is invisible among black brothers, and that as a black man he doesn't exist in the gay meccas of Christopher and Castro Streets.

In questioning the language of cultural representation, identity, and difference, Trinh has called for "distinctions" between the alienating notion of "otherness" (the other of man, the other of the West) and an empowering notion of "difference." But she asks, "How do you inscribe difference without bursting into a series of euphoric, narcissistic accounts of yourself and your kind? Without indulging in a marketable romanticism or in a naive whining about your condition? In other words, how do you forget without annihilating? Between the twin chasms of navel-gazing and navel-erasing, the ground is narrow and slippery. None of us can pride ourselves on being sure-footed there."

Like Trinh, I believe the answer lies not in accepting or choosing identity, but in creating one. And one way we create identity is through art. Critic Lucy Lippard says, "Art would not have to speak for everyone if everyone could speak for themselves." But how hard it is to find one's own voice. How difficult it is to affirm cultural identities, to recreate them so that they are not simply a counternarrative to the authoritative center, what African-American poet Audre Lorde calls the mythical norm, or that which is "white, thin, male, young, heterosexual, Christian, and financially secure." How hard it is to get past the privileged authority who doesn't even have to be present to exert his influence. How hard to give form to oneself honestly. . . .

French philosopher Michel Foucault stated that "we have to not only affirm ourselves as an identity, but as a creative force." In their interview with Foucault, Bob Gallagher and Alexander Wilson point out that this declaration raises important issues. "Should gay people embrace a social identity that was largely created from the sexual mores of the late nineteenth century, or pursue relationships of differentiation, or creation, or innovation . . . an

identity unique to ourselves?" "If gay people are truly to know themselves," suggests Foucault, "they must examine and rely on their own potential—in short, create themselves—rather than insist on conforming to the socially constructed role of 'the homosexual,' a consciousness that has primarily been defined by others." Foucault said, "We must define who we are, who we can become, what our community consists of, and how we are going to change the world so it will accommodate us . . . we are shaped by our sexual identity, and it, in turn, is shaped by us. It is not a simple matter of accepting or deny-ing our sexual identity; we must continually construct it. Let us hope that it will be an identity strong enough to protect us and flexible enough to liberate us." . . .

Ironically, because of right-wing attacks on sexually explicit art and gay and lesbian artists, the need to assert sexual identity has intensified, and there is literally a renaissance of overtly queer art and exhibitions. In direct response to xenophobia, censorship, and the war on so-called deviants, gay, lesbian, and queer artists are out, proud, and flaunting it—insisting on the right to produce images that reflect their diverse identities, experiences and cultures if they so choose. Much of this work directly addresses the social construction of gender, sexuality, and identity politics. . . . Queer identity and its expression have the potential of not only confronting the tyranny of enforced heterosexuality and empowering gays and lesbians, but of critiquing the politics of patriarchy, thus playing a major role in the empowering of all marginalized peoples. It is only by examining this connectedness which doesn't deny difference, thus crossing racial, sexual, and cultural borders, that we will be able to fight the reactionary forces at work today. It is not only about supporting individual artworks or artists as they get attacked (although we must do that too), but rather looking at the underlying issues. In challeng-ing heterosexist assumptions, homosexuals disrupt and destabilize many established codes and institutions of oppression.

To get a sense of our artistic power, I find it helpful to look at border-art practices. Emily Hicks, an Anglo member of the ethnically mixed *La Taller Frontera* (Border Arts Workshop) in SanDiego/Tijuana, describes the border as a zone of mergings, confrontations, skirmishes and healings that constant-ly changes and replenishes itself. It is a place where we physically act out beliefs and philosophies. Border-art practices are based on multiplicity and understanding of both sides. And border art is any art that questions the hegemonic western discourse. Hicks elaborates that to even read a border text, for example, is to cross over into another set of referential codes, for one is now open to a multiplicity of discourse as text is decentered. In crossing, or even getting too close, the writer and reader are changed. "The borderline boundaries begin to dematerialize through personal action and art."

Queer art is border art. For all the talk about multiculturalism and diver-sity, the fact is that homosexuality is still a border that many do not want to cross. Linda Burnham, writing an editorial in *High Performances*, puts it this way: "As fear stampedes across America, everybody is learning a lot about

where they draw the line, and many draw it at the acceptance of homosexuality. If some group has to be the scapegoat in these conservative times, let it be the queers, so the rest of us can go on with business as usual."

Audre Lorde also wrote, "Certainly there are very real differences between us of race, age and sex. But it is not those differences between us that are separating us. It is rather our refusal to recognize those differences, and to examine the distortions which result from our misnaming them and their effects upon human behavior and expectation." She says we must find new patterns of relating across difference. "For we have, built into all of us, old blueprints of expectations and response, old structures of oppression, and these must be altered at the same time as we alter the living conditions which are a result of those structures. For the master's tools will never dismantle the master's house. . . . Change means growth, and growth can be painful. But we sharpen self-definition by exposing the self in work and struggle, together with those whom we define as different from ourselves, although sharing the same goals."

There are all kinds of crossings. Some are noisy, visible, and meant to draw attention. Some are quiet. We do not hear them. Some are secret. We do not see them. Some go unnoticed until it is too late. And some who have gone first have paid the price. Sometimes we are scared. Sometimes we don't think about it. But the crossings go on day and night, in light and shadow. Most of us cross back and forth daily and take others with.

Untitled (You Invest in the Divinity of the Masterpiece), 1982. Unique photostat, $71^{3}/_{4}$ x $45^{5}/_{8}$ in. (with frame: $72^{7}/_{8}$ x $46^{3}/_{4}$ in.). Collection: The Museum of Modern Art, New York. Larry Aldrich Foundation Fund

BARBARA KRUGER

B. 1945

IN HER SIGNATURE works, Barbara Kruger uses appropriated photographic images overlaid with gender-laden slogans to call attention to the power imbalance in western patriarchal culture. Trained as a graphic artist, Kruger finds her images in the popular culture and returns them to that context via their reproduction on matchbooks, billboards, tee-shirts, and shopping bags. The written word is brought to bear a central importance in her artwork through the incorporation of textual elements, mostly in the form of "pronomial shifters"—pronouns such as "I," "you," "me," "we," "they"—that predominate in almost all of her mature works. Language is also important to Kruger's work as a media critic. Her analyses of film and television have appeared regularly in *Artforum* for over a decade.

The only child in a lower-middle-class Jewish family, Kruger was born in Newark, New Jersey. She graduated from Weequahic High School and, in 1964, spent a year at Syracuse University. Her father's death in 1965 occasioned her return to the New York metropolitan area and the beginning of her art education at Parsons School of Design, where she studied with Diane Arbus and Marvin Israel. Arbus provided her with a role model of a committed woman photographer, while Israel introduced her to the world of graphic design and, through his encouragement and support, helped her to consider a career in that field for herself. After barely a year, she dropped out of Parsons and was

hired by Condé Nast Publications to design ads for *Mademoiselle* magazine, where she rapidly moved from an entry-level position to that of chief designer. Soon she took on free-lance work designing book covers. Her early experiences in the field of graphic design had a lasting impact on her work and her way of seeing.

While continuing to hold her position at *Mademoiselle*, in 1969 Kruger resumed her pursuit of a career as a fine artist. Inspired by an exhibition of Magdalena Abakanowicz's weavings, Kruger initially experimented with fabric wall hangings, whose lexicon of stitchery she believed to be consistent with what was "allowed" to women artists. She has described her early fiber pieces as "very decorative, very gorgeous, very sexualized." By the early seventies Kruger had begun to define herself as an artist: she had quit her job, although she continued her free-lance work, and had moved into a large loft/studio. At this time, too, she first began to write and publish poetry, influenced "by the transgressive female presence" of poet and rocker Patti Smith. These poems relate to her later work in that they show her interest in creating a connection between the words associated with popular culture and its imagery. A mixed-media work, *2 A.M. Cookie*, was included in the 1973 Whitney Biennial, and her first one-artist exhibit occurred in 1974 at the alternative gallery Artists' Space, followed by another in 1975 at the Fischbach Gallery. She spent about a year exploring the medium of painting through large, abstract, shaped works. However, she still did not feel that she had found the appropriate medium for expressing the concerns about which she felt most strongly, particularly those related to her perception of social and political issues.

In 1976, while holding a temporary teaching position at the University of California at Berkeley, Kruger took a break from art-making to reassess the direction she wanted to take in her work. As is so often the case, this hiatus had a salutary effect on her subsequent artistic development. Upon her return to image-making, she implemented an art based on the proximity of photographs to words, particularly as seen in her artist's book *Pictures/Readings* (1977). In this work, she placed images of bland, California-style architectural exteriors on the rectos, juxtaposed with interior monologues of imagined inhabitants on the facing versos. These narratives are similar in tone to her stories of this period in their deadpan observation of the ennui of contemporary life, as conveyed through precisely rendered details. Although she had not yet conceptualized the format taken in her mature work, the dynamic interrelationship of text and image exemplified in this piece underlies all her subsequent artwork. Her abandonment of painting in favor of uniting photography and written text was a significant step toward finding an effective vehicle for communicating her ideas. She later described herself as having been "alienated" by her production as a painter, but "on the cutting edge" of her intelligence while writing.

Between 1978 and 1980 Kruger experimented with several different approaches to the juxtaposition of graphic images and text. In 1978 she created pairings of images with evocative texts in several multi-paneled series;

while these were on a larger scale than *Pictures/Readings*, they used text more sparsely. Although the earliest consisted of double panels, she soon developed the four-paneled "Hospital Series": a picture of hospital equipment (e.g., the overflowing top of a trashbin) is shown in the left-hand panel, accompanied by a series of four somewhat sinister descriptive phrases in the second panel ("The technology of early death / The manufacture of plague"), an appropriated image of an ambiguous human interaction in the third, and finally a short exhortatory phrase in the final panel ("No don't"). By 1979, Kruger had begun to combine suggestive words and phrases with appropriated imagery. In one untitled work, the word "Container" is superimposed on a photograph of a suburban-style ranch house. Another, a view of a headless female figure with her hands clasped against her chest, contains the word "Perfect" (1980).

Kruger's earliest work in what became her hallmark style dates from 1981, consisting of appropriated black-and-white images that have been superimposed with a clearly printed, somewhat accusatory phrase, and framed in bright red enamel. They were first exhibited later that year in the group show "Public Address" (which also included works by Jenny Holzer and Keith Haring) at the Annina Nosei Gallery. Included in the exhibition were such outstanding examples of Kruger's mature style as the untitled photograph of a man's face and a woman's face separated by the phrase "You destroy what you think is difference" and another untitled image, of men's feet in business shoes accompanied by the slogan "You make history when you do business." All Kruger's subsequent work to date, despite some significant variations in scale and media, has been related to the format arrived at in 1981. In the later 1980s Kruger experimented with various eccentric media, as in a series of lenticular works in which she engaged the viewer's participation by pairing two layers. For example, a black-and-white photograph of a woman's face behind a grid, with the tiny words "we are astonishingly lifelike" each placed in a corner, yields the phrase "HELP! I'm locked inside this image" when the viewer changes point of view. Kruger also made a series of color photographs silkscreened on vinyl, and a series of photoengravings printed in red ink on magnesium.

One significant aspect of Kruger's adoption of a form that combined words and imagery is that it enabled her to make art that was actively engaged in cultural critique. From the time of her involvement with the group Artists Meeting for Social Change in the mid-seventies, Kruger has been involved in reading about and formulating theoretical issues related to the analysis of both high art and popular images in their cultural contexts. The several exhibitions that she has curated attest to her interest in this area: "Pictures and Promises. A Display of Advertisings, Slogans, and Interventions," installed at the Kitchen Center for Video and Music in 1981, and "Picturing Greatness" (1988), curated by Kruger for the Museum of Modern Art. In this latter show, Kruger juxtaposed photographs of "great" artists whose works were represented in MoMA's collection with a narrative printed in large type, challenging our perception of greatness, and displayed on a large panel. Kruger also has been involved in organizing

several symposia that deal with politics, culture, and representation, as the 1988 series of discussions entitled "Remaking History" (published as a series of essays in 1989). For ten years she was a television and film critic for *Artforum*, writing two regular columns. She also edited an anthology of television criticism, *TV Guides* (1985). Her critical writings have been collected in *Remote Control* (1993), the title taken from the name of her *Artforum* television column.

Kruger has consistently resituated her work in the popular media. While many of her photographic images are appropriated from media sources, they take on another life when Kruger returns them to that context. From an early point in her career Kruger used unconventional means to distribute her images. Disturbed at the paucity of women exhibitors in the "Documenta VII" exhibit in Kassel, Germany (a show in which her work was included), Kruger pasted the town with posters that read "Your moments of joy have the precision of military strategy." Many of her works loom over the visual landscape on billboards in various cities; they also have been printed in small, intimate scale on matchbooks, on tote bags, and on tee-shirts. A phrase such as "I shop therefore I am" has a particularly double-edged resonance when emblazoned on the side of a laden shopping bag. Like Jenny Holzer, Kruger used that cultural artifact, the Spectacolor lightboard at Times Square, to crank her words into the public domain. Kruger's 1983 project was a mini-essay that ultimately equated TV's nightly news with a sex show, via an analogy between manhood and weaponry.

Kruger has stated that one major goal in her work is "to welcome a female spectator into the world of men." Indeed, her visual/textual strategies collaborate to disrupt the power imbalance associated with the gaze in western culture. In this regard they are aligned with the writings of such critics as Laura Mulvey who, in 1975, identified the scopophilic, voyeuristic "visual pleasure" that characterized the dominating male gaze. Kruger achieves her goal through her use of pronomial shifters—e.g., "you," "we," "I," "they"—that form the basis of the majority of her images. As Jane Weinstock asks, What does she mean to you? In other words, who are you? Are you male or female? Most often, "you" is presumed to be male and "me," "I," and "we" are presumed female. Thus, it is the male gaze that "hits the side of my [female] face." Likewise, it is male "manias that become science" and "we [women] have received orders not to move" from an implied masculine "you;" therefore, we are hunched over and pinned into place, because "you [men] are giving us [women] the evil eye" and "I [female] can't look at you [male] and breathe at the same time." Thus by inserting a female presence as the speaking and seeing subject, Kruger disrupts the dominant point of view (and with particular effectiveness due to the great number of her statements that deal with looking, seeing, and being seen). In Kruger's work, the recipient of the gaze (she who has been seen) talks back to its donor, objecting that "we are being made spectacles of." This upends the traditional hegemony that was able to exist because the object was silenced, her point of view never articulated.

Kruger extends her analysis of the imbalance of power to an examination of its abuse by white males in the culture at large. While she believes that power is gender-determined, Kruger's pictorial constructions critique aspects of the culture that go beyond sexual politics. In such statements as "Charisma is the perfume of your gods" and "You invest in the divinity of the masterpiece," the word "you" is still presumed to be a dominating masculine presence that "get[s] away with murder." The realm of its mastery, however, is not limited to the female but to a broad spectrum of the cultural array. In the images that accompany the phrases just cited, domination is achieved through the identification of money with power; it is a masculine "you" who "make[s] history when you do business" (as Weinstock points out, a double-entendre based on an American euphemism for defecation). Kruger identifies the frightening and menacing aspects of those who "have searched and destroyed," who "thrive on mistaken identity," who "reenact the dance of insertion and wounding," who are "an experiment in terror." She underlines the loss of humanity imposed by the power structure, for it is also a male "you" whose "pleasure is spasmodic and short-lived," whose "life is a perpetual insomnia," whose "moments of joy have the precision of military strategy," and who "construct[s] intricate rituals which allow you to touch the skin of other men." Ultimately she deconstructs the power of the white male, who "rule[s] by pathetic display" and "transforms prowess into pose."

The impact of Kruger's works is achieved through her ingenious melding of visual and textual elements, in which her experience as a graphic designer is clearly evident. She has said that the hardest part of her art-making consists in writing the phrases and making them work with the images in "rich" ways. Since about 1981 Kruger has used a bold, blocky typeface in most works, which contributes to the images' authority, their look of official pronouncement. The size and placement of the lettering sets up a dynamic relationship with the appropriated image, and Kruger has stressed the importance of the layout stage in her art-making process, during which she "plays" with the placement of text. In an untitled work, the phrase "I can't look at you and breathe at the same time" is superimposed across the eyes of a full-faced chest-length image of a female, blocking her vision, while her ability to breathe also seems inhibited by a wrapping of cellophane covering her nose and mouth and extending to her chest. Kruger uses the placement of lettering as an active visual communicator, as in the short, choppy spacing in her untitled work of male hands in a bowl, on the right side of which is written "Your plea/sure is/ spas/modic/ and/ short/lived." She varies the size of the type for emphasis (the words "Your" and "science" are enlarged in an image of a mushroom-shaped cloud reading "Your manias become science") or for de-emphasis (as the tiny words "I am your almost nothing" against a backlighted image of male hands in a tangle of female hair). Often the visual/textual intersection provides Kruger with an avenue for ascribing the gender of her pronomial shifters. In the untitled work reading "Your life is a perpetual insomnia," a male in a striped shirt and tie cradles his head in his hand; in the untitled work "We have received orders

not to move," the silhouetted figure pinned in place is clearly female. In a more ambiguous work, a lushly colored field of phallic *petits fours* viewed head-on, it is her variation on her usual typeface—here, a hot-pink italic—that suggests that the phrase "Give me all you've got" expresses female, rather than male, desire.

Through written word and visual image, Barbara Kruger presents a perceptive critique of the intersection of culture and power in the late twentieth century, disrupting comfortable stereotypes and opening up possibilities for change.

SOURCES

Kruger, Barbara. *Pictures/Readings*. 1978.

_____. *TV Guides: A Collection of Thoughts about Television*. Kuklapolitan Press, 1985.

_____. *Remote Control: Power, Cultures, and the World of Appearances*. Cambridge: MIT Press, 1993.

_____. "Selected Poems." *Tracks* 3 (Spring 1977), pp. 130-36.

Linker, Kate. *Love for Sale: The Words and Pictures of Barbara Kruger*. New York: Harry N. Abrams, 1990.

Mulvey, Laura. "Dialogue with Spectatorship: Barbara Kruger and Victor Burgin." In *Visual and Other Pleasures*, pp. 127-136. Bloomington: Indiana University Press, 1989.

Nixon, Mignon. " 'You Thrive on Mistaken Identity,' " *October* 60 (Spring 1992), pp. 58-81.

Owens, Craig. "The Medusa Effect, or The Spectacular Ruse." In *We won't play nature to your culture: Works by Barbara Kruger*, pp. 5-11. Exhibition catalogue. London: Institute of Contemporary Arts, 1983.

Squiers, Carol. "Diversionary (Syn)tactics," *ARTnews* 86 (February 1987), pp. 76-85.

Weinstock, Jane. "What She Means to You." In *We won't play nature to your culture: Works by Barbara Kruger*, pp. 12-16. Exhibition catalogue. London: Institute of Contemporary Arts, 1983.

BARBARA KRUGER—SELECTED WRITINGS

INSCRIPTIONS ON WORKS (ARRANGED ACCORDING TO FIRST PRONOUN)

You/Your

You invest in the divinity of the masterpiece
You are giving us the evil eye
You thrive on mistaken identity
You are seduced by the sex appeal of the inorganic
You are the perfect crime
You kill time
You construct intricate rituals which allow you to touch the skin of other
 men
You substantiate our horror
You make history when you do business
You get away with murder
You delight in the loss of others
You transform prowess into pose
You rule by pathetic display
You reenact the dance of insertion and wounding
You are an experiment in terror
You destroy what you think is difference
You rejoice in novelty
You molest from afar
You are a captive audience
This is for someone special. You know who you are
All that seemed beneath you is speaking to you
Why you are who you are
Now you see us now you don't
What big muscles you have
If you can't feel it, it must be real
Money can buy you love
Your comfort is my silence
Your life is a perpetual insomnia
Your moments of joy have the precision of military strategy
Your manias become science
Your gaze hits the side of my face
Your money talks
Your pleasure is spasmodic and shortlived
Your assignment is to divide and conquer
Your property is a rumor of power

Your devotion has the look of a lunatic sport
Your fictions become history
Charisma is the perfume of your gods
Memory is your image of perfection
Put your money where your mouth is
Surveillance is your busywork
You are not yourself
You can dress him up but you can't take him out
Your body is a battleground

WE/US/OUR

We are your circumstantial evidence
We don't need another hero
We construct the chorus of missing persons
We get exploded because they've got the money and God in their pockets
We decorate your life
We are astonishingly lifelike
We have received orders not to move
We are the objects of your suave entrapments
We are unsuitable for framing
We are the failure of ritual cleansing
We won't play nature to your culture
We refuse to be your favorite embarrassments
We are being made spectacles of
We will undo you
Are we having fun yet?
Tell us something we don't know
Keep us at a distance
It's our pleasure to disgust you

I/ME/MY

I can't look at you and breath at the same time
I am your reservoir of poses
I am your slice of life
I shop therefore I am
I won't be what I mean to you
I am your immaculate conception
I will not become what I mean to you
Do I have to give up me to be loved by you

Help! I'm locked inside this picture
My hero
Buy me. I'll change your life
Remember me
Give me all you've got
What me worry
God said it I believe it and that settles it
When I hear the word culture I take out my checkbook

Who

Who is bought and sold?
Who is beyond the law?
Who is free to choose?
Who follows orders?
Who salutes longest?
Who prays loudest?
Who dies first?
Who laughs last?

Not Pronomial

no radio
use only as directed
The marriage of murder and suicide
Busy going crazy
Admit nothing. Blame Everyone. Be bitter
Endangered species
God sends the meat and the Devil cooks
Free Love
Turned Trick
Business as usual
There is only/one antidote/to mental/suffering/and that is/physical pain
Jam life into death

SELECTED POEMS

"the race"

> lack of motion
> locomotion
> little eva
> magic potion
> jamoca almond fudge
> king of the tropics
> under a palm tree
> reading a palm
> of a lady
> in a sarong
> which becomes
> untied on purpose
> and is making him
> crazy
> with desire
> he reclines her
> on some coconuts
> each thrust
> propelling them
> thrice
> around the island
> to the sounds
> of traveling music
> they pick up speed
> passing the italian team
> coming in third
> in the bobsled
> with just
> a sarong
> some coconuts
> and the good old
> in and out

"office death"

that is a suicide window
i can tell

i water philodendrons
with paper cups
jordan almonds
for traveling
a pink one
for paree
a white one
for lisbon
they take off their wedgies
and say
"have a nice weekend"
what is a nice weekend?
the question is 12 years old
and still
i have no barbecue children
each lump of sugar
a cardinal
a sparrow
cleaning ears
with paper clips
nails filed
in pencil sharpeners
the cats enter
the two of them
dragging a chaise lounge
shaking from lovers
like the king of siam
i water philodendrons
in fluorescent light
showing wrinkles
in dresses
that cry for pantyhose
if it was a yellow space
if i could make you a meal
of toasted dying philodendron
and you would accept
i would add on a wing
i have nowhere to go
but down

FROM *PICTURE/READING* (ARTIST'S BOOK, 1978)

The trouble with the pronunciation started when he was a child. They were
on the front door and the bathroom and kitchen windows. Jalousie? Jalousey?

Was it french? Who cares? He thought this while sitting in the chair in the liv-ingroom, staring at the window, which actually wasn't jalousie, but a contem-porary derivation. Thinking about the window was a device he used to dis-tract himself from thinking about Anne and where she was and what she was doing. It was already late afternoon and the shank of the day was being wast-ed. He had thought that the rental of this so-called villa on the beach would take the edge off their marital tension. She seemed to ignore his presence and he frequently caught her standing by the kitchen sink with the water running, detergent bubbling onto the Formica, staring through the jalousie out to sea. Was it another man? He had noticed, the other day at the club, when he introduced her to Stan, their eyes lingered on one another for an inappropriate amount of time. This very moment, they could be at the club, sitting in soft leather chairs. She is laying nutted cheese spread onto round yellow crackers and staring into Stan's eyes. Stan downs a scotch and beck-ons to her. That mysterious animal language. They go off somewhere and lay down. He shakes and tries to change his train of thought. He forces his mind to concentrate on the window. How the tilted panes are frosted, like glasses at a cocktail party.

Irving sits in the livingroom on a sunny day and reads the front page of the paper. He turns to page 46 where the article is continued. As he folds the paper into a comfortable reading position, he feels a sudden press to his bow-els. He gets up, paper in hand, and walks through the livingroom, down the foyer, and makes a left at the bathroom. He closes the door, unzips his pants, and watches them bag around his calves as he sits down. He stops reading and looks at the crossword puzzle at the bottom of the page. He looks at the puzzle for about seven seconds. He leans his elbows on the newspaper print and cups his face in his hands and starts staring at the white hexagon tiles on the floor. Then he looks at the spot where the enamel of the bathtub meets the floor and follows the line vertically to the wall by the door. Then he places each large toe in a hexagon, and sees that the wedge of all five toes takes up approximately four hexagons. He counts the number of hexagons at the widest expanse of the floor, does the same vertically, and then multiplies the two amounts. He finds it impossible to do this figuring in his head, so he scratches the numbers on his arm with the nail of his index finger. His fore-arm is relatively tan, so the numbers read a hazy white tinged with pink, and fade quickly, like skywriting. When the calculation is finished, the result is an approximation of the number of hexagons on the bathroom floor. He spells this number out and places each letter in numbers four, five and six of the crossword puzzle and pulls up his pants.

Helen shopped for five weeks trying to locate the correct style of venetian

blind for the front window. They renovated the window three years ago. It used to have small glass panes in the side panels, but the frame warped, so they installed one large immovable sheet of glass. She is running her hand over the armrest on the livingroom sofa. An archway separates the livingroom from the diningroom. In the middle of the room is a large blond table with matching chairs. To its left, against the wall, is a glassed cabinet, filled with unused sets of melmac. She gets up and walks past the bathroom to the kitchen. She sits down at the table and looks around her. She takes out a sky blue piece of stationery, and with a red ballpoint pen, starts writing a letter to her sister Marie in Boston. She presses the point to the paper, but no mark is left. She presses down harder, making two or three half inch scars on the stationery. She looks carefully at the the pen. First at the point, which, although soaked with ink, is unable to make its mark. On the red plastic body is the name of the department store where she works. The white letters have begun to chip off in places, especially around the vowels. She presses the point deeper and deeper into the paper, starting out with staunch verticals and finishing with a vehement flourish of six or seven circles. By the middle of the sixth circle, a small trail of blue ink begins to assert itself, and by circle number seven a mature mark has been completed. Assured of herself by now, she starts at the left margin and begins writing down the side of the paper, over and over again . . . Dear Marie, Dear Marie, Dear Marie, Dear Marie, Dear Marie.

FROM "TV GUIDES". REPRINTED IN *REMOTE CONTROL* (1993).

NOVEMBER 1985

A well-oiled bicep fills the screen and flexes to the strains of the already ancient "Purple Rain." It's sort of an orange color and, in this extreme close-up viewing, totally unrecognizable as a swatch of human anatomy. It mobs the viewing aperture and looks like a cross between a slab of fatty bacon and kryptonite approaching its melting point. It is then quickly replaced by a talking roll of toilet tissue which pleads with members of a family to "touch" it. The rotund glob of needy, animated paper gives way to an anchorman, a somber talking head who reports a catastrophic plane crash. We look at images of emergency medical teams packaging the dead in yellow body bags. The runway is littered with blood and spare body parts. This segment is immediately followed by a shot of a kitten in sunglasses propped under a beach umbrella.

As this clashing litany suggests, television is the most relentless purveyor of the messages that constitute and perpetuate our severely fragmented public consciousness. It slices our attention span into increments too infinitesimal to get up and measure. Spending a large part of our lives planted in front of a piece of talking furniture, we are held hostage by the pleasure of the cut-

ting and the repetition, by a kind of intermittent fascination which is facilitated by the relief we feel in numbness, and has the feel of the erratically riveted wonderment experienced by infants. That television's parade of segments follow one another but do not "go together" does not seem strange or problematic to its viewers. Seen cinematically, these disjunctions might appear as affronts to narrative, or some kind of "kooky" avant-garde collage. But on TV they are just right, business as usual.

Television tells us not of a vision but of visions. It evades singularity and loiters amidst the serial, the continual, the flow. Its interest in storytelling is peripheral yet promiscuous. For although a large portion of broadcast time is given over to Hollywood-style filmic drama and the familiar closure of storytelling, television, perching in our living rooms like a babbling, over-controlling guest, is deeply embroiled in the authoritative declarations and confessionals of "direct address." The cinema frames and brackets particular incidents and in doing so reveals its connections to painting and photography, while television seems to emerge via the coupling of new picture and computer technology with the chattering of radio. As film's anecdotal accountings necessarily speak of the past, television's direct address inhabits the present. The "nonfiction" genres (news, sports, talk shows) that use direct address also appropriate the stuff of events almost instantaneously and play them back with the relentlessness of an avenging mirror. And because all this combined with ads, sitcoms, soaps, game shows, and docudramas looks like what we've come to think of as life, its simulation grants it perpetual license. Blurring the distinction between the thought and the act, between imagination and experience, TV's constant broadcast alleviates the truth of its special sanctity and sprinkles it on everything that moves.

Direct address dominates and lets the viewers think they know who's doing the talking and to whom. We know when Dan Rather is going to break the bad news and we're not surprised when we're contradicted by a talking tub of margarine or seduced by a roll of toilet paper. We know TV meant what it said when it announced, "You Are There." We know that we have received orders not to move and that we're learning to walk in place at the speed of light.

FROM "MOVING PICTURES". REPRINTED IN *REMOTE CONTROL* (1993).

"DIFFERENCE: ON REPRESENTATION AND SEXUALITY" (1985)

The films included in the "Difference: On Representation and Sexuality" exhibition are clearly not the same as those produced by corporate Hollywood. Selected by Jane Weinstock, there are no stories of adorable boy hoodlums overtaking entire high schools, no renegade cops undermining

police bureaucracies by virtue of their sheer wit and cuteness, and no square-jawed private eyes navigating through a miasma of calculating jiggle. Rather than showing sexuality in an immutable, natural state, the films suggest a socially constructed sexuality, a perpetual shifting of positions, voices, and bodies only biologically fixed to gender. This collapsing of a binary notion of sexuality into a series of locations, pleasures, and repetitions is accomplished through a variety of cinematic procedures, ways to show and tell which escape conventional narrative closures and singular "character development." Stories are punctured and rewritten, histories are undermined, humor is deployed, conjugations are conjured, and pronouns are paraded promiscuously.

In *Thriller*, 1979, Sally Potter rereads and rewrites Puccini's *La Bohème* (1896). Opera seemed to Potter an apt form for scrutiny since she sees it as "a particularly clear example of the role of fiction in the production of ideology." To call *Thriller* a rereading might imply attention only to a text and its subsequent skewing via other texts, but a film is not a book, and *Thriller*'s complexity results from the joining of its textual activity to a string of fluently pleasing images, a collection of black and white "still lives" which splinter the scene of the "original" spectacle and substitute its melodic lyricism with a series of questions, quotes, and laughters.

A voice-over by Mimi (Colette Laffont) examines the possible difference between her own labor as a seamstress, the work of the prostitute Musetta, and the creativity of the young men in the opera: a poet, a painter, a musician, and a philosopher. Is all poverty the same? "Do they suffer to create as I must suffer to produce?" "Could I have been the subject of the scenario rather than its object?" "Could I have been the bad girl, the one that didn't die?" In *La Bohème* Mimi's identity is fixed in a single body, but *Thriller*'s Mimi is all over the place. She investigates her own murder, becomes a "bad girl," and reads books on theory and laughs at them. Potter's scrutiny of *La Bohème* casts aspersions not only on opera as a cultural offering but also on the class and subject/object relations at work in a unified narrative, on the humorlessly rote repetition and mimicry of some theoretical pronouncements, and on the picaresque adventures in poverty that envelop much artistic production.

In *Committed*, 1984, Sheila McLaughlin and Lynne Tillman engage in the rewriting of a different story: that of the actress Frances Farmer's dive from activity to lobotomy. The medical procedure Farmer underwent is described as one that "severs those nerves which give emotional power to ideas," so the film can be seen as addressing the silencing, the rendering inactive and absent, of a speaking subject. While Hollywood's rendition of Farmer's life is just another "life story," McLaughlin and Tillman work to break down the singular sad song into a chorus of ambient exhortations, rationales, confessionals, and audience participations. Moments of expository speech dot the film, giving it a sense of histories, differing narratives, and melancholy soliloquies. Frances's mother (Victoria Boothby) warns a radio audience to beware

of commie entrapment. She is accompanied by an announcer extolling the virtues of mental hygiene, which has found its "right humus in America." Frances (McLaughlin) languishes in a mental hospital and confesses to a nurse that she is a casualty of love, involved in a relationship where "pleasure and pain are inextricably linked," where you "can't tell feeling good from feeling bad." Clifford Odets (Lee Breuer) zigzags from punishing sadist to sorry little boy; acting out the old "good nipple/bad nipple" routine to the hilt, he degrades Frances and praises his wife as a saint. Farmer and Odets are seen as romantic contortionists in a grim ballet. Their "scenes" are powerful because they are free of the manner and stylistic embellishments that loiter around most narrative depictions of sexual obsession. No magenta light bounces off Frances' forehead, no Armani is strewn sloppily around the room, no sunglasses or raincoats soften the blows. *Committed*'s formidable script takes on American-style red-baiting, psychiatry's mania for alignment and "normality," the complexities of the mother/daughter relationship, the brutal choreography of romance, and the unified expediencies of the biographical mode.

If *Thriller* is about a number of different "shes" and *Committed* fractures the singular historical "she," perhaps Chantal Akerman's *Je, Tu, Il, Elle* (*I, You, He, She,* 1974) is an outline of the possibilities of the pronoun as the motor of narrative, the shifting focus of the conjugation. Throughout the film Akerman's own figure is a constant, whether embroiled in the narcissism of display, contained by passivity, or activated by passion. But though *Je, Tu, Il, Elle* has the makings of a flaunting confessional, its severe exposition, long shots, and tableau-like presentations lend an anthropological feel to the proceeding, turning even explicit sex scenes into "scenery," into "exhibit A's," into studies in sensations, noises, and bodies. Multiple bodies also inhabit Yvonne Rainer's *Film about a Woman Who . . .* , 1974, to the extent that "who" the "woman who" is becomes questionable. A number of unnamed women take part in a meandering conflation of verbal admissions, conversational and photographic arrangements, and smidgens of moments which suggest a woman's reaction to "her own perfection or deformity." Rainer's work proceeds amidst the acknowledgment that "if the mind is a muscle, then the head is a huntress and the eye is an arrow." If the eye can be an arrow, perhaps the film attests to the possibility of removing women from the line of fire and doing so with smart impertinence and knowing laughter.

These films and many others in the program suggest a different way of storying, of not making a point but straying persuasively. But although *having* a point can be a gender designation, *making* a point can be a sexually instructed activity, and one hopes in the future to see more critical work by men that addresses issues of sexuality and representation. The films I have mentioned, however, are made by women. They should encourage other projects intent on recognizing a female spectator, on welcoming a multiplicity of feminisms. So we hope for the emergence of different kinds of films, whether through the maneuvers of a theoretically derived cinema, from a more artisanal, art-world context, or even sneaking between the phantasms of

Hollywood. The boys may be taking over the high school but the girls' minds are elsewhere. And when they show and tell us about it, it just might be a very different kind of story.

"NOT NOTHING" (1982). REPRINTED IN *REMOTE CONTROL* (1993).

You are walking down the street but nothing is familiar. You are a child who swallowed her parents too soon; a brat, a blank subject. You are the violence of mourning objects which you no longer want. You are the end of desire. You would not be this nothing if it wasn't for courtliness. In other words, religion, morality, and ideology are the purification and repression of your nothing. In other words, romance is a memory of nothing which won't take no for an answer and fills the hole with a something called metaphor, which is what writers use so they won't be frightened to death: to nothing. You ransack authority by stealing the works of others, but you are a sloppy copyist because fidelity would make you less of a nothing. You say you are an unbeloved infidel. When you are the most nothing you say "I want you inside of me." And when you are even more nothing you say "Hit me harder so I won't feel it." As a kind of formal exercise, you become a murderer without a corpse, a lover without an object, a corpse without a murderer. Your quick-change artistry is a crafty dance of guises, coverups for that which you know best: nothing. And all the books, sex, movies, charm bracelets, and dope in the world can't cover up this nothing. And you know this very well since you are a librarian, a whore, a director, a jeweler, and a dealer. Who's selling what to whom? Supply and demand mean nothing. People talk and you don't listen. Explicits are unimportant, as they lessen the weight of meaninglessness to the lascivious reductions of gossip. You prefer to engage the in-between, the composite which skews the notion of a constituted majority, questioning it as a vehicle for even that most exalted of daddy voices, the theorist. He hesitantly places his hand on your belly as if he were confronting the gelatinously unpleasant threat of a jellyfish and decrees you a kind of molecular hodgepodge, a desire-breaching minority. You turn to him slowly and say "Goo-goo." He swoons at the absence-like presence of what he calls your naive practices: "the banality of the everyday, the apoliticalness of sexuality, your insignificantly petty wiles, your petty perversions." You are his "asocial universe which refuses to enter into the dialectic of representation" and contradicts utter nothingness and death with only the neutrality of a respirator or a rhythm machine. Goo-goo. But you are not really nothing: more like something not recognized as a thing, which, like the culture that produced it, is an accumulation of death in life. A veritable map and vessel of deterioration which fills your writing like a warm hand slipping into a mitten on a crisp autumn day. And like the exile who asks not "Who am I?" but "Where am I?", the motor of your continuance is exclusion: from desire, from

the sound of your own voice, and from the contractual agreements foisted upon you by the law. Order in the court, the monkey wants to speak. He talks so sweet and strong, I have to take a nap. Goo-goo.

〰

"INCORRECT" (1983). REPRINTED IN *REMOTE CONTROL* (1993).

Photography has saturated us as spectators from its inception amidst a mingling of laboratorial pursuits and magic acts to its current status as propagator of convention, cultural commodity, and global hobby. Images are made palpable, ironed flat by technology and, in turn, dictate the seemingly real through the representative. And it is this representative, through its appearance and cultural circulation, that detonates issues and raises questions. Is it possible to construct a way of looking which welcomes the presence of pleasure and escapes the deceptions of desire? How do we, as women and as artists, navigate through the marketplace that constructs and contains us? I see my work as a series of attempts to ruin certain representations and to welcome a female spectator into the audience of men. If this work is considered "incorrect," all the better, for my attempts aim to undermine that singular pontificating male voice-over which "correctly" instructs our pleasures and histories or lack of them. I am wary of the seriousness and confidence of knowledge. I am concerned with who speaks and who is silent: with what is seen and what is not. I think about inclusions and multiplicities, not oppositions, binary indictments, and warfare. I'm not concerned with pitting morality against immorality, as "morality" can be seen as a compendium of allowances inscribed within patriarchy, within its repertoire of postures and legalities. But then, of course, there's really no "within" patriarchy because there's certainly no "without" patriarchy. I am interested in works that address these material conditions of our lives: that recognize the uses and abuses of power on both an intimate and global level. I want to speak, show, see, and hear outrageously astute questions and comments. I want to be on the sides of pleasure and laughter and to disrupt the dour certainties of pictures, property, and power.

〰

"PICTURING 'GREATNESS' " (WALL TEXT FOR EXHIBITION AT THE MUSEUM OF MODERN ART, NEW YORK, 1988). REPRINTED IN *REMOTE CONTROL* (1993).

The pictures that line the walls of this room are photographs of mostly famous artists, most of whom are dead. Though many of these images exude a kind of well-tailored gentility, others feature the artist as a star-crossed Houdini with a beret on, a kooky middleman between God and the public. Vibrating with inspiration yet implacably well-behaved, visceral yet oozing

with all manner of refinement, almost all are male and almost all are white. These images of artistic "greatness" are from the collection of this museum. As we tend to become who we are through a dense crush of allowances and denials, inclusions and absences, we can begin to see how approval is accorded through the languages of "greatness," that heady brew concocted with a slice of visual pleasure, a pinch of connoisseurship, a mention of myth, and a dollop of money. But these images can also suggest how we are seduced into the world of appearances, into a pose of who we are and who we aren't. They can show us how vocation is ambushed by cliché and snapped into stereotype by the camera, and how photography freezes moments, creates prominence, and makes history.

FROM "ARTS AND LEISURES" (*NEW YORK TIMES*, 1990). REPRINTED IN *REMOTE CONTROL* (1993).

This coupling [of arts and leisure] is an oldie but goody that neatly perpetuates the conventional gap between the fine arts and so-called popular culture. Okay, let's . . . try to figure out which is art and which is leisure. Or, in other words, what is "high" and what is "low." Let's see. Art is obviously art, right? And sometimes theater is art, but sometimes it's just a lot of escapist hullabaloo, right? Dance is art. TV and movies are leisure, I guess. But what about "the cinema," that high-toned and serious activity? Pop has got to be leisure. Recordings can be art in their inception and leisure in their reception. Music is a little bit of both, depending on the music. Antiques can be either art or pop in their creation, but their collection is highly serious leisure. And where does architecture fit in, with its careful collapse of form into function?

In fact, architectural discourse spawned one of the most recently cited categories, that vaporous buzzword, that zany genre with legs: postmodernism. But what does this term, inflated into a ridiculous journalistic convenience, actually mean? To some it's an excuse to pile together oodles of wild and crazy decor, to others it's another example of the weakening of standards and values, to others a transgressive resistance to the sureness of categories, to others a handy way to describe a particular house, dress, car, artist, dessert, or pet, and to others it's simply already *over*. But aside from all these possible meanings, it's the prefix itself which is problematic. All "posts" seem to declare particular genres or periods over and done, and this sure is troubling. If you think in terms of continuums rather than encapsulations, if you note the power of historic processes rather than that of fixed objects or groupings, this declaration of finality is strangely suspect. (The most egregious example of this usage is the journalistically touted "post-feminism" which emerged, not coincidentally, just as the conventional relations between gender and power entered a period of crisis.) So, if the term "post-modernism" *has* to be used, it would be nice if it could question the sanctity of

categories themselves: playing fast and loose with their seriousness, spreading their wealth, welcoming compelling multiplicities and inclusions rather than singular "great" achievements.

But wait a minute! What's the matter with great achievements? And what about values and standards? Is that the muttering I hear in the wings? Isn't it a bit foolhardy to propose an end to the structures that really matter? Matter to whom, I ask. Are these values and standards dollops of divine rule that have wafted down to earth? Or are they simply the pleasures and preferences of those who archivize, hierarchize, and capitalize; who construct cultural history through their admittances and exclusions. And technology, that relentless magic show, has changed our lives while both enlarging and shrinking the cultural field. It is now obvious that segments of society are not discrete categories, but rather simultaneous processes that collide, seep, and withdraw with, into, and from one another. Seeing is no longer believing. The very notion of truth has been put into crisis. In a world bloated with images, we are finally learning that photographs do indeed lie. In a society rife with purported information, we know that words have power, but usually when they don't mean anything. . . . This concerted attempt to erase the responsibilities of thought and volition from our daily lives has produced a nation of couched-out soft touches, easily riled up by the most cynically vacuous sloganeering and handily manipulated by the alibis of "morality" and false patriotism. To put it bluntly, no one's home. We are literally absent from our own present. We are elsewhere, not in the real but in the represented. Our bodies, the flesh and blood of it all, have given way to representations: figures that cavort on TV, movie, and computer screens. Propped up and ultra-relaxed, we teeter on the cusp of narcolepsy and believe everything and nothing.

Now in the short run, none of this might feel too bad. It's groggily comfy and when it hurts, it hurts so good. But to those who work with numbers, we are literally on the money, as polling has become the measure of us; the way we are made to count or not. And to those who understand how pictures and words shape consensus, we are unmoving targets waiting to be turned on and off by the relentless seductions of remote control. We are demi-living proof that the video camera has replaced the mirror as the reflection of choice.

So what does all this mean and what can be done about it? If we experience life *only* through the filters of rigid categorizations, and binary oppositions, things will definitely be business as usual. Good will battle evil. Objectivity will be enthroned and "politics" suspect. Art will be high and popular culture low. But what do these terms mean? How can we begin to question these stereotypes of heroism and villainy? And what is objectivity, that wild and crazy, value-free site located nowhere near opinions and desires? And isn't it time we realized that there's a politic in every conversation we have, every deal we make, every face we kiss? And what about art? It can be defined as the ability, through visual, verbal, gestural, and musical means, to

objectify one's experience of the world: to show and tell, through a kind of eloquent shorthand, how it feels to be alive. And of course a work of art can also be a potential commodity, a vessel of financial speculation and exchange.

But doesn't so-called popular culture have the ability to do some of the same things: to encapsulate in a gesture, a laugh, a terrific melodic hook, a powerful narrative, the same tenuously evocative moments, the same fugitive visions? Does a spot in a museum's chorus line of wall trophies guarantee an experience of art that an urgently pleasurable piece of pop music can't aspire to? What about the witty eloquence of urban Afro-American dance, the brilliant nuances of Tracey Ullman's and Sandra Bernhard's comedic characterizations, and Queen Latifah, Salt-n-Pepa, Yo-Yo, and other much awaited female rappers telling it like it *really* is? Aren't these eloquently drawn pictures of some of our lives? And have there been more incisive refutations of the deluded fantasies that pass for family life than the intensely negative (that's "bad" as in good) depictions of Tim Hunter's film *River's Edge*, Sam Fuller's *Naked Kiss*, Spike Lee's *Jungle Fever*, or Matt Groening's TV *Simpsons*?

Clearly, "art" is still primarily a cottage industry. As opposed to most architectural, film, and TV works, which need constant infusions of client capital to happen, "art" (up until now at least) can remain relatively unmediated by the armies of "collaborators" whose desires must be considered and wallets stroked. But against all odds and in spite of the dumb conventions and convoluted corporate power trips that give "popular" culture its numbing effect, a few works of intensely compelling clarity do manage to emerge.

Times have changed and the world comes to us in different ways. Narrative has leaped from the page to the screen, music demands to be seen as well as heard, computers have jumbled our relationship to information, surveillance, and money, and television has merely changed *everything*. Now things feel like they're moving *really* fast, leaving us with the attention spans of kitties riveted by mouse-like movements. With the blink of a blind eye, we are soaked in sales pitches and infotainments that make history when they do business.

Running in place at the speed of light, we defensively cling to our unexamined notion of categories, our dilapidated signposts in a bleak landscape. They make things simple again. Reflections of control, they reassure us that there's a time and a place for everything. Declaring what's right and wrong, they can strengthen stereotypes and murmur the false humilities of "common sense." Glowing with a veneer of studied connoisseurship, they can grow nostalgic over times that never were. They are easy systems. Use them but doubt them. They are the rules of the game, but perhaps no longer the one being played.

Political Self-Portrait #3, 1980. Photostat, 24 x 36 in. Courtesy John Weber Gallery, New York

ADRIAN PIPER

B. 1948

Since very early in her career, the artist Adrian Margaret Smith Piper has been producing avant-garde works of art whose purpose is to catalyze the viewer's awareness concerning the politics of race relations. As a light-skinned woman of African-American descent, Piper believes that she had neither the white nor the black, but the "gray," experience, and that gave her the "hybrid" point of view on which she bases her work. Although many of her works involve performance, Piper prefers to be considered a conceptual artist (following Sol LeWitt's definition) in that she subordinates medium to idea in order to allow herself flexibility in choosing the most "strategically important" media for each instance. A doctorate-holding philosopher, Piper also has a career in that field; she has published Kantian analyses and is a tenured full professor of philosophy at Wellesley College. The written word is especially important to Piper's artistic endeavors; she has used textual elements in her art in several different ways, and she has also written about her artistic goals, practice, and life experiences.

The daughter of a secretary at City College in New York and a real estate lawyer who allowed his neighborhood clients to pay him with barter, Adrian Piper spent her childhood in Harlem, a member of what she has described as "the genteel poor." From an early age, she felt herself separated from the children in her neighborhood because of her light skin (she was taunted with the

nickname "Paleface," now included in the text of one of her *Political Self-Portraits*) and because of her "educational advantages," particularly her attendance on scholarship at the elite, private New Lincoln School. At the same time she was made acutely and unpleasantly aware of how she differed from the whites with whom she interacted, through a variety of painful racist incidents, chronicled in her art and autobiographical writings. In her teens she began to take classes at the Art Students League and, in 1966, after graduation from New Lincoln, she began to study at the School of Visual Arts in New York, from which she graduated with an associate's degree in fine arts in 1969. By 1970 she had begun to work toward a bachelor's degree in philosophy from City College, and in 1981 she received her doctorate in philosophy from Harvard University where she specialized in the writings of Immanuel Kant. She held several academic positions as a philosopher before arriving at Wellesley, continuing throughout to pursue her artistic career.

Piper has called her "garden of Eden" stage that very short period in the late sixties and 1970 before she began to make art that came from her political consciousness. Although when she first enrolled in the School of Visual Arts she had been working in a figurative style, she soon became involved with a group of conceptual artists, including Sol LeWitt, who had a decisive influence on her work and attitude toward it. Her work at that time, as exemplified by her series *Hypothesis Situation* (1968-69), was based on diagrams, graphs, and her own self-image, and was exhibited in group shows at the Paula Cooper and Dwan Galleries. It is significant that even at that early period, she stressed the conceptual element in her work and aligned herself with other conceptual artists.

Awareness of the social and political situation in the United States, along with her own personal history of being discriminated against, led Piper to abandon a detached point of view very early in her career. Her preface to *Talking to Myself* (1974) chronicles the artistic crisis precipitated by these circumstances, and her solution to it. In 1970 she made her first characteristic major artistic statement with a series of eight performances called *Catalysis*, each of which involved the drastic alteration of her physical appearance to radically depart from the socially acceptable norm of personal comportment. In *Catalysis I*, she "saturated a set of clothing in a mixture of vinegar, eggs, milk, and cod-liver oil for a week, then wore them on the "D" train during evening rush hour, and while browsing in the Marboro bookstore on Saturday night." In *Catalysis V* she "recorded loud belches made at five-minute intervals, then concealed the tape recorder on [her]self and replayed it at full volume while reading, doing research, and taking out some books and records at the Donnell Library." The only work that took place in a museum setting, rather than simply as part of the ongoing street life of New York, was *Catalysis VII*, in which she went to the [Metropolitan Museum's] "Before Cortes" show "while chewing large wads of bubble gum, blowing large bubbles, and allowing the gum to adhere to [her] face." The link of this project to issues of gender and body will be discussed below. Piper has stated that her purpose in these works was to

provoke the viewers and to "catalyze" them into confronting their own xenophobia.

Although her media and strategies have evolved over the years, Piper's fundamental message remains the same, to "induce a reaction or change in the viewer." In subsequent work, however, Piper began to concentrate specifically on forcing the viewer to become aware of the racist aspects of xenophobia. *The Mythic Being* (begun in 1974), an ongoing work that consisted of components conceptualized through several media, was the first work in which Piper dealt with racist assumptions head-on. The core of this work was the persona of a black/Latino street kid, a male alter ego that Piper assumed via dress and a penciled black mustache. As in her earlier performances, Piper took this character out into public situations; for example, in one instance "he" engaged in a (staged) scuffle with a white youth in a park. From still photographs of the Mythic Being's forays, Piper made posters (some of which appeared as advertisements in the *Village Voice*) onto which she inscribed thoughts from her journal, in comic-strip-like balloons. The Mythic Being participated in Piper's first museum performance, *Some Reflective Surfaces* (1975-76), a complex, multimedia, theatrical event in which she used both film and video elements, along with live performance.

Piper expanded upon several aspects of her Mythic Being pieces in her later works. Between 1978 and 1980 she created three *Political Self-Portraits*, posters in which she superimposed a self-image over an autobiographical text chronicling, as in the Mythic Being posters, her personal experience of race, class, and gender. The second, for example, recounts the conflicting aspects of "the gray experience" and the unease she was made to feel with both blacks and whites because of her light skin. In the *Vanilla Nightmares* series (1986-89), she superimposed charcoal drawings of black men over full-page *New York Times* ads, producing dramatically provocative intersections of racism, sexism, and classism. For example, in *Vanilla Nightmares #8*, based on an ad for the perfume "Poison" that remains as a caption at the top of the field, a slender, swooning white model seems to be devoured by black male faces that loom from the background. In *Vanilla Nightmares #18* a horde of black faces appear to push out against the field, over which is superimposed the phrase "Membership Has Its Privileges," a slogan for American Express. Piper has continued to manipulate found photographic elements in several more recent series, such as *Ur-Mutter* in which she juxtaposes "third-world hunger with first-world smugness and success" by pairing an image of a Somalian mother and child with several different photographs borrowed from popular media and advertising sources.

During the same period that she worked with graphic media, Piper also continued to produce several works with performance elements. Her goal in these pieces, as in her works on paper, was to catalyze the audience's confrontation with racism. In *Funk Lessons* (1983-85), performed at various venues, she gave a lecture-discussion on the moves and origins of funk dance with the ultimate goal of enabling "everyone present to get down and party

together." In her video installations, most notably *Cornered* (1988) and its sequel *C of the Corner* (1989), Piper addressed the loaded issue of miscegenation and rac purity in American society. As she says near the opening of the tape, her identifyi herself as black is not only *her* problem, but that of her audience who would like h to "not make a fuss" and accept being white as the norm. She combined performar with graphic media in *My Calling (Card) #1*, a "metaperformance" that she handed immediately upon being confronted with the "embarrassment" of racial hostility, a which, like her video, began with the statement "I'm black."

Although Piper says that her art is not autobiographical, elements of her spec life experiences are integrated into her work and provide the impetus for many piec Her art is, as she says, "personal." Referring to her calling cards, Piper explains t they responded to racist comments she was forced to hear in social situations, ma by speakers who did not realize her ethnic origins, and that "ruined her evenin Likewise, *Funk Lessons* grew from her perception of her dinner guests' discomf with her playing "street music" instead of jazz or European classical music. Piper I always used her self as the subject of her art, a consciousness that provides unity her endeavors in diverse styles and media. Even her earliest pre-political works w focused around her own image and movement through space. In her many perf mance pieces she herself *is* the work of art, a point of view corroborated by the titl her essay *Talking to Myself: The Ongoing Autobiography of an Art Object*. Her politi self-portraits are also based upon narratives of her formative experiences of ra class, and gender. A work commemorating her fortieth birthday (*The Big Four-0*) c sists of a video installation along with jars containing specimens of her bodily fluid

Another strand that connects Piper's various artistic endeavors is their relati ship to the Duchampian, Dadaist enterprise—not surprising, given conceptual a roots in Dada. In Piper's work there is a strong tension between found and manipu ed elements. In performances she is willing to work with chance and with risk. Ot people's photographs form the basis of much of her graphic work. Sometimes she l its her manipulation to juxtaposition or textual additions, as in the *Ur-Mutter* sequer for example, in which she relies on the jarring visual impact of two paired images in *Aspects of the Liberal Dilemma*, her installation emphasizing her audience's ne tive response to (found) photos of black men. On the other hand, although she says t she is more interested in the idea embodied in a work than in the aesthetic exploral of a particular medium, Piper is quite adept at manipulating the media she use achieve maximum visual communication. Her effective blending of photographic ments with her own drawings in the *Vanilla Nightmares* series affords these wo their shocking visual impact. Her video *Cornered* is tightly constructed; the placem of the monitor in the gallery, Piper's centered position on camera, even the alignm of the part in her hair with the room's corner, emphasize not only the artist's predi ment, but also produce an analogous sense of claustrophobia in the viewer, that is, feeling of being "cornered."

An important subtheme of Piper's artistic endeavor throughout the years has b the exploration of issues related to gender. An obvious example of this is *My Cal (Card) #2*, "a reactive guerilla performance for bars and discos," to be handed ou the spot when faced with persistent and unwanted attention in social situations. In

Mythic Being she created a male alter ego, primarily significant as a vehicle for exploring racial stereotypes, the black/Latino youth as marginal "other." However, Piper has described aspects of her experience of being "in" a male body and how it altered her ability to relate to both men and women. Piper's most challenging thematic use of gender issues has been in her references to expectations about women and their bodies. In the *Catalysis* series, for example, she deliberately made her body unacceptable, an especially poignant move for a young woman. In direct opposition to the idea of the female body as the site of pleasure, she allowed herself to appear in public while she was smelly, freakish, sloppy. (Such an appearance creates an interesting intersection with racial stereotypes, particularly the negative ones associated with the supposed "animalistic" and "oversexed" nature of women of color.) In *Cornered* she affects an opposite image of femininity, the "bourgie" nice lady. Her proper blue dress, strand of pearls, neatly pulled-back hair, and polite demeanor present a marked contrast to the potentially threatening aspects of her message. Such works as *What Will Become of Me* (1989) incorporate discarded bodily elements, such as strands of hair and nail clippings.

Piper is an extremely prolific and widely published writer. The written word has played an important role in her artistic endeavor in two ways. From the start, she articulated her aesthetic and artistic concerns through discursive writings, such as *Talking to Myself* (1974) and her "Notes on the Mythic Being." More recently, she has written essays about art and racism; in "Higher Order Discrimination," she examined the basis of her artistic theme of xenophobia from the perspective of a moral philosopher. Piper has also used textual elements in numerous works of art themselves. Her early *Political Self-Portraits* are based on essays detailing her personal experiences with race, sex, and class; the words, tightly clustered and barely legible on the field, literally form a background for the image. While her video works achieve their impact through the manipulation of formal elements, their textual components play a significant role in communicating her message.

In all of her work, Piper explores issues related to interpersonal racial intolerance. As she says, she wants her work "to contribute to the creation of a society in which racism and racial stereotyping no longer exist," a society in which her art is unnecessary because the xenophobic incidents she highlights simply do not occur. Through avant-garde artistic practice Piper effectively challenges her audiences to effect political change.

Sources

Adrian Piper: Reflections 1967-1987. Exhibition catalogue (exhibition curated by Jane Farver). New York: Alternative Museum, 1987.

Berger, Maurice. "Black Skin, White Masks: Adrian Piper and the Politics of Viewing." In *How Art Becomes History: Essays on Art, Society, and Culture in Post-New Deal America*. New York: HarperCollins, 1992.

_____. "The Critique of Pure Racism: An Interview with Adrian Piper." *Afterimage* 18 (October 1990), pp. 5-7.

Johnson, Ken. "Being and Politics: Adrian Piper's Discursive Videos, Graphics and Performances." *Art in America* (September 1990), pp. 153-59.

Lippard, Lucy. "Catalysis: An Interview with Adrian Piper." In *From the Center: Feminist Essays on Women's Art.* New York: E. P. Dutton, 1976.

Piper, Adrian. "Higher Order Discrimination." In *Identity, Character, and Morality: Essays in Moral Psychology,* ed. Owen Flanagan and Amelie Oksenberg Rorty. Cambridge: MIT Press, 1990.

_____."Xenophobia and the Indexical Present." In *Reimaging America: The Arts of Social Change,* ed. Mark O'Brien and Craig Little. Philadelphia: New Society Publishers, 1990.

_____."Notes on the Mythic Being, I, March 1974." In *Individuals: Post-Movement Art in America,* ed. Alan Sondheim. New York: E. P. Dutton, 1977.

_____. *Talking to Myself: The Ongoing Autobiography of an Art Object.* Brussels: Hossmann Hamburg, 1974.

Wilson, Judith. "In Memory of the News and of Our Selves: The Art of Adrian Piper." *Third Text* 16/17 (Autumn/Winter 1991), pp. 39-64.

ADRIAN PIPER—SELECTED WRITINGS

EXCERPTS FROM *TALKING TO MYSELF: THE AUTOBIOGRAPHY OF AN ART OBJECT*

VIII. An Autobiographical Preface January 1973

... When I entered the School of Visual Arts in 1966 I had been committed to art for over ten years. My art activity had consisted in figurative, mildly surrealistic drawing, painting, and sculpture done in grade school, high school, and the Art Students League. My favorite artists were da Vinci, Raphael, Ingres, and Rodin. In my second year at Visual Arts I had a teacher, Joseph Raffaele, who insisted that we go to approximately fifteen galleries every two weeks, and write about what we had seen. In addition, he suggested subscribing to *Artforum* and *Art News* magazines. We also held numerous

class discussions on our own work and work we had seen exhibited. In that year I assimilated more, comprehended more, and produced more work than I had in all the previous years I had been working.

Having this experience solved a problem which had brought me to an impasse in my work. The problem was this: I had been totally committed to figurative art. But at the same time, I found myself interested in problems which had little to do with the content of particular work: problems which I later learned, from reading *Artforum*, to describe, as e.g., illusionistic but non-perspectival space, colors versus form, the displacement of environmental space, etc. These were ideas which could only be confused or lost by trying to deal with them in terms of figurative images. But before this time, I knew no other way of exploring these ideas. Being exposed to contemporary art, e.g., Frank Stella, Carl André, Tony Smith, Don Judd, Kenneth Noland, etc. gave me the formal tools—hard-edge and color-field painting, minimal sculpture—with which to treat these ideas.

In addition, the work I saw demonstrated the possibility of posing entirely new problems as aesthetic concerns. I think the work of Sol LeWitt, especially his "46 Variations on Three Different Kinds of Cube" exhibit, was the single most profound educational experience I had. This, plus reading his "Notes on Conceptual Art" in the October 1967 *Artforum,* did far more for my artistic development than the previous eleven years I had spent drawing nudes. From this point on, I felt freed, not only from the technical and formal constraints of figurative art, but also from my preconceptions about what art had to be. I saw that there were in fact no absolute standards of art which I had to meet, and that whatever standards there were had their source in artists. And that it was therefore up to me to define or develop my own. I did not literally know all this at the time. What I knew was that my work was developing very rapidly; that my aesthetic interests no longer outstripped the tools at my disposal for investigating them; that there were many ideas I did not realize because I saw them satisfactorily realized by other artists before me; that after a time my teachers came to have a critical rather than an educative value for me. . . .

In the spring of 1970 a number of events occurred which changed everything for me: 1. The invasion of Cambodia; 2. The Women's Movement; 3. Kent State and Jackson State; 4. The closing of CCNY, where I was in my first term as a philosophy major, during the student rebellion. . . . all these events affected me more deeply than I realized at the time. A large part of my reaction was due not just to the significance of the political events themselves—I had, after all, managed to insulate myself completely from all previous significant political events—but to the fact that I was in situations which were themselves deeply affected: 1. The art world united in a really remarkable way, the repercussions of which are still being felt. There were meetings about what to do—whether or what to exhibit, what actions to take; gallery owners and museum curators offered the use of space for political purposes, information distribution, protest, announcements, meetings; artists picketed

the major New York museums; . . . 2. I had a lot of contact at CCNY with political rallies, speakers, discussions of what the students ought to do, posters, handouts, etc. . . .

When I finally began to work again, it was in the vein of the works described here—a complete reversal from that which I had done up to that point. This essay grew out of the fact that I could not explain to myself why I had felt compelled to overcome the impasse in the way that I did. I felt, quite helplessly, that this was the only kind of art it was possible or acceptable for me to make, although I knew it probably would not be so to anyone else. I began writing this in order to clarify to myself what I was doing and why; to explain it, analyze it, give it frame of reference by which I could understand it. Although at the time there seemed not the slightest possibility of understanding from anyone else, this seems to be changing now. I felt not only compelled to do what I was doing, but also quite unable to define it in any aesthetic terms I had at my disposal; I was very much at sea.

I see now that the crisis and solution [were] the result of the invasion by the "outside world" of my aesthetic isolation. Although I will never be a really political person, I now feel that in a sense I don't need to worry about that. Those forces have managed to infiltrate my awareness, and thereby determine me and my work in ways which confront me with the politics of my position whether I want to know them or not; I have become self-conscious.

The art world I reacted against continues, although more and more feebly each year. And for me it is already sterile and declining. My work continues, and my basic aesthetic presuppositions have been laid out in the first few entries of this essay. Though the work has changed a great deal since I began it, those presuppositions have essentially remained the same. It remains for me to continually define and articulate my concerns by reflecting on the works I produce (not the other way around). The later entries are continuing attempts to do this: to regard my work critically, to generalize about it when possible, to find out what I'm really up to. Clearly, the ideas expressed are not part of any recognizable aesthetic. But as I said before, I suspected a while back that it was up to artists to decide what art was anyway.

I. Art as Catalysis August 1970

One reason for making and exhibiting a work is to induce a reaction or change in the viewer. The stronger the work, the stronger its impact and the more total (physiological, psychological, intellectual, etc.) the reaction of the viewer. The strength of such a work is a function of the viewer's response to it. The work is a catalytic agent, in that it promotes a change in another entity (the viewer) without undergoing any permanent change itself. The value of the work may then be measured in terms of the strength of the change, rather than whether the change accords positively or negatively with some

aesthetic standard. In this sense, the work as such is non-existent except when it functions as a medium of change between the artist and the viewer. . . .

<p style="text-align:center">❦</p>

III. Note on "Notes and Qualifications" (Further Qualifications)
October 1970

Problems with process:

The main point of all this is that while I still feel compelled to make art, I also feel compelled to reject discrete forms as being insufficient vehicles for the ideas, and ideas alone as being insufficient for art. It seems that abandoning the use of discrete forms is, for me, the only way of preserving the idea within the reality of the art-making activity. . . .

Problems with context:

. . . The more non-art world contacts I have, the more I become painfully aware of my cultural alienation from the rest of society. I discover, through interminable arguments, hostility, derision, and lack of comprehension from non-art-oriented friends that in fact the art world is not coextensive with the world at large; and the unspoken presuppositions which allow me to exhibit and discuss my work within the art community are practically unacceptable to anyone outside it. This makes me think that there must be something wrong with a system of aesthetic values which can be preserved only in isolation from the rest of society, and only by severely limiting the audience to a highly educated minority. That there must be some way of making high quality, exciting art that doesn't presuppose an intensive education in Art Since 1917 in order to appreciate it.

Although I can see a conceptual continuity between present and past work, I find that in fact knowing all about Art Since 1917 no longer suffices to define my aesthetic concerns even to myself. The language of Formalist/Minimal painting and sculpture is no longer adequate to describe or discuss my work. Increasingly, I turn to philosophy in search of the concepts I need to articulate to myself what my aesthetic concerns are, and it seems that many of my artist colleagues are feeling the same kind of dissatisfaction and looking to other fields. I think we need to assimilate new information from the outside world; we need to breathe fresh air. The well-sealed self-enclosed closet of Formalist aesthetics is stifling us all. Although these new sources don't succeed in bridging the gap between contemporary art and everyone else (the uninitiated still question my right to call it art), this tendency has the effect of infiltrating the preciousness of the contemporary art context with ideas which at least do not refer to previous art history.

Finally, I feel that the aesthetic possibilities of discrete objects have somehow been exhausted by my aesthetic vision of the innumerable non-art objects in the world. I seem to instinctively view all discrete art objects as not

essentially different from interesting non-art objects. Art objects are still a source of aesthetic enjoyment to me, but I don't believe they can any longer be a source of aesthetic education or excitement. They cannot add to or expand my perception of the world in an aesthetically significant way (the way they did when I first found out about minimal sculpture, color-field painting, the symbolic potential of maps and photographs).

For me, no art object, however well enclosed in an art context it is, can be only what it purports to be. It can no longer be self-referential in the way the minimal aesthetic demands, nor successfully denotative as the conceptual aesthetic demands. Everything seems to suggest a possible non-art counter-part—or vice versa. I don't think this means that I can't look at art anymore; just that I can no longer see art as separate from everything else. I don't entirely reject events or happening-type performance situations; only the ones which are self-referential or denotative in the way I've tried to indicate this by using the term "discrete form" to define that quality of separateness, isolation, that art objects have, and that any art work which occupies its own time and space also has; that makes it possible for the work to exist within an art context independently of the interaction of the artist and the viewer.

IV. Concretized Ideas I've Been Working Around January 1971

I can no longer see discrete forms or objects in art as viable reflections or expressions of what seems to me to be going on in this society: they refer back to conditions of separateness, order, exclusivity, and the stability of easi-ly accepted functional identities which no longer exist. For what *a posteriori* seems to be this reason, the elimination of the discrete form as art object (including communications media objects), as a thing in itself with its isolat-ed internal relationships and self-determining aesthetic standards, really interests me. I've been doing pieces the significance and experience of which [are] defined as completely as possible by the viewer's reaction and interpre-tation. Ideally the work has no meaning or independent existence outside of its function as a medium of change. It exists only as a catalytic agent between myself and the viewer. E.g., *Catalysis I*, in which I saturated a set of clothing in a mixture of vinegar, eggs, milk, and cod-liver oil for a week, then wore them on the "D" train during evening rush hour, and while browsing in the Marboro bookstore on Saturday night.

Making artificial and nonfunctional plastic alterations in my own bodily presence of the same kind as those I formerly made on inanimate or non-art materials. Here the art-making process and end product [have] the immedia-cy of being in the same time and space continuum as the viewer. This process/product is in a sense internalized in me, since I exist simultaneously as the artist and the work. I define the work as the viewer's reaction to it: the strongest, most complex, and most aesthetically interesting catalysis is the

one that occurs in uncategorized, undefined, non-programmatic human confrontation. The immediacy of the artist's presence as artwork/catalysis confronts the viewer with a broader, more powerful, and more ambiguous situation than discrete forms or objects. E.g., *Catalysis IV*, in which I dressed very conservatively, but stuffed a large red bath towel into the sides of my mouth until my cheeks bulged to about twice their normal size, letting the rest of it hang down my front, and riding the bus, subway, and Empire State Building elevator; *Catalysis VI*, in which I attached helium-filled Mickey Mouse balloons from each of my ears, under my nose, to my two front teeth, and from thin strands of my hair, then walked through Central Park, the lobby of the Plaza Hotel, and rode the subway during morning rush hour.

Preserving the impact and uncategorized nature of the confrontation. Not overtly defining myself to viewers as artwork by performing any unusual or theatrical actions of any kind. These actions tend to define the situation in terms of the pre-established categories of "guerrilla theatre," "event," "happening," "streetwork," etc., making disorientation and catalysis more difficult. E.g., *Catalysis III*, in which I painted a set of clothing with sticky white paint with a sign attached saying "WET PAINT," then went shopping at Macy's for some gloves and sunglasses; *Catalysis V*, in which I recorded loud belches made at five-minute intervals, then concealed the tape recorder on myself and replayed it at full volume while reading, doing research, and taking out some books and records at Donnell Library. For the same reason I don't announce most of these works, since this immediately produces an audience vs. performer separation, and has the same effect psychologically as a stage surrounded by rows of chairs has physically.

Art contexts per se (galleries, museums, performances, situations) are becoming increasingly unworkable for me; they are being overwhelmed and infiltrated by bits and pieces of other disintegrating structures: political, social, psychological, economic. They preserve the illusion of an identifiable, isolatable situation, much as discrete forms do, and thus a prestandardized set of responses. Because of their established functional identities, they prepare the viewer to be catalyzed, thus making actual catalysis impossible (rather than its more comfortable illusion, which consists of filling in the particulars of an aesthetic experience, the general outlines of which are predetermined). Alternate contexts I've been using include subways, buses, Macy's, Union Square, the Metropolitan Museum of Art (as a spectator in *Catalysis VII*, in which I went to the "Before Cortes" show while chewing large wads of bubble gum, blowing large bubbles, and allowing the gum to adhere to my face), etc.

Eliminating as many decision-making steps, procedures, and controls as possible. This has a necessary psychological function for me in that it decreases or eliminates the separation between original conception and the final form of an idea; the immediacy of conception is retained in the process/product as much as possible. For this reason I have no way of accounting for the final form which an idea takes. It may be objected that all

the ideas described above constitute decision-making criteria, but in fact just about everything I've written occurred to me *a posteriori,* including the idea expressed in this paragraph. Which may mean it's time to start doing something else.

EXCERPTS FROM "NOTES ON THE MYTHIC BEING" MARCH 1974

. . . 2. I began by dressing in the guise of the Mythic Being and appearing publicly several times during the month (reascription of my thoughts and history, sentence by sentence, to a masculine version of myself; myself in drag). I now consider shelving this aspect of the piece for fear that the Mythic Being will gradually acquire a personal autobiography of experiences and feelings as particular and localized—and limited—as my own. This was the misfortune of Rrose Sélavy.

My behavior changes. I swagger, stride, lope, lower my eyebrows, raise my shoulders, sit with my legs wide apart on the subway, so as to accommodate my protruding genitalia.

My sexual attraction to women flows more freely, uninhibited by my fear of their rejection in case my feelings should show in my face; unencumbered by my usual feminine suspicions of them as ultimately hostile competitors for men. I follow them with my eyes on the street, fantasizing vivid scenes of lovemaking and intimacy.

My sexual attraction to men is complicated and altered by my masculine appearance. I envision the possibility of deep love relationships based on friendship, trust, camaraderie, masculine empathy; but I instinctively suppress expression of my sexual feelings for fear of alienating the comparatively tenuous feelings of kinship with men I now have.

How might I be different if the history I chronicled in my journal had happened to a man? My adolescent preoccupations with men would have been infused with guilt; my conflicting feelings and behavior towards my girl friends would have been viewed with alarm by my parents; my stints as model and discotheque dancer would have schooled me in the subtle arts of transvestism; my period in a mental hospital would have included attempted reorientation of my adolescent homosexuality; my drug experiences might have been more traumatic and conflict-ridden, perhaps more sexually than mystically oriented.

Has this part of the piece taught me about myself, or about the Mythic Being?

3. The Mythic Being is, or may be:

An unrealized but possible product of the particular history of events I in fact underwent, a necessary alternative to the limits of my sense of self;

An abstract entity of mythic proportions, whose history is a matter of public knowledge, and whose presence and thoughts are dispersed over the

totality of individuals who apprehend him in the *Voice*;

A nonmaterial art object, unspecified with regard to time or place, the bearer of a finite number of properties, the number and quality of which are circumscribed by my own life, and acquired coextensively with my growth into a *different* person;

A product of my own self-consciousness, and unlike other pieces I have done in not being the generator of my self-consciousness;

A therapeutic device for freeing me of the burden of my past, which haunts me, determines all my actions, increasingly habituates me to the limitations of my personality and physical appearance.

4. A conceptual problem: I find it difficult to figure out what this piece is really about, if it is really about anything, because it is not one in a series of similar pieces over which I can generalize. Because this is the only one of its kind that I have worked on since last September, I have no way of finding out what it has in common with other such pieces (although I can say things about its relationship to everything I've done in the last few years), thus no way of knowing what direction it represents to me, nor what I intend by doing it. All my speculations about it thus seem inconclusive to me, I have the feeling that I will never be sure of what it is I'm really up to.

〰️

EXCERPTS FROM *POLITICAL SELF-PORTRAITS*

FROM *POLITICAL SELF-PORTRAIT #1* (1979)

. . . There are at least four more recent cases [of women friends turning on her because they perceive she is interested in their men] . . . all following the same pattern: I am rejected, ostracized, or double-crossed by a woman whom I thought was a close friend because of her interest in a man or men. In many of these cases I have felt doubly betrayed by my own prior willingness to forgo my interest in the man for the sake of my friendship with the woman. The only women friends I have with whom this has not happened are either lesbians, or straight women who have had a stable relationship wth the same man for at least three years. When I am around these couples I cannot relax. I have to be very careful about how I look and act. I am impersonal, assertive, almost butch with the man. I try to be polite and genial, but also to exhibit a special lack of interest in him. I barely look at him, and make sure I do not appear to be listening too intently to whatever he has to say. I never address my remarks to him alone. I feel uncomfortable and resentful at having to go through these contortions. But it seems to be necessary in order to get the woman to trust me. For I see now that most of my women friends will probably always subordinate our friendship to their relationships with men in various ways, and this forces me to do the same. I see why it is that friendship with another woman is so important to me, yet so

fragile. It is because we have not yet learned genuinely to trust one another, in spite of all that the women's movement has achieved.

From *Political Self-Portrait #2* (1978)

. . . I started going to school by myself and the neighborhood kids would waylay me as I was walking the two blocks from the bus stop to my house and would pull my braids and tease me and call me Paleface. By then I knew what they meant. . . . Later when I was in fifth grade and getting sick a lot and hating school I had a teacher named Nancy Modiano who really bullied me. Once we all went on a hike and I became very thirsty and she wouldn't let me get any water. Then we went back to school and she forced me to follow her around school while she did her errands but she wouldn't let me stop at the water fountain for some water. When my mom came to pick me up I was almost fainting. In conference with my parents she once asked them, does Adrian know she's colored? I guess she must have thought I was too fresh and uppity for a little colored girl. . . . [Later] I noticed that all my friends were white and that I didn't have much in common with the children of my parents' very light-skinned, middle-class, well-to-do black friends. They seemed to have a very determined self-consciousness about being colored (they said Colored) that I didn't share. They and many of my relatives thought it a scandal that I went out with white men. I felt just as alienated from whites as blacks, but whites made me feel good about my looks rather than apologetic. When someone asked me why I looked so exotic I would either say I'm West Indian (my mother's Jamaican) or if they looked really interested I would go on at length about my family tree. . . . But I would never simply say black because I felt silly and as though I was coopting something, i.e., the Black Experience, which I haven't had. I've had the Gray Experience. Also I felt guilty about unjustifiedly taking advantage of justified white liberal guilt. But I would never deny that I am black because I understand how it can be a matter of pride and honor for my folks to positively affirm their heritage and I don't want to deny a part of myself that I'm proud of. But sometimes I wonder why I should be caught in this bind in the first place; why I should have to feel dishonest regardless of whether I affirm or deny that I'm black, and whether I, my family and all such hybrids aren't being victimized by a white racist ideology that forces us to accept an essentially alien and alienated identity that arbitrarily groups us with the most oppressed and powerless segment of the society (black blacks) in order to avoid having that segment gradually infiltrate and take over the sources of political and economic power from whites through the de facto successful integration of which we hybrids are the products and the victims. When I think about that I realize that in reality I've been bullied by whites as well as by blacks for the last three hundred years and there is no end in sight.

From *Political Self-Portrait #3* (1980)

For a long time I didn't realize we were poor at all. We lived in that part of
Harlem called Sugar Hill, where there were lots of parks and big houses that
had once been mansions but had been converted into hotels or funeral par-
lors. When I was little it was nice. . . . My parents spent all their money on
me. . . . Once I even got a coat from Bonwit Teller's. . . . But I became
ashamed to invite anyone over or have my boyfriends pick me up because I
lived so far away and my neighborhood and everyone in it seemed so sinister
next to my rich, white New Lincoln friends. . . . The final blow came when I
was eleven. . . . I had started noticing all the advertised vacant apartments on
Fifth Avenue, Park Avenue, and Central Park West as I came home from visit-
ing my friends who lived there. And one day I said to my mother, Why don't
we move? I just saw a sign for a lovely twelve-room apartment at Fifth
Avenue and Eighty-Sixth Street, and it's so small and dark and crowded here.
My mother laughed a very angry and bitter laugh and said, get that idea out
of your head right now. We don't move to Fifth Avenue because we don't and
never will have that kind of money. I was shocked and didn't believe her at
first. I thought she was just in a bad mood the way she always was when I
asked her for new clothes, and that she was that way because she just didn't
want me to have them. But when I brought it up again, carefully, a few days
later, she saw that I really didn't understand. So she explained very patiently
and carefully that we lived where we did because we had to, not because we
wanted to. She explained about Daddy's deciding to serve his community and
getting paid in apple pies and embroidered shirts when he got paid at all, and
about how many weeks of a secretary's salary a coat from Bonwit Teller's
cost. I was stunned. I became very depressed. Reality began to look very dif-
ferent after that. I started becoming more and more estranged from my
school friends. I saw that I would never be able to keep up with them eco-
nomically and was almost relieved to drop out of the race. . . .

My Calling (Card) #1 (1986; REACTIVE GUERRILLA PERFORMANCE
FOR DINNERS AND COCKTAIL PARTIES)

Dear Friend,
 I am black.
 I am sure you did not realize this when you made/laughed at/agreed
with that racist remark. In the past, I have attempted to alert white people to
my racial identity in advance. Unfortunately, this invariably causes them to
react to me as pushy, manipulative, or socially inappropriate. Therefore, my
policy is to assume that white people do not make these remarks, even when
they believe there are no black people present, and to distribute this card

when they do.

I regret any discomfort my presence is causing you, just as I am sure you regret the discomfort your racism is causing me.

<div style="text-align:right">
Sincerely yours,

Adrian Margaret Smith Piper
</div>

CORNERED (1988; TEXT OF A VIDEO INSTALLATION)

I'm black.

Now, let's deal with this social fact, and the fact of my stating it, together.

Maybe you don't see why we have to deal with it together. Maybe you think it's just my problem, and that I should deal with it by myself.

But it's not just my problem. It's our problem.

For example, it's our problem if you feel that I'm making an unnecessary fuss about my racial identity, if you don't see why I have to announce it like this.

Well, if you feel that my letting people know I'm not white is making an unnecessary fuss, you must feel that the right and proper course of action for me to take is to pass for white.

Now this kind of thinking presupposes the belief that it's inherently better to be identified as white. It bespeaks an inability to imagine or recognize the intrinsic value of being black. Perhaps you even take my rejection of a white identity as a sign that I'm hostile to whites. If you think any of these things, then, I would say, you have a problem.

But if you then respond to me accordingly, as though I had somehow insulted you by refusing to join your racial club, then you make it our problem. It's our problem because your hostile reaction to my identifying myself as black virtually destroys our chances for a relationship of mutual trust and good will.

It's also our problem if you think I'm telling you I'm black in order to exploit an advantage, get publicity, or make it big as an artist.

If you think this, obviously you must be feeling pretty antagonized and turned off by what I'm saying. So I'd be interested in hearing more about exactly how you think antagonizing and turning off my audience is going to help me make it big as an artist.

But the larger problem would be your feeling antagonized and turned off at all. Why does my telling you who I am have that effect? Do you feel affronted? Or embarrassed? Or accused?

I think we need to look more closely at why my identifying myself as black seems to you to be making a fuss. I think we need to keep in mind that it's a fuss only if it disturbs your presumption that I'm white. So perhaps the solution is for you not to make that presumption. About anyone.

That certainly would be better for me, because I don't look forward to

your confusion and hostility at all. I'd really prefer not to disturb you.

But you see, I have no choice. I'm cornered. If I tell you who I am, you become nervous and uncomfortable, or antagonized. But if I don't tell you who I am, I have to pass for white. And why should I have to do that?

The problem with passing for white is not just that it's based on sick values, which it is. It also creates a degrading situation in which I may have to listen to insulting remarks about blacks, made by whites who mistakenly believe there are no blacks present. That's asking a bit much. I'm sure you agree.

So you see, the problem is not simply my personal one, about my racial identity. It's also your problem, *if* you have a tendency to behave in a derogatory or insensitive manner toward blacks when you see none present.

Now if you have no such tendency, then you won't regard my letting you know I'm black as a problem at all. Because you won't have to worry about being embarrassed or shamed by your own behavior.

In that case I'm simply telling you something about who I am, on par with where I was born or how old I am, which you may or may not find of interest.

Furthermore, it's our problem if you think that the social fact of my racial identity is in any event just a personal, special fact about me. It's not. It's a fact about us.

Because if someone can look and sound like me and still be black, then no one is safely, unquestionably white. No one.

In fact, some researchers estimate that almost all purportedly white Americans have between 5% and 20% black ancestry.

Now, this country's entrenched conventions classify a person as black if they have any black ancestry. So, most purportedly white Americans are, in fact, black.

Think what this means for your own racial classification. If you've been identifying yourself as white, then the chances are really quite good that you're in fact black.

What are you going to do about it?

Are you going to research your family ancestry, to find out whether you're among the white "elite"? Or whether perhaps a mistake has been made, and you and your family are, after all, among the black majority?

And what are you going to do if a mistake has been made? Are you going to tell your friends, your colleagues, your employer that you are in fact black, not white, as everyone had supposed?

Or perhaps you're going to keep quiet about it, and continue enjoying the privileges of white society, while inwardly depicting yourself as a "quiet revolutionary" who rejects this country's entrenched conventions anyway?

Or maybe combine your silence and continued enjoyment of these privileges with compensatory social activism on behalf of the disadvantaged?

Or will you try to discredit the researchers who made this estimate in the first place?

On the other hand, what if your research into your family tree reveals that you are, after all, among the white minority, who really do have no black ancestry? Then what?

Will you find a way to mention this fact, casually, in the course of most conversations? Perhaps you'll narrate your European family history with great enthusiasm and detail at parties?

How will you feel about being certifiably white? Relieved? Proud? Will you get annoyed or irritated when someone mentions the proximity to Africa of Spain, France, Italy, Greece, and Israel?

Or will you feel disappointed, deprived of something special? Perhaps you'll even lie, and tell people you're black, even if you're not? There's a nice, subversive strategy for you! As long as you don't blow your cover when things get hot, which they inevitably will.

Or are you going to do no research, indeed nothing at all about your black ancestry? Are you going to just pass out of this room, after this video-tape is over—or perhaps even before—and into your socially preordained future?

Are you going to simply put this information about your black identity out of your mind? Or perhaps relegate it to that corner of your mind you reserve for interesting art experiences that bear no relation to your personal life?

Or maybe dismiss the whole business as just another hoax an artist is trying to put over on a gullible public?

Obviously, the choices that now confront you are not easy ones. They're so problematic that you may be finding it difficult to think seriously about them at all right now. It may not be penetrating, as you're listening to this, that you really do have some serious, hard decisions to make.

But remember: Now that you have this information about your black ancestry, *whatever* you do counts as a choice.

So. Which choice will you make?

You may feel that no choice is required. You may believe that anyone who can pass for white has no moral right to call themselves black, because they haven't suffered the way visibly black Americans have.

Of course if we're going to distribute justice and moral rectitude on the basis of suffering, then happy idiots and successful Uncle Toms don't get any anyway, no matter how visibly black they are, right?

Besides, if you've been identifying yourself as white, and you think light-skinned blacks don't suffer enough, then you have nothing to lose by publicly affirming your own black identity. So why not try it? Just to test out your hypothesis that light-skinned blacks don't suffer enough?

Or you may think people like me identify ourselves as black in order get the institutionalized rewards of being black—like affirmative action pro-grams, while avoiding the daily experience of racism that visibly black Americans have to cope with all the time.

Well, let's see what we can do about that. Now that you know you're

probably black, you, too, have the option of publicly proclaiming your black identity in order to get into affirmative action programs.

Lucky you. Are you going to do it? No? Why not? Think about all the "institutionalized rewards of being black" you're passing up!

Obviously, there are much better reasons than that to affirm your black identity.

Of course you may disagree. You may have different values, different priorities. If you don't recognize the importance of Black American culture, you may find it easy to reject.

And, if you're very attached to the rewards and privileges of identifying yourself as white, you may find it virtually impossible to reject those rewards and privileges.

If you feel this way, you may be reacting to what I'm saying here as nothing but an empty academic exercise that has nothing to do with YOU.

But let's at least be clear about one thing: This is not an empty academic exercise. This is real. And it has everything to do with you.

It is a genetic and social fact that, according to the entrenched conventions of racial classification in this country, you are probably black.

So if I choose to identify myself as black whereas you do not, that's not just a special, personal fact about me. It's a fact about us. It's our problem to solve.

Now, how do you propose we solve it? What are you going to do?

[Fifteen-second pause. Slow fade-out to black. White letters appear on a black background, saying WELCOME TO THE STRUGGLE]

FROM "HIGHER ORDER DISCRIMINATION" (1990)

6. Some Familiar Examples of Higher-Order Discrimination

These attitudes may find expression in an expectation of greater deference or genuflection from a member of the disvalued group. The simple first-order discriminator expresses his anger at the violation of this expectation in certain familiar stereotypes: the "uppity nigger" whose refusal to behave subserviently is seen as impudence or disrespect, or the "Jewish American Princess," whose assertiveness, presumption of self-worth, and expectation of attention and respect is seen as a sign of being spoiled, selfish, or imperious. But for the higher-order discriminator, such anger is displaced into more subtle but similar reactions. Such an individual may just feel angered or personally affronted by a woman's presumption of equality in personal, social, or intellectual status or in professional worth or as a competitor for social or professional rewards, or he may feel unduly irritated by her failure to defer or back down in argument. She may be viewed as forward in conversation, when in fact she contributes no more and no less than anyone else, or stubborn, unresponsive, or impervious to well-intentioned criticisms, when in

fact the only acceptable response to those criticisms, in the eyes of the high-er-order discriminator, would be for her to concur with them wholeheartedly and apologize for her dereliction. Or, to take another example, the higher-order discriminator may feel invaded or compromised by a black person's jocularity or willingness to trade friendly insults that one accepts as a matter of course from those considered to be one's peers. The black person may be viewed as overly familiar, insolent, or presumptuous. In all such cases the disvaluee's behavior is seen as a *presumption*, not a right or an accepted practice. . . . The higher-order discriminator is tortured by the suspicion that he is somehow being ridiculed or shown insufficient respect or that the dis-valuee's conduct bespeaks contempt.

In a recent compelling analysis of anger (1984), N. J. H. Dent suggests that anger is based ultimately on feelings of personal inferiority. These lead one to overestimate the importance of others' expressions of regard and esteem for one, which in turn multiplies the number of occasions in which one feels slighted when such expressions are not forthcoming or are of insuf-ficient magnitude relative to one's importunate requirements. This oversensi-tivity to being slighted in turn provokes in one the desire to rectify one's situ-ation through retaliation by lashing out at the offender. This analysis by itself does not, I think, cover all cases of anger, nor does it explain the origins of simple first-order discrimination. But it does provide insight into why higher-order discriminators, like simple first-order discriminators, are apt to become so angry so often at imagined slights from seemingly arrogant disvaluees. The more inferior one feels, the more expressions of esteem one requires. And the more inferior one perceives a disvaluee to be, the more elaborate the disvaluee's expression of esteem of one is required to be. Whereas a friendly nod from a perceived superior is sufficient to transport one to a state of bliss, anything less than a full-length obeisance from a perceived inferior appears to be an insult. . . . In all such cases, irascibility regularly directed at particu-lar members of disvalued groups should not be dismissed as simply an idio-syncrasy of character, even if it is not intentionally directed at members of disvalued groups *as such*. It is nevertheless an overt expression of higher-order discrimination.

A second, related example of behavior and judgments distorted by high-er-order discrimination is the treatment of disvaluees in a way that would constitute a clear insult or *faux pas* if the person so treated were one of one's recognized peers. For example, a white Gentile may privately make an anti-Semitic remark to a black colleague in a misguided effort to establish rap-port, whereas such a remark would be seen as a serious social lapse even among other white Gentiles. Or a heterosexual may make gratuitous dis-paraging remarks to a gay colleague about her work or job performance of a sort designed to "cut her down to size" rather than to provide constructive criticism. Or a man may make offensively personal remarks to a woman col-league about her physical appearance, personal life, or manner of dress, of a sort that would be highly inappropriate if they were made to another man. Or

he might expect from a woman colleague extra forbearance for fits of temper or irresponsible conduct, or he might expect extraordinary professional demands that he would not from a man. The higher-order discriminator, in other social contexts, may be acclaimed quite rightly as a "prince among men." To disvaluees, however, he reveals himself as Mr. Hyde. . . .Yet unlike President Lyndon Johnson, who conferred with his cabinet through an open bathroom door while uninhibitedly and indiscreetly performing his morning ablutions, the higher-order discriminator cannot be supposed to commit these boorish excesses with any offensive intent. Rather, he regards his response to a person's disvalued attributes as socially innocuous, as an acceptable variation in social etiquette keyed to the variations among the personality traits of different individuals.

A third example of judgments and behavior poisoned by higher order discrimination is the kind of arbitrariness in evaluating a person's assets and liabilities as a member of one's group or community mentioned earlier: attributes that would qualify as assets in a valuee or impartially considered individual are liabilities in a disvaluee, and attributes that would qualify as liabilities in a disvaluee or impartially considered individual are assets in a valuee. For instance, a disvaluee being considered for a creative writing instructorship may be belittled on grounds that she is merely "clever," "bright," or a "hard worker," whereas a valuee showing the same traits may be congratulated on his resourcefulness, intelligence, and drive. Or a potential law partner who is a valuee and is "long on ideas but short on argument" may be praised for her creativity, while a similarly situated disvaluee may be suspected of underlying incompetence.

A fourth example of such distorted behavior is the implicit treatment of disvaluees as being obligated by different rules of conduct than those that govern oneself and those considered to be one's peers. Among one's peers, humor or irreverence at the expense of some sacred relic—a work, personage, or achievement in one's field—may be an acceptable source of entertainment, while such humor on the part of a disvaluee is a sacrilege, personal affront, or iconoclasm that expresses the same lack of respect as that manifested in the "presumption" of equality. Or one may apply different criteria of interpretation of the behavior of disvaluees. Whereas enigmatic behavior by valuees is excused, overlooked, or given the benefit of the doubt, similar behavior on the part of disvaluees is interpreted as proof of vice or malevolence. This interpretation motivates the higher-order discriminator not only to avoid but also to justify the avoidance of direct interaction with the disvaluee and thus to avoid the conflict of conscience described earlier. Or one may apply rules of honor, loyalty, and responsibility only to those considered to be one's peers but may have no scruples about betraying the trust or confidentiality of a disvaluee, who is implicitly viewed as unentitled to such consideration. Alternatively, one may hold disvaluees to far more stringent moral standards than the members of one's own community in fact practice among themselves. Any violation of these standards by the disvaluee then creates an

irradicable moral blemish to which the valuees are not vulnerable by reason of their status as valuees. These cases express quite clearly the conviction that disvaluees just do not have quite that same status, and hence are not to be subject to the same standards of treatment, as members of one's recognized community. And at the same time the higher-order discriminator vehemently and in all honesty denies that any such discrimination is taking place. Indeed, in all of these examples the higher-order discriminator may sincerely deny that the person's race, gender, sexual orientation, class background, ethnic or religious affiliation, etc., arbitrarily influences his evaluations when his behavior shows patently that they do.

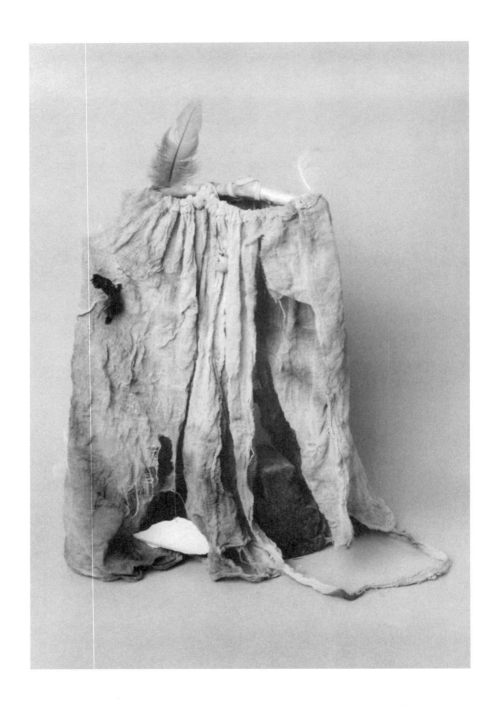

la falda de la momia (the mummy's skirt), 1989. Mixed media, 18 x 9 x 5 in.
Photo: John Paniker

Cecilia Vicuña

B. 1948

IN BOTH HER VISUAL and liter-
ary works, the Chilean poet and artist Cecilia Vicuña embodies her definition
of the *machi*, the woman-shaman who "cures with her chant." Dedicated to
retrieving that which is "precarious," Vicuña encourages both words and
objects to "open up" and reveal their true meaning. Her art consists of site-spe-
cific installations built of ephemeral materials, sometimes documented photo-
graphically, but at other times left to return unmarked to their natural states.
She is an accomplished and prolific poet, having published eight volumes of
poetry. Although born and raised in Chile, Vicuña has been living in New York
since 1980, exiled by Pinochet's military coup. Her artistic and poetical pro-
jects, which often play on the same themes, are inextricably entwined; both
involve the "contemporary recreation of [the] ancient vocabulary" of the
indigenous, Andean cultures. Vicuña has said of their interconnectedness, that
"the silence in poetry, that which could not be expressed in words, drew me to
art."

Born in La Florida, Chile, to a family of artists and intellectuals, Vicuña
began her literary education at an early age, exposed to such classics as *The
Iliad* and *The Odyssey* in the library of her father, a lawyer. Her mother (who
encouraged her never to get married) taught her to be independent and to trust
in her own abilities. When she was seven, the family moved to a prosperous

neighborhood in Santiago and Vicuña was sent to an English school. At fourteen she encountered the work of Surrealist poets Joyce Mansour and Gisèle Prassinos who, as women, showed her that it was possible for her to write. Through her aunt Rosa Vicuña, a sculptor who "lived to create," Vicuña discovered pre-Columbian ceramic sculpture, books about art history, and, most important, veneration for the artistic way of life. She began her formal education at the University of Chile's School of Architecture, but eventually changed to the Escuela Nacional de Bellas Artes, from which she received her Master of Fine Arts in 1971. During the late sixties and early seventies, Vicuña was involved with Chilean politics, particularly as an organizer for Tribu No (The No Tribe), a revolutionary group of artists and writers who wrote manifestos and staged public actions, consistent with the optimistic enthusiasm of the Allende years. The relationship between artistic practice and political protest has remained of paramount importance throughout Vicuña's career.

Even before completing her formal studies, Vicuña began working on the artistic project to which she has dedicated her life. As a teenager, in 1963, she began to paint, a medium in which she worked on and off for the next fifteen years. In the mid-1960s she made her first constructions from feathers, sticks, shells, and other flotsam that she found on the beach. She called these works *"basuritas"* (little bits of garbage) or *"precarios,"* because of their precarious status, as they were often left to be washed away by the tide. She later was pleased to learn that the words "precarious" and "prayer" shared the same Latin root, which she saw as appropriate to these works that were created as prayerful offerings. Her ritual performance *Con-Cón* (1966), on the beach near Santiago at the junction of the Pacific Ocean and the Aconcagua River, was her earliest documented work. In this piece, built on a spiral motif with stones, sticks, and feathers, she drew lines in the sand (in reference to pre-Columbian divination rituals), interacting visually with the patterns left by the tide and by which it was ultimately erased. Significantly, in that same year, about a hundred words, which she called "divinations," "opened to reveal their inner associations, allowing ancient and newborn metaphors to come to light." These formed the basis for her subsequent book, *Palabrarmas* ("wordweapons"), published in 1984. The word *solidaridad*, for example, reveals "Give and give sun, which gives strength, solidity, in people coming together."

Another important early work was her installation *Autumn* (*Otoño*, June 1971). In this, based on a 1969 piece in which she stuffed leaves into plastic bags, she filled a room at the National Museum of Fine Arts in Santiago with leaves three feet deep, with the text of her "Autumn Journal" placed on the wall. She conceived the exhibition "as a contribution to socialism in Chile" and later explained that "at first I tried to catch Spring, but the petals rotted away. The leaves lasted longer." That same year she exhibited her autobiographical oil paintings and images of popular saints at the National Museum of Fine Arts. Vicuña's paintings were rendered in a "naive and visionary" style, which she

has described as a "continuation of colonial images of saints . . . a Spanish tradition with an American touch." She painted such "heroes of the revolution" as Lenin and Karl Marx—and Salvador Allende shown in the act of welcoming Fidel Castro to Cuba—as well as the popular singer and poet Violeta Parra, one of the major influences on Vicuña's life, broken into three parts, representing the violence done to her by the world. A particularly controversial painting was *The Angel of Menstruation*, a nude female figure with a red flow emerging from her exposed genitals, painted "because [she] thought women needed an angel to bring menstruation each month."

In 1972 Vicuña left Chile with a fellowship for post-graduate study at the Slade School of Fine Arts in London. Her life underwent a radical change at that time when, as a result of the overthrow of Salvador Allende's government, she became exiled from her homeland. (Although she has returned to visit several times, she has never lived in Chile again.) Vicuña remained in London until 1975, participating in resistance activities, including an Arts Festival for Democracy in Chile in October 1974. During her residency in London, her bilingual artist's book *Sabor a Mí* (1973) was published. The book, actually, was the second version with that title; the first, a compilation of her autobiographical, lushly erotic poems—for which she had been under contract with the University of Valparaíso Press—was censored in Chile, Colombia, and Ecuador. (It now seems likely that these earlier writings will soon be published.) The revised book, published in England, contained eighteen poems (ten of which were translated), descriptions and reproductions of a selection of earlier paintings (referred to in characteristic wordplay as "Pain things") "lost in Santiago," and a transcription of her "Autumn Journal." *Sabor a Mí's* primary purpose, however, was the documentation of objects "made every day [for a year, beginning in June 1973] in support of the Chilean revolutionary process." After Allende's assassination the objects changed. "In the beginning," she wrote, "I wanted to prevent the coup. Now the objects intend to support armed struggle against the reactionary government." She continued: "The objects try to kill three birds with one stone: politically, magically and aesthetically. I conceived them as a journal. Each day is an object (a chapter), all days make a novel. I didn't want to make it with many words since there is hardly any time left to live."

Feeling isolated and cut off from her roots, Vicuña returned to South America in 1975, to live in Bogotá, Colombia, where she remained through 1979. She became involved in design and technical work for the theater, which she had studied during her years in England, making banners for stage sets. She began a film, "What is Poetry to You?" based on responses to that question in interviews with ordinary people, including prostitutes, bus drivers, and workers. She also began painting again, despite her difficult financial circumstances, a collection of oils depicting various popular saints, as well as such images as her mother with a guitar-shaped mask, and herself embracing her totem animal, the vicuña. In 1978 she decided to abandon painting and to concentrate only on film and performance art, although she exhibited her earlier

oil paintings in Santiago de Chile in 1979. After her return to Bogotá from Chile, Vicuña performed the important piece *A Glass of Milk Spilled under a Blue Sky* (1979). In this work, she spilled a glass of milk in front of Simón Bolívar's house, to protest the deaths of children from the government-condoned contamination of milk. Of this work she wrote " . . . the sky is blue, the milk is spilt, the poem is written on the pavement." The poem read: "The cow / is the continent / whose milk (blood) is spilt. . . ."

In 1980 Vicuña moved to New York, where she continues to live. Shortly thereafter she married the Argentinian painter César Paternosto. During the following decade she continued to perform precarious rituals that, like *A Glass of Milk*, came to consist of three parts: intervention in the environment, documentation via photography, and an accompanying poetic invocation. She also began to record some of these events on videotape. Although her work was included in several group exhibitions, for instance, the important "Decade Show" (1990; held simultaneously in three New York museums) and the magisterial "America, Bride of the Sun" exhibit (1992; Royal Museum of Fine Arts, Antwerp, Belgium), Vicuña did not have a solo show until 1992 at the Exit Art gallery in New York because, as she said, "I am really a poet." In fact, she published several important books of poems during the eighties and early nineties, including *Precarios/Precarious* (1983), *Palabrarmas* (1984), *La Wik'uña* (1990), and *Unravelling Words and the Weaving of Water* (1992), a selection from her previous books, in English translation. While living in New York Vicuña has given numerous poetry readings and ritual performances at various locations in North and South America. Dating from the time of *La Wik'uña*, these "ritual readings," as she calls them, exemplify how her poetic and plastic creations are really two parts of the same endeavor. She continues to create and install *"precarios"* for gallery exhibition.

Vicuña's work is built upon what has been called "the poetics of debris," in that she takes what has been lost or discarded and transforms it into art. Her activity in this regard can be placed in the context of the twentieth-century artistic practice of using found objects, as exemplified by Marcel Duchamp and Kurt Schwitters. In works made according to this aesthetic, revelation is born from the juxtaposition of disparate items. Lautréamont's description, championed by the Surrealists, of an umbrella and a sewing machine meeting on a dissecting table was paraphrased in relation to Vicuña's work by Eliot Weinberger, in his introduction to *Unravelling Words*. It is significant in this connection that her painting style evokes a fantasy state. Vicuña goes beyond the absurdist approach of the modernists, however, in that she believes that the discarded items that she transforms in her work are imbued with a spiritual presence. Her work has been compared to that of Jimmie Durham, David Hammons, and Betye and Alison Saar, all of whom recognize the spiritual power gained by reusing discarded objects. Vicuña can also be compared to Harmony Hammond, who uses recycled materials because she doesn't like "wasting things that have histories and reference other time, places, and peoples." There are other noteworthy similarities between Vicuña and Hammond:

first, that the processes of binding and wrapping are important to each and, second, that both see the transformation of discarded objects through the art-making process as a shamanistic activity.

The most significant aspect of Vicuña's artistic enterprise is its profound link with her ancestral roots, the ancient, indigenous American poetic and shamanistic traditions. In her essay "Choosing the Feather," Vicuña recounts how she became aware of, lost, and finally retrieved her Indian heritage, which for her meant letting "the slow, hidden presence within raise its voice above [her] European education." A connection between the choice to let her Indian voice speak and her process of finding the sacred in small, discarded things is further articulated in a poem in which she asks, "and if I devoted my life / to one of its feathers?" Primary to this world view is the idea of artist as shaman and art as a religious act. To Vicuña the process of assembling her construc-tions is a sacred activity, in which by following the will of the materials she "traveled down pathways of the / mind that led [her] to an ancient silence wait-ing to be heard." Precarious, her constructions are valuable not for their per-manence but for their immanence, their embodiment and reflection of the divine. She writes that "precarious is what is obtained by prayer," as well as that which is "uncertain, exposed to hazards, insecure." Through her inter-vention, these common objects become transformed in a way that is related to the use of ceremonial objects in pre-Columbian societies. A similar process of transmutation takes place in the poems in *Palabrarmas,* where she sees words "opening up" to reveal their inner meanings, "allowing ancient and newborn metaphors to come to light." Through these revelations, their unraveling, the words are analogous to found objects in that, by looking closely and receptive-ly, Vicuña finds their hidden intention. The title itself is significant: *"palabra,* word; *labrar,* to work; *armas,* arms; *mas,* more. To work words as one works the land is to work more; to think of what the work does is to arm yourself with the vision of words."

Consistent with Vicuña's grounding in her Indian cultural heritage, fabric is the most significant recurring metaphor in her work. The importance of weaving, thread, binding, and cloth stems from her awareness of the tradi-tional value of textiles in ancient Andean cultures, "where they were more important than gold." Vicuña identifies strongly with the animal from which she takes her name, the vicuña (la wik'uña), an indigenous fiber-bearing crea-ture, related to the alpaca and the llama. She speaks of it with reverence, call-ing it an "effervescent fountain of wool." "Thread of water, thread of life," she writes, "people say that the wik'uñas / are born where the springs are born." In Vicuña's cosmology fiber, weaving, and prayer are interconnected. She writes that "fiber of prayer, to weave is to pray," and "prayers are threads and weaving is the birth of light." Many of Vicuña's earlier *precarios* involved the binding of disparate scraps and objects with string, or crossing the landscape with string trails. Several recent works feature knotted ropes (in reference to the Incan practice of *quipu,* counting with knots) and woven fabric compo-nents, *ponchos,* resembling traditional Andean garments.

The cloth metaphor is extended in Vicuña's work to the idea of weaving the fabric of society. "The world / is a loose stitch / I've lost / the thread / but I rag on," she writes. To Vicuña, the thread of fiber and the thread of life are one. She "literally and figuratively weaves together the past and the present." In her work, she offers the potential for healing the late-twentieth-century world by binding it to the wisdom of an almost lost, ancient culture.

SOURCES

America, Bride of the Sun: 500 Years Latin America and the Low Countries. Exhibition catalogue (Paul Vandenbroeck and Catherine de Zegher, curators). Antwerp, Belgium: Royal Museum of Fine Arts, 1992.

Blau Duplessis, Rachel. "Noticings." *Sulfur* 14 (Spring 1994), pp. 191-94.

Cecilia Vicuña. MATRIX/BERKELEY 154. University Art Museum/Pacific Film Archive, late November 1992-late January 1993.

Flores, Angel. *Spanish American Authors: The Twentieth Century.* New York: Wilson, 1992.

Flores, Angel and Kate. *Poesia feminista en el mundo hispañico.* Mexico, 1984.

Levin, Kim. "Cecilia Vicuña: Exit Art," *The Village Voice,* May 9-15, 1992.

Lippard, Lucy. "The Vicuña and the Leopard: Chilean Artist Cecilia Vicuña Talks to Lucy Lippard." *Red Bass* 10 (1986), pp. 16-18.

Vicuña, Cecilia. "Choosing the Feather" (trans. Lorraine O'Grady). *Heresies* 15 (1982), pp. 18-19.

_____."Das Exil" and "Uber Das Exil" (trans. Annette von Schönfeld). In *Chilenas, Drinnen und Draufsen.* Berlin: Kunstamt, Kreuzberg, 1983.

_____."Palabrarmas" (trans. Eliot Weinberger). In *Fire over Water,* ed. Reese Williams. New York: Tanam Press, 1986.

_____. *Precarios/Precarious* (trans. Anne Twitty). New York: Tanam Press, 1983.

_____."Quattro donne." *Revista Latinoamerica* 5, no. 13 (Rome, 1984).

_____. *Sabor a mí* (trans. Felipe Ehrenberg). London: Beau Geste Press, 1973.

_____. *Unravelling Words and the Weaving of Water* (trans. Eliot Weinberger and Suzanne Jill Levine). St. Paul, Minn.: Graywolf Press, 1992.

CECILIA VICUÑA—SELECTED WRITINGS

FROM "AUTUMN JOURNAL" (1971)

in june 1971 i filled with autumn leaves a room at the national fine arts museum in santiago, in collaboration with claudio bertoni and nemesio antúnez.

this piece was conceived as a contribution to socialism in chile.

autumn 1969

my first idea was to preserve autumn leaves before someone swept them away or burnt them, not to make them last, but as an act of folly. what i like best about my idea was the collection itself. it was an extremely agreeable, soft and contemplative job.

it gave me an intense pleasure to see the leaves inside the bags because i had never seen such a thing, and because they looked so good.

a million years after the invention of leaves and a few years after the creation of plastic bags i decided to keep autumn in a bag. . . .

june 1971

. . . to explain this piece to the public i should say that this is an interior piece rather than an exterior one, because its conception and the experience of doing it counts more than the sculpture itself.

this is what i call to live the sculpture, everybody could do their own sculptures.

look at this phrase by lautréamont rearranged: "art should be done by every one."

this piece has no concern for the future. it evolves within the present, the absolute joy of an instant can't be perpetuated, any attempt to do so will kill this joy, that's why i used such perishable things as autumn leaves.

the concern for Here and Now cannot be expressed in a lasting piece because then it would be concern for the Here and Now and A Little Bit Later. it is also a "within" piece because bags and leaves are everywhere, it is the perception of them that changes them into pieces of art.

this being inside the head is the most precious thing about art. a person perceiving like that can never feel too bad, "seeing" everything in a different way, even traffic lights or patterns etched on the road.

seeing in this way a person could feel impelled to do creative work, would feel part of greater energies moving in space; perceiving like that a person would enjoy everything in a deeper way.

politically people could find it more and more necessary to create and fight for a world where everybody could get turned on by reality.

this room wants to give joy. art was born for playing and though people may have forgotten, it is time that they remember. joy is a necessity. working

on the piece autumn i experienced joy. working on my joy i experienced autumn.

seeing so many leaves people will think i am deeply interested in leaves. they in turn might think they didn't pay enough attention to autumn or to leaves.

whenever doing one thing they are thinking of the next thing to do. knowing no concentration they know no joy.

everybody has only 70 years to live (more or less). most of the people coming to see the piece are between 15 and 50 years old; some have 45 years left, some only 20. keep this in mind. people aware of their own death are more likely to become revolutionaries.

the "new being" is the one who has a new perception of time and who knows it can't be wasted. the new being will work to accelerate revolution, to metamorphosize her mind and relationships, because it doesn't make sense to suffer having such a short time to live.

joy could make people aware of the need to fight for joy. the urgency of the present is the urgency for revolution.

<center>❦</center>

"PAIN THINGS & EXPLANATIONS" (MAY 1973)

The real explanations of my paintings are lost in Santiago.

I regard my act of painting as a ritual. Any objects that this activity produces exist beyond art history as if art history was already dead or it would have never existed.

In my paintings I need every form to irritate, disgust or disturb. They issue from a convulsed state in which images, helix forms moving as propellers, force their way out.

What are those images I yearn to capture in a poem, a painting, a conversation or a concept thing? I want to use them as vehicles to move from inner into outer space & from outer into inner space, because they can lead me to a state of joy & revelation. These forms come from a specific place & they go to another equally specific place.

When I paint, the certainty of being in a center is so deep that it makes the back of my head ache. I am within a raw flesh heart and need my painting to provoke and be the raw flesh itself.

I am slowly getting closer to a form. To find it I need an opener and then a needle to join the loose ends into a structure that is not only a diagram, a spider's web in the cosmos or a mandala but a particular universe to be used by the thinker. It could be said that thought functions by creating diagrams in which each point is used only as a reference for movement within the unlimited. The thinker pretends that these references are fixed so that he can establish certain particularities as unalterable truths, arbitrarily chosen. Thus immovability within movement is created and along with it the illusion of Order and Time.

In thinking of the form for which I am looking I can't help but find other forms for things outside my paintings, for any search must associate and connect with the search for a social way. If not it is a castrated search, an apolitical occupation good for nothing, or good to help maintain the present structures which have been established for the benefit of the few and the destruction of the rest.

But now these structures must be established taking into consideration facts other than profit or power. It will be possible to simplify these facts to these three categories:

—The way in & out of air in the lungs

—The way in & out of the food

—The way in of the semen and the way out in the shape of a child

This is the elemental spider-web. The only structure loved by the planet, the only one that has a right to be sustained upon the others because it can be called wise or good for life.

The search for structure in society is analogous to the search I undertake for form in my works. The social form is easier to find, it's obviously socialism, self-sufficient communities, but is harder to do it. The form I search for is harder to find, but easier to do.

The finding of paradise will coincide with the finding of a language.

(paintings coming out of darkness go back to darkness. automatic images issue from *regiones esquivas,* evading regions, and right after exposure, like dreams, they return to their burrows in inaccessible places. all my work comes from stupidity and nausea. paintings coming from these feelings seem to change and establish an appearance and dialogue unique to the observer; just as the fairy tale mirrors.)

🌿

"CHOOSING THE FEATHER" (*HERESIES*, 1982)

When I was a little girl I liked to put a feather in my hair and say to the other children in the neighborhood: "Can you imagine what we'd be doing if the Spaniards hadn't come here? Dressed or naked, we would be jumping from rock to rock, swift as arrows after a small bird, or quiet and absorbed in the perfume of fruit, we would be listening to the sound of waterfalls, ferns swaying in the mist. . . . We wouldn't be subject to the silly idea of spending life sitting in a chair, listening to what the teacher says."

But in the neighborhood where I lived, the Sunday movies annulled my work of persuasion: the cowboy and Indian films imposed prestige of the opposite version. The Indians appeared defeated and impoverished, so who would want to be like them? Most of us came out of the theater imitating the fractured English of the Far West: "Wasa matta, yu stickemop."

In our war games, I became the leader of the girl's army, probably inspired by Wonder Woman and other ancient amazons. To conquer fear and

demonstrate that we, too, could run with our eyes closed to the edge of the abyss, on a building top, was the main test. I like the image of heroism in battle, until I began to read and discovered that I liked the image in pre-Columbian mythology, Shakespeare, and Homer better than fighting.

I became a writer and discovered that I had chosen a double symbol: the feather was both my race and my form of doing battle.

From the start I understood art and poetry as a form of transgression. I had no intention of accepting the role assigned to me. My family had a long European cultural tradition, but the advice of the women sculptors saved me time. Aunt Rosa had learned from the old Indian pottery makers techniques she later applied in her ceramic sculpture.

My first works were an emblem or declaration. A joyful challenge nurtured them: the primal impulse to make an offering, and a conscious desire not to repeat what already existed.

As I wrote poetry, I instinctively followed my inner voice. I would notice a tension at the nape of my neck—proof of a clear, sustained listening. The density of the texts produced this way differentiated them from my other verbal constructions. I surely had at the back of my mind the images and metaphors of Guarani literature. The spiritual and concrete eroticism of their body-song: "The divine soles of the feet, / their little round seats / The divine palms of the hands / with their flowering branches." And the incorporation of this vision into their laws: "Whoever, out of lack of love for his neighbor's beautiful body, sets fire to their house shall suffer the same punishment. Only this way will there be justice." (*La literatura de los Guaranies*, ed. & trans. Leon Cadogan [Mexico: Joaquin Mortiz, 1965]).

Poetry as the essential life-transforming experience, led me to search for different ways to extend its effectiveness. And the silence in poetry, that which could not be expressed in words, drew me to art.

I began to paint, and painting led me to sculpture . . . a process that began in 1963 and culminated in 1966, when I found myself gathering debris on the beach. The stones, sticks, and feathers I found as I walked, and the sun above me, called out for a form. The sticks asked for a specific tying, the stones for a specific placement. I had to listen and obey. The same tension, vibrating at the nape of my neck, would occur as I listened. The paths of the mind I explored, looking for the precise position, led me to an ancient silence, waiting to be heard.

These fragile constructions on the beach, which high tide would carry away, were the symbols of an inner rite.

In 1966 I called this work *"arte precario,"* from its propensity to disappear. Years later I discovered that *precario* comes from the Latin *precis*, prayer, and from *precarius*, what is obtained through prayer.

I understood this work as a way of remembering, of recovering a language; the shaman is the one who remembers his other lives.

All along, the obverse of this silent work was my collective experience with Tribu No (the No Tribe), a group of artists and writers who gathered

around my "No Manifesto" (1967) and remained active until 1971. Together we produced actions, manifestos, theatrical works, and readings in Santiago. Our poetry was published in Mexico City and other Latin American and European cities, but in Chile it was neither acknowledged by literary critics nor anthologized.

My *Autumn* installation, a room full of tree leaves piled three feet deep, and the pages of my "Autumn Journal" were presented at the National Museum of Fine Arts in Santiago in 1971. The installation's spatial metaphor established a specific intersection between sculpture and poetry . . . the celebration of autumn and the text's call to attend to the here-and-now evoked the seasonal cults of primordial religions. This piece was dedicated to the construction of socialism. . . but it was not and has never been mentioned by art critics or art historians in Chile.

In 1972 I signed a contract with the University Press of Valparaiso for my poetry book *Sabor a mí*. It was never fulfilled. [It was published with changes and additions in England in a bilingual edition by Beau Geste Press, 1973.]

It took me years to understand the silencing of these works. *Autumn* and the precarious sculpture had been pioneer events. (Experimental art forms began in Chile much later. In 1971 the scene was dominated by political art— "political" in content, but formally derivative.) And my poetry was not *like* anyone else's, so who could notice it?

I left Chile for London in 1972, to do post-graduate work, and was caught there by the military coup in 1973. There was no time for thinking about the suppression of art when the anti-fascist movement demanded an active concern with the human and political problems of the day. . . . Eventually reflection on the failure to secure the democratic process began and I questioned the effectivness of my previous work. As a result I adopted the prevailing view that our struggle had room only for the most immediate calls to rebel. I forgot the double symbol I had chosen: the poetry of self-discovery I had produced until then.

I returned to Latin America in 1975—not to Chile, but to Colombia. Encountering the mountains of Bogotá, the smell of the land, the color and bones of the poeple, made me feel again my Indian ancestry. But the feeling did not become awareness until the Guambiano tribal cooperative invited me to Cauca to give an art workshop. Being with them taught me that the Latin American struggle for independence cannot be fought exclusively with European ideologies, which are derived from the same ethnocentric world view that suppressed the Indian cultures.

The search for liberating thought would have to include the spiritual vision of the American Indian, just as it has already begun to acknowledge the contribution of revolutionary christianity.

One day, the leader of the cooperative asked me: "What tribe are you from?" A shiver ran down my spine. I don't think I ever felt so proud. Suddenly my mestizo blood took sides, as clearly as it had when I was a little girl: I was an Indian, even if I had lost my tribe generations ago.

For me being an "Indian" means to listen, to let the slow, hidden presence within raise its voice above my European education. This is the business of poetry.

I remembered what Guarani literature had meant to me: poetry from them had the power to heal, to communicate with the divine. "In their dreams they obtain their most sacred song, the most powerful, those that benefit their fellow men." Their poetic images were not simply beautiful arrangements of words, they were the complete and truthful image of their reality, and they had to be taken "literally," that is to say, poetically.

But who knows now what it means to think poetically?

I had known from the beginning that Western civilization had done away with poetry as a necessity of life, that poetic thinking was a transgression, that the poet had to struggle to be heard, because poetry had been divorced from thinking centuries ago.

But I had had to forget, in order to remember.

Finally I understood the suppression of my art and poetry in the context of a much larger phenomenon. I concluded that its eroticism (I almost said heroticism, or heroism of the erotic), apparently so shocking to the machismo and Catholic squeamishness of the publishers, had obfuscated the deeper vein of my work; its link with our Ancient American poetic tradition.

Latin American intellectuals for the most part ignore this tradition, conceiving of pre-Columbian poetry as an aspect of anthropology.

And this blatant ethnocentrism is enforced with all the more strength because our dependent, colonial societies are perpetually trying to demonstrate their Westernness.

The poet Humberto Diaz Casanueva has noted that no anthology of Chilean poetry includes either Mapuche ceremonial poetry, chants and prayers, or their battle harangue.

Only if we choose to understand who we are, and decide to pay heed to our ancestors, to the immense richness of their knowledge . . .

Only if we choose to respect the surviving Indian communities, will we respect ourselves.

Only then will we be able to allow a metamorphosed poetic thinking to arise from our mestizo America, and thus call ourselves an independent people.

❧
SELECTED POEMS

FROM *SABOR A MÍ* (1973)

"Solitude" **"Solitud"**

We'd lose half Perderíamos más de la mitad
our oneness de nuestra unión

if I stopped being your friend.	si dejo yo de ser tu amigo
There was no way out I was feeling kind.	yo no tenía salida me sentía gentil
Do you want to make me see the sky? Touch that white space between my thighs softly without intentions almost without wanting.	Quieres hacerme ver el cielo? Tócame ése espacio blanco entre los muslos suavemente sin otras intenciones casi sin querer.

"Mastaba" (1968)	**"Mastaba"**
I had the feeling I was leaning into a waterfall in the forest while you pushed your hand between my buttocks	Me pareció que estaba asomada en una cascada del bosque mientras metías tu mano en mis nalgas
I thought I was flying, dismounting from a horse, your hand on my sex impelled me like a humid bird.	Creí que volaba bajándome del caballo tu mano en mi sexo me impulsaba como pájaro húmedo
I floated joyously on the occasion, was wet down to my knees and two tears blackened my cheeks from being upside down so long.	Floté gozosamente en la ocasión me mejé hasta las rodillas y dos lágrimas me pusieron negras las mejillas tanto estar cabezoa abajo

"Mawida" (1971)	**"Mawida"**
Since they started exterminating the puma or american lion,	Desde que comenzó el exterminio del puma o león americano

and since women were stripped of their gardens of smoke	y desde que las mujeres fueron deprovistas de sus jardines de humo
some have turned savage	algunas de ellas se han vuelto salvajes
and abandoning all return to the mountain range.	y abandonándolo todo vanse a la cordillera
They have been seen roaming solitary cities by the side of friendly lions, swift leopards guide their steps.	Inocentes caballeros consumidos pretendiendo darles alcance han encontrado lustrosas motocicletas abandonadas en riscos y ventisqueros
Haggard, innocent men hoping to overtake them have found shiny motorcycles in cliffs and glaciers.	Han sido vistas merdeando ciudades solitarias en compañía de amigables leones leopardo veloces guían su marcha
Fleeting, intractable she-wolves threaten their lovers with animal habits wielding the lipstick as their central symbol.	Hudidiza lobas intratables amedrentan a sus amantes con práctica animales cuyo símbolo central es el lápiz labial

FROM *LUXUMEI O EL TRASPIE DE LA DOCTRINA* (1983)

"Luxumei"

I have to say
my native dress
is flowers
though I'd rather be
incredible
wear
feathers
madmen's teeth
& handfuls of hair
from Taiwan & Luxumei.
Every time I sneeze
the sky fills with sparks
I tumble and turn
demonic pirouettes
every night

I grow another shoulder.
I'd rather
have four paws
and branches growing out of my skin
but I'm forced to be
an angel
with my hips in flames.

FROM PRECARIOS/PRECARIOUS (1983)

And if I devoted my life	Y su yo dedicara mi vida
to one of its feathers	a una de sus plumas
to living its nature	a vivir su naturaleza
being it and understanding it	serla y comprenderla
until the end	hasta el fin?
Reaching a time	Y llegar a una época
in which my acts	en que mis gestos
are the thousand	son las mil varilla
tiny ribs of the feather	ínfimas
	de la pluma
and my silence the humming	
the whispering	y mi silencio
of wind in the feather	los zumbidos y susurros
	del viento en la pluma
and my thoughts	y mis pensamientos
quick sharp precise	veloces
	ajustados y certeros
as the non-thoughts	como los no-pensamientos
of the feather.	de la pluma.

"Entering" (1983-91)

I thought that all this was nothing more than a way of remembering.
To remember (*recordar*) in the sense of playing the strings (*cuerdas*) of emotion.
Re-member, *re-cordar,* from *cor, corazón,* heart.

First there was listening with the fingers, a sensory memory: the shared
bones, sticks and feathers were sacred things I had to arrange.
To follow their wishes was to rediscover a way of thinking: the paths of

mind I traveled, listening to matter, took me to an ancient silence waiting
to be heard.
To think is to follow the music, the sensations of the elements.
And so began a communion with the sky and the sea, the need to respond to
their desires with works that were prayers.
Pleasure is prayer.
If at the beginning of time, poetry was an act of communion, a form of
collectively entering a vision, now it is a space one enters, a
spatial metaphor.

Metaphor stakes out a space of its own creation.
If the poem is temporal, an oral temple, form is a spatial temple.
Metapherein: to carry beyond
 to the other contemplation:
to con-temple the interior and the exterior.
Space and time, two forms of motion that cross for a moment,
 an instant
 of doubled pleasure, concentration, conpenetration

The precarious is that which is obtained through prayer.
To pray is to feel.
"The quipu that remembers nothing" an empty string, was my first
precarious work.
I prayed by making a quipu, offering the desire to remember.
Desire is the offering, the body is nothing but a metaphor.

In ancient Peru the diviner would trace lines of dust in the earth, as a
means of divination, or of letting the divine speak through him.
Lempad, in Bali, says "All art is transient, even stone wears away." "God
tastes the essence of the offerings, and the people eat the material
remains."

To recover memory is to recover unity
 To be one with sea and sky
 To feel the earth as one's own skin
 Is the only kind of relationship
 That brings joy.

From *Palabrarmas* (1984)

I saw a word in the air	Prima vi una palabra en el aire
solid and suspended	sólida y suspendida
showing me	mostrándome

her seed body

She opened up and fell apart
and from her parts sprouted
sleeping thoughts
 of love, lived
 in love, living
 out of love
came madder violet

Enchanting me
nipples and cupolas
chanting in me

She ascends in a spiral
as I fall in the break
between chant and cupola

In and out
of deserted palaces I wander
seeing the image of chanting
and entering
the beginning
 the end
 the word

The fractal image has thighs,
hips and wounds
to enter

She is mother and wind
her lean body
stalks and waits

She seeks the door
whistling in love
pushing it
with a terse blow as
the door rolls
 in place

No one will see the same palace
once the threshold has been crossed
no one will see the same flowers
except through the gift

su cuerpo de semilla

Se abría y deschacía
y de sus partes brotaban
asociaciones dormidas
 Enamorados
 en amor, morado
 enajenados

Encantándome se sucedían
domos y cúpulas de encanto
cantaban en mí

Ascendía en el vértigo
 desbarrancándome
en el quiebre
entre canto y dome
canto y en

Entraba y salía
por palacios desiertos
viendo la imagen
del canto y el entrar
el principio y el final

La imagen tiene muslos
en su fractal
caderas y llagas
por donde entrar

Ella es madre y ventolera
su cuerpo fino
acomete y espera

Busca y atiende
la puerta
consilbante solicitud
la urge amándola
y al golpe terso
del portal
entra rodando
a su lugar

Nadie vería el mismo palacio
una vez cruzado el portal
nadie observaría las mismas flores
más que por un don

of ubiquity	de ubicuidad
Coincidence is a miracle	La coincidencia es un alcance
of chance, the crossing	milagroso del azar
of two vectors,	el cruce de dos vectores
carelessly placed perhaps	poco cuidadosos quizás
Each word	Cada palabra
waits the traveler	aguarda al viajero
hoping to find	que en ella
in her trails and suns	espera hallar
of thought	senderos y soles
	del pensar
They wait	Esperan silentes
singing in silence	y cantarinas
one hundred times touched	cien veces tocadas
and changed	y trastocadas
exhausted for a moment	agotadas por un instante
and then revived	y vueltas a despertar
Lost or abandoned	Perdidas o abandonadas
they shine again	esplenden de nuevez
Celestial bodies	Cuerpos celestes
each	cada una
in its orbit	en su movimiento
Quartz structure	Estructura cuárzica
sensed by touch	al oído y al tacto
and the inner ear	interior
Body music	Música corporal
forms transform	sus formas transforman
born to die	nacen y mueren
enjoying	y se solazan
their conjugation	en la unión
Space	Espacio
that we penetrate	al que
	compenetramos
Lords of pen	Amos del com
in trance	pene y entrar
Lords of words	Amos y dueños
or do they	del palabrar

love our works?	o aman ellas nuestro labrar
Do they desire us as we desire them?	Lo desean como nosotros a ellas.

Words want to speak; to listen to them is the first task

To open words is to open oneself.

To discover the ancient metaphors condensed in the word itself.

A history of words would be a history of being, but this writing is only a meditation through hints and fragments—from the imagination for the imagination

 IMAGEN EN ACCION image in action

FROM *LA WIK'UÑA* (1990)

"Gold is Your Spinning"	**"Or es tu hilar"**
Gold is your thread of prayer	Oro es tu hilo de orar
Temple of forever threading eyelet	Templo del siempre enhebrar
Your house built from the same braid	Armando casa del mismal treznal
Weave on	Teja mijita no más
thunder & lightning embroidered as you go	Truenos y rayos bordando al pasar
Twisting and twisting	Tuerce que tuerce
Till the gold	El dorado

rises	enderezo
A fresh	El fresco
offering	ofrendar
The unquiet thoughts	Nustas calmadas
of the quiet weaving girl	de inquieto pensar
Marks & signs	Marcas señales
Here & there	Pallá y pacá
The threads & strings	Hilos y cuerdas
Black	Los negros
& gold	y los dorá
Thinking	Cavilan
before each stitch	el punto
Not to let it drop	No se vaya
	a escapar
A grid	Hilo y vano
of empty space	
A fabric of holes	Lleno y vacío
The world	El mundo
is a loose stitch	es hilván
I've lost	Pierdo
the thread	el hilo
but I rag on	Y te hilacho
	briznar
It's a code	Código y cuenta
and a count	cómputo communal
an account	Todo amarran
of the people	
Tying it all	Hilando
	en pos
Threading	Cuerdas y arroyos
towards it all	

Streams & strings

Aunar lo tejido

The stars
the river weaves

¿No es algo
inicial?

The woven
woven into one

El cálido fuelle

A thing of origin

Oro templar

Hot bellows

Habla y abriga

Tempered gold

El mejor juglar

A troubador's
words & cape

**"Inkamisana" (The Message
of the Inka)**

"Inkamisana"

Stairs & rites
not for the foot

Escaleras y ritos
no para el pie

The building
thinks

Edificio
que piensa

Angular rock

Roca angular

Green skyscraper

Verde rascacielos

Black ziggurat

Negro zigurat

Miniature
of time
Made
into altar

Miniatura
de tiempo
Trocado
en altar

Invention
of the night

Invento
de noche

Sprouting
at dawn

Saliente
al albar

Carved rock

Roca tallada

praying as it buds	en brotes de orar
Seeking the seed to sprout!	Búsquido rasgo de lo germinal!
Saliva in torrents	Saliva en torrente
Cooling waterfall	Arrullo de aguar
You redeem your field	Redima tu cancha
Salt head	Cabeza de sal
Stream of lights	Arroyo des luces
Double reflection	Doble refleja
Stone & water	La piedra y el agua
The same sprouting	El mismo brotar

❦

"Litter Me"	**"Ba Surame"**
A little litter	Bá surame
Lit in me	Sura en mí
Alit on me alive in me	Ven a surear
A litter love	Séme Sur
Alit	Sur ame Ya!

INDEX

CREDITS

Magdalena Abakanowicz
All selections used with permission of the author.

Barbara Chase-Riboud
© Barbara Chase-Riboud.

Dorothy Dehner
All selections used with permission of the author.
"Life on the Farm," unpublished manuscript used with permission of the Storm King
Art Center, Mountainville, N.Y.

Audrey Flack
Courtesy of Audrey Flack.

Harmony Hammond
All selections used with permission of the author.
"Creating Feminist Wor'.s," from a panel discussion at the Scholar and the Feminist V
Conference. Sponsored and published by the Barnard Women's Center,
New York, 1978.
"A Sense of Touch," *Heresies* 13 (Spring 1981). (First version, *The New Art Examiner*,
Summer 1979).
"Spiral," *The New Art Examiner* 10 (November 1982).
"Monstrous Beauty: The Woman Gone Wild," in *Beauty and Critique*, ed. Richard
Milazzo (New York: TSL Press, 1983).
"Lesbian Artists," in *Our Right to Love*, ed. Ginny Vida (New York: Prentice-Hall, 1978).
All of the above selections reprinted in Harmony Hammond, *Wrappings: Essays on
Feminism, Art and the Martial Arts.* (New York: TSL Press, 1984).
"Mechanisms of Exclusion," *THE Magazine* (April 1993), pp. 41-43.

Eva Hesse
© The Estate of Eva Hesse. Reprinted by permission. All rights reserved.

Mary Kelly
Courtesy of Mary Kelly.
Post-Partum Document: Documentation II, 23 units, mixed media, 20.3 x 25.4 cm each,
1975. Collection Art Gallery of Ontario.
Post-Partum Document: Documentation IV, 8 units, hand-cast plaster with cotton duck,
27.9 x 35.6 in., 1976. Kunsthaus Zurich (Switzerland).
Post-Partum Document: Documentation VI, 15 units, slate and resin, 20.3 x 25.4 cm,
1978. London, Arts Council of England.
Interim: Corpus, 30 panels, laminated photo positive, silkscreen and acrylic on
Plexiglas, 36 x 48 in. each, 1984-85.
Interim: Potestas, 14 units total, etching, brass, and mild steel, 100 x 114 x 2 in. overall,
1989. The New Museum of Contemporary Art, New York.
Interim: Historia, 4 units, silkscreen, oxidized steel, and stainless steel on wood base,
154.9 x 91.4 x 73.7 cm each, 1989. Collection of the Mackenzie Art Gallery,